M000026320

ART COLLEGE ADMISSIONS II

An insider's guide to Art, Design, & Architecture programs from over 40 Colleges & Universities in the US, Europe, & Asia. Interviews with School Chairs, Faculty, Staff, including Design Company CEOs, Artists, & Designers.

Art College Admissions II
Third Edition, July 2016

Produced by
Oogie Publishing House
New York, NY
oogiepublishinghouse.com

Copyright © 2016

© **Text**
Wook Choi

© **Photographs of Artworks**
Licensed under Oogie Art®. All rights reserved.

Editor
Melissa Choi

Designer
Jiaru Lin

Distributor
Oogie Publishing House
10 E. 33 St. 3 Floor
New York, NY 10016
United States
(212) 714-1011

ISBN 978-0-692-66440-7
Printed in the United States.

"Oogie Art" is a registered tradmark of Oogie Art, Inc.

ART COLLEGE ADMISSIONS II

An insider's guide to Art, Design, & Architecture programs from over 40 Colleges & Universities in the US, Europe, & Asia. Interviews with School Chairs, Faculty, Staff, including Design Company CEOs, Artists, & Designers.

WOOK CHOI

Oogie Publishing House
NEW YORK

CONTENTS

LETTER FROM THE AUTHOR

In order to improve upon our society, placing an emphasis to nurture creativity in education is one of the first steps we can take. Having taught the arts for over 30 years in the U.S.A. and abroad, I've taken a 50/50 approach (art education in Asia: art education in the USA), and I've helped guide hundreds of students preparing to enter their top art, design, and architecture schools.

While students start their own research with the help from parents or teachers, they simply do not have a broad overview or insight into the admissions process. Furthermore, I've noticed parents oftentimes showed hesitance towards their children pursuing an art career, or a general misconception about the arts.

This misconception led me to write my first book, *Art College Admissions*, where I focused on 10 of the most well known schools in the U.S. for their successful programs in the arts, design, and architecture. I included what I considered

to be the most helpful tips on portfolio development, successful artwork samples from previous students, scholarship amounts they received, overall tips on growing students' art practices, and the importance of art today.

In this second book, I've included similar information, but this time reached out to nearly 50 art & liberal arts schools. My team and I contacted admissions officers, department chairs, faculty, and staff, and looked in depth at each school's programs, the admissions process and any new developments.

In this book, we provide students with some of the best schools that have both an emphasis in traditional arts & design, and a growing trend of merging the arts with science, technology and business in both program and faculties. While traditional studio practices remain to be the foundational step for students pursuing a visual arts career, including art, design, & architecture, it is

clear that there is a growing trend of combining science, business, and technology into those same curriculums and departments. For example, the current "STEM to STEAM" movement at RISD, is "a RISD-led initiative to add Art and Design to the national agenda of STEM (Science, Technology, Engineering, Math) education and research in America. STEM + Art = STEAM. The goal is to foster the true innovation that comes with combining the mind of a scientist or technologist with that of an artist or designer."

The rapid globalization and advanced growth of technology remains a constant in our world now; we now have automated cars, virtual reality experiences, and our jobs require us to understand and use technology on a daily basis. Offering this kind of knowledge to the student and parents could start a conversation about the future of their careers. I've always told my students to imagine how their lives might look like in 5 years, a vision of how the world could look like and how the role of their artwork and careers would change.

Here are some examples of recent Science, Technology, & Business programs/facilities in schools and Art Schools:
• At **Parsons**, the B.B.A. in Strategic Design and Management educates students in the entrepreneurial and strategic aspects of design and in design aspects of business.

• **School of Visual Arts** founded the Bio Art Lab within the Fine Arts facilities. It allows students to experiment with scientific tools and techniques to be integrated into students' art practices or general research.

• **MIT** recently started CAST, (Center for Art, Science, & Technology) "a multidisciplinary platform that presents performing and visual arts programs, supports research projects for artists working with science and engineering labs, and sponsors symposia, classes, workshops, design studios, lectures and publications." [2]

• **Boston University** has a lab called EPIC, which stands for Engineering Product Innovation Center, a 15,000-square-foot, $9 million facility that provides students experience with hands-on design, prototyping and small-scale manufacturing as an integral part of their overall engineering curriculum. It is open for any BU Student, and some art students have taken advantage of the facilities.

• With its vision of 'An innovative society', **Aalto University** in Sweden has a new mission that can be summed up as 'Shaping the future: Science and art together with technology and business.' [3]

• At the **ArtCenter College of Design**, a new major called Interaction Design

"emphasizes core methods, tools and processes that prepare you to lead as new technologies emerge."

• Programs at the graduate level, such as the Integrated Product development course held in the University of Michigan, combine business and design, giving students a chance to create their own product and carry it through the manufacturing process.

Studying Abroad

It is the common route for students in the U.S. to graduate from H.S. and remain in the U.S. when attending a college or university. Many of my students have gone to school abroad, and also end up having some of the most positive, well-rounded experiences when it comes to studying art, design or architecture in another country. Not only do they experience a new culture, but they bring back a unique perspective which helps their creativity and ideas greatly.

I always suggest that students should go abroad just for one semester to learn a new language, meet different people, learn cultural differences, and have new experiences, even if they aren't related to art. It's one of the only times when a student won't be held down from other obligations.

Most schools offer study abroad programs, and some are even mandatory. At **STAMPS- U. of Michigan**, all B.A. and B.F.A. degree students are required to participate in an international experience during their undergraduate study. At **NYU's Steinhardt Studio Art** Program, the school "partners with **NYU-Berlin** to provide an unparalleled studio experience for art majors. Berlin is home to the most innovative contemporary art scene in Europe, with an ever-expanding expatriate art community. Art students work in newly renovated studio spaces dedicated to digital art, painting, drawing and exhibition." [4]

Having these unique experiences is what will distinguish one student from another, and prove to be a huge benefit when solving creative problems.

A NOTE FOR PARENTS AND STUDENTS

While you're in school, do not focus too much on what you have to do to gain a safe and stable job. Stay constantly curiou and never give up on what you initially fell in love with doing; Continue to grow deeper in your creative practice until you feel satisfied. It will take hard work, but the world changes positively with people who are passionate about they are doing. And do not do what everyone else is doing, but think about what no one else is doing. That is where the creativity comes from. That is how you can change the world.

It is also important for you to have a positive mentor. Your creative potential is nurtured by passionate, committed teachers that will guide you on the right track. You can try to follow their path until you feel satisfied. And think about what you have learned, if it's something that is valuable and changes your life. It is so unfortunate to see that a student has a negative view of art because they met uninspired or hardened teachers, parents or people. It's also very important that you **read lots and lots of books, newspapers, magazines (Art in America, ArtNews, Artnet, museum websites, workshops, Saatchi Online Gallery, etc.)** covering all topics. Having an understanding of what's currently going on in the world will give you a wider range of ideas and knowledge in nurturing your unique voice. You have instant access to any sort of information you need online.

An example I always go back to is Steve Jobs' commencement speech and many different interviews. Those give me positive energy and encourage me when I loose my confidence. As cliché as it sounds, life really is like a roller-coaster and it goes up and down unpredictably. As Steve Jobs said, "Your work is going to fill a large part of your life, and the only way to be truly satisfied is to do what you believe is great work." Therefore, when you have a hard time, think of it as a chance on how to

improve yourself. But, you have to be the one that puts in the effort, knows how to get better and change. Stay positive! Work harder! Think how no one else thinks!

So what's the importance of going to a good art or liberal arts school? Some might argue that a great artist or designer needs to learn their craft "on their own," that this is the best way for any artist to develop their unique voice. However, going to a good school provides countless benefits you wouldn't receive otherwise. The main benefit is meeting great professors that will influence you and your work throughout your lifetime, and developing strong friendships with your peers. Having a solid network in the creative field is absolutely essential these days. And be open to criticism. Without criticism, your artwork would not improve.

However, the only ones who should consider college are those that will take full advantage of their experience there. Some of the hardest students I've struggled to teach over the years is a lazy student that is uninspired. It is up to each one of you to find what moves you, to find the things that interest you or bother you. You should take **bold action**, and by having conversations with your teachers and peers, I believe it can make all the difference.

THANK YOU NOTE

As an educator, what I learned in my life is that I want to return everything that I have learned back to society. I didn't write this book for a profit, and I wasn't assigned to write it. Rather, I wanted to share my knowledge with all the students & parents, because my hope is that they don't follow their passions based on practicality and compensation, but follow their hearts when making decisions for their future paths. It is necessary to have people in this world who follow their passions.

In 2012, I made an art & technology program where I took students on a trip through Silicon Valley, meeting with top CEO's and designers. Among them are Alfredo Muccino of Liquid Agency, Ron Johnson of Wagic, Benjamin Chia of Elemental8, and Charlotte Jones (no longer there) of Speck Design, many museum's curators and college admission officers.

My team and I had sent out over 100 letters to design companies & agencies, but these were the few that answered and I am forever grateful for their support and willingness to share their lives with my students and I.

When we went into the offices of **Elemental8** and met with **Benjamin Chia**- he was kind enough to show us his diverse portfolio. Ranging from surfboards, to cookies developed by BMW, and a cancer treatment machine. My students were very tired but as soon as he started speaking, they were alert and curious to take in what they were hearing.

During our visit at the offices of **Wagic, Ron Johnson** gave my students and I a chance to play around with the tools that his company designed for Home Depot and talk about the product process. He even showed us products that weren't out in the market yet. Somehow through the curator of the San Jose Institute of Contemporary Art, I met, on

recommendation we connected with **Alfredo Muccino of Liquid Agency** (now CEO of Solid Agency) and we walked into the offices with a last minute appointment. After warmly greeting us, he gave my students and I the speech of a lifetime. We were so touched by his great speech and we will never forget it.

It was clearly a different experience to meet with people working in the field. Everyone was kind, and generous enough to share their knowledge on their profession. All my students left each place with such great inspiration and hope for their future careers, some even broke out in tears because they were so moved. I believe this is one memory that will stick in their minds forever.

I also invited **Vito Acconci** and **Christy Karacas** into our studio. Christy was kind enough to bring my students merchandise based off of his successful TV show "Superjail" and explain his process and the way an animation studio works. His enthusiasm for talking about animation was contagious, and he even warmly invited us into his studio in New York to talk with the animators and designers there!

Vito Acconci brought his portfolio and my students were blown away. While he's an architect, he's known for combining his conceptual art with his architecture, creating dynamic & innovative solutions to the way we see space. In a short time within 2 hours, it seemed like he switched the gears in our brains to think beyond architecture, to think conceptually and different.

I went to Japan to see **Yoshi Shiraishi**'s architecture and when I went to Tokyo he showed me his buildings, and I really thank him for doing this interview and contributing. **Marco LaFiandra** visited our studio to give a lecture on Italian design; for students that just grew up in NY it was a great experience to broaden their minds. He provided a reference paper with great designers.

To my good friends **Judy Collischan** & **Angiola Churchill**, I am so thankful for your contribution to my book and thank you for always taking care of me. Your dedication to the arts inspires me time and time again. And I thank **Alex Jeong**, my friend of 33 years old who lived in the transition time of design in Korea and contributed especially to the c. phone design industry and it was very important to know the history of G.U.I. design through his interview.

I give thanks to the founder of the International Child Art Festival, **Ashfaq Ishaq** and the author of *The Art of Creative*

Thinking, **Rod Judkins**, my previous student **Angela Lee** who graduated from Parsons School of Design and works at the Gap as a fashion designer and **Alex Khomyakov** who graduated from Rhode Island School of Design and works at Apple. In addition, I thank the people whom I found, with innovative design solutions and companies in top world ranking lists, **Elisa Jagerson + Jason Stone, Jonathon Jeffrey, Liza Enebeis, Pete Wright, Ron Johnson, Svein Haakon Lia**.

I also want to give a huge thanks to all the **Professors, Admissions Counselors, Directors of Admissions, Department Chairs, Deans, Communications Officers, & Interns** that were interviewed and helped in providing information to us.

USA

ArtCenter: President Lorne Buchman, Sheila Low, Assistant to President, Jered Gold- VP Marketing & Communications
Boston University: Jen Guillemin, Director Admissions Interim
California College of the Arts: Chris Bliss, Vice President for Communications
Carnegie Mellon University: Pam Wigley: Director, Media & Public Relations, College of Fine Arts
School of Art: Clayton Merell, Associate Head & Professor of Art
School of Architecture: Steve Lee, Head of the School of Architecture BXA programs: M. Stephanie Murray, Ph.D. Director and Academic Advisor, Assistant Teaching Professor
College for Creative Studies: Carla R. Gonzalez, Director of Admissions
Columbia University: Nicola López, Asst. Professor, Director of Undergraduate Studies in Visual Arts
The Cooper Union: Day Gleeson, Associate Professor and Academic Advisor School of Art, Kim Newman, Media Relations Manager
Dartmouth College: Maria Laskaris, special assistant to the provost for arts and innovation, former Dean of Admissions and Financial Aid, Amy D.Olson, Sr. Media Relations Officer Office of Communications
Harvard University:
Thomas Batchelder, Staff Assistant Coordinator of Undergraduate Studies
MICA: Theresa Bedoya, Dean & Vice President, Admission & Financial Aid
MIT: Marion O. Cunningham, Administrative Officer MIT Program in Art, Culture and Technology School of Architecture + Planning
Moore College of Art & Design: Michele Cohen, Associate Director of Communications
New York University: Steinhardt: Marlene McCarty Clinical, Associate Professor of Visual Arts
New York University: Tisch-ITP Program: Midori Yasuda, Admissions/Special Events/

Alumni Administrator
RISD: Jaime Marland, Director of Public Relations
SFAI: Colleen Mulvey Sr., Associate Director for Undergraduate Admissions
SVA: Yoi Tanaka Gayler, Director of Admissions at SVA
Syracuse University:
Shawn Rommevaux, Senior Recruiting Specialist, Social Media Strategist
Temple University: Grace Ahn Klensin, Senior Admissions Counselor
University of Cincinnati: Robert Probst, Dean & Professor of DAAP
University of Michigan:
STAMPS: Karina Galvan Moore, Director of Admissions and Enrollment Management, Truly Render, Director of Communications and Marketing IPD: Professor Bill Lovejoy, Faculty Co-Director, Master of Entrepreneurship Program, Raymond T J Perring Family Professor of Business Administration, Professor of Technology and Operations, Professor of Art, School of Art and Design
U. Penn: Kenneth Lum, Professor and Director of the Fine Arts Undergraduate Program
Virginia Commonwealth University: Erin Neff, Associate Director of Admissions, Suzanne A Silitch, Director of Communications and Teresa Ilnicki, Associate Director of Communications
Yale University: Lisa Kereszi, Director of Undergraduate Studies in Art

Aalto University: Finland: Ossi Naukkarinen, Dean of Aalto University School of Arts
University of the Arts London (UAL): UK: Jen Shannon, Head of Brand and Content Department of Marketing and Student Recruitment, and Natalie Oldham, Brand & Content Executive at University of the Arts London
Goldsmiths University: UK: Michael Archer, Programme Director of Fine Arts
Royal College of Art: UK: Department of Architecture, Dr. Adrian Lahoud, Head of Architecture
Domus Academy: Italy: Angela Ambrogio, Marketing & Communication Specialist
Design Academy Eindhoven: Netherlands: Ella Van Kessel, Communication, Publicity and Projects
Hochschule Pforzheim University: Germany: Antje Dreißig, Faculty of Design
Istituto Europeo di Design: Italy: Andrea Tosi, Dean of International Partnership and Innovation
Nuova Accademia di Belle Arti: Italy: Federica Arrighi, Marketing Communication
Strate School of Design: France: Cecilia Talopp, Head of International Affairs
UMEA University: Sweden: Maria Goransdotter, Head of Department at Umeå Insitute

17

of Design

ASIA
Musashino Art University: Japan: Tanikawa Minori, Admissions and Public Relations
Hong Kong Polytechnic University: HK: Anita Law, Assistant Marketing Manager, School of Design
Nanyang Academy of Fine Arts: Singapore: Emma Goh, Manager of Corporate Communications, Outreach & Media Relations
National Taiwan Normal University: Taiwan: Chun-liang Lin,Dean of College of Arts

Lastly, I thank my Oogie Art students and parents, specially to **Melissa Choi** who did a lot of research and helped me with my interviews, and **Jiaru Lin** who designed this book.

I am truly blessed to have met and be amongst great people who are my friends and mentors. Because of your help, I've been able to successfully navigate the creative field and keep my curiosity fresh.

CHAPTER 1

TIPS FOR APPLYING TO ART SCHOOLS

PORTFOLIO DEVELOPMENT

5 Tips for
Art Portfolio Development

The art portfolio is one of the most important factors in determining your admissions to a college, aside from your academic performance and extracurricular activities. However, do not neglect your grades completely. Yes, art schools place heavy emphasis on the portfolio, but having a good academic standing, like a good GPA, SAT/ACT scores, combined with a great portfolio will also put you in consideration for higher scholarships. There's a myth that grades don't matter at all, and that really is a myth.

Preparing a portfolio is a rigorous process. Both the physical development of pieces takes time, as well as the growth of your technical skills and ideas. Many students underestimate the amount of time it will take to produce a portfolio so it's very important to plan ahead accordingly.

Supplementary Portfolios
Often submitted when applying to a liberal arts schools to demonstrate an interest in the arts, or used as an outside extra-curricular activity.

Mandatory Portfolios
If you are interested in applying to an art, design, or architecture centered school, chances are the portfolio is mandatory. Also, depending on each department, portfolio requirements may differ.

SlideRoom
Most colleges in the USA use the online platform called "SlideRoom" for artwork submission, an application tracking and management system that's also directly linked to the common app. Everything is going digital, and gone are the days of creating slides and mailing them in.
On SlideRoom, you will need to enter this information:
• Title
• Year
• Medium

Title

Saudade

Additional details

Material: Acrylic paint on illustration board
Size: 21 x 29 inch

Description:
One summer day, I took an old train facing the ocean on the way to visit my grandmother in southwest Japan. The ocean reflected the sunlight in the afternoon. The passengers' faces were barely seen by the contrast of light and shadow, then I was a filled with deep nostalgia like traveling back to my old memories.

Continue to next file ›

Artwork by Keika Okamoto

- Size
- Additional Details

TIPS

- There should be a flow to the images in your portfolio. Admissions Officers will browse through hundreds, if not thousands of entries on SlideRoom. Arranging the artwork in a cohesive, balanced way is an important practice, and can capture their attention in a unique way.

- One artwork Description include 1000 words, some schools require 3-5 sentences. It is very important to write a good description for each artwork.

- On SlideRoom, you can also provide links to your videos/ artwork via YouTube, Vimeo, or SketchFab.

-Some schools may even accept a blog or website you've created in place of the portfolio.

1. START WITH REAL-LIFE OBSERVATION, NOT PHOTOGRAPHS

Photographs should be used only as a guiding tool, not the main image you work from to copy or render. These days, it's honestly rare that students learn how to draw properly. The curriculums taught in Visual Arts classes in high-school have certain limitations with time and materials, so sometimes teachers are ok with students drawing from photographs. More often than not, artwork is not corrected, and students aren't guided properly before

"Prelude" Photography- by Mark Chearavanont admitted to Harvard University, 2015

they know the basic principles of light, shape and form. Don't use photographs as a crutch! Only as a reference.

Instead, practice drawing from life. Come up with unique ideas, for example: set up a still-life, but make it interesting and put your own twist on it by adding a graphic fabric that apples can rest on, have a dynamic composition, or do a self-portrait that doesn't rest entirely within the frame but goes outside of it. This is important because the many major-specific concepts and skills art colleges look to teach you in your formative years as an undergraduate can only be fully actualized upon knowing basic principles.

Admissions officers are able to spot a student's ability to draw/render reality within seconds!

2. SHOW YOUR INTERESTS

This may sound obvious, but some students only draw what they're used to or what's in front of them. Colleges want to see what subjects you're interested in as an artist, not only technical skills. They want to see a versatile portfolio showing your range of interests in subject matter.

You can include self-portraits, still life, direct observation, abstract or conceptual ideas, landscapes, sketchbook pages, installation or location specific pieces, sculptures, digital art, mixed media. For subject matter, focus on what matters to you like family, adolescence, a specific place etc.

If you are already interested in a specific major like graphic design, you can integrate some work that shows this. A school like CalArts for example, looks for graphic design pieces if that's the major you plan on entering. You can choose to depict a colorful still-life using products with fun, bold texts, showing your understanding for strong composition & design. Another example is doing a concept in packaging design that can show your creative process, like designing simple objects such as a bottle of water, coffee, and juxtapose those images together. If you're going into fashion, for example at Parsons, the portfolio is fine art based, but you can integrate fabric, textiles, and design into some of your pieces. At School of Art Institute of Chicago for example, you can pick a theme and have different ways of expressing the subject using different mediums.

3. MATERIALS & MEDIUM

Colleges also like to see your experimentation with unusual materials and perhaps even conceptual ideas. For example, one of my students used Q-tips to create an interesting structure of a dress. Another created a series of backpacks out of skateboards. Experiment with mirrors, glass, hair, etc., and don't think of garbage as garbage —

there's always room to create with found materials. Many stick with the traditions of pencil, pastel, charcoal, and acrylic/oil paint, but if you utilize an entirely different medium, you can bring about a different impact in your artwork too. Remember to also try and include 3-dimensional artwork, and digital artwork that's done in Photoshop, and/or photography. These days, schools like to see your ability to use digital programs and photography.

4. KEEP READING BOOKS AND OBSERVING ART, AND FAMILIARIZE YOURSELF WITH CONTEMPORARY ART

I mentioned this in my previous book, but I can't stress the importance of reading enough. Reading will exercise a different part of your brain, expanding your imagination. To make really great art, read and simultaneously visit museums or galleries. Usually, you can generate ideas after you process the artwork. Also, as a designer or artist, being somewhat familiar with art history will greatly benefit the creation of your artwork. If you don't study art history while working on your portfolio, your pieces can actually turn out to be rather lacking in depth or too familiar— studying on artists and the time context really helps. It is important to place yourself into art history, then, you can gauge the quality of the artwork.

5. YOUR VOICE- KNOW IT AND BE VERBAL ABOUT IT

Keep reading and studying modern and contemporary artists, then you can find your own voice. You have to know your own voice in order to talk and write about your artwork, like influences (books, movies, music, etc.) and time periods in history. Be specific about your interests too. Your voice is constantly changing, but at least find out the things that interest you.

Also, talk to as many people as you can, and not just artists but people from all ages and career groups. One-to-one critiques are good, but I stress that group critiques are equally, if not more important. I don't really recommend private lessons and hiding your artwork process. I believe involving discussion will really help your artwork.

One fun example I like to tell students is about Facebook's artist-in-residency program where artists create are given the opportunity to go around the campus to talk with all different people, for example, they can mingle with engineers and try to solve creative problems together. Their artwork is also displayed anywhere in the headquarters, and it gives inspiration to people within the community. This is just one example, but it shows the importance of collaboration, and openly talking about and sharing creative ideas.

Extra Tips:

Keep in mind that even though schools require you to submit roughly 10-15 pieces of artwork (for mandatory portfolios) you should produce at least 25-30 solid works of art to choose from. Really try to understand the importance of trying out as many mediums as possible and knowing your speed.

Keep a Solid Sketchbook

When you sketch your ideas, always do it in your sketchbook, as it can be part of your portfolio later on. Include swatches of fabric, paper, or collaged ideas too.

Submitting a portfolio that's not made by you

Over the years, I've had a few students that have actually bought portfolios created by professionals or, the teachers helped them too much, and in the process overshadowed the voice of the student. Please stay away from doing this! It may get you into college, but it doesn't help anyone and you will inevitably struggle with the course load.

Interviews

Students can opt to sign up for an interview for a more in depth review of their portfolio. It's a great opportunity for the school to get to know you, your interests, and bringing your sketchbook of ideas and working process will be a plus.

For international students, it may be required due to distance. Nowadays, there are several digital platforms and agencies where you can store an interview online and send it to schools all over the country. Practice before your actual interview day.

"Society's Tendencies" by Mary Safy, admitted to Carnegie Mellon University BXA Dual Degree Program 2015

"Abstract direction" by Nicoline von Finck, admitted to Parsons School of Design Dual Program 2015

"Monsieur, Bon Appétit!" by Jiyoung Jeong, admitted early to Princeton University

"Urban Coral" by Aaron Smithson admitted to Columbia University, 2015

WRITING SAMPLES

Most schools that you apply to will require a sample of your writing. This could be in the form of an artist's statement, personal statement, or specific questions the school wants you to answer.

WRITING AN
ARTIST'S STATEMENT

An artist statement is about your artwork specifically. Writing your artist statement can be a daunting task, but the more you learn to write and talk about your work, the more natural it'll become, and it will help inform decisions in your artwork practice as well. If you're in school as a Fine Arts major, for example, critiques will become second nature to your studio practice. In a creative environment, where it's expected for you to complete projects, talking about the process of your work with others will become key to the successful completion of your work.

For example, are you drawn to certain forms of painting, sculpture, film, photography, etc? Talk about the materials. Who and what were some of the influences? Be specific. What's a common theme or interest that you find yourself going back to? Are there any personal experiences or memories that come back to you? What was your initial motivation?

PERSONAL ESSAY

Personal essays ask more questions regarding your background, whether it's about experiences that have shaped you, family, academic, etc. These essays are mostly required amongst liberal arts schools, included in a section of the common application.

Some examples are:
"Reflect on a time when you challenged a belief or idea. What prompted you to act? Would you make the same decision again?"
"Describe a problem you've

"Umbilical Cord" by Ruby Schechter admitted to Rhode Island School of Design 2014

solved, or a problem you'd like to solve. It can be intellectual challenge, a research query, an ethical dilemma-anything that is of personal importance, no matter the scale. Explain its significance to you and what steps you took or could be taken to identify a solution"

Here are some examples of writing prompts from several schools:

ArtCenter College of Art & Design

• Who do you believe to be the three major artists and designers who are shpaing the discipline you are interested in pursuing or who have influenced you?

• The ability to think critically and to approach the classroom with curiosity is vital to success at art center and in the professional world, explain something that you once believed to be true that you have since come to question, OR

Taking a risk comes more easily to some than others but for most it will be an important part of becoming an artist or designer, explain a risk you've taken in your life that has paid off-exploring something new, confronting a fear or problem, or taking a stand on an issue.

SVA

In 500 words or less, discuss your reasons for pursuing undergraduate study in the visual arts. Feel free to include any information about yourself, as well as your goals and interests that may not be immediately apparent from the review of

31

"Humming in my Head" by Jaimey Shapey admitted to Columbia & CalArts, 2015

your transcripts or portfolio.

NYU

A one-page artist's statement describing your:

a) goals as an artist;

b) artistic influences, including two contemporary artists who are nationally or internationally recognized (these artists should have created new work within the past 20 years and they should be represented in major art museums or art galleries which feature contemporary visual artists);

c) background and interests, including previous art training, and films, literature, or music you enjoy and how they relate to your art work;

d) what you hope to gain from studying in the studio art program at NYU.

RISD

Writing Sample

Submit one example of your writing, up to 650 words. Remember, this is the limit, not a goal. Use the full limit if you need it, but don't feel obligated to do so.

The writing prompts are listed below, but you will also find these prompts in the Personal Essay section of the Common Application and in the Writing section of the RISD online application. Select one of the following options:

• Some students have a background, identity, interest, or talent that is so meaningful they believe their application would be incomplete without it. If this sounds like you, then please share your story.

• The lessons we take from failure can be fundamental to later success. Recount an incident or time when you experienced failure. How did it affect you, and what did you learn from the experience?

• Reflect on a time when you challenged a belief or idea. What prompted you to act? Would you make the same decision again?

• Describe a problem you've solved or a problem you'd like to solve. It can be an intellectual challenge, a research query, an ethical dilemma or anything that is of personal importance, no matter the scale. Explain its significance to you and what steps you took or could be taken to identify a solution.

• Discuss an accomplishment or event, formal or informal, that marked your transition from childhood to adulthood within your culture, community, or family.

While we encourage you to adhere to the rules of good writing, we look for applicants who are not afraid to take risks in their expression. Please don't hesitate to use a writing style or method that may be outside the mainstream as you express a distinctive personal position in the samples you submit.

PARSONS

Written Essays: Submit the essays as indicated below:

Essay 1, BA/BFA Essay: Please elaborate specifically on what a liberal arts education means to you and how it can inform your studio practice or how you see your studio practice being enhanced by also studying liberal arts. Describe how the BA/BFA dual-degree program at Eugene Lang and Parsons can work together to help you realize your goals. (maximum 250 words)

Essay 2, Artistic Statement (optional): What do you make, how do you make it, and why do you make? Ultimately, where do you see your creative abilities and academic study taking you after your education here at Parsons? (maximum 500 words)

Always stay true to your own voice. Don't overcompensate with elaborate stories, but write your draft a few times and plan ahead. It's good to have time in between writing to assess which parts to keep and which parts to leave out in your essay.

TIPS

Remember to write in the present tense, and try not to use common phrases like, "I'm trying to say.." or open the paragraph with "I've always loved art...."

"Looking into mirror" by Gregory Winawaer admitted early to Syracuse University for Architecture Program, 2015

DIFFERENCES BETWEEN DEGREES

BACHELOR'S OF FINE ART (BFA)

Bachelor's of Fine Arts degree programs generally take 3-4 years to complete, and includes a concentration or major of interest. It requires approximately 2/3 of the coursework focusing on the study and creation in the Visual Arts, and 1/3 in liberal arts (psychology, history, literature, etc.)

BACHELOR'S OF ART, DESIGN, OR ARCHITECTURE (BA, B.A., B. Des, B. Arch, AB or A.B.)

Bachelor of Arts degree programs generally take three to four years to complete. Liberal arts schools and smaller universities usually offer BA's. It is considered a more academic route, and requires approximately 2/3 focus on liberal arts (psychology, history, literature, etc.) and 1/3 focus in the visual arts. B. Des: Bachelor's of Design, which focuses design including industrial design, graphic design, etc. Most schools don't specialize in B. Design but it is becoming popular amongst American schools.

*In the UK & Europe, a BA might be referred to as a BA(hons) which are standard higher education qualifications recognized in those countries.

Breaking down a Concentration vs. a Major

Declaring a concentration means emphasizing a specific area within your chosen major. However, some schools consider a concentration to be the same thing as a minor, so it's always important to check the website for more information.

For example, at NYU's Studio Art Major, it is mandatory that the student complete a freshman foundation course before deciding their concentration in their 2nd or 3rd year, which includes:
• Sculpture
• Craft Sculpture: Ceramics, Metalsmithing, Fabric, and Glass,
• Photography

- Design/Video Studio & Digital Imaging
- Digital Fabrication Studio
- Painting and Drawing
- Print
- Environmental Activism

At a school like RISD, it is optional for students to choose a concentration (which then acts like a minor). There are four concentrations available. The first three listed are in Liberal Arts and the fourth is interdepartmental:
- Concentration in History of Art and Visual Culture (HAVC)
- Concentration in History, Philosophy, and the Social Sciences (HPSS)
- Concentration in Literary Arts and Studies (LAS)
- Concentration in Nature, Culture, Sustainability Studies (NCSS)

What's a Minor?

A minor within the art school or art dept. is similar to having a concentration. When a student graduates, they will receive their degree, as well as recognition for a minor if they choose to pursue the minor. It could be a liberal arts minor such as art History, or a humanities focus.

At MICA, students have the option to minor in the liberal arts, art history, literary studies, creative writing, gender studies, culture and politics, or critical theory,

They also have a choice for a studio concentration which includes Animation, Architectural Design, Book Arts, Ceramics, etc.

Some schools offer a minor in art or studio art to students enrolled in a separate dept. such

"Chaos & Cords" by Grace (Ha Won) Lee admitted to School of Visual Arts, 2015

"Infinite Observation" by Chanel Lee admitted to Central Saint Martins, 2015

"Breaking Free" by Oleksandra Maksymova admitted to Parsons School of Design, 2015

as engineering, theatre & dance, business, etc.

At NYU, The Department of Art and Art Professions offers three distinctive minors for undergraduates majoring in other departments throughout New York University.

The minors each consist of four courses for a total of 16 points.

The Studio Art Minor allows students the opportunity to explore three areas of contemporary studio practice: Drawing/Painting/Printmaking; Sculpture/Ceramics/Jewelry; and Photography/Video Art/ Digital Art.

The Digital Art & Design Minor provides students with the knowledge and skills necessary to conceive and create digitally based design work.

The Global Visual Art Minor consists of four courses taken here and abroad that combines studio practice and critical and historical studies.[6]

What's a Dual Degree?
Oftentimes called a double degree, or combined degree, you can work for two different university/school degrees, either at the same institution or different institutions. This usually takes about 5 years to complete. For example, RISD and Brown University have a 5-year Dual Degree program that allows students to take courses from each school to receive a BA and BFA simultaneously.

Another school that has a Dual Degree program is Carnegie Mellon University, that includes their own program within the university called the BXA Intercollege Degree Programs, allowing students to receive a BSA (Bachelor of Sciences & Arts) BHA (Bachelor of Humanities & Arts) BCSA (Bachelor of Computer Science & Arts).

At U. of Michigan, "Students who wish to pursue two degrees — one from the Stamps School of Art & Design (BFA or BA), and a second from another academic unit (school or college)—should read the bulletins/handbooks of both units carefully and plan a program of study that meets the degree requirements for both units."[7]

It is important to distinguish between a double major and the dual degree program: A student pursuing a double major satisfies the requirements for two separate major programs within the College but earns a single B.A. degree. A student pursuing a dual degree will receive two bachelor's degrees simultaneously, from two separate schools of the University.

④

MAJORS OF INTEREST/ CAREER PATHS

ACCESSORY DESIGN

An accessory designer is a type of fashion designer that specializes in different accessories. They also need to have a good knowledge of the trends and predict what might be popular for certain seasons. Some skills necessary are drawing and computer software skills.

• Handbag Designer
• Shoe Designer
• Leather Goods Designer
• Soft Goods Designer
• Entrepreneur
• Lead Patternmaker
• Trend Forecaster
• Trend Analyst
• Product Researcher
• Product Merchandiser
• Product Line Developer
• Color andMaterials
• Specialist
• ProductionPersonnel
• MaterialsSourcing
• Supply Specialist

ADVERTISING DESIGN

Design created to reach a broad audience to promote and purchase products and services. It requires a great visual knowledge of graphic design elements as well as the effective use of illustration and photography.

• Art Director
• Creative Director
• Copywriter Producer
• Associate Creative
• Director
• Blogger
• Catalog Content Writer
• Copy Supervisor
• Copywriter
• Creative Director
• Online Content Writer
• Producer
• Public Relations Writer
• Social Media Specialist

ANIMATION

Animators create the illusion of motion and change through images. Having a great knowledge of computer software used to create 2-D and 3-D images for television shows, films, computer games, and video games will be vital as an animator, but equally important

is character development and the understanding of story-telling. Most animators work primarily in Motion Picture & Video Industries, Computer Systems Design & Related Services, Software Publishers, Advertising, Public Relations and Related Services, or Specialized Design Services.

• Layout Artist
• Storyboard Artist
• Character Animator
• Editor
• CG supervisor
• 2-D animator
• Stop Motion Animator

ARCHITECTURE

Architects plan, design, and construct buildings and other physical structures. Architects need to have experience with drafting, 3D modeling, engineering, math, physics, etc. Some other majors linked to Architecture are City/Urban, Community and Regional Planning.

• Architect
• Interior Architect
• Architectural Photographer
• Land Planner
• Architectural Writer/Critic
• Public Architect
• Architecture Educator
• Sustainable Design Specialist
• Building Pathologist
• Urban Designer
• CAD Specialist
• Urban Planner
• Construction Manager
• Corporate Architect
• Exhibit Designer
• Facility Designer
• Facility Managers Architects
• Industrial Designer

ART ADMINISTRATION

Arts Administrators are responsible for the business and overseeing of an arts organization. They facilitate the day-to-day

"Figure Studies" by Katherine Chi admitted to Columbia University and CalArts for animation, 2013

"Cosmopolitan Dreams" by Jenna Chen, admitted to Boston University 2014

operations of the organization and help fulfill its mission.

- Non-profit
- Museum
- Dance & Theatre company
- Auction House
- Appraiser
- Art Adviser
- Curator
- School Administrator

ART EDUCATION

As an art education major, you will take various forms of studio art as well as liberal art courses in pedagogy techniques. Students will also experience hands-on learning environments where student teachers explore educational issues and techniques.

- Community Arts
- Programmer
- Community Arts
- Gallery Director
- K-12 Art Teacher
- Museum Educator

• (Elementary, Secondary, Post-Secondary Education; Community, Art, Cultural Centers; Art Galleries, nursing/drug/daycare centers; weekend programs)
• Art Critic/Writer
• Art Teacher
• Artist-in-Residence/Artist-in-the-Schools
• Arts Administrator
• Freelance Instructor
• Postsecondary Instructor
• Recreation Specialist
• Teacher/Instructor - Overseas
• Teacher of Art and Recreation

ART THERAPY

Art Therapists use art and the creative process to help people with mental, emotional, developmental, or physical problems. It includes a good knowledge of art history, behavioral science, art theory, etc. Some environments where Art Therapists work in are:

• Medical and psychiatric hospitals and clinics
• Mental health agencies
• Halfway houses
• Homeless shelters
• Domestic violence shelters
• Schools and colleges
• Correctional facilities
• Nursing homes

CARTOONING

Create booklets, comic strips, comic books, editorial cartoons, graphic novels, manuals, gag cartoons, graphic design, illustrations, storyboards, posters, shirts, books, advertisements, greeting cards, magazines, newspapers and video game packaging.

COMMUNICATION DESIGN

A mixed discipline of design and information-development, which is concerned with how media intermission such as printed, crafted, or electronic media or presentations to communicate with people.

• Illustrator
• Web designer
• Animator
• Ad Designer
• Copywriter
• Marketing or Public Relations

COMPUTER ART/MEDIA ART

Computer art includes the creation of art in which computers play a role in production or display of the artwork. For example, such can be an image, sound, animation, video, CD-ROM, DVD-ROM, performance, gallery installation, etc. It can also include commercials, billboard ads, and company brochures. Media art includes digital art, computer graphics, computer animation, virtual art, internet art, interactive art, video games, computer robotics, 3D printing, and art as biotechnology.

• Animator

- Computer Graphic Artist
- Digital Filmmaking
- Digital Art
- Video Game Designer

FASHION DESIGN

Fashion designers are responsible for the design and aesthetics applied to clothing and accessories. Fashion is shaped by cultural and social attitudes since it has been varied over time and place. Fashion designers must be familiar with market trends and predict any changes to consumer tastes.

- Fashion Merchandising/Sales and Marketing
- Production Management
- Visual Presentation/Styling
- Public Relations
- Editorial
- Fashion Buyer
- Designer
- Pattern Maker
- Retail
- Seamstress/Tailor

FINE ARTS

The field of Fine Arts starts with more traditional mediums, including Painting, Drawing, Ceramics, Sculpture, Printmaking, and Metalsmithing, moving onto more conceptual artwork. Fine Arts is different from applied arts in that its historical implication is for aesthetics, beauty, or history.

- Fine artist

- Arts Administrator
- Commercial art gallery manager
- Further education teacher
- Higher education lecturer
- Museum/gallery curator
- Printmaker
- Secondary school teacher
- Multimedia programmer

GRAPHIC DESIGN

Graphic Designers use typography, space, image and color, to visually communicate their ideas and solve problems.

- Advertising, Corporate, Publishing
- Art Director
- Book Illustrator, Technical/ Production Illustrator
- Editorial Designer
- Environmental Designer
- Exhibitions Designer
- Freelance Photographer
- Font Designer
- Information Designer
- Interactive Designer
- User Experience Designer
- Social Media Manager
- Package Designer, Product Designer
- Publication Designer
- Photo/Computer/Digital Lab Technician
- Urban Graphics Designer (display, signs, billboards)
- Type Designer
- Web Designer, Webmaster

MOTION GRAPHIC

Motion Graphic artists use digital footage and/or animation technology to create the illusion

of motion or rotation, and are usually combined with audio for use in multimedia projects.

- Exhibition designer
- Furniture designer
- Interior/Spatial designer

INDUSTRIAL DESIGN

Industrial Designers are involved in the design and creation of physical products that will be mass-produced.

- Industrial/product designer
- Clothing/textile technologist

INTERACTION DESIGN

Interaction design is designing and improving how humans interact with digital products, technology, environments and systems. The ultimate goal is to foster a better relationship between people and the

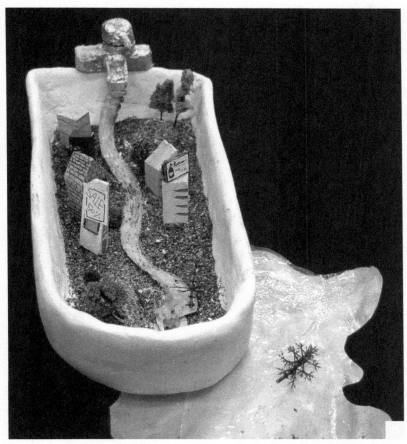

"Tub of Dreams" by Eunji Shin admitted to Nuova Accademia di Belle Arti (NABA, Italy) 2014

products or services they use.

- Entertainment Artist
- Freelance Illustrator
- Storyboard Artist

INTERIOR DESIGN

Interior Designers create beautiful and functional environments with their working knowledge of space and design. They shape the experience of an interior space suitable for people's activities and functions such as a restaurant or living space.

- Color and Trim Designer
- Commercial/Contract Designer
- Corporate Designer
- Exhibit and Display Designer
- Facilities Manager
- Residential Designer
- Retail and Hospitality Designer

ILLUSTRATION

Drawing, painting, and knowing how to use the computer for digital illustration are necessary components as an illustrator. Illustration is different from Fine Art, and includes career options such as book and children's book illustrator, newspaper or magazine illustrator, Film or television animator, etc.

- Advertising Illustrator
- Animator
- Artist for Video Games
- Book Illustrator
- Caricaturist
- Cartoonist
- Comic Book Artist
- Editorial Illustrator

JEWELRY DESIGN

The Art or profession of designing and creating jewelry. Jewelry designers develop their own style and study design, stone cutting, metal casting, and molding.

- Appraiser
- Designer
- Buyer
- Retail
- Lab & Research Professional
- Wholesaler

PACKAGE DESIGN

Package designers evaluate and design the packaging for products through heavy market research. They come up with functional and aesthetically pleasing designs for the successful marketing and distribution of a product.

PHOTOGRAPHY

Photographers will convey ideas through their point of view through a lens using black and white, color, or digital photography. Students generally work with a variety of equipment, learning to photograph 2-D and 3-D projects, shooting with 35mm cameras, and understanding how lenses, tripods and film function. Nowadays, being versatile and knowing how to use the camera for any visual art field will be a huge benefit.

- Cinematographer
- Commercial Photographer
- Digital Retoucher
- Documentary
- Photographer
- Fashion Photographer
- Fine Art Photographer
- Food Photographer
- Forensic Photographer
- Lighting Designer/ Film
- Photojournalist
- Portrait Photographer
- Studio Photographer
- Travel Photographer

PRINTMAKING

Printmakers communicate ideas and emotions by transferring designs from one surface to another. Some practices include lithography, silkscreening, woodcut, and other techniques. It can include designing posters or signs, and be integrated into graphic design.

- Fine Artist
- Teaching & Running Workshops
- Advertising: posters, catalogues, exhibition displays & signs
- Textile industry-printing on clothes or soft furnishings
- Education organization

PRODUCT DESIGN

Product Designers identify, develop, and investigate new products, evaluating materials and visual considerations, and analyze the market trends. It is a more specialized field within Industrial Design.

*Product Design may also refer to the digital platform of Interaction/ UX design & animation.

- Consumer Product Designer
- Exhibit Designer
- Furniture Designer
- Housewares Designer
- Office Product Designer
- Product Development
- Designer
- Shoe Designer
- Toy Designer

SCULPTURE

Sculptor is the branch of the visual arts that involves creating two- or three-dimensional representative or abstract forms, especially by carving stone or wood or by casting metal or plaster.

- Art Critic
- Foundry Manager
- Installation Artist
- Professor
- Sculpture Installation Consultant

STUDIO ART

Is more specific, including the disciplines of drawing, design, painting, and sculpture, plus specialized tracks in ceramics, printmaking, photography, illustration, electronic media, and computer imaging. Usually students receive a BA, taking about 70-75% of their credits in studio art with the rest in "academic" courses.

TEXTILE DESIGN

Textile Designers create designs for woven, knitted or printed fabrics, and different surfaces. It requires knowledge of computer software and trends, as well as traditional or digital printing methods.

• Pattern Maker
• Knit Designer
• Home Furnishing Designer
• CAD Designer
• Designer or Senior Designer in Company
• Fiber Artist
• Embroiderer
• Costume Designer
• Dressmaker

TRANSPORTATION DESIGN

Transportation Design involves designing and developing vehicles that includes cars, boats and aircrafts, trucks & motorcycles.

• Airplane Designer
• Automotive Designer
• Bike Designer
• Boat Designer
• Mass Transit Designer
• Motorcycle Designer

TOY DESIGN

A toy designer is a specialized field within Product Design. The designer develops toys with proper research and prototyping. Many professionals might specialize in a certain type of toy or for certain age groups. For example, they may focus on infant products, while another designer focuses on action figures or board games.

UX DESIGN

UX design is the process of designing products that are useful, easy to use and aesthetically pleasing to interact with. UX designers enhance the users experience with the product.

• UX Designer
• UX Consultant
• UX Director
• Head of User Experience
• Startup design consultant
• Design instructor
• Product Manager

VIDEO ART

Video Artists use video as a medium of expression, commonly seen in installations, a combination with performance art, or computer art. It is more closely related to Fine Arts than filmmaking.

• Video Editor
• Fine Artist
• Animator
• Digital Illustrator

WEBSITE DESIGN

Web designers are responsible for the visual aspect, which includes the layout, coloring and typography of a web page.

• Assistant web designer
• Web graphic designer
• Multimedia designer
• User interface designer

"Deflated Egos" by Charlie Mo admitted to New York University, Tisch for Game Design 2015

Oogie Art Leadership Program through Art in Uganda Art lunch for Kasangula School in 2014

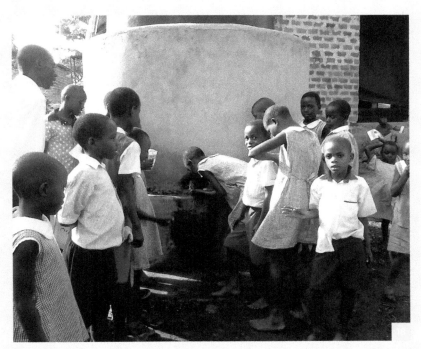

Oogie Art Uganda Water Project 2015

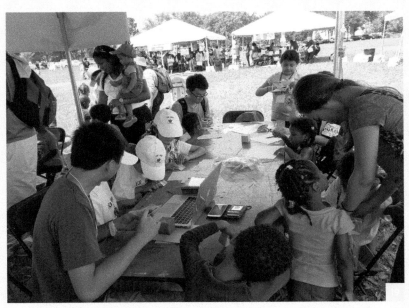

Oogie Art Leadership Program in Washington D.C. in 2015, collaboration with International Child Art Festival (ICAF)

CHAPTER 2

SCHOOLS IN THE U.S.A.

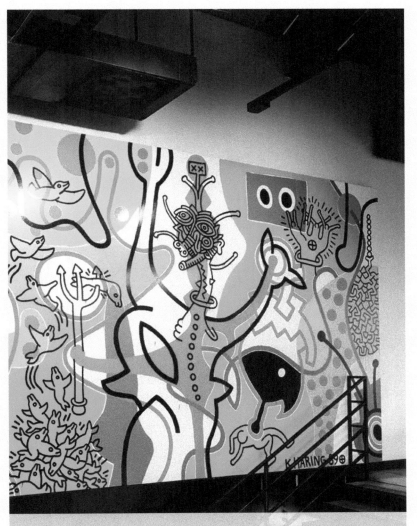

ARTCENTER
COLLEGE OF DESIGN
Pasadena, California
www.artcenter.edu

20

ARTCENTER COLLEGE OF DESIGN
DESIGN

Learn to create. Influence change. This is the mission of ArtCenter College of Design. For more than 85 years, ArtCenter has achieved an international reputation for our rigorous, transdisciplinary curriculum, faculty of professionals, strong ties to industry and a commitment to socially responsible design. ArtCenter prepares artists and designers to make a positive impact in their chosen fields — as well as the world at large.

FACT!
1:9 faculty-student ratio

WHAT MAKES YOUR DESIGN PROGRAMS DIFFERENT & UNIQUE FROM OTHER SCHOOL'S PROGRAMS?

We do not offer a general foundation freshman year, but instead require students to enter directly into one of our majors. This allows us to spend additional time on a more in-depth approach to each of our disciplines and has a positive effect on the portfolios of our graduating students.

ARE THERE ANY EXCITING DEVELOPMENTS FOR YOUR PROGRAMS THAT STUDENTS SHOULD KNOW ABOUT?

We have added a major in Interaction Design and expect to add a new graduate program in Graphic Design within the next several years. We've also recently launched new areas of focus in Character Animation (Entertainment Design), Wearables and Soft Goods (Product Design), and Vehicle Interiors (Transportation Design).

CAN STUDENTS TAKE COURSES IN OTHER SCHOOLS?

We have exchange programs with Occidental College, California Institute of Technology, Tama Art University, INSEAD and Konstfach College of Design among others.

*HOW ARE NEW TECHNOLOGIES
AFFECTING STUDENTS'
CURRICULA AND/OR WAYS OF
COLLABORATING/LEARNING AT
YOUR SCHOOL?*

We are integrating new technologies like user experience and interaction design within many aspects of our curriculum.

*WHAT ARE THE TOP 3 PROGRAM
FEATURES THAT MAKE YOUR
PROGRAM STAND OUT?*

1. Rigorous curriculum with sequential structure.
2. Faculty of practicing professionals
3. Highly committed and focused students

*HOW DOES YOUR PROGRAM
HELP GRADUATING STUDENTS*

*WITH INTERNSHIPS OR JOBS?
CAN STUDENTS EXPECT JOB
PLACEMENT MORE AT YOUR
PROGRAM THAN IN OTHERS? IF
SO, HOW OR WHY?
WHAT KINDS OF JOB
OPPORTUNITIES HAVE YOU SEEN
STUDENTS TAKE ONCE THEY
COMPLETED THEIR DEGREES?*

Our graduating students have an excellent record of job placement. Based on a recent survey with 35% responding, 91% of those students had positions in their fields within one and a half years. We offer internship opportunities for interested students, and have over 200 companies per year visit our campus to recruit students for their companies.

*WHAT STEPS DO YOU TAKE
TO EVALUATE A STUDENT'S
CANDIDACY, APART*

ArtCenter's rich history in interaction design spans the fields of graphic design, transportation design, entertainment design, industrial design and media design, with graduates now holding leading positions at companies like Apple, Google, Microsoft and IDEO.

FROM REVIEWING THEIR CREATIVE PORTFOLIO?

We review their academic record and test scores, and pay close attention to their written essays.

WHAT DOES YOUR PROGRAMME LOOK FOR MOST IN THE CREATIVE PORTFOLIO DURING ADMISSIONS? WHAT DO YOU THINK MAKES AN A+ PORTFOLIO?

We look for a combination of skill in their area of focus along with a sense of personal expression, originality, and intelligent approach to communicating visually.

WHAT IS THE BEST ADVICE YOU HAVE FOR STUDENTS ENTERING THE ART AND DESIGN FIELD? AND WHAT DO YOU THINK IS THE ROLE OF THE ARTIST TODAY?

It is a wonderful time to engage in the creative fields. There is an increased understanding of the role of creative individuals in the economy as well as storytellers and influencers than ever before. Creatives are taking on leadership roles in all types of organizations, from corporations to humanitarian based endeavors.

by Lorne Buchman
President, and
Sheila Low
Assistant to President

APPLICATION MATERIALS
Online or through through application forms

PORTFOLIO REQUIREMENTS
10-15 images

TRANSCRIPTS
Required

WRITING SAMPLE
Required and depends on the major

RECOMMENDATION LETTERS
Recommended

INTERVIEW
Recommended

APPLICATIONS DEADLINES
Early Decision:
Summer Term: Jan 15
Fall Term: Feb 15
Spring Term: Oct 1

Regular Application:
Ongoing decisions

FOR INTERNATIONAL STUDENTS
Fall Term: Feb 15
Spring Term: Oct 1
Summer Term: Jan 15

TOEFL: minimum 80
IELTS: minimum 6.5

DEGREES

BFA & BS:
1. Advertising Design
2. Entertainment Design
3. Environmental Design
4. Film
5. Fine Art
6. Graphic Design
7. Illustration
8. Interaction Design
9. Photography and imaging
10. Product Design
11. Transportation Design

RANKING

INDUSTRIAL DESIGN
#1 Design Intelligence 2016

GRAPHIC DESIGN
#7 U.S.News 2015

ADMISSIONS OFFICE

ArtCenter College of Design Admissions Office
Hillside Campus, 1700 Lida Street,
Pasadena, CA 91103
+1 (626)-396-2373

ALUMNI
Michael Bay, Filmmaker
Zack Snyder, Filmmaker
Chris Bangle, Car Designer
Syd Mead, Entertainment Designer
Yves Behar, Industrial Designer
Matthew Rolston, Photographer
Bruce Heavin, Illustrator and
lynda.com Co-founder

DID YOU KNOW?
At ArtCenter, students are **required to choose a major and create a portfolio geared towards that specific major.** *Your portfolio needs to show a basic understanding and skill set, unique to that major. They do not accept general drawing and painting portfolios as admissions portfolios.*

59

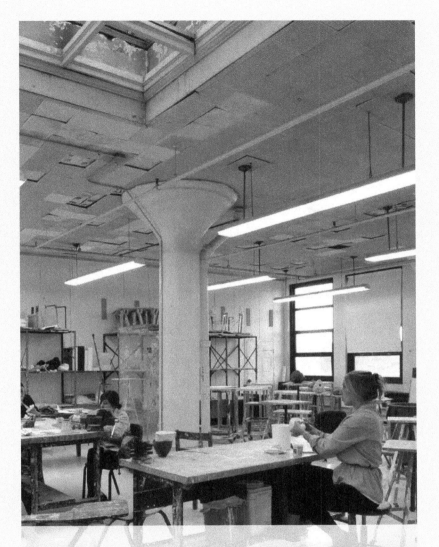

BOSTON UNIVERSITY
Boston, Massachusetts
www.bu.edu

22

BOSTON UNIVERSITY
COLLEGE OF FINE ARTS, VISUAL ARTS MAJOR

Boston University College of Fine Arts is more than a community of artists—it is a specialized educational experience that demands inquiry and exploration, individuality and teamwork, and academic and artistic immersion. This is a place where students and faculty can fully explore and expand the study of music, theatre, and visual arts in the context of an elite research university.

FACT!
CFA students can also apply for the **Boston University Collaborative Degree Program** *(BUCOP), where students simultaneously earn undergraduate degrees at CFA and in one of 14 undergraduate colleges of the university.*

WHAT ARE THE TOP 3 PROGRAM FEATURES THAT MAKE YOUR PROGRAM STAND OUT?

The three features that make BU's School of Visual Arts stand out would be incredible access to one of the world's best research institutions and the opportunity to pursue other academic interests, our Arts Leadership Minor, and our unique and passionate faculty.

WHAT MAKES YOUR SCHOOL'S ART & DESIGN PROGRAMS DIFFERENT & UNIQUE FROM OTHER ART & DESIGN SCHOOL PROGRAMS?

Boston University's art program is unique because we offer students a rigorous studio experience as well as the opportunity to combine their passion for the arts with other academic interests being studied at the highest level. We also offer an intensive Foundations year that focuses on developing a fundamental skill set that prepares students to work in any medium that they may decide to pursue later.

CAN STUDENTS TAKE COURSES IN OTHER SCHOOLS?

Absolutely! Many of our students choose to take elective courses,

pick up minors, or even pursue dual degrees in any of the University's 250+ areas of study.

WHAT STEPS DO YOU TAKE TO EVALUATE A STUDENT'S CANDIDACY, APART FROM REVIEWING THEIR CREATIVE PORTFOLIO?

In addition to the portfolio, Boston University requires that students complete the Common Application with includes a personal essay, two letters of recommendation and a students official high school transcript. Boston University has a high level of academic rigor and therefore carefully considers the level of rigor demonstrated in high school. BU is also looking for students who will create a unique, diverse community at BU. For example, students who are volunteers, entrepreneurs, passionate about a single pursuit or exploring a wide variety of subjects. Therefore, BU considers extracurricular activities and interests, special talents and skills.

WHAT DOES YOUR PROGRAM LOOK FOR MOST IN THE CREATIVE PORTFOLIO DURING ADMISSIONS? WHAT DO YOU THINK MAKES AN A+ PORTFOLIO?

Exhibiting a strong foundation in observational drawing is important for a strong portfolio, and students who submit the most successful and exciting portfolios are ones who also exhibit exceptional skill and execution as well as the use of compelling concepts and ideas. It is this combination that makes for an A+ portfolio.

HOW ARE NEW TECHNOLOGIES AFFECTING STUDENTS'

The BU College of Fine Arts structure at 855 Commonwealth Ave. used to be the finest Buick dealership in the city around 1919. CFA moved into the space in 1954, making it the backdrop for this BU community of artists to learn, imagine, and investigate.

CURRICULUMS AND/OR WAYS OF LEARNING/COLLABORATING AT YOUR SCHOOL?

A unique opportunity exists for BU students to work in Boston University's Engineering Project and Innovation Center (EPIC). This is a pioneering facility for fabrication that offers laser cutting, 3D printing, robotic manufacturing and more.

HOW DOES YOUR PROGRAM HELP GRADUATING STUDENTS WITH INTERNSHIPS OR JOBS? CAN STUDENTS EXPECT JOB PLACEMENT MORE AT YOUR PROGRAM THAN IN OTHERS? IF SO, HOW OR WHY? WHAT KINDS OF JOB OPPORTUNITIES HAVE YOU SEEN STUDENTS TAKE ONCE THEY COMPLETED THEIR DEGREES?

BU offers career placement through our Center of Career Development, as well hundreds of visual arts specific internships that students may participate in for credit. Every fall the School of Visual Arts holds an internship fair to help facilitate these opportunities.

ARE THERE ANY EXCITING DEVELOPMENTS FOR YOUR PROGRAMS THAT STUDENTS SHOULD KNOW ABOUT?

A new and exciting initiative has been our Arts Leadership Minor. This minor is for any student at Boston University who feels that the arts have a greater role in society and can be an agent of social change. The minor in Arts Leadership is designed to provide students with the practical and strategic skills to become leaders in the arts. Course selection is intentionally flexible in order to serve not only a broad constituency but also to allow students to hone leadership and thinking skills in particular areas of interest, including arts entrepreneurship, arts administration, and arts activism. The College of Fine Arts recognizes that artists and creative thinkers need practical preparation for a life in the arts. As natural problem-solvers, artists are already well suited as agents of social change and possess the potential to also be dynamic leaders. The Arts Leadership minor provides students with the tools and skills to put ideas into action.

FACT!
Average Class Size
Undergraduate: 16
Graduate: 11
Student/Faculty Ratio
9.5:1

WHAT IS THE MOST DISTINGUISHED FEATURE AT YOUR SCHOOL?

As a University, BU has a rich and distinguished history of alumni and important achievements including the formation of the School of Music, this first of it's kind. Also, The SVA's largest

The BU Arts Initiative partners with the College of Fine Arts on a number of initiatives and programs, including, but not limited to the MED Campus Outreach, special events, art installations, conferences, performances, and workshops.

professional gallery, the 808 Gallery, was formally a Cadillac Dealership showroom and maintains some of the original interior finishes from that era!

WHAT IS THE BEST ADVICE YOU HAVE FOR STUDENTS ENTERING THE ART, DESIGN & ARCHITECTURE FIELD? WHAT ROLE DOES THE ARTIST PLAY TODAY?

Artists today have an incredible opportunity to be agents of social change. It requires not only the drive to create compelling work, but also the passion to be involved in the community. Training beyond the studio is critical, as is a willingness to approach the arts from a broad prospective.

by Jen Guillemin
Director Ad Interim

DID YOU KNOW?
Scarlet and white are BU's school colors. BU's mascot is named Rhett because of the **_Gone with the Wind quote_***: "No one loves Scarlet more than Rhett!"*

APPLICATION MATERIALS
Common Application

PORTFOLIO REQUIREMENTS
15–20 pieces

Early Decision: Nov 1
Reg Decision: Jan 6
* All portfolios submitted before the February 1 deadline will be considered for merit-based Financial Aid from the Boston University.

WRITING SAMPLE
1. Common App Essay
2. Artist Statement on Slideroom (few sentences)

65

TRANSCRIPTS
Required

RECOMMENDATION LETTERS
1 Counselor Recommendation
1 Teacher Evaluation

APPLICATIONS DEADLINES
Early Decision: Nov 2
Early Decision 2: Jan 4

Regular Decision: Jan 3

FOR INTERNATIONAL STUDENTS
Early Decision: Nov 1
*Dec 1 - for scholarship
consideration
Regular Decision: Jan 3

TOEFL min. 90-100
(scores of 20 or higher on
each subsection)
IELTS: min. 7.0
*SAT/ACT test scores are not
required for applicants to the
College of Fine Arts, with the
exception of those applying
to the Double Degree
Programs, Kilachand Honors
College, or for any of BU's
merit scholarships.

TIPS
Required in Portfolio:
1. Portrait from Observation
2. Still-Lifes from Observation

*There is an optional official
portfolio review day in which
students have their portfolios
reviewed by faculty members
as part of their application
for admission.*
*Students will also have an
opportunity to attend a class.
You must register ahead of time.*

*The Arts Leadership Minor at BU is designed to provide students with the practical
and strategic skills to become leaders in the arts and is designed to meet the needs of
students in all BU colleges.*

DEGREES
BFA:
1. Art Education
2. Graphic Design
3. Painting
4. Printmaking
5. Sculpture
6. Undeclared*

Arts Leadership Minor

RANKING

ART AND DESIGN
#Top Design Schools Graphic Design 2016 for Graphic Design according to GDUSA (Graphic Design USA)

ADMISSIONS OFFICE
BU Admissions - Alan and Sherry Leventhal Center
233 Bay State Rd,
Boston, MA 02215
+1 (617)-353-2300

ALUMNI
Brice Marden, Artist
Gael Towey, Short films document artists
Katie Noyes, Artist
Uzo Aduba, American actress and Singer

UNIVERSITY OF CINCINNATI
Cincinnati, Ohio
www.uc.edu

26

UNIVERSITY OF CINCINNATI

COLLEGE OF DESIGN, ARCHITECTURE, ART AND PLANNING

The University of Cincinnati offers students a balance of educational excellence and real-world experience. UC is a public research university with an enrollment of more than 44,000 students.

The College of Design, Architecture, Art, and Planning at the University of Cincinnati has as its primary mission the creation of a better visual and design environment. Through excellence in educational programs, research, creative works, and service to the community, the faculty, the students, and administrative officers of DAAP are dedicated to achieve this mission.[10]

FACT!
Student/Faculty Ratio
18 to 1
Programs of Study
379
Total Enrollment
44,251

WHAT MAKES YOUR SCHOOL'S DESIGN, ARCHITECTURE, ART,

AND PLANNING PROGRAM DIFFERENT & UNIQUE FROM OTHER SCHOOLS' PROGRAMS?

The University of Cincinnati's College of Design, Architecture, Art, and Planning (DAAP) is part of a comprehensive, public, state university and consistently ranked among the top design schools in the world. One reason for this ranking is DAAP's cooperative education program (co-op), which is unmatched in its scope of disciplines and opportunities. DAAP's co-op program puts students in each of the college's four schools to work, alternating semesters of coursework with real-world experiences that prepare them for careers, build impressive resumes, and grow their professional networks. By the time they graduate, DAAP students have one and a half years of work experience in their chosen fields.

WHAT ARE THE TOP 3 PROGRAM FEATURES THAT MAKE YOUR

PROGRAM STAND OUT?

1. At DAAP, design, architecture, art, and planning are all housed under one roof, providing students with many opportunities for cross-disciplinary study.
2. DAAP is a component of one of America's premier urban research universities where students are encouraged to study and collaborate across departments and colleges.
3. Cooperative education and experiential learning are a part of the curriculum structure.

CAN STUDENTS TAKE COURSES IN OTHER SCHOOLS?

Yes, not only are students encouraged to complete certificate programs and minors in other disciplines at the university, DAAP students must take a certain number of university-required courses to graduate with a bachelor's degree.

WHAT STEPS DO YOU TAKE TO EVALUATE A STUDENT'S CANDIDACY, APART FROM REVIEWING THEIR CREATIVE PORTFOLIO?

DAAP is always looking for academic excellence from its students. There is no portfolio review for undergraduate admission. Students submit the University of Cincinnati's Common Application and related materials, and a holistic review is completed. Items reviewed include: academics (e.g., GPA, test scores, rigor of courses taken, grade trends); co-curricular activities (e.g., school groups, community service, leadership roles, and other activities); writing samples (e.g., essay and personal statement); and letters of recommendation.

HOW ARE NEW TECHNOLOGIES AFFECTING STUDENTS' CURRICULUMS AND/OR WAYS OF LEARNING/COLLABORATING AT YOUR SCHOOL?

DAAP has taken a leadership role in the University of Cincinnati's Digital Media Collaborative, a network of the university's faculty members, colleges, departments, research centers, libraries, labs and interested industry and alumni partners to promote excellence in digital media education, research and creative work at UC. The Digital Media Collaborative emphasizes interdisciplinary collaboration and explores aspects of digital media production and its role in society, while creating experiential and professional learning opportunities in the field.

WHAT DOES YOUR PROGRAM LOOK FOR MOST IN THE CREATIVE PORTFOLIO

DURING ADMISSIONS?
WHAT DO YOU THINK MAKES AN
A+ PORTFOLIO?

DAAP is always looking for excellence in concept, execution and presentation. DAAP does not conduct portfolio reviews for undergraduate admissions. For graduate admission, a portfolio is required.

HOW DOES YOUR PROGRAM
HELP GRADUATING STUDENTS
WITH INTERNSHIPS OR JOBS?
CAN STUDENTS EXPECT
JOB PLACEMENT MORE AT
YOUR PROGRAM THAN IN

OTHERS? IF SO, HOW OR WHY?
WHAT KINDS OF JOB
OPPORTUNITIES HAVE YOU SEEN
STUDENTS TAKE ONCE THEY
COMPLETED THEIR DEGREES?

Because of the strong network of colleagues, mentors and friends that DAAP students build during their cooperative learning semesters, many of them have job offers at graduation. About 75% of DAAP graduates have secured a position by the time they graduate. DAAP graduates go on to work at leading global agencies, Fortune

The Co-op was the first established in the US. It provides guaranteed, paid experience as part of the curriculum. Most students in business, engineering, science, DAAP, and some other majors gain 1.5 years of paid and varied experience.

500 companies, cities of all sizes, boutique design firms, institutions, and universities.

FACT!
Constructed in 1953, the Alms building was the first building constructed in what is now known as DAAP at UC.

ARE THERE ANY EXCITING DEVELOPMENTS FOR YOUR PROGRAMS THAT STUDENTS SHOULD KNOW ABOUT?

In addition to DAAP's involvement in the growth of the University of Cincinnati's Digital Media Collaborative, which will impact all DAAP students, DAAP's fine arts program has implemented cooperative education into its curriculum. Beginning in 2015, students joining DAAP's fine arts program will complete three co-op placements during their five-year degree program. This will be the only fine arts cooperative education program at a public university in the United States.

WHAT IS THE BEST ADVICE YOU HAVE FOR STUDENTS ENTERING THE ART, DESIGN & ARCHITECTURE FIELD? AND WHAT DO YOU THINK IS THE ROLE OF THE ARTIST TODAY?

Have an open mind and think creatively and expansively about how to create a better tomorrow. Do what you love and remember there are multiple ways to pursue your passion. In a world that is dominated largely by science and technology, the role of the artist and designer is becoming increasingly important. Being able to qualitatively evaluate aspects and alternative perspectives of life and culture is critical to how we live now and in the future.

*by Robert Probst
Dean*

APPLICATION MATERIALS
Common application

SUPPLEMENTARY
PORTFOLIO REQUIREMENTS
Portfolio is not considered

TRANSCRIPTS
Required

WRITING SAMPLE
Personal Statement

RECOMMENDATION LETTERS
1 Teacher or counselor

INTERVIEW
Not required

APPLICATIONS DEADLINES
Early Action: Dec 1
Regular Decision(Rolling): Mar 1

FOR INTERNATIONAL STUDENTS
Early Action Deadline: Dec 1
Rolling Deadline: Mar 1

TOEFL: 79
(iBT-min. 15 on each section)
IELTS: 6.5
(min. 5.5 on each section)
PTE: 53

TIPS

To apply for more than one area of concentration, separate applications, fees, and supporting documentation must be submitted. The work submitted should be representative of the applicant's experience in that particular field.

DID YOU KNOW?

DAAP offers students industry experience through co-ops and access to general education opportunities that'd be hard to gain in smaller settings. Most of the students that have a job before graduation give credit to the co-op.

Two of "The New York Five" architects attended the University of Cincinnati: Michael Graves and John Hejduk (though Hejduk did not ultimately graduate from the program)

Students for Ecological Design: SED was created to bring together and transmit knowledge between a collective of people interested in the education, promotion, and implementation of environmentally focused design.

ALUMNI
Michael Bierut, Designer
Jim Dine, Artist
Mike Gasaway, Animator
Michael Graves, Architect
Sean Gresens, Art Director
Stan Herman, Designer
Cathy Davenport Lee, Creative Director
Joseph Marioni, Painter
David Opdyke, Artist
Michael Reynolds, Architect
Kevin Roche, Interior Designer
Joe Stitzlein, Creative Director
Shane Wolf, Artist
Luke Woods, Product Designer

DEGREES

BLUE ASH COLLEGE
BA:
1. Graphic Design
2. Painting/Printmaking
3. Photography
4. Sculpture

COLLEGE OF DESIGN, ARCHITECTURE, ART AND PLANNING
BFA: Fine Arts
BA:
1. Architecture
2. Art History
3. Communication Design
4. Fashion Design
5. Horticulture
6. Industrial Design
7. Interior Design
8. Urban Planning
9. Urban Studies

RANKING

INDUSTRIAL DESIGN
#1 Design Intelligence 2012-4

INTERIOR DESIGN
#4 Design Intelligence 2014

ADMISSIONS OFFICE

University Of Cincinnati Undergraduate Admissions
University Pavilion, PO Box 210091
Cincinnati, OH 45221-0091
+1 (513)-556-1100

CALIFORNIA COLLEGE OF THE ARTS

Oakland, California
www.cca.edu

28

CALIFORNIA COLLEGE OF THE ARTS
ART, DESIGN & ARCHITECTURE

California College of the Arts was founded in 1907 by Frederick Meyer to provide an education for artists and designers that would integrate both theory and practice in the arts. Meyer's vision continues to the present day. President Stephen Beal says, "CCA's history is tied to the Arts and Crafts movement, a time when artists and designers were producing work that would address the social issues of the time and have a positive impact on the world. This spirit is still very much a part of the college today."

FACT!
CCA benefits from its location in the San Francisco Bay Area. The Bay Area and Silicon Valley are global hubs of entrepreneurship, technology, and design. 40 percent of all venture capital money in the United States is invested here.

WHAT MAKES YOUR SCHOOLS' ART PROGRAMS DIFFERENT & UNIQUE FROM OTHER ART & DESIGN SCHOOL PROGRAMS?

California College of the Arts (CCA) is distinguished by the depth and breadth of its programs. The college offers 22 undergraduate and 13 graduate programs in the areas of fine arts, architecture, design, and writing.

The education at CCA is highly influenced by its location. The San Francisco Bay Area is defined by entrepreneurship, sustainability, and social activism as well as design and technology. Innovation and creativity permeate all aspects of daily life. CCA is located in the hub of the Bay Area's "innovation corridor," where Silicon Valley drives the need for design and technology solutions to real-world problems.

CCA is also a community of artists who believe creative work can positively and powerfully affect society. Our motto is make art that matters. We push boundaries by creating bold and innovative solutions that bridge design and technology. We reach outside our community

to engage in learning practices from around the globe, sharing how we create. CCA's large international student population (28%) makes it a global leader in arts education.

WHAT ARE THE TOP 3 PROGRAM FEATURES THAT MAKE YOUR PROGRAM STAND OUT?

1. Small classes: average class size is 13
2. The student/faculty ratio is 8:1. This means that students get a lot of individual attention and can easily find mentors.
3. Professional faculty: 88 percent are practicing professionals who are leaders in their fields

CAN STUDENTS TAKE COURSES IN OTHER SCHOOLS?

Students are encouraged to explore interdisciplinary opportunities and can take courses in other programs. For example, Fashion Design students often take courses offered in Textiles and many Graphic Design students have enjoyed Printmaking classes.

FACT!
CCA faculty work at Apple, Google, Facebook, IDEO, Frog, Method, and other innovative companies. As one of the world's first undergraduate interaction design programs, CCA is defining the field.

WHAT STEPS DO YOU TAKE TO EVALUATE A STUDENT'S CANDIDACY, APART FROM REVIEWING THEIR CREATIVE PORTFOLIO?

Application, Personal essay / writing sample, Transcripts Letter of recommendation, Portfolio, English language proficiency (International applicants only)

WHAT DOES YOUR PROGRAM LOOK FOR MOST IN THE CREATIVE PORTFOLIO DURING ADMISSIONS? WHAT DO YOU THINK MAKES AN A+ PORTFOLIO?

The portfolio should include a focused series of images that shows the student's current interests as well as additional work that reveals an awareness of formal visual organizational principles and experience with a variety of tools, media, styles, and approaches.
We prefer the majority of drawings submitted in the portfolio be derived from direct observation, rather than other sources (such as photographs). Still life, landscape, figure drawings, portrait, perspective, and diagrammatic drawings are all recommended.
Further 2D, 3D, or 4D work may be abstract or representational and may range from design projects to fine art pieces or installation documentation. Strong portfolios typically

include work that demonstrates solid technical skills and reflects thoughts and concepts. Consider including work that speaks to your personal experiences, your culture, and so on.

We encourage students to get outside opinions of their artwork prior to applying. Teachers, other artists, mentors, and college representatives can offer this type of informal review. We also recommend practicing discussing your work. Students shouldn't be afraid to talk about their work and what it means to them.

HOW ARE NEW TECHNOLOGIES AFFECTING STUDENTS' CURRICULUMS AND/OR WAYS OF

LEARNING/COLLABORATING AT YOUR SCHOOL?

Located close to Silicon Valley, CCA benefits from close relationships with leading tech and innovation firms. Many of these firms sponsor studios and support the school in other ways, such as providing expertise in the classrooms and studios, attending critiques, and providing the latest software.

HOW DOES YOUR PROGRAM HELP GRADUATING STUDENTS WITH INTERNSHIPS OR JOBS? CAN STUDENTS EXPECT JOB PLACEMENT MORE AT YOUR PROGRAM THAN IN OTHERS? IF SO, HOW OR WHY?

CCA's spring School to Market course is offered as part of the interdisciplinary craft curriculum initiative. Over the course of the semester, the faculty members guide students through the process of producing, displaying, and then exhibiting their their fine craft works and that of their peers at the prestigious American Craft Council Show held July 31 through August 2 at the Fort Mason Center Festival Pavilion in San Francisco.

WHAT KINDS OF JOB OPPORTUNITIES HAVE YOU SEEN STUDENTS TAKE ONCE THEY COMPLETED THEIR DEGREES?

CCA is committed to helping our students transition to professional life. Every year there are more than 600 internships offered. More than 200 employers visit the campus every year looking for talent. And 76% of our graduates have found a fulltime job within 6 months of graduation.

The Career Development Office offers a number of programs and events, including the Career Expo, one-on-one coaching, portfolio & résumé preparation labs, career workshops, a dedicated job board, and networking opportunities.

Job opportunities run the gamut. The accomplishments of our alumni are varied and far-reaching. CCA graduates have designed graphics for MTV and VH1, created characters for animated films by Pixar, illustrated editorials for major national publications, created Emmy-award-winning motion graphics, and produced Oscar-winning documentaries. They have shown their work at the Cannes and Sundance film festivals and at museums around the world. They have started their own companies and worked for corporations, community organizations, and nonprofit organizations. CCA alumni have created products and services that have changed people's lives.

ARE THERE ANY EXCITING DEVELOPMENTS FOR YOUR PROGRAMS THAT STUDENTS SHOULD KNOW ABOUT?

The college is undergoing a major campus planning effort. In the next five years many new facilities will be built on the San Francisco campus, including affordable student housing, new studios and collaborative facilities for making, green space, and space for community events and recreation.

FACT!
The Princeton Review designates CCA as one of the most environmentally responsible colleges in the United States and Canada.

WHAT IS THE BEST ADVICE YOU HAVE FOR STUDENTS ENTERING THE ART & DESIGN FIELD? AND WHAT DO YOU THINK IS THE ROLE OF THE ARTIST TODAY?

Advice for students: By pursuing an arts education you will gain the power to transform the world. By connecting the arts to today's most pressing social, economic, and political issues, creative people can find solutions to previously unsolvable problems — and invent breakthroughs. To fully realize your own creative

ambitions, you should consider not only what you study, but also where you study. The San Francisco Bay Area is a world-famous center of innovation, creativity, and entrepreneurship. You will be constantly energized by your surroundings to push the boundaries of your own creativity.

The role of the artist, or creative person, is becoming more important in society. There is a growing demand for creative people across a broad range of industries. Employers that have traditionally looked solely to graduates of large research universities are now seeking artists and designers who bring to the table an entrepreneurial spirit, unique problem-solving skills, and a hacker/DIY mentality.

by Chris Bliss
VP for Communications

APPLICATION MATERIALS
Online CCA App or Common App

PORTFOLIO REQUIREMENTS
10-20 pieces Slideroom

TRANSCRIPTS
Required

WRITING SAMPLE
Personal Essay

RECOMMENDATION LETTERS
1 Teacher or Counselor

INTERVIEW
Not required

APPLICATION DEADLINES
Rolling Admissions
Early Decision: Feb 1
Regular Decision: Mar 1

FOR INTERNATIONAL STUDENTS
TOEFL: 550 on the PBT or 80 on the iBT.
IELTS: minimum 6.5
PTE Academic: 58 or greater.

Fall: Feb 1
Spring: Oct 1

TIPS
Your portfolio should include a focused series of images that shows your current interests, and additional work that reveals an awareness of formal visual organizational principles and experience with a variety of tools, media, styles, and approaches.
We prefer that the majority of drawings submitted in the portfolio be derived from direct observation rather than other sources (such as photographs). Still life, landscape, figure drawings, portrait, perspective, and diagrammatic drawings are all recommended. Further two-, three-, or four-dimensional work may be abstract or representational and may range from design projects to fine art pieces or installation documentation.

DEGREES

BFA:

1. Animation
2. Architecture
3. Ceramics
4. Community Arts
5. Fashion Design
6. Film
7. Furniture
8. Glass
9. Graphic Design
10. Illustration
11. Individualized Major
12. Industrial Design
13. Interaction Design
14. Interior Design
15. Jewelry / Metal Arts
16. Painting/Drawing
17. Photography
18. Printmaking
19. Sculpture
20. Textiles

BA:

1. Visual Studies
2. Writing and Literature

RANKING

World's best design schools, BusinessWeek magazine
#25 AC Online: Highest Return on Investment Colleges in California, 2013

OFFICE OF UNDERGRADUATE ADMISSIONS
Enrollment Services Office
1111 Eighth Street
San Francisco CA 94107
+1 (510)-594-3600

ALUMNI
Nathan Oliveira, Painter
Raymond Saunders, Painter
Robert Arneson, Ceramicists
Viola Frey, Ceramicists
Peter Voulkos, Ceramicists

Wayne Wang, Filmmaker
David Ireland, Conceptual artists
Dennis Oppenheim, Conceptual artists
Lucille Tenazas, Designer
Michael Vanderbyl, Designer

CARNEGIE MELLON
UNIVERSITY
Pittsburgh, Pennsylvania
www.cmu.edu

30

CARNEGIE MELLON UNIVERSITY
SCHOOL OF ART

The university began as the Carnegie Technical Schools, founded by Andrew Carnegie in 1900.

School of Art at CMU is a degree-granting institution and a division of the Carnegie Mellon College of Fine Arts. It offers a Bachelor of Fine Arts degree with concentrations in four major fields: Painting, Drawing, Print Media and Printmaking (PD3); Electronic and Time-Based Media (ETB); Sculpture, Installation and Site Specific work (SIS); and Contextual Practices (CP). The school emphasizes Postmodern, conceptual, and abstract art making ahead of classical training, though this varies largely depending on faculty.

A B.Arch curriculum that distinguishes CMU SoA completely by leveraging the unparalleled opportunities at Carnegie Mellon. Our students graduate with a professional degree that prepares them to excel in practice — but that also launches them into key specialties within the profession. BXA Programs: The BXA Intercollege Degree Programs are designed for students who want to turn talent and passion into viable professions for the future through a challenging academic regimen. BXA students pursue their goals with the help of multifaceted advising, innovative pedagogical strategies, and a focus on the impact arts have on technology and vice versa.

The goal of the Bachelor of Humanities and Arts (BHA), the Bachelor of Science and Arts (BSA), and the Bachelor of Computer Science and Arts (BCSA) BXA Intercollege Degree Programs is to allow a select group of students who demonstrate interest and accomplishment in the fine arts and the humanities, social sciences or natural sciences, computer science, and emerging media to explore beyond the traditional academic major, or integrate more than one field of study across disciplines.[12]

FACT!
The Frank-Ratchye STUDIO for Creative Inquiry is a laboratory for atypical, anti-disciplinary, and

Today CMU's global presence includes campuses in Qatar and Silicon Valley, Calif., more than a dozen degree-granting locations, and more than 20 research partnerships such as Los Angeles; New York City; Washington, D.C.; Australia; China; Portugal and Rwanda. Photo: Design by Justin Lin

inter-institutional research at the intersections of arts, science, technology and culture.

WHAT MAKES YOUR SCHOOL'S ART & DESIGN PROGRAMS DIFFERENT & UNIQUE FROM OTHER ART & DESIGN SCHOOL PROGRAMS? WHAT ARE THE TOP 3 FEATURES?

1. A strong emphasis on cutting-edge interdisciplinary work, inside the School of Art, and in connection with the world-class research University of which we are part.
2. An intensive art school environment with an excellent studio art curriculum that respects traditional media and processes, embedded within the exciting creative environment of CMU's technological innovation, fostering exciting opportunities for working with new media and tools.
3. Our focus on engagement with contexts and audiences beyond the studio and gallery — our contextual practice curriculum gets students involved in big projects in the real world.

CAN STUDENTS TAKE COURSES IN OTHER SCHOOLS OR MAJORS?

Yes, in fact they are required to take XXX courses outside of the School of Art, and we strongly encourage students to pursue interdisciplinary study and take advantage of the rich offerings of the University.

WHAT STEPS DO YOU TAKE TO EVALUATE A STUDENT'S CANDIDACY, APART FROM REVIEWING THEIR CREATIVE PORTFOLIO?

87

We take into account their creative portfolios, their academic achievements, their extracurricular activities, essays and answers to our online questionnaire. Applicants also have the option to visit campus for an interview with School of Art faculty.

WHAT DOES YOUR PROGRAM LOOK FOR MOST IN THE CREATIVE PORTFOLIO DURING ADMISSIONS? WHAT DO YOU THINK MAKES AN A+ PORTFOLIO?

We are very interested in seeing evidence of creative thinking skills as well as technical skills. We want to see work that was made independently outside of classroom assignments. We encourage students to show us the work that they have done that is the most personal and unique. The most important aspect of any portfolio is that it have a creative voice and personality. We are not looking for any particular kind of work, but rather evidence of real exploration, real curiosity and real creative experimentation.

FACT!
The Digital Arts Studio [DAS] provides digital imaging and fabrication services and support, focused on large format printing, large-format scanning, and 3D printing and consultation with School of Art technicians.

HOW ARE NEW TECHNOLOGIES AFFECTING STUDENTS' CURRICULUMS AND/OR WAYS OF LEARNING/COLLABORATING AT YOUR SCHOOL?

CMU has been named the "Most Wired Campus in the Country". New technologies are one of our strongest areas of expertise, and they are woven into virtually every class in the school. Students at CMU are not just using the latest technologies, but are inventing the technologies of the future and shaping the ways that they will be used. The Studio For Creative Inquiry, which is housed in the same building as the School of Art, is a research unit that exists at the intersection of art and technology, and is a hub for exciting developments in this area.

HOW DOES YOUR PROGRAM HELP GRADUATING STUDENTS WITH INTERNSHIPS OR JOBS? CAN STUDENTS EXPECT JOB PLACEMENT MORE AT YOUR PROGRAM THAN IN OTHERS? IF SO, HOW OR WHY? WHAT KINDS OF JOB OPPORTUNITIES HAVE YOU SEEN STUDENTS TAKE ONCE THEY COMPLETED THEIR DEGREES?

CMU School of Art graduates are well positioned to embark on a very wide range of careers. In recent years,

post-graduation activities have included fellowships such as Fulbright Grants to Turkey, China, Thailand, India, Finland and Mongolia; Creative Capital Grants; and a Rhodes Scholarship. Other students have gone on to pursue advanced degrees at top MFA programs such as Yale, RISD, UCSD, Columbia, SAIC, etc. Still others find employment in the animation, gaming, television, music and multimedia design industries, landing jobs at Laika Studios, Disney Research Labs, Nikelodeon, NBC, Autodesk, Amazon Studios, etc. Alumni also start their own companies, such as: Silvertree Media, DeepLocal, Satanspearlhorses, and Deepspeed Media.

ARE THERE ANY EXCITING DEVELOPMENTS FOR YOUR PROGRAMS THAT STUDENTS SHOULD KNOW ABOUT?

The new IDEATE program creates opportunities for students to explore the intersection of art and technology through minors in areas of specialization such as: Game Design, Animation and Special Effects, Learning Media, Physical Computing, Media Design and Intelligent Environments.

WHAT IS THE BEST ADVICE YOU HAVE FOR STUDENTS ENTERING THE ART, DESIGN &

ARCHITECTURE FIELD?

Follow your curiosity relentlessly — always looking for unexpected connections between media, ideas, processes and people.

WHAT IS THE MOST DISTINGUISHED FEATURE AT YOUR SCHOOL?

Founded in 1905, the College of Fine Arts was the first comprehensive arts teaching institution in the United States.

by Clayton Merell, Associate Head & Professor of Art

APPLICATION MATERIALS
Common App

MANDATORY PORTFOLIO
12-20 pieces on Slideroom

WRITING SAMPLE
Common App Essay & Personal

INTERVIEW
Optional

RECOMMENDATION LETTERS
1 Counselor
1 Teacher

APPLICATION DEADLINES
Early Decision: Nov 1
Regular Decision: Jan 1
Portfolio by Jan 15

SCHOOL OF ARCHITECTURE

USA • CARNEGIE MELLON UNIVERSITY

***WHAT MAKES YOUR SCHOOL'S
ART & DESIGN PROGRAMS
DIFFERENT & UNIQUE
FROM OTHER ART & DESIGN
SCHOOL PROGRAMS?***

The CMU School of Architecture has a long history of deep disciplinary excellence in architecture, as do other top-ranked peer institutions. What distinguishes CMU SoA from other schools is our position within one of the world's leading research and entrepreneurship institutions. Our unique undergraduate curriculum allows students to take full advantage of all that CMU has to offer. Carnegie Mellon's computer science and engineering schools, for instance, are widely considered the best in the world. At many universities, departments are kept separate—but CMU is committed to interdisciplinary learning and research. To take full advantage of this, the School of Architecture has structured its undergraduate curriculum such that students learn architecture fundamentals in the first three years, and forge their own paths with a great amount of freedom in the fourth and fifth years. More on that in our response to question 2.

WHAT ARE THE TOP 3 FEATURES?

1. Our 5-year BArch curriculum. All students begin with a highly scripted three-year core sequence of courses and studios — the fundamental architecture education essential for every professional. In the fourth and fifth years, students follow a path forged by their own interests, choosing an Advanced Synthesis Option Studio (ASOS) and electives each semester. Some students take a traditional path in the fourth and fifth years, choosing a variety of studios and electives intended to prepare them professionally to design complex buildings and systems. Others specialize — taking, for instance, four robotics-based ASOSes, plus universitywide

90

robotics-related electives. (Not incidentally, at Carnegie Mellon, "university-wide robotics-related electives" are the best in the world.) Other students take a hybrid approach, selecting studios and electives that create unique aggregates: sustainable computational design, or public-interest urban design, for example. It's a "choose your own journey" approach to architecture education.

2. Our state-of-the-art facilities. From day one, students have access to the Design Fabrication Lab(dFAB), whose design, prototyping, and manufacturing equipment includes two industrial robotic arms with automated tooling, laser cutters, vacuum formers and laminators, 3D printers, and a CNC router; the Computational Design (CoDe) Lab, a maker-space designed to facilitate collaboration among architects, computer scientists, artists and engineers in the realm of physical computing; the Robert L. Preger Intelligent Workplace (IW), a "living and lived-in laboratory" for the study of building systems; and the 3800SF wood and metal-shop. Our architecture students are unquestionably at home in the geeky-intellectual oasis that is Carnegie Mellon University, but they also get their hands dirty with both traditional and incredibly cutting-edge tools and spaces.

3. Pittsburgh. Pittsburgh now tops dozens of "Most Liveable Cities" lists. On its face, this fact is great for CMU students. The city is thriving (over 70 unique neighborhoods, world-class cultural institutions, gorgeous public parks) with tons to explore — but small enough in which to get a foothold. But context is perhaps more important to architecture students than to any others. Student designers learn differently in an urban environment than in a rural or suburban environment. Pittsburgh is our laboratory partner. The city is home to a number of elite architectural firms, whose leaders teach in our undergraduate design studios. Students' education, then, is an excellent combination of world-class research and front-lines practice.

CAN STUDENTS TAKE COURSES IN OTHER SCHOOLS OR MAJORS?

Absolutely; in fact, it's encouraged and expected. See the description of our undergraduate curriculum in #2 above.

WHAT STEPS DO YOU TAKE TO EVALUATE A STUDENT'S CANDIDACY, APART FROM REVIEWING THEIR CREATIVE PORTFOLIO?

Applications to the BArch program are evaluated by

both the university's Office of Admission and the School of Architecture. In addition to university-wide application requirements, we take into consideration the following factors:

1. Quality of creative work. Applicants must submit either a portfolio of creative work or the SoA Design Project. (The portfolio is the best option for students who already have a strong body of creative work completed within the past four years; the design project is the best option for applicants with limited or no portfolio work. The admission committee values the portfolio and design project equally, so applicants should choose the option that best fits their needs and situation.)

2. Responses to form questions submitted with the portfolio or design project Carnegie Mellon University School of Architecture: Profile for Art, Design & Architecture College Admissions

3. Applicants' participation in pre-college architecture programs (at CMU or elsewhere) and/or engagement with the profession (e.g, job shadowing or participation in career-oriented programs)

4. On-campus review: not required, but strongly recommended. Applicants who visit campus on scheduled on-campus review days meet with current faculty to discuss their creative work and ask questions about the program. This is an excellent way for applicants to learn more about the school and engage in a conversation about their creative experience and goals — with faculty who may become their professors.

WHAT DOES YOUR PROGRAM LOOK FOR MOST IN THE CREATIVE PORTFOLIO DURING ADMISSIONS? WHAT DO YOU THINK MAKES AN A+ PORTFOLIO?

You might specialize: if your heart is in architectural robotics, you could take a robotics-based ASOS four semesters in a row — and university-wide supporting electives to match. Or you could hybridize: our students are building bizarre and beautiful niches for themselves at the crossroads of sustainability and computation, or urban design and building performance — the very combinations that will save the world a decade from now.

We strongly believe that there is no "special sauce" for a portfolio or design project submission. Our students come from a wide variety of backgrounds and enter our program with truly unique combinations of skills. An "A+ portfolio" tells a story about you, about what excites your curiosity, about where your creativity leads you (even if it seems unorthodox). We are not looking for polish or technical perfection — we're looking for your particular brand of making and creativity.

FACT!

Carnegie Mellon worked with IBM in the 1980s to develop Andrew — a pioneering computer network that links the entire campus through thousands of personal computers and work stations. In 2000, Carnegie Mellon continued its technical tradition with a campus-wide wireless network. Today, Carnegie Mellon consistently ranks as one of the "most wired" campuses in America.

HOW ARE NEW TECHNOLOGIES AFFECTING STUDENTS' CURRICULUMS AND/OR WAYS OF LEARNING/COLLABORATING AT YOUR SCHOOL?

Of course, advanced technologies have changed architecture education, and our facilities and curriculum help students expose students to cutting-edge design and fabrication tools. But, as one of our faculty members said in a recent interview, we're moving beyond the unproductive distinction and hierarchy between digital and analog; our students are empowered to use a thoughtful hybrid of both methods in every project.

HOW DOES YOUR PROGRAM HELP GRADUATING STUDENTS WITH INTERNSHIPS OR JOBS? CAN STUDENTS EXPECT JOB PLACEMENT MORE AT YOUR PROGRAM THAN IN OTHERS? IF SO, HOW OR WHY? WHAT KINDS OF JOB OPPORTUNITIES HAVE YOU SEEN STUDENTS TAKE ONCE THEY COMPLETED THEIR DEGREES?

Our program uniquely prepares students for a range of careers, from traditional architectural practice, to theoretical academic pursuits, to work in innovative emerging technologies, to entrepreneurial endeavors. The core + options curriculum described above allows students to explore nontraditional ways to apply their studio-based education. Our students and recent alumni work at the world's most prestigious design firms — but they also work for Motorola, Disney, federal government agencies, and the next big startups.

ARE THERE ANY EXCITING DEVELOPMENTS FOR YOUR PROGRAMS THAT STUDENTS SHOULD KNOW ABOUT?

Our Urban Design Build Studio (UDBS) is a leader in public interest design, which brings high-quality architecture to the people and communities otherwise denied access to it. In their pursuit of thoughtful, innovative, socially-engaged architecture, UDBS students spend hours meeting with community members, developing innovative architectural solutions, and fabricating anything from a modular wardrobe divider, to a mobile neighborhood spray park/water filtration system, to PROJECT RE_, a 10,000SF community space for fabrication, education, and collaboration.

WHAT IS THE MOST DISTINGUISHED FEATURE AT YOUR SCHOOL?

The Robert L. Preger Intelligent Workplace (IW) is the world's first "living and lived-in laboratory" for the study of building systems. It acts on a hands-on learning tool for undergraduate and graduate students to create and test system innovations in enclosure, HVAC, daylighting, ventilation, telecommunications, interiors, building controls, and dashboards.

WHAT IS THE BEST ADVICE YOU HAVE FOR STUDENTS ENTERING THE ART, DESIGN & ARCHITECTURE FIELD?

The creative arts require patience, bravery, iteration, and a willingness to appreciate ambiguity. It can be difficult for intelligent, accomplished young people to deviate from the search for a "right" answer. But while architecture certainly requires precision, memorable architecture grows from curiosity, flexibility, and joy.

by Steve Lee
Head of the School of Architecture

DID YOU KNOW?
Carnegie Mellon's original campus architect is said to have modeled his design after a ship. The prow of the historic USS Pennsylvania rests atop Roberts Hall, which overlooks Panther Hollow and the Carnegie Museum complex.

APPLICATION MATERIALS
Common App

PORTFOLIO REQUIREMENTS
10 pieces, no more no fewer on Slideroom OR Architecture Design Project (for students w/ limited portfolio)

* All applicants are encouraged to include examples of drawings.

Drawings can be from life or from the imagination, but they should not be copied from a photo or other two-dimensional image. CAD drawings should not be included.

WRITING SAMPLE
Common App Essay & Personal Statement

TRANSCRIPTS
Required

INTERVIEW
Strongly Recommended

RECOMMENDATION LETTERS
1 Counselor
1 Teacher

APPLICATION DEADLINES
Early Decision: Nov 1
Regular Decision: Jan 1
Portfolio by Jan 15

FOR INTERNATIONAL STUDENTS
Early Decision: Nov 1
Regular Decision: Jan 1
Portfolio by Jan 15

TOEFL: 102
IELTS: 7.5
PTE: n/a

* Carnegie Mellon carefully reviews the sub-scores of each of these exams and considers those candidates with reading, listening, speaking and writing sub-scores of 25 or more on TOEFL and 7.5 or more on IELTS to be candidates with high levels of English proficiency.

BXA PROGRAM

WHAT MAKES YOUR SCHOOL'S ART & DESIGN PROGRAMS DIFFERENT & UNIQUE FROM OTHER ART & DESIGN SCHOOL PROGRAMS? WHAT ARE THE TOP 3 FEATURES?

1. The BXA programs are designed for talented students interested in blending coursework in the fine arts with coursework in the humanities and/or social sciences. They offer students the opportunity to combine and accomplish goals that lie at the intersection of these two concentration areas.
2. The BXA programs include the Bachelor of Humanities and Arts (BHA), the Bachelor of Science and Arts (BSA), and the Bachelor of Computer Science and Arts (BCSA). All three programs combine a concentration in the College of Fine Arts (Architecture, Art, Design, Drama, or Music) with an academic concentration.
3. BXA students gain foundational skills in both areas of concentration, as well as the opportunity to explore interdisciplinary work and thought through BXA-specific seminar courses. The BXA Capstone that students complete during their senior year shows the concrete results of their prior interdisciplinary work.

HOW DOES YOUR PROGRAM HELP GRADUATING STUDENTS WITH INTERNSHIPS OR JOBS? CAN STUDENTS EXPECT JOB PLACEMENT MORE AT YOUR PROGRAM THAN IN OTHERS? IF SO, HOW OR WHY? WHAT KINDS OF JOB OPPORTUNITIES HAVE YOU SEEN STUDENTS TAKE ONCE THEY COMPLETED THEIR DEGREES?

BXA students have access to the career and internship resources of both their areas of concentration. In addition, the BXA advisors work directly with students to polish their job materials and make networking contacts in their desired fields. During the senior-year Capstone seminar, BXA students work on relevant job materials, including resumes, cover letters, artists' statements, and social media profiles.

BXA students have gone on to jobs in creative industries, education, cultural organizations, and traditional industry. Our students have been especially successful in new media fields, such as game design and development. As a program, we've established relationships with a well-known animation studio and a large game company and have hosted information sessions and portfolio reviews with them. We plan to expand on these industry contacts for more of these events.

CAN STUDENTS TAKE COURSES IN OTHER SCHOOLS OR MAJORS?

CMU is the only university to offer these specific intercollege degrees. They are among the only undergraduate degrees that combine the arts with academic fields.

WHAT DOES YOUR PROGRAM LOOK FOR MOST IN THE CREATIVE PORTFOLIO DURING ADMISSIONS? WHAT DO YOU THINK MAKES AN A+ PORTFOLIO?

Students entering a creative field need to be able to think creatively about their path toward their goals. There's no one route to success, and BXA students have struck out in every direction in pursuit of their ultimate goals. There are dead ends and detours, but being aware of your skills, passions, and goals will help you navigate toward your destination.

ARE THERE ANY EXCITING DEVELOPMENTS FOR YOUR PROGRAMS THAT STUDENTS SHOULD KNOW ABOUT?

All three BXA programs continue to grow through internal transfers as well as the incoming first-year class. We're looking forward to celebrating

The Integrative Design, Arts and Technology Network (IDeATe) connects diverse strengths across CMU to advance education, research and creative practice in domains that merge technology and arts expertise. The core activities of IDEATE include eight undergraduate concentration and minors on new creative industry themes: game design, animation and special effects, media design, sound design, learning media design, entrepreneurship for creative industries, intelligent environments, and physical computing.

the 25th anniversary of our first graduating class of BHA students in 2018 with a series of student and alumni events.

The University is currently working on a Bachelor of Engineering and Arts degree program. Stay tuned.

by M. Stephanie Murray, Ph.D.
Director and Academic Advisor,
Assistant Teaching Professor

ALUMNI
Andy Warhol, Artist
Philip Pearlstein, Painter
Dara Birnbaum, Video and Installation artist
Joyce Kozloff, Artist
Mel Bochner, Conceptual Artist
Deborah Kass, Artist
John Currin, Painter
Carrie Schneider, Artist
Zak Prekop, Artist
Sonni Abatta, Artist
Joanna Ricou, Painter
Jessica Phillips-Silver, Musician
Courtney Wittekind, Artist
Roger Duffy, Architect
Greg Mottola, Architect
George Marsh, Architect

DID YOU KNOW?
Students interested in Carnegie Mellon's BXA interdisciplinary degrees **must be accepted into one of the five CFA schools, as well as their second college of interest** *(e.g. the School of Computer Science, Dietrich College of Humanities and Social Sciences or Mellon College of Science).*
(These are not accredited professional degrees; therefore, they do* **NOT *meet the educational requirement for professional architecture licensure.)*

DEGREES
BFA:
1. Drawing, Painting, Printmaking and Photography [DP3]
2. Sculpture, Installation and Site-Work [SIS]
3. Electronic and Time Based Media [ETB]
4. Contextual Practice [CP]

B.Arch:
School of Architecture

BXA:
1. Bachelor of Humanities and Arts Degree (BHA)
2. Bachelor of Science and Arts Degree (BSA)
3. Bachelor of Computer Science and Arts Degree (BCSA)

RANKING
#22 Times Higher Education in 2015
#School of Architecture Professors Design Intelligence's "30 Most Admired Educators"

OFFICE OF UNDERGRADUATE ADMISSIONS
Warner Hall, 5000 Forbes Avenue
Pittsburgh, PA 15213-3890
+1 (412)-268-7838

COLLEGE FOR
CREATIVE STUDIES
Detroit, Michigan
www.collegeforcreativestudies.edu

COLLEGE FOR CREATIVE STUDIES
ART & DESIGN

The College for Creative Studies (CCS) is a nonprofit, private college authorized by the Michigan Education Department to grant Bachelor's and Master's degrees. CCS, located in midtown Detroit, strives to provide students with the tools needed for successful careers in the dynamic and growing creative industries. CCS fosters students' resolve to pursue excellence, act ethically, engage their responsibilities as citizens, and learn throughout their lives. With world-class faculty and unsurpassed facilities, students learn to be visual communicators who actively use art and design toward the betterment of society. The College is a major supplier of talent to numerous industries, such as transportation, film and animation, advertising and communications, consumer electronics, athletic apparel, and many more. Its graduates are exhibiting artists and teachers, design problem solvers and innovators, as well as creative leaders in business.

Founded in 1906 as the Detroit Society of Arts and Crafts, CCS plays a key role in Detroit's cultural and educational communities.[13]

FACT!
Student-to-Faculty Ratio - 9:1
98% of CCS students receive some form of institutional, State or Federal financial assistance.

WHAT MAKES COLLEGE FOR CREATIVE STUDIES PROGRAMS DIFFERENT AND UNIQUE FROM OTHER ART AND DESIGN SCHOOLS?

CCS has been teaching art and design for over 100 years. We began as the Society for Arts and Crafts in Detroit — a community of makers responding to mass-industrialization and production, with an earnest commitment to fine craftsmanship and the making of beautiful and useful objects. We are still committed to this principle today, but we are very open and responsive to incorporating new technologies into our curricula. Our strong heritage, established connections to industry and our continued pursuit of making fine art, finely crafted beautiful and useful objects, means our

students master the skills and develop the confidence needed to succeed in any creative realm they choose to apply their skills.

Top Three Features:
Alumni Network and Success — Our strong alumni network means connections for current students and graduates seeking to make their way into a creative career. Graduates understand and respect the CCS approach and seek out young talent for internships and jobs.

Facilities and Faculty — CCS has an outstanding campus with state-of-the-art facilities across all departments. Students have access to shops and studios within and outside of their major. CCS is one of a few undergraduate programs with access to a Color and Material Library. We also have extensive Digital Image and Publications Library, and our Audio Visual Center ensures our students have free and available access to high-end sound, lighting, camera, video and recording equipment.

Career Services — Our Career Services office does an excellent job preparing our students to apply for internships and jobs through workshops in resume and portfolio building, interview skills, an on-line Job Book. Career Services also hosts recruitment and career development events on and off-site.

HOW ARE NEW TECHNOLOGIES AFFECTING STUDENTS' CURRICULUMS AND/OR WAYS OF LEARNING/ COLLABORATING AT YOUR SCHOOL?

Digital 3D modeling has been incorporated into curricula across majors like Product Design, Crafts, Entertainment Arts, Transportation Design, Interior Design, and Fashion Accessories Design. Digital ink printers are being using in Ceramics and Fiber Arts, and state-of-the-art studios include the latest software and design tools including PCs, Macs and Cintiques. Our Graphic Design and Advertising: Design majors develop user interfaces and experiences through the design of apps, motion graphics and time-based media. Learning and using the latest technologies prepares students for work using industry-standard tools and methods; employers tell us that once our grads are on the job, they often don't need additional training.

CAN STUDENTS TAKE COURSES IN OTHER DEPARTMENTS/MAJORS?

Yes. Each major's curriculum allows room for studio electives, and students have the ability to fulfill these requirements with courses from other departments. The majority of our majors support

opportunities for students to seek out experiences that will help them reach their creative or career goals. We have any number of students working across departments at any given time.

WHAT KIND OF JOB OPPORTUNITIES ARE AVAILABLE FOR CCS GRADUATES?

CCS's post-graduation rate is 94%- in jobs related to graduates' field of study. Our Career Services office works to ensure students have internship opportunities while they are students, and job opportunities as they graduate. Graduates take positions across the US, and internationally. Typically, our graduates are gaining positions that are above entry-level, in fields directly related to their field of study. CCS was recently ranked #3 Design School in the US and best in the Midwest based on Alumni Success by LinkedIn.

WHAT DOES YOUR PROGRAM LOOK FOR MOST IN STUDENTS' BFA PORTFOLIOS/APPLICATIONS DURING ADMISSIONS?

The application portfolio only requires the submission of 5-8 pieces of artwork. We look to see the strongest work from each applicant, and works do not need to reflect experience in the applicant's intended major.

We recommend that students do not include work they are not confident about simply to offer "variety" in the portfolio. Copywriting applicants are not required to submit a portfolio. Applicants to the following majors must include 5 drawings from observation or imagination: Entertainment Arts (Animation and Game Design only), Fine Art, Illustration and Transportation Design. Applicants to Advertising: Design, Crafts (Art Furniture, Ceramics, Fiber Design, Glass, Jewelry and Metalsmithing), Entertainment Arts (Video), Fashion Accessories Design, Graphic Design, Interior Design, Photography, Product Design can submit digital design, photography, technical drawing, drawing from observation, video, three-dimensional works, installation works, painting, print media, etc. The application portfolio is to be submitted digitally. Applicants should be sure to photograph their work with care and on neutral backgrounds.

WHAT DO YOU THINK MAKES AN A+ PORTFOLIO?

The strongest applicant portfolios include work that highlight a student's conceptual ability in and skills. Works that are unique in perspective, concept, composition and technique are most impressive. Portfolio strength can also be

impacted by the selection of works; not all works need to inter-relate, but should show thorough effort, higher-level thinking, and exposes the applicant's passion.

FACT!
Alumni include 7 Turner Prize winners and recipients of Oscars, Mercury Music prizes, Ivor Novellos and BAFTAS

WHAT DOES YOUR PROGRAMME LOOK FOR MOST IN THE CREATIVE PORTFOLIO DURING ADMISSIONS?

We are looking for a portfolio that conveys a sense of the passions, curiosities and interests of the candidate. It is more important they include a selection of work that demonstrates their own enthusiasms than for them simply to show that they are competent across a range of technical skills. Much work in a portfolio is likely to have been made in response to the setting of a project. We are keen to see evidence of those occasions where a candidate has gone beyond the requirements of the brief and taken it further for their own satisfaction.

ARE THERE ANY EXCITING DEVELOPMENTS FOR YOUR BFA ART/DESIGN PROGRAMS THAT

STUDENTS SHOULD KNOW ABOUT?

Aki Choklat, internationally respected and collected, footwear and leather goods designer comes to CCS to lead our newest major, Fashion Accessories Design as its Chair. Our program will have students designing fashion footwear, soft leather goods, accessories hardware and working in merchandizing and trend forecasting. Our students will have access to the expertise of Detroit's Shinola production studio, which is housed on CCS' Taubman Center campus, and opportunities to work and learn internationally.
We are very excited to welcome Tim Flattery back home (CCS alum, 1987) to represent the Entertainment Arts Department as our new Chair. Flattery brings strong connections to the entertainment industry to our students and experience on over 40 films to the classroom. Flattery joined CCS in fall 2015.

HOW DOES YOUR PROGRAM HELP GRADUATING STUDENTS WITH INTERNSHIPS OR JOBS? CAN STUDENTS EXPECT JOB PLACEMENT MORE AT YOUR PROGRAM THAN AT OTHERS? IF SO, HOW OR WHY?

Our Career Services office works to ensure our students have diverse internship opportunities while they are in school, and

excellent job opportunities when they graduate. Throughout the year, Career Services hosts workshops and career-centric events that are customized for students in each major. In 2014-2015, Career Services brought 175 companies to campus to recruit our students for internships and jobs. More than 656 employers seeking talent from among our students and graduates registered for our online Job Book in 2014-2015. In that year alone, over 1,000 positions were posted and 530 students and alumni registered their portfolio on the site. Our Art Education program has 100% post-graduation rate. Our program is unique because it is a Dual Major- students choose a Studio Major and Art Education and complete the entire program, including 1 semester of in-class teaching practicum, in four-and-a-half years. Our graduates are prepared for their teaching certification test for K-12 classrooms.

WHAT IS THE MOST DISTINGUISHED FEATURE AT YOUR SCHOOL?

CCS has maintained a strong commitment to world-class faculty and facilities. As a non-profit, the College invests funds into the development of faculty and in maintaining the highest level of technology for its students. With an extensive academic facilities footprint, the College ensure both its classrooms, studios and shops include new technologies that are accessible to all students. Students have ready, and free access to sound stages and recording studios; lighting and shooting studios; animation and stop-motion studios, glass, ceramics, fiber design studios; wood, metal, rapid prototyping shops; Color and Material library, digital image and publications libraries; high-end projection and surround sound auditorium; exhibitions spaces; and over one-million square feet of teaching, learning and work space.

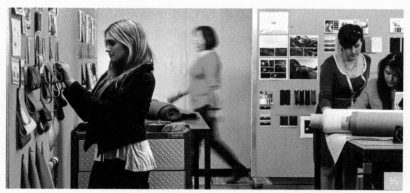

A business concentration and a number of academic minors are also available.

WHAT IS THE BEST ADVICE YOU HAVE FOR GRADUATING HIGH SCHOOL SENIORS?

Our best advice is really for high school sophomores and juniors — it is important to understand that when they apply to college, they are providing us with their GPA from freshman, sophomore and junior years. This means they must get their grades up, and keep them, early in their high school years. We also encourage any student interested in studying art or design at the college level to take art classes as early as possible in high school. Some high school guidance counselors don't understand that students applying to art or design college need to create a portfolio for their application. This can result in students waiting until their last year of high school to take art, which will put them at a disadvantage for early application deadlines.

For graduating high school seniors, we advise that they keep their grades up and keep making art. They also need to read, understand, discuss and follow up on all the information their school of choice sends them with their family and/or other supportive individuals. They also need to get ready to be challenged, work hard, have fun and grow. We don't expect you to come in with college-level skills, but we do expect you to graduate with them.

IF STUDENTS SPECIFY THAT THEY WANT TO MAJOR IN ART AT YOUR SCHOOL, WHAT STEPS DO YOU TAKE TO EVALUATE THEIR CANDIDACY APART FROM REVIEWING THEIR ART PORTFOLIOS?

CCS portfolio requirements for students applying for Entertainment Arts' Animation or Game Design concentration, or Fine Arts, Illustration or Transportation Design must include 5 drawings from observation in their portfolio.
All applications are reviewed based on their academic GPA, academic Test Score and Portfolio. International students must provide either a TOEFL or IELTS test score.

WOULD IT ALSO BE POSSIBLE TO SPEAK A LITTLE ABOUT THE CAR DESIGN PROGRAM? WHAT ARE THE TOP 3 FEATURES OF THE CAR DESIGN PROGRAM?

CCS has been teaching Transportation Design for over 50 years, and has placed more graduates in the industry than most other programs. 175 of GMs Designers are CCS graduates and 60% of Chrysler's design team are CCS alumni. Graduates work for transportation, automotive, aerospace and related industries around the world.

Through Corporate Sponsored Studios our students have the opportunity to work with

companies from around the world, on our campus. Past projects included the design of boats, motorcycles, public transportation, and of course-cars. At the upper levels of the program, students will take additional studio courses within the area they wish to specialize. These studios ensure our graduates understand the design connections across the entire vehicle.

Our curriculum teaches exterior, interior and color and material trim design for a variety of vehicles- not just cars. While the program requires strong sketching and concept development, students also learn to model their designs in clay and using digital 3D modeling. CCS has an extensive rapid prototyping studio with several small-to-medium scale SLA machines as well as two 5-axis mills, and a fully-furnished finishing studio and paint booths.

Carla R. Gonzalez
Director of Admissions

DID YOU KNOW?

Detroit has become the first U.S. city to receive the "city of design" designation from the **United Nations Educational, Scientific and Cultural Organization.** *The College also offers free art education for more than 4,000 Detroit youth annually through its Community Arts Partnerships program.*

APPLICATION MATERIALS
Online CCS Application

PORTFOLIO REQUIREMENTS
5-8 pieces
*5 should be from direct observation and/or imagination [for Entertainment Arts, Fine Arts, Illustration, & Transportation Design].
In order to be considered for our highest, up to full tuition, scholarships — you must submit all parts of your application and upload your work to Slideroom before December 1.

TRANSCRIPTS
Required

APPLICATION DEADLINES
Early Action: Dec 1
Priority Deadline: Feb 1

DEGREES
BFA:
1. Advertising: Copywriting
2. Advertising: Design
3. Art Education
4. Crafts
5. Entertainment Arts
6. Fashion Accessories Design
7. Fine Arts
8. Graphic Design
9. Illustration
10. Interior Design
11. Photography
12. Product Design
13. Transportation Design

RANKING

ART AND DESIGN
#3 Design School in the country, LinkedIn
#Best America's Architecture & Design Schools 2016
#Top Design Schools featured on GDUSA

ADMISSIONS OFFICE - COLLEGE FOR CREATIVE STUDIES
201 East Kirby
Detroit, MI 48202-4034
+44 (313)-664-7400

ALUMNI
Ralph Gilles, President/CEO
Wendy Froud, Puppet-maker
Veronika Scott, CEO
Jason Mayden, Global
Design Director
Andrea Kowch, Illustrator
Heidi Brown, Graphic Designer
Bill Morrison, Creative Director
Tim Flattery, Concept Artist
Dong Tran, Lead Designer
Kevin Beasley, Artist
Brett Golliff, Lead Designer

Jay Shuster, Art Director, Aimator
Donald Crum, Aimator
Melissa (Endress) Rodriguez,
Interior Designer, Proprietor
and Designer
Ian Grout, Toy Designer
Pat Shiavone, Motor Designer
Jenny Risher, Photographer
Jaymer Starbody, Motor Designer
April Wagner, Owner
Michelle Andonian, Artist

COLUMBIA UNIVERSITY
New York City, New York
www.columbia.edu

36

COLUMBIA UNIVERSITY

VISUAL ARTS
UNDERGRADUATE PROGRAM

The intent of our interdisciplinary program is to enable Visual Arts students to explore every conceivable form of visual expression. Students majoring in Visual Arts at Columbia University is provided with instruction in the tools and techniques necessary for the production of art while enhancing their creative, critical and analytic voice. Whether choosing to concentrate in Drawing, Painting, Sculpture, Photography, Printmaking or Video, or embracing an artistic practice that incorporates any combination of these disciplines, the emphasis is on developing a student's personal vision.

Our majors benefit from working under the guidance of a distinguished full-time and adjunct faculty, all of whom are active visual artists with national and international reputations.

FACT!
Student Body
Full-time: 21,441
Part-time: 3,365
Total: 24,806

WHAT MAKES YOUR SCHOOL'S ART & DESIGN PROGRAMS DIFFERENT & UNIQUE FROM OTHER ART & DESIGN SCHOOL PROGRAMS? WHAT ARE THE TOP 3 FEATURES?

Columbia University is a great choice for students looking for an exceptional liberal arts education. Columbia's unique Core Curriculum provides undergraduates at the College with a common basis for conversation shared by all students regardless of their major, as well as the strong foundation for informed creativity as they focus on Visual Arts. This lays the groundwork for Visual Arts classes where diverse ideas and rigorous critical dialogue thrive as they are fostered by our world-class visual arts faculty.

Our undergraduate Visual Arts majors take a two-semester 'Senior Thesis' class during their senior year, in which they are provided with individual or shared studio space to

develop their own studio practice and the chance to exhibit their work in their final semester. The proximity of our renowned MFA program in Visual Arts also provides invaluable opportunities: to foster mentor relationships with our MFA candidates and to attend weekly presentations by respected artists at our MFA's Visiting Artist Lecture Series.

students to take classes in different areas of study. The Core Curriculum reflects this philosophy and requires students to engage in a variety of classes that cover subjects in different fields. We believe that this breadth of academic exploration only enriches the conversation as students focus on their interest in Visual Arts.

CAN STUDENTS TAKE COURSES IN OTHER SCHOOLS OR MAJORS?

Yes. Columbia values a diversity of ideas and encourages

FACT!
4th Largest international student population of any U.S. University

37

The undergraduate VA studies fosters close mentor relationships with candidates from the renowned MFA program.

WHAT STEPS DO YOU TAKE TO EVALUATE A STUDENT'S CANDIDACY, APART FROM REVIEWING THEIR CREATIVE PORTFOLIO?

Admissions are not done through individual departments so although Visual Arts faculty do review supplemental art portfolios submitted with applications, the admissions process is administered through Columbia College.

WHAT DOES YOUR PROGRAM LOOK FOR MOST IN THE CREATIVE PORTFOLIO DURING ADMISSIONS? WHAT DO YOU THINK MAKES AN A+ PORTFOLIO?

We are looking for students whose work demonstrates exceptional fluency in the mediums presented as well as unique artistic vision and dedication.

HOW ARE NEW TECHNOLOGIES AFFECTING STUDENTS' CURRICULUMS AND/OR WAYS OF LEARNING/COLLABORATING AT YOUR SCHOOL?

New technologies are used to enhance our curriculum and streamline access to information both inside and outside of the classroom and studio. We encourage students to explore widely: to engage the possibilities of creating artwork that developing technologies make possible while embracing more traditional approaches as well.

FACT!
There are roughly 30 Visual Arts majors. as witnessed by one student "There's an intimacy here you just won't get in a bigger program."

HOW DOES YOUR PROGRAM HELP GRADUATING STUDENTS WITH INTERNSHIPS OR JOBS? CAN STUDENTS EXPECT JOB PLACEMENT MORE AT YOUR PROGRAM THAN IN OTHERS? IF SO, HOW OR WHY? WHAT KINDS OF JOB OPPORTUNITIES HAVE YOU SEEN STUDENTS TAKE ONCE THEY COMPLETED THEIR DEGREES?

Our students graduate with a rigorous education that prepares them for a wide range of career opportunities. Graduates from our program have gone on to pursue further studies, including MFA programs in Visual Arts, to work in galleries, museums and other art-related institutions, to teach art at all levels and to be professional artists.
Columbia's Center for Career Education works in collaboration with academic departments to support students by providing access to internships and jobs on an annual basis, career counseling appointments, and employer

connections. Our students benefit greatly from being in NYC, where they have a wealth of opportunities to connect with premier organizations and people in the arts and other industries. The connections available to our graduates as they become part of a thriving network of alumni are especially valuable.

All of this together gives our students an unparalleled foundation upon which to build a vibrant career.

WHAT IS THE MOST DISTINGUISHED FEATURE AT YOUR SCHOOL?

Our students get a lot of personal attention: we have a hands-on, caring faculty and the relatively small number of Visual Arts majors means that students are part of a tight-knit community with high professor-to-student ratios. Going to school in New York gives our students access to incredible resources including the opportunity to tap into a deep and vibrant network of alumni who are active in every aspect of the art scene here.

WHAT IS THE BEST ADVICE YOU HAVE FOR STUDENTS ENTERING THE ART, DESIGN & ARCHITECTURE FIELD?

Experiment. Take risks. Question everything. See the largest picture. Cherish and develop your own artistic voice as opposed to copying others.

by Nicola López
Asst. Professor, Director of Undergraduate Studies - Visual Arts

APPLICATION MATERIALS
Common application

SUPPLEMENTARY MATERIALS
Up to 20 digital images
Slideroom

WRITING
Common App questions

TRANSCRIPTS
Required

RECOMMENDATION LETTERS
1 Counselor Recommendation
2 Teacher Evaluations

APPLICATIONS DEADLINES
Early Decision: Nov 1
Regular Decision: Jan 1

FOR INTERNATIONAL STUDENTS
TOEFL: minimum 600 (paper-based test) or 100 (Internet-based test)
IELTS: minimum 7.0

*If you have a 650 or higher on the Critical Reading or Writing sections of the SAT, or a 29 or higher on the English or Reading sections of the ACT, you are exempt from taking an English proficiency examination.
*Columbia welcomes

Typically no more than 10 students complete the senior thesis each year. The department is also able to offer summer research travel grants to facilitate the preparation of a senior thesis.

applications from international transfer students. However, in order to be eligible to apply as a transfer, you must first meet certain criteria. You must be enrolled in a college in **North America or in a US-style college abroad.** Applicants from China: Columbia recommends that applicants attending high school in China schedule admissions interviews with InitialView. Interviews must be scheduled, completed and submitted to Columbia by December 1 for Early Decision or February 1 for Regular Decision

TIPS

Architecture: There is no specific number of submissions that need to be included.

Digital Media: Portfolios should include at least one drawing or painting as well as any other work that highlights your talent. All forms of media are welcomed. Limit your selection to 5-12 pieces, or a maximum of 5 minutes worth of video.

Fine Arts: Portfolios should include a minimum of 10 different works. Uploading an artist's statement of approximately 300 words is strongly encouraged.

DEGREES
DESIGN
BFA:
1. Fine Arts
2. Architecture

BA: City and Regional Planning

RANKING
UNIVERSITY IN THE USA
#4 U.S.News 2015
FINE ART
#6 U.S. News 2015

ADMISSIONS OFFICE
212 Hamilton Hall, Mail Code 2807,
1130 Amsterdam Ave,
New York, NY 10027
+1 (215)-898-7507

DID YOU KNOW?
93% *of the students admitted*
for Fall 2014 came from the top
10 percent of their high school
graduating class. The middle
50% of scores, as well as the
median scores, on each of the
three SAT components, are as
follows:
Reading: 680 to 780
Math: 700 to 790
Writing: 700 to 790

ALUMNI
Jonathan Allen, Artist
Martin Basher, Artist
Hilary Berseth, Artist
Rochelle Feinstein, Artist
Julia Goldman, Artist
Paul Heyer, Artist
Stephen Hilger, Photographer
Ajay Kurian, Artist
Margaret Lee, Artist
Eric Lindman, Artist
Nicola López, Artist
Joe Maida, Artist
Alisa Margolis, Artist
Chloe Piene, Artist
Aurora Robson, Artist
Tom Sanford, Painter
Greg Parma Smith, Artist
Emma Sulkowicz, Performing artist
Beau Willimon, Playwright

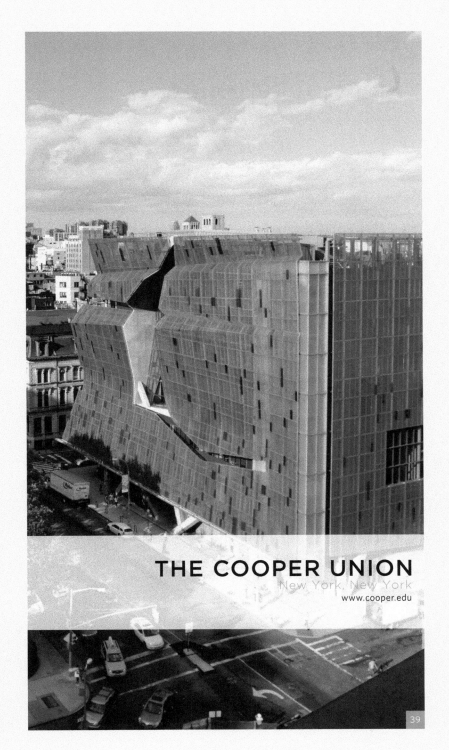

THE COOPER UNION
New York, New York
www.cooper.edu

39

THE COOPER UNION
UNDERGRADUATE ART MAJOR

The Cooper Union for the Advancement of Science and Art, established in 1859, is among the nation's oldest and most distinguished institutions of higher education. The college, founded by inventor, industrialist and philanthropist, Peter Cooper, offers a world-class education in art, architecture and engineering as well as an outstanding faculty of humanities and social sciences. The College admits undergraduates solely on merit and currently awards a minimum of a 50 percent tuition scholarship to all enrolled students. The institution provides close contact with a distinguished, creative faculty and fosters rigorous, humanistic learning that is enhanced by the process of design and augmented by the urban setting.

FACT!
The Cooper Union has historically been one of the most selective colleges in the United States, with an acceptance rate typically below 10%. Both the art and architecture

schools have acceptance rates below 5%

WHAT MAKES YOUR SCHOOL'S ART & DESIGN PROGRAMS DIFFERENT & UNIQUE FROM OTHER ART & DESIGN SCHOOL PROGRAMS? WHAT ARE THE TOP 3 FEATURES?

1. The admissions process is a uniquely directed and determined solely by Faculty. A student attending is selected by a review of Faculty committee.
2. Students are not accepted into specific majors. The curriculum is an integrated offerings of prerequisites and advanced studio classes representing all areas of concentration, providing students with a broad based rigorous visual education enhanced by a humanities and art history program.
3. After the Foundation year students craft their own course of study in consultation with their Faculty and the Academic Advisor.

CAN STUDENTS TAKE COURSES IN OTHER SCHOOLS OR MAJORS?

The students from the School of Art can take a minimum 11 credits of Free Electives from any class across the institution.

WHAT STEPS DO YOU TAKE TO EVALUATE A STUDENT'S CANDIDACY, APART FROM REVIEWING THEIR CREATIVE PORTFOLIO?

The application process requires a home test to be submitted in addition to a portfolio requirement.

WHAT DOES YOUR PROGRAM LOOK FOR MOST IN THE CREATIVE PORTFOLIO DURING ADMISSIONS? WHAT DO YOU THINK MAKES AN A+ PORTFOLIO?

The portfolio provides the opportunity through the work submitted to understand how well the student thinks visually beyond the craft of production. It is an important element of gauging the appropriate fit.

HOW DOES YOUR PROGRAM HELP GRADUATING STUDENTS WITH INTERNSHIPS OR JOBS? CAN STUDENTS EXPECT JOB PLACEMENT MORE AT YOUR PROGRAM THAN IN OTHERS? IF SO, HOW OR WHY? WHAT KINDS OF JOB OPPORTUNITIES HAVE YOU SEEN STUDENTS TAKE

ONCE THEY COMPLETED THEIR DEGREES?

There is a very active Career development and Outreach office and an internship program, funded by the school, that often leads to summer or continued employment.

by Day Gleeson, Associate Professor and Academic Advisor, The Cooper Union's School of Art

DID YOU KNOW?
Bruce Degen is a 1966 graduate of the school's arts program and the illustrator of the children's book series **The Magic School Bus**.

SCHOOL OF ART
SCHOOL OF ARCHITECTURE
APPLICATION MATERIALS
Common application

PORTFOLIO REQUIREMENTS
Slideroom 5-10 pieces

*Home Test & Studio Test: Regular Decision applicants to the School of Architecture and/or School of Art will be sent a studio test or home test, respectively, in January. Early Decision applicants to the School of Art will receive a home test in December. This

must be completed within one month of receipt. The home test and studio test will be sent to all applicants via email on the same day after the online application deadline.

WRITING SAMPLE
Part of hometest

TRANSCRIPTS
Required

RECOMMENDATION LETTERS
1 Teacher or Counselor

INTERVIEW
Not Required

APPLICATIONS DEADLINES
Early Decision: Dec 1
Regular Decision: Jan 11

FOR INTERNATIONAL STUDENTS
TOEFL: 600 paper or 100 (iBF)
IELTS: n/a
PTE: n/a

Early Decision: Dec 1
Regular decision: Jan 11

ALUMNI
Roy DeCarava, Photographer
Patty Jenkins, Filmmaker
Whitfield Lovell, Artist
Ellen Lupton, Graphic designer, Writer, Curator and Educator
Mike Mills, Filmmaker
Jack Whitten, Painter
Alex Katz, Figurative artist
Milton Glaser, Graphic designer
Herb Lubalin, Graphic designer, Creative Director for publications
Wangechi Mutu, Artist
Javaka Steptoe, Artist, Illustrator
Audrey Flack, Painter, Performer
Sylvia Mangold, Painter

FACT!
SEA2M3 provides a forum within which students from the schools of Engineering, Art and Architecture come together to develop new design criteria that yield materials, manufacturing techniques, habitats and lifestyles that are sustainable, and that, ultimately, reduce the chasm between the rich and the poor.

DEGREES
BFA:
Bachelor of Architecture
Bachelor of Engineering
Bachelor of Fine Arts

RANKING
#1 Best Value for its region U.S.News 2015
#2 Best overall undergraduate school U.S.News 2015

ADMISSIONS OFFICE
30 Cooper Square
New York, NY 10003-7120
+1 (212)-358-4120

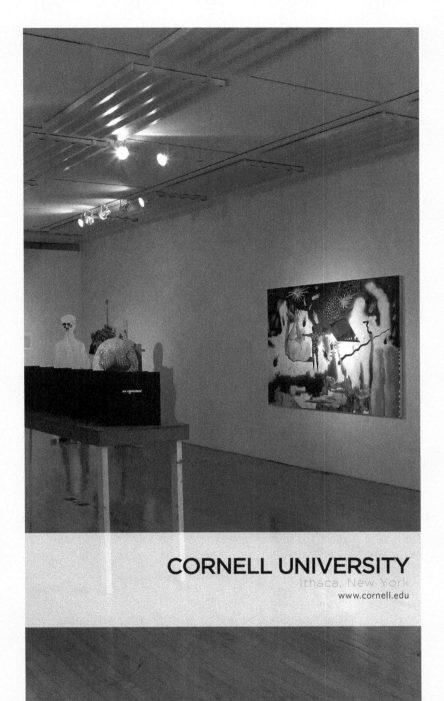

CORNELL UNIVERSITY
Ithaca, New York
www.cornell.edu

40

CORNELL UNIVERSITY
AAP: ARCHITECTURE, ART, PLANNING

One hundred and twenty-five years ago Andrew Dickson White, the first president of Cornell University, challenged the Board of Trustees to establish a new program to provide formal academic training in architecture. White combined a fascination with architecture with a sense of its importance to cultural history. While still a young man he had begun collecting architectural books and journals. He offered his collection, possibly the best in the U.S. at the time, to the University. In return, the Trustees agreed to found a School of Architecture. Providing the first four-year course in architecture in an American university, it presented an alternative to apprenticeship programs or to study in Europe. Charles Babcock was named professor of architecture, the first such appointment in the country. By 1896 the College of Architecture also offered classes in drawing, painting, and sculpture, and a department of art was formally added in 1921. A City and Regional Planning program began in 1935, and in 1967 the College of Architecture, Art, and Planning officially acquired its current name.[16]

FACT!
Cornell awarded the world's first degree in journalism, the nation's first degree in veterinary medicine, and the first doctorates in electrical and industrial engineering.

WHAT MAKES YOUR SCHOOL'S ART & DESIGN PROGRAMS DIFFERENT & UNIQUE? WHAT ARE THE TOP 3 FEATURES?

Cornell University offers a unique opportunity for the serious pursuit of studio arts and architecture in a rigorous academic environment. We expect our students to become the cultural mark-makers of their generation, and therefore it is crucial that they are informed and educated world citizens, as well as excellent visual artists and designers. Our facilities are phenomenal, especially given the small size of our programs. Students also have the opportunity to spend a semester abroad or away through our Cornell in Rome or AAP NYC programs.

CAN STUDENTS TAKE COURSES IN OTHER SCHOOLS OR MAJORS?

Yes, students can and must take classes outside of their major department. In addition to general distribution requirements (such as humanities, math/science, etc.) there is a generous provision for academic electives.

WHAT STEPS DO YOU TAKE TO EVALUATE A STUDENT'S CANDIDACY, APART FROM REVIEWING THEIR CREATIVE PORTFOLIO?

Applicants must be academically competitive in order to be eligible for any Cornell program. While there is no GPA or SAT minimum, our admitted students have strong grades (As and some Bs) and average SAT critical reading and math scores in the high 600s or low 700s. However, the whole of the application is greater than the sum of its parts:

we are looking for, creativity, ideas, individual voice, fit for both the AAP program of choice and the university, and the kind of student that is going to both thrive and be happy here.

WHAT DOES YOUR PROGRAM LOOK FOR MOST IN THE CREATIVE PORTFOLIO DURING ADMISSIONS? WHAT DO YOU THINK MAKES AN A+ PORTFOLIO?

There is no one perfect kind of portfolio. We value student-driven work (vs. assignment-driven) and the pursuit of ideas within the work. Students should not try to put together a portfolio of what they think we want to see — we are much more interested in the unique story the portfolio tells about any given applicant. We do require a few observational drawings, and we like to see breadth of media but not at the expense of quality.

45 Nobel laureates affiliated with Cornell as faculty members or alumni.

HOW ARE NEW TECHNOLOGIES AFFECTING STUDENTS' CURRICULUMS AND/OR WAYS OF LEARNING/COLLABORATING AT YOUR SCHOOL?

New technologies are being introduced to the art and design world all the time, and at Cornell students have the opportunity to explore new media in formal and informal ways. For more information about our fabrication and studio facilities, please visit http://aap.cornell. edu/resources/fabrication-shop or http://aap.cornell.edu/resources/art-studios.

HOW DOES YOUR PROGRAM HELP GRADUATING STUDENTS WITH INTERNSHIPS OR JOBS? CAN STUDENTS EXPECT JOB PLACEMENT MORE AT YOUR PROGRAM THAN IN OTHERS? IF SO, HOW OR WHY? WHAT KINDS OF JOB OPPORTUNITIES HAVE YOU SEEN STUDENTS TAKE ONCE THEY COMPLETED THEIR DEGREES?

Our B.Arch. graduates typically pursue professional employment in the field of architecture immediately after graduation. BFA graduates go on to pursue many different art-related career paths, including art education, art therapy, curating/museum studies, publication, design, etc. We also have a comparatively high number of graduates who support themselves as working studio artists. Students take advantage of our excellent career services and internship office AAP Connect in order to prepare themselves professionally for their field. Please visit http://aap.cornell. edu/resources/jobs-internships for more information.

ARE THERE ANY EXCITING DEVELOPMENTS FOR YOUR PROGRAMS THAT STUDENTS SHOULD KNOW ABOUT?

For the most up-to-date information about our programs, please visit our website: http://aap.cornell.edu/. There you will find news about faculty accomplishments and research, student awards and studio work, alumni updates, as well as on-campus events presented by AAP.

FACT!
Cornell is No. 6 green campus according to Princeton Review

WHAT IS THE MOST DISTINGUISHED FEATURE AT YOUR SCHOOL?

The B.Arch. program is the #1 undergraduate architecture program in the US as rated by DesignIntelligence again this year. The BFA program offers the only opportunity we are aware of to pursue two separate undergraduate degrees (BFA

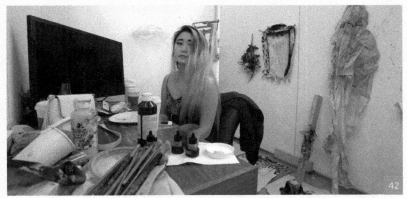

42

AAP NYC: Bachelor of Fine Arts Semester. The art program at AAP NYC is offered in the spring and is planned for second year art majors, though students may opt to attend in their third or fourth year (if pursuing a five-year degree). In addition to their class work, B.F.A. students are required to undertake a two-day-per-week professional placement (Tuesdays and Wednesdays) at one of many prestigious New York City art institutions.

and something else entirely) at the same time, within the same institution.

WHAT IS THE BEST ADVICE YOU HAVE FOR STUDENTS ENTERING THE ART, DESIGN OR ARCHITECTURE FIELD?

The best advice I can offer is that students should NOT focus entirely on rankings of programs or the reputation of the university. Students should be looking for a school that feels like the right fit — philosophically, physically, and socially. If the school is the right fit, a student will be happy and thrive in the program. It is much better to thrive than to just get by in a program that isn't a good fit and doesn't make you happy. Also, be prepared to challenge yourself and your ideas about what art and design really are, on

a daily basis. College is supposed to be hard, supposed to push you in ways you aren't familiar with yet. Embrace that, be open to new ideas, work hard.

By Maureen Caroll, Director of Admissions, College of Architecture, Art, and Planning

DID YOU KNOW?
*For nearly 30 years, **AAP's Cornell in Rome international education program** has been a transformative experience for talented undergraduate artists, architecture students, and urbanists. With a maximum enrollment of 60 students each semester, students benefit from an intimate environment that gives ample opportunity to get to know one another and their instructors.*

APPLICATION MATERIALS
Common Application

PORTFOLIO REQUIREMENTS
ARCHITECTURE
SlideRoom 15-20 pieces

ART
SlideRoom 18-20 pieces
*At least 4 freehand
observational drawings
* The portfolio should contain
examples of work from at least
three of the department's studio
practice areas: drawing, digital
media, painting, photography,
print media, and sculpture.

WRITING SAMPLE
Online Essay

TRANSCRIPTS
Required

INTERVIEWS
ARCHITECTURE required
ART Interview Not Required

REFERENCES LETTERES
1 Counselor
2 Teacher

APPLICATION DEADLINES
Early Decision: Nov 1
Regular Decision: Jan 2

FOR INTERNATIONAL STUDENTS
Early Decision: Nov 1
*Dec 1 - for scholarship
consideration
Regular Decision: Jan 3

TOEFL: 100(iBT) or
600(paper exam)
IELTS: 7.0

Every year in mid-March, in a tradition that goes back more than 100 years, an enormous dragon created by first-year architecture students parades across campus. Accompanied by AAP students in outrageous costumes, the dragon lumbers to the Arts Quad where it does battle with a phoenix created by rival engineering students. This rite of spring is one of Cornell's best-known traditions.

DEGREES
B.Arch.: Architecture
BFA: Art
Urban and Regional Studies

RANKING
#2 America's Best Architecture & Design Schools according to DesignIntelligence 2014

OFFICE OF UNDERGRADUATE ADMISSIONS
Cornell University, College of Architecture, Art, and Planning
235 Sibley Dome
Ithaca, NY 14853
+1 (607)-255-5241

ALUMNI
John Ahearn, Sculptor
Jeff Budsberg, Effects supervisor
Maria Calandra, Artist
Joel Carreiro, Artist
Hansen Clarke, Former
U.S. Congressman
Erik den Breejen, Artist
Judith Eisler, Photographer
Peter D. Gerakaris, Artist
Mark Gibian, Sculptor
Sam Jury, Artist
Pat Lipsky, Artist
Josh Owen, Industrial designer
Mark Parsons, Faculty at
Pratt Institute
Seth Sgorbati, Founder of
Sgorbati Projects
James Siena, Artist
Mustafa K. Abadan, Architect
Bruce Abbey, Architect
Peter Choi, Architect
Peter Eisenman, Architect
and educator

M. Arthur Gensler, Architect
Andre Guimond, Architect
Robert Joy, Architect
Dan Kaplan, Architect
Jeff Kovel, Architect
David J. Lewis, Architect
William Lim, Interior architect
Bryant Lu, Architect
Amanda Martocchio, Architect
Richard Meier, Architect
Enrique Norten, Architect
Chad Oppenheim, Architect
Mark Pasnik, Architect
Garth Rockcastle, Architect
Scott Rodwin, Architect
Alison Spear, Architect and
Interior designer
Ratan Tata, Chairman of Tata Sons
Timothy W. Ventimiglia, Museum
planner and exhibition designer
Ricardo Zurita, Architect

131

DARTMOUTH COLLEGE
Hanover, New Hampshire
www.dartmouth.edu

44

10

DARTMOUTH COLLEGE
STUDIO ART

USA • DARTMOUTH COLLEGE

Studio Art courses at Dartmouth offer students a serious and sustained exploration of the creative processes in visual art. Technical, perceptual and aesthetic issues are addressed in a historical and contemporary context. Classes are structured so that students experience the creative process through a direct and dynamic engagement with visual media.[17]

FACT!
Average annual scholarship for the 2014-2015 academic year: $46,315

WHAT MAKES YOUR SCHOOL'S ART & DESIGN PROGRAMS DIFFERENT & UNIQUE FROM OTHER ART & DESIGN SCHOOL PROGRAMS? WHAT ARE THE TOP 3 FEATURES?

Dartmouth is one of the nation's top undergraduate institutions, with a particular distinction for undergraduate teaching.

Student faculty ratio — Dartmouth has a 7:1 student faculty ratio. Classes are taught by Dartmouth's stellar faculty. Dartmouth was ranked No. 2 for "Strong Commitment to Undergraduate Teaching" in U.S. News and World Report's "Best Colleges 2016."

ARE THERE ANY EXCITING DEVELOPMENTS FOR YOUR PROGRAMS THAT STUDENTS SHOULD KNOW ABOUT?

Our newest Studio Art faculty members are Zenovia Toloudi, who is both an architect and artist, and Christina Seely, whose work stretches into the fields of science, design and architecture.
Toloudi's research builds on a cultural approach of technology, craftsmanship, and activism in architecture with installations that interplay with the physical qualities of space (air, light, sound) and their sensual perception (smell, vision, hearing) to enhance awareness and participation.

Seely is interested in humans'

134

contemporary relationship to nature and time. Her expedition based work finds its home in the conversation between the photographic image and our contemporary relationship with the natural world.

CAN STUDENTS TAKE COURSES IN OTHER SCHOOLS?

Dartmouth is a liberal arts college, which provides students with the opportunity to take courses in other majors (with over 57 to choose from and 1,000 independent studies). Students may also take courses at the Tuck School of Business and Thayer School of Engineering at Dartmouth.

A very popular course of study for today's Dartmouth students involves a double major or major/minor with Studio Art and Engineering.

HOW ARE NEW TECHNOLOGIES AFFECTING STUDENTS' CURRICULA AND/OR WAYS OF COLLABORATING/LEARNING AT YOUR SCHOOL?

Below is some info that addresses the question more broadly to the overall college:

The Computer Science Department houses a minor in Digital Arts in collaboration with Film Studies, Psychological and Brain Sciences, Studio Art, Music and Theater. The Digital Arts Minor is designed to allow students from multiple departments an opportunity to bring their talents and skills into the digital arts realm.

WHAT ARE THE TOP 3 PROGRAM FEATURES THAT MAKE YOUR PROGRAM STAND OUT?

1. Rigorous curriculum with sequential structure.
2. Faculty of practicing

Dartmouth has many Studio Art awards available for application, including The Class of 1977 Grant of $1,000 (established 2015) will be awarded to a Studio Art major. This grant will support a collaborative art project with another student, either cross departmental or with an outside organization.

One other notable feature is that Dartmouth has a year-round academic calendar of four 10-week terms, where students can decide when to study on and off campus, participate in a service project, and/or complete an internship.

professionals
3. Highly committed and focused students

WHAT IS THE MOST DISTINGUISHED FEATURE AT YOUR SCHOOL?

Dartmouth has the Hood Museum of Art, which is first and foremost a teaching museum, and its extensive collection.

1. Dartmouth has been collecting objects since 1772, just three years after its founding, and there are presently about 65,000 objects in the Hood Museum of Art's care. These collections are among the oldest and largest of any college or university in the country. The Hood makes all of its collections available for use by Dartmouth students and faculty in a special classroom setting.

2. The Hood offers over 10 special exhibitions and more than one hundred lectures, gallery talks, tours, workshops, family programs, programs for regional schools, and special programs forDartmouth students each year.

3. The Hood also features A Space for Dialogue—an exhibition space curated exclusively by undergraduates participating in the museum's competitive senior internship program. Since 2001, more than 80 interns have created exhibitions using objects from the College's collections, determining a theme, choosing objects, designing the installation, and giving a public gallery talk.

In addition, Dartmouth's campus also features the Hopkins Center for the Arts, which features over

100 live performances of music, theater and dance, and other events each year, as well as over 200 film screenings each year.

HOW DOES YOUR PROGRAM HELP GRADUATING STUDENTS WITH INTERNSHIPS OR JOBS? CAN STUDENTS EXPECT JOB PLACEMENT MORE AT YOUR PROGRAM THAN IN OTHERS? IF SO, HOW OR WHY? WHAT KINDS OF JOB OPPORTUNITIES HAVE YOU SEEN STUDENTS TAKE ONCE THEY COMPLETED THEIR DEGREES?

Dartmouth's Center for Professional Development provides students with resources to identify opportunities for internships, jobs and more. The Studio Art program also provides students with recommendation and referrals to various jobs, residencies, programs, and internship. The department also has a program called the Studio Art Department Intership, where recent graduates apply to work as the teaching assistants, lab monitors, and mentors for the students in the department. There are two Studio Art interns during the Summer, and five Studio Art interns during Fall, Winter and Spring terms.

FACT!
Average student debt for all four years combined = $16,339

WHAT STEPS DO YOU TAKE TO EVALUATE A STUDENT'S CANDIDACY, APART FROM REVIEWING THEIR CREATIVE PORTFOLIO?

The Dartmouth Admissions Office employs a holistic admissions selection process, taking into consideration the full range of each individual applicant's academic history, demonstrated potential, personal attributes, accomplishments, and background and/or life circumstances which may have afforded or limited educational and personal opportunity. The highest priority for the selection process is the tangible academic accomplishment and evident intellectual engagement and potential of each candidate. Excellence in extracurricular and personal pursuits also receive attention in the review process. Application reviewers are also attuned to the intangible human qualities and diversity of experience and perspective that enrich the Dartmouth student community.

WHAT DOES YOUR PROGRAM LOOK FOR MOST IN THE CREATIVE PORTFOLIO DURING ADMISSIONS? WHAT DO YOU THINK MAKES AN A+ PORTFOLIO?

Applicants to the College are welcome to submit a creative portfolio although it is not a requirement for admission and

is not a requirement for taking arts courses at Dartmouth.

WHAT IS THE BEST ADVICE YOU HAVE FOR STUDENTS ENTERING THE ART AND DESIGN FIELD? AND WHAT DO YOU THINK IS THE ROLE OF THE ARTIST TODAY?

As you explore the art, design &/or architecture field, think about how your work can make a meaningful impact in our world, by providing design solutions to challenges facing our society today.

by Maria Laskaris, Special Assistant to the provost for Arts and Innovation, former Dean of Admissions and Financial Aid and Amy D. Olson Sr. Media Relations Officer Office of Communications

APPLICATION MATERIALS
Online or through application forms

SUPPLEMENTARY PORTFOLIO
Slideroom

WRITING SAMPLE
Common App Essay
Dartmouth Writing Supplement

RECOMMENDATION LETTERS
1 Counselor
2 Teacher

STRONGLY ENCOUARGED
1 Peer
1 from Arts Instructor

APPLICATION DEADLINES
Early Decision: Nov 1
Regular Decision: Jan 1
Transfer: Mar 1

FOR INTERNATIONAL STUDENTS
Early Decision: Nov 1
Regular Decision: Jan 1
Transfer: Mar 1
TOEFL: N/A

DID YOU KNOW?
Every year, **five graduating seniors are chosen to remain at Dartmouth for a post-graduate year as Studio Art interns**. *Each is provided with a studio and small annual stipend. In return they assist in classes, monitor shops, and also serving as role models and mentors for undergraduates. See more at http://studioart.dartmouth. edu/internships#sthash. TZVvxois.dpuf*

DEGREES

BA:
1. Architecture
2. Drawing
3. Painting
4. Photography
5. Printmaking
6. Sculpture
7. Film & Media Studies

OFFICE OF UNDERGRADUATE ADMISSIONS
6016 McNutt Hall
Dartmouth College
Hanover, NH 03755
+1 (603) 646-1110

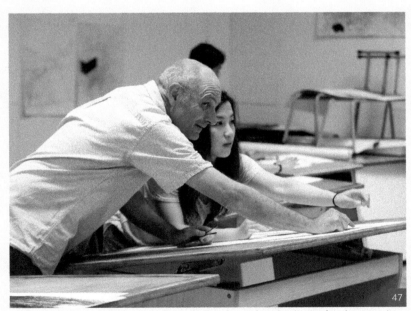

47

Artists at the Artist-in-Residence Program are chosen by a Studio Art faculty committee and exhibit their work in the Jaffe-Friede Gallery. The Studio Art Department produces a catalog of the exhibition and provides studio space and living accommodations for the artist.

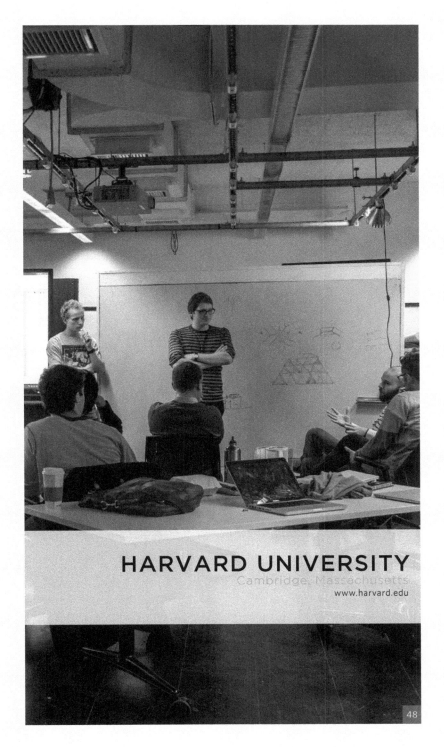

HARVARD UNIVERSITY
Cambridge, Massachusetts
www.harvard.edu

48

11

HARVARD UNIVERSITY

UNDERGRADUATE,
DEPARTMENT OF HISTORY OF ART &
ARCHITECTURE-ARCHITECTURE "TRACK"

Harvard University is a private Ivy League research university inCambridge, Massachusetts, established 1636, whose history, influence and wealth have made it one of the most prestigious universities in the world.

For students of Harvard College, Architecture Studies is a track within the Faculty of Arts and Sciences, History of Art and Architecture concentration, jointly administered by the History of Art and Architecture and the Graduate School of Design.[18]

FACT!
Acceptance Rate
6%

WHAT MAKES YOUR DESIGN PROGRAMS DIFFERENT & UNIQUE FROM OTHER SCHOOL'S PROGRAMS?

Our Architecture Studies track is emphatically a Liberal Arts curriculum, where the practical, studio component is integrated into a broader framework of historical,

analytical, and critical work. Students in this track may plan to go on to graduate training at an architecture school, but the track also prepares students for other professions due to its broad understanding of the concept of "design" and indeed of architecture generally.

WHAT ARE THE TOP 3 PROGRAM FEATURES THAT MAKE YOUR PROGRAM STAND OUT?

1. The program is fully integrated into a Liberal Arts curriculum at one of the foremost undergraduate educations in the world.
2. The program draws on faculty and resources from Harvard's Graduate School of Design, arguably the strongest professional architecture program in the world.
3. Enabling work between Harvard College and the GSD, the program draws on the strengths of Harvard University as a whole, breaking down the boundaries between knowledge (the traditional value of a university) and making.

ARE THERE ANY EXCITING DEVELOPMENTS FOR YOUR PROGRAMS THAT STUDENTS SHOULD KNOW ABOUT?

The program itself is new and innovative: an architecture studies undergraduate program engineered to be also a strong, flexible Liberal Arts education.

WHAT IS THE BEST ADVICE YOU HAVE FOR STUDENTS ENTERING THE ART & DESIGN FIELD?

Harvard has one of the strongest professional schools of architecture, has distinguished undergraduate programs in studio art, film, and environmental studies in the V.E.S. department, in addition to the most extensive art university art museum in the world.

CAN STUDENTS TAKE COURSES IN OTHER SCHOOLS? (I.E., TAKE CLASSES IN DIFFERENT MAJORS/ SCHOOLS)

Students are required to take other courses both for the concentration and for the undergraduate degree.

WHAT STEPS DO YOU TAKE TO EVALUATE A STUDENT'S CANDIDACY, APART FROM REVIEWING THEIR CREATIVE PORTFOLIO?

All Harvard undergraduates are eligible for admission to the concentration.

HOW DOES YOUR PROGRAM HELP GRADUATING STUDENTS WITH INTERNSHIPS OR JOBS? CAN STUDENTS EXPECT JOB PLACEMENT MORE AT YOUR PROGRAM THAN IN OTHERS?

49

The track's requirements include "Landmarks of World Architecture," plus two courses in the history and theory of architecture, two studio courses that will introduce basic architecture techniques, and four courses in an area of focus—either history and theory or design studies.

IF SO, HOW OR WHY?
WHAT KINDS OF JOB
OPPORTUNITIES HAVE YOU SEEN
STUDENTS TAKE ONCE THEY
COMPLETED THEIR DEGREES?

As with all undergraduate concentrations at Harvard, students are assisted in their future careers both by their advisors in their concentration and by special agencies at the College.

WHAT DOES YOUR PROGRAMME
LOOK FOR MOST IN THE
CREATIVE PORTFOLIO DURING
ADMISSIONS? WHAT DO YOU
THINK MAKES AN
A+ PORTFOLIO?
No portfolio is required, and no portfolio is produced.

HOW ARE NEW TECHNOLOGIES
AFFECTING STUDENTS'
CURRICULA AND/OR WAYS OF
COLLABORATING/LEARNING AT
YOUR SCHOOL?

New technologies are the focus of at least one of the required studio courses.

by Joseph Koerner
Director of Undergraduate
Studies in Dept. of History of
Art & Architecture

50

Peer institutions such as Princeton, Yale, Barnard, and the University of Pennsylvania offer architectural concentrations, but Harvard's track differs, due to the close collaboration with the GSD.

APPLICATION MATERIALS
Common App
Universal College App

SUPPLEMENTARY MATERIALS
Slideroom 2-25 pieces

TRANSCRIPTS
Required

RECOMMENDATION LETTERS
2 Teachers

WRITING SAMPLE
Common App Harvard
Questions & Supplement
OR Harvard Supplement w/
Universal College Application

INTERVIEW
Recommended

APPLICATION DEADLINES
Early Action: Nov 1
Regular Decision: Jan 1

FOR INTERNATIONAL STUDENTS
Early Action: Nov 1
Regular Decision: Jan 1

TOEFL: 700 or higher
IELTS: 7 or higher

DID YOU KNOW?
*Harvard's **Loeb Fellowship** has been a home for over 450 exceptional leaders in the design world, from architects and landscape architects to journalists, public artists, conservationists and affordable housing developers.*

DEGREES

DEPARTMENT OF HISTORY OF ART & ARCHITECTURE
BArch: Architecture "track"

GRADUATE SCHOOL OF DESIGN
MArch: Architecture
MLA: Landscape Architecture
MUP: Urban Planning and Design
MDes: Design Studies
MDE: Design Enigineering

DEGREE
Joint Degrees
1. Urban Planning program at GSD
2. Public Policy(MPP) or Public Administration(MPA) at HKS
3. Law (JD) at HLS

RANKING
#1 Design Intelligence 2012-2015
#2 U.S.News 2015

ADMISSIONS OFFICE
Harvard University Graduate School of Design
48 Quincy Street, Gund Hall, Cambridge, MA 02138
+1 (617)-495-5453

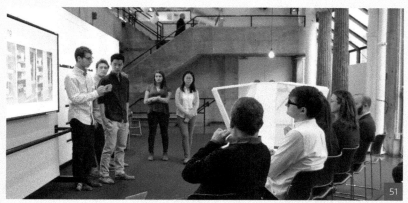

About a dozen students will be accepted into graduate-level classes in the history and theory of architecture, studio courses, and basic architectural techniques.

ALUMNI

Christopher Alexander, Architect
John Andrews, Designer
Edward Larrabee Barnes,
Modernist Architect
Christopher Charles Benninger,
Architect
Christopher Charles Benninger,
Architect
Garrett Eckbo, Architect
Andy Fillmore, Urban Designer
Danny Forster, Architect and
Television Host
Frank Gehry, Pritzker Prize
Laureate, Awarded
Honorary Doctorate
Lawrence Halprin,
Landscape Architect
Charles Jencks, Landscape
Architect
Philip Johnson, Pritzker
Prize Laureate
Grant Jones, Landscape Architect
Dan Kiley, Modernist
Landscape Architect
Philip Lewis, Landscape Architect
Fumihiko Maki, Pritzker
Prize Laureate
Thom Mayne, Pritzker
Prize Laureate
Ian McHarg, Landscape Planner,
GIS Development
Cornelia Oberlander,
Landscape Architect
Michele Michahelles,
Paris-based Architect
Roger Montgomery, First HUD
Urban Designer, and Dean at
U.C. Berkeley
Michel Mossessian, Architect
IM Pei, Pritzker Prize Laureate
Hideo Sasaki, Landscape Architect
Ken Smith, Aarchitect
Edward Durell Stone,
Modernist architect
Edward Durell Stone, Jr.,
Landscape Architect
Kongjian Yu, Landscape Architect
Bruno Zevi, Architect, Critic,
and Historian
Henry N. Cobb, Architect
Jack Dangermond,
Environmental Scientist
Michael Graves, Architect
John Hejduk, Architect
Mitchell Joachim, Architect
Farshid Moussavi, Architect
Richard T. Murphy, Jr., President
and CEO of Murphy Warehouse Co.
Eliot Noyes, Architect and
Industrial Designer
Monica Ponce de Leon,
Architect and Educator
Joshua Prince-Ramus, Architect
Paul Rudolph, Architect and
the Chair of Yale
University's Department
Harry Seidler, Architect
Yoshio Taniguchi, Architect
Alejandro Zaera-Polo, Architect
Jeanne Gang, Architect

UNIVERSITY OF MICHIGAN
Ann Arbor, Michigan
www.umich.edu

52

UNIVERSITY OF MICHIGAN

PENNY W. STAMPS SCHOOL OF ART & DESIGN

The University of Michigan was founded in 1817 as one of the first public universities in the nation. It remains one of the most distinguished universities in the world and a leader in higher education.

The mission of the Stamps School of Art & Design is simple and profound — to prepare students to think in new ways, to educate them to become concerned world citizens, and to equip them with the skills for life-long accomplishment.[19]

FACT!

The Penny W. Stamps Distinguished Speaker Series brings respected artists and designers to Ann Arbor every Thursday at 5:10 pm during the academic year. These talks are free of charge and open to the public.

WHAT MAKES THIS PROGRAM STAND OUT, AND WHAT ARE THE 3 TOP FEATURES?

1.) Small Creative Community, Big University Setting
Unlike stand-alone art schools, the Stamps school is part of the University of Michigan. Our students have the resources that only a top-tier research university can provide. Collaboration with individuals immersed in different fields of study is a hallmark of the Stamps experience.

2.) International Experience
Stamps students are required to have at least one International Experience during their undergraduate studies. As we prepare students for a globalized economy, an international perspective is a critical component to the Stamps curriculum. Students can join a faculty-led trip, study abroad for a semester or a summer, complete an internship abroad, or even propose their own international experience in order to fulfill the requirement.

3.) Open, Cross-disciplinary Curriculum. Stamps students do not choose a major. Instead, their curriculum spans across mediums, providing a holistic, expansive view of the creative process. Students can

select a BA, BFA, or a Dual Degree or Minor with another participating U-M college. More here: http://stamps.umich.edu/undergraduate-programs

CAN STUDENTS TAKE COURSES IN OTHER SCHOOLS?

Yes, in fact they are required to do so as part of their curriculum. Our students have the opportunity to pursue any minor offered at U-M, such as Creative Writing, History of Art, Computer Science, Engineering or Business. They can also pursue dual-degrees and graduate from U-M with two diplomas.

WHAT STEPS DO YOU TAKE TO EVALUATE A STUDENT'S CANDIDACY, APART FROM REVIEWING THEIR PORTFOLIO?

We take a holistic review approach when evaluating

our applicants. The portfolio is just as important as the academics, which include grades, test scores, essays, letters of recommendation, extracurricular activities, and rigor of academic curriculum. We are also interested in finding students who are a good fit for Stamps, especially given the nature of our curriculum.

HOW ARE NEW TECHNOLOGIES AFFECTING STUDENT'S CURRICULUMS AND/OR WAYS OF COLLABORATING AT THE SCHOOL?

New and emerging technologies are always shaping and informing our students' experiences. For example, the Studio: 3D course required in the first semester now includes projects that involve working with 3D software and printers. New courses are added every year and are offered by Stamps faculty who

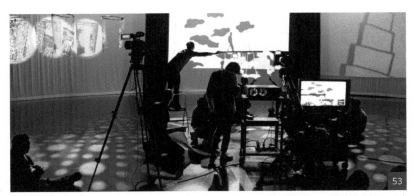

Stamps is continually working to expand our research initiatives, collaborating with partners in a wide range of fields, from nanotechnology to business, on projects that create new avenues to understanding.

STAMPS (School of Art & Design) students (except for minors and non-US residents) are required to undertake a course of study (at least 3 weeks) outside of the U.S. The school believes that an international experience will prepare students to be more qualified and ready to enter the global economy, simultaneously gathering new life experiences and knowledge of different cultures.

are collaborating with other faculty around the University and exposing our students to new technologies — working with U-M Medical School professors to create apps for children with Diabetes, or coming up with creative solutions to the Ebola outbreak. Outside of the classroom, students have access to a vast number of resources that include the latest technologies.

HOW DOES YOUR PROGRAM HELP GRADUATING STUDENTS WITH INTERNSHIPS OR JOBS?

In addition to the University's Career Center resources, Stamps has its own career advisor, who requires our students to meet with him at least once a year. Our career advisor hosts a career fair every winter, holds workshops and networking events, and posts internship and job opportunities on our web site everyday. He also helps our students connect with U-M alums — U-M has the largest living alumni network in the world at 500,000+ alumni.

WHAT MAKES A GREAT PORTFOLIO?

A Strong Portfolio Includes:
At least 3 drawings from direct observation. If you have in the past copied from photographs or other flat copy, you can improve your portfolio with drawings from observation. Include sketches as well as finished drawings.
2D media : Design, drawing, painting, photography, printmaking, and mixed media 3D media : Fibers, ceramics, metalwork, sculpture and installations Digital media : computer animation, video, audio, interactive art and internet-based projects Performance, conceptual work, or other work not easy to categorize.

A strong portfolio does not include: Work created prior to 9th grade should not be considered. Your most recent work is usually the strongest work.

More is not always better. In other words, don't include more work for the sake of having a lot to show. Be sure to choose your best work. Think about quality over quantity.

Drawings from magazines, comic books, animation, CD covers, or movie posters are not acceptable. Remember, work should be your own. Avoid overused, stereotyped, or timeworn imagery.

ADVICE FOR STUDENTS ENTERING THE CREATIVE CLASS?

The Stamps experience focuses on creative practice as an engine for cultural change and innovation, in large part because these are the real world issues that students will face in their post-university lives.

by Karina Galvan Moore
Director of Admissions and
Enrollment Management
& Truly Render Director of
Communications
and Marketing

APPLICATION MATERIALS
Common application

PORTFOLIO REQUIREMENTS
12-15 pieces Slideroom

TRANSCRIPTS
Required

WRITING SAMPLE
Writing Prompts on
Common App

INTERVIEW
Not required

REFERENCE LETTERS
1 Art Teacher
1 Academic Teacher
1 Counselor

APPLICATION DEADLINES
Early Action: Nov 1
Regular Decision: Feb 1

FOR INTERNATIONAL STUDENTS
Early Action Deadline: Nov 1
Regular Decision Deadline: Feb 1

TOEFL: 600 range or 100 range
IELTS: 7.0 range with section
scores 6.5+
PTE: 68 with all sections
equally strong

TIPS
Include at least 3 drawings from direct observation. If you have in the past copied from photographs or other flat copy, you can improve your portfolio with drawings from observation. Include sketches as well as finished drawings.

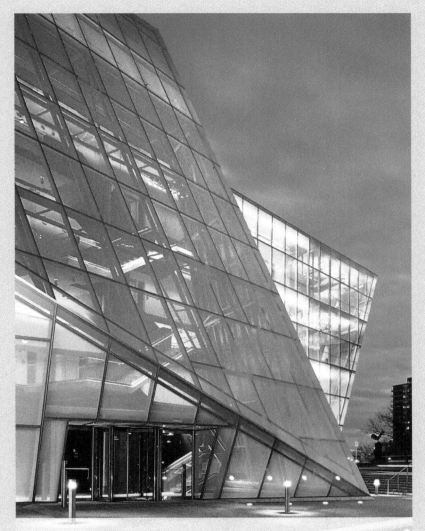

MARYLAND INSTITUTE COLLEGE OF ART

Baltimore, Maryland

www.mica.edu

MARYLAND INSTITUTE COLLEGE OF ART
ART, DESIGN, & ARCHITECTURE

Founded in 1826, MICA is among the top visual arts colleges in the nation. MICA has become the leader in the education of artists and designers by fostering a community of talented, creative individuals committed to redefining the boundaries of art and design and to expanding their own vision and perspective through rigorous study.

The MICA curriculum integrates writing, liberal arts coursework, and intensive studio practice, so that students become literate and knowledgeable of our cultural background and their place as artists and designers in creating and shaping culture. By the end of their studies at MICA, students are expected to be able to work independently in their chosen medium, to collaborate with others, to communicate with others, and to have a global perspective.

FACT!
MICA administers the most study abroad programs of any art college in the U.S.

WHAT MAKES YOUR SCHOOL'S ART AND DESIGN PROGRAM DIFFERENT AND UNIQUE FROM OTHER ART AND DESIGN SCHOOL PROGRAMS? WHAT ARE THE TOP 3 FEATURES?

1. Maryland Institute College of Art (MICA) provides a distinctively different learning environment from many other art and design schools in that we believe in educating the whole person — professionally and personally, artistically and intellectually. MICA's programs of study balance challenging studio practice in art and design with rigorous liberal arts coursework, concurrent with student affairs and residential life programming intended to facilitate the personal, career and leadership development of the student.

2. MICA students can uniquely customize their studies in support of personal creative exploration and career goals by combining a major area of study with a studio concentration. Imagine

Founded in 1826— the oldest continuously degree-granting college of art in the nation.

majoring in Architectural Design along with a concentration in Sustainability and Social Practice, or majoring in Painting with a concentration in Curatorial (Museum) Studies. Programs of study can be further individualized through the addition of internships, professional project-based research, study abroad, and community-based social engagement. The possibilities are endless.

3. MICA's programs of study in art and design reflect deeply held institutional values and a commitment to developing leadership and social responsibility through collaborative and project-based coursework with individuals, non-profit organizations and communities. Many students at MICA consider themselves "Artist-Citizens" who can make a difference in the world.

CAN STUDENTS TAKE COURSES IN OTHER SCHOOLS OR MAJORS?

Through a long standing academic exchange program, MICA students can take courses at fourteen other Baltimore colleges and universities including nearby Johns Hopkins University. Most popular courses taken at other schools are science, math, psychology and languages. Students can also take elective courses in any major, studio concentration or liberal arts minor at the College.

WHAT STEPS DO YOU TAKE TO EVALUATE A STUDENT'S CANDIDACY, APART FROM REVIEWING THEIR CREATIVE PORTFOLIO?

In addition to the visual portion of the application for admission, MICA requires transcripts of grades, test scores, essays and letters of recommendation, which are carefully assessed to

determine if the candidate is prepared to handle college-level work. Selective institutions such as MICA place equal weight on art and academics in the admission decision. MICA also asks students to provide a list of their extra-curricular activities during high school. the galleries and museums they have visited in the last two years along, and their favorite books and films. This supplemental information helps to paint a portrait of the candidate useful in determining if they are a good fit for MICA.

WHAT DOES YOUR PROGRAM LOOK FOR MOST IN THE CREATIVE PORTFOLIO DURING ADMISSIONS? WHAT DO YOU THINK MAKES AN A+ PORTFOLIO?

It is assumed that all applicants should include work in their portfolio that demonstrates a baseline of art and design competency and technical ability in their chosen medium(s). Typically, this is the result of several years of art study. However, the most successful candidates for admission are those who also exhibit a high level of conceptual development in the portfolio through work that is creative, innovative and includes multiple solutions to one problem. In other words, portfolios that demonstrate a candidate's ability to incorporate both their head and their hand.

HOW ARE NEW TECHNOLOGIES AFFECTING STUDENT CURRICULUM AND/OR WAYS OF LEARNING/COLLABORATING AT YOUR SCHOOL?

Technologies that incorporate making, building, designing, sharing, printing, and collaborating permeate the curriculum at MICA and are reflected in the state-of-the-art facilities at MICA. And they are evolving at a rapid rate. For example, digital fabrication has revolutionized the possibilities for individuals to create and market products that were not even conceivable a few years ago. Distance bridging systems, from Skype to Adobe Connect are allowing students to collaborate with faculty and other experts in their fields as well as other students from afar — such as current projects in which MICA students are working with students and faculty in Europe and Scandinavia on real time collaborations.

FACT!
The goal of MICA's Center for Design Thinking is to develop and publish original research on graphic design while providing opportunities for MICA faculty and students to create and publicly disseminate their visual and written work.

HOW DOES YOUR PROGRAM HELP GRADUATING STUDENTS

WITH INTERNSHIPS OR JOBS?
CAN STUDENTS EXPECT JOB
PLACEMENT MORE AT YOUR
PROGRAM THAN IN OTHERS?
IF SO, HOW OR WHY?
WHAT KINDS OF JOB
OPPORTUNITIES HAVE YOU SEEN
STUDENTS TAKE ONCE THEY
COMPLETED THEIR DEGREE?

MICA offers a complete array of career services through the Joseph Meyerhoff Career Development Center including a listing of more than 800 internships in Baltimore and across the U.S. as well as nearly 2000 job listings posted by prospective employers. The Center also offers a complete toolkit of strategies to get internships and jobs including counseling and workshops specific to a student's major area of study. As you can imagine, a painting major will most likely have different career goals than a graphic design major. Students interested in pursuing an advanced degree or wish to apply for a Fulbright Fellowship or Artist's Residency are also advised and counseled. The Center hosts job fairs on campus and the staff travel the country to make connections with recruitment personnel at cultural institutions, government and businesses.

As a result, MICA alumni are admitted to the most prestigious graduate schools including Yale, Harvard and UCLA. They work for a far ranging list of companies and cultural institutions including Google, Adobe, HBO, the Whitney Museum, the Smithsonian, Kate Spade, Anthropology, Nickelodeon Animation Studios and Pixar. They are published in the New York Times, Marvel Comics and are National Book Award Finalists. They have also gained the skills to start their own successful businesses from technology start-ups to owners of art galleries or design firms. The Chronicle of Higher Education has also named MICA a top Fulbright producer among specialty schools providing the funds for young alumni selected by this prestigious institution to travel and live in all parts of the world.

ARE THERE ANY EXCITING
DEVELOPMENTS FOR YOUR
PROGRAMS THAT STUDENTS
SHOULD KNOW ABOUT?

There are several new initiatives that are especially exciting for prospective students. The first is the launch of two new major areas of study — Game Design and Product Design — for which a new building is being constructed to open in the Fall of 2017 along with an expanded 3D prototyping facility. Additionally, MICA has partnered with Johns Hopkins University to develop the JHU MICA Film Center where students from both institutions share space, facilities, faculty

and coursework — an innovative program that capitalizes on our relative expertise. And lastly, MICA is the first art and design school to launch an entrepreneurship program through our Career Development Center which will provide education, training and funding to students and alumni who wish to become successful entrepreneurs.

WHAT IS THE MOST DISTINGUISHED FEATURE AT YOUR SCHOOL?

Established in 1826, MICA is the oldest, continuously degree granting, art college in the U.S.A.

WHAT IS THE BEST ADVICE YOU HAVE FOR STUDENTS ENTERING THE ART, DESIGN AND ARCHITECTURE FIELD?

Not since the Renaissance has there been a better time to pursue these fields of study. Creativity and innovation, a natural ingredient in the study of art, design and architecture, are in great demand not only in these fields but in business and industry. So follow your dream!

by Theresa Bedoya
Dean & Vice President,
Admission & Financial Aid

DID YOU KNOW?
The Baltimore Collegetown

Network's Website *(www. baltimorecollegetown.org) is also a great resource if you want to hang out with people who aren't artists; the site has a complete schedule of what's happening at the region's colleges and universities, and you'll also be able to find information on everything from arts/culture, to restaurants/ clubs and sports/recreation.*

APPLICATION MATERIALS
MICA Online Application or Common App

MANDATORY PORTFOLIO
12-20 pieces

WRITING SAMPLE
Personal Essay

RECOMMENDATION LETTERS
1 Counselor Required

APPLICATIONS DEADLINES
Early Decision: Nov 15
Early Action: Dec 15
Early Action II: Jan 15
Regular Decision: Feb 15

*Feb 1 Application due for priority scholarship consideration

FOR INTERNATIONAL STUDENTS
Early Action: Dec 15
Early Action II: Jan 15
Regular Decision: Feb 1

TOEFL: 80 (iBT)
IELTS: 6.5
PTE: n/a

DEGREES
BFA:
1. Animation
2. Architectural Design
3. Art History, Theory, and Criticism
4. Ceramics
5. Drawing
6. Fiber
7. Film and Video
8. Game Design (in development)
9. General Fine Arts
10. Graphic Design
11. Humanistic Studies
12. Illustration
13. Interactive Arts
14. Interdisciplinary Sculpture
15. Painting
16. Photography
17. Printmaking
18. Product Design (in development)

RANKING

ART
#TOP 25 U.S. Design Schools ID magazine
#TOP 20 U.S. Design Schools GDUSA magazine
#Best Northeastern College each of the last eight years.
The Princeton Review

ADMISSIONS OFFICE
1300 W Mt Royal Ave,
Baltimore, MD 21217
+1 (410)-669-9200

ALUMNI
Jeff Koons, Artist
Abbi Jacobson, Performance Artist
Derek Blanks, Photographer
Martha Colburn, Filmmaker
Gaia, Street Artist
Al Hurwitz, Artist
James Kochalka, Cartoonist
John Lehr, Photographer
Michael Owen, Artist

Joyce Scott, Artist
Elizabeth Turk, Artist
Errol Webber Jr., Cinematographer
Reggie Wells, Makeup Artist

161

MASSACHUSETTS INSTITUTE
OF TECHNOLOGY
Cambridge, Massachusetts
web.mit.edu

57

MASSACHUSETTS INSTITUTE OF TECHNOLOGY
ACT (ART, CULTURE, & TECHNOLOGY)

The MIT Program in Art, Culture & Technology (ACT) is an academic program and research unit headed by internationally renowned practicing artists. At ACT, students, fellows, and affiliates engage in hybrid artistic research and practice that experiments with new compositions of media and new forms of art technologies and deployments at the personal and the civic scale. In the spirit of artist and educator György Kepes — founder of ACT's predecessor, the Center for Advanced Visual Studies — ACT promotes artistic leadership in the field and engages with critical investigations in art and culture that aspire the future of technologies and science in transforming the world and its perception.

WHAT IS ACT?

The Program in Art, Culture and Technology (ACT) is an academic department and research center, part of the Department of Architecture, that facilitates artist-thinkers' exploration of art's broad, complex, global history and conjunction with culture, science, technology, and design via rigorous critical artistic practice and practice driven theory.

THE HASS REQUIREMENT

All MIT undergraduates must select a HASS concentration to meet their General Institute Requirements. ACT offers a diverse range of subjects, from courses exploring media that include photography, video, and sound, to examinations of cinema, public art, and the intersections of art and culture in the public sphere. If students elect to take two or three more courses in their concentration area, they can declare a HASS minor.[21]

FACT!
2014-15
Acceptance Statistics
Acceptance: 8.3%

WHAT MAKES YOUR SCHOOL'S ART & DESIGN PROGRAMS DIFFERENT & UNIQUE FROM OTHER ART & DESIGN SCHOOL PROGRAMS? WHAT ARE THE TOP 3 FEATURES?

58

Adi Hollander (SMACT '15), installation view, "when the lines went for a walk," 2015. Photo: Madeleine Gallagher.

1. Art, Culture & Technology (act.mit.edu) is an academic program and research unit at MIT headed by internationally renowned practicing artists. At ACT, students, fellows, and affiliates engage in hybrid artistic research and practice that experiments with new compositions of media and new forms of art technologies and deployments at the personal and the civic scale. In the spirit of artist and educator György Kepes — founder of ACT's predecessor, the Center for Advanced Visual Studies — ACT promotes artistic leadership in the field and a critical investigation of the role of technologies and science play in transforming the world.

2. Born out of a merger between MIT's influential Center for Advanced Visual Studies (CAVS founded in 1967) and Visual Arts Program (VAP founded in 1986) in 2009, ACT shares in a rich heritage of work expanding the notion of visual studies and pushing the capacity of art to enlist science and technology in cultural production and critique. Situated within the School of Architecture and Planning (SA+P), ACT inhabits a dynamic ecosystem of centers, institutes, and programs promoting the interplay between STEM and the arts. Within this broader network, ACT has a unique role to play: it offers students, researchers, practitioners, and guests the opportunity to expand the interrogative function of art: to develop art as a set of perspectives and means for addressing the social, cultural and ecological consequences of technology; to use art to build bridges between technics and life, industry and culture, representation and

165

embodiment; and to challenge the boundaries between self and other, fiction and history, public and private, human and non-human, research and life.

3. In addition to basic research, art production, and medium-specific training, the program offers access to a robust set of institutional resources, facilities, and classes, both within and beyond MIT, as well as a community of students, professors, fellows, affiliates, and visitors with an astounding wealth of specialties and creative energy. We provide an innovative learning environment that fosters complex, eclectic projects and personalities, and are committed to ensuring that MIT remains a critical hub for doing and studying contemporary art — a hub of rigorous artistic and pedagogical experimentation and a launch pad for new modes of transdisciplinary, transcultural, and inter-institutional collaboration.

The program currently offers an undergraduate minor and concentration, as well as a highly selective two-year graduate program, the Master of Science in Art Culture and Technology (SMACT). It also offers a variety of introductory courses to the general MIT student population and courses tailored to undergraduates majoring in architecture. Advanced courses related to specific media and topics are offered as electives for both undergraduate and graduate students. ACT studio courses are complemented by practical workshops and discussions in theory and criticism, often provided by fellows and visitors to the program. Studios also regularly involve in situ engagements and research field trips, which, in addition to their research/pedagogical value, are intended to establish an MIT presence in international circuits of artistic and scholarly collaboration.

CAN STUDENTS TAKE COURSES IN OTHER DEPARTMENTS?

Yes. Most MIT courses are open to ALL students; and we encourage our students to take courses in other disciplines and collaborate with students from other schools, departments and majors within the Institute. All undergraduate students have the option to take classes in our program to fulfill their humanities requirement. Interdisciplinarity is, in fact, a crucial component of ACT's mission and vision. In addition, full-time MIT students may take subjects for credit at Harvard University, Wellesley College, the Massachusetts College of Art and Design (MassArt), and the School of the Museum of Fine Arts (SMFA) without paying additional tuition.

WHAT STEPS DO YOU TAKE TO EVALUATE A STUDENT'S CANDIDACY, APART FROM REVIEWING THEIR CREATIVE PORTFOLIO?

An application includes information about the candidate's academic background, artistic practice, professional references, and personal statement. The admissions committee, comprised of ACT faculty, reviews each of these elements carefully for all applicants and interviews the top candidates.

WHAT DOES YOUR PROGRAM LOOK FOR MOST IN THE CREATIVE PORTFOLIO DURING ADMISSIONS? WHAT DO YOU THINK MAKES AN A+ PORTFOLIO?

A portfolio that clearly and succinctly presents a body of work is important. Portfolio requirements are very open, therefore applicants may be creative. An A+ portfolio should embody/reflect the content of the work through its form. In addition, the committee wants to see evidence in the portfolio and in the applicant's personal statement that he or she could leverage the faculty, facility, and institutional resources to produce work at new level.

FACT!
Average Credits Attempted Per Term and Average Time to Graduation
Students take an average of 11 credits per quarter for degree programs and 9 credits per quarter for diploma programs.

HOW ARE NEW TECHNOLOGIES AFFECTING STUDENTS' CURRICULUMS AND/OR WAYS OF LEARNING/COLLABORATING AT YOUR SCHOOL?

59

Adi Hollander (SMACT '15), "Karada" experimental opera and interactive installation, 2015. Featuring: ACT Grads, Anne Macmillan, Bjorn Sparrman and Gedney Barclay. Photo: Amanda Moore.

ACT students interface with a broad range of technologies and communications platforms in the development of their work as tools for teaching, interacting, and research. These technologies may influence the way our students learn and collaborate, they may be appropriated in the development of new works, or they may be developed specifically as collaborative teaching tools, such as Stellar, edX.

HOW DOES YOUR PROGRAM HELP GRADUATING STUDENTS WITH INTERNSHIPS OR JOBS? CAN STUDENTS EXPECT JOB PLACEMENT MORE AT YOUR PROGRAM THAN IN OTHERS? IF SO, HOW OR WHY? WHAT KINDS OF JOB OPPORTUNITIES HAVE YOU SEEN STUDENTS TAKE ONCE THEY COMPLETED THEIR DEGREES?

There is heavy reliance on the faculty and alumni/ae network

ARE THERE ANY EXCITING DEVELOPMENTS FOR YOUR PROGRAMS THAT STUDENTS SHOULD KNOW ABOUT?

MIT ACT is aggressively increasing its teaching community and inviting prominent and accomplished artist-thinkers to be a part of the MIT ACT community as faculty, research affiliates, and guests.

WHAT IS THE MOST DISTINGUISHED FEATURE AT YOUR SCHOOL?

MIT has an impressive public art collection among colleges in the US, the first architecture program in the US, and was a leader in the collaboration of art, science and technology with the founding of the Center for Advanced Visual Studies in 1967 by György Kepes. This tradition of leadership in art, culture, and technology continues today.

WHAT IS THE BEST ADVICE YOU HAVE FOR STUDENTS ENTERING THE ART, DESIGN & ARCHITECTURE FIELD?

Opportunities in art, architecture, and design are often self-started. Work to create networks of professionals familiar with your work. These individuals may become future collaborators, supporters, or mentors.

by Marion O. Cunningham
Administrative Officer
MIT Program in Art, Culture and Technology School of Architecture + Planning

DID YOU KNOW?
ACT holds the archive of the Center for Advanced Visual Studies (CAVS) containing materials concerning collaborative and time-based productions generated by or

DEGREES
BS:
1. Architecture
2. Architecture Studies

RANKING
#Top3 Universities worldwide Times Higher Education 2015
#7 Narional University U.S.News 2016

MIT UNDERGRADUATE ADMISSIONS PROCESSING CENTER
P.O. Box 404
Randolph, MA 02368
+1 (617)-253-3400

related to the tenure of nearly 100 internationally recognized artist-fellows over the past 40+ years.

APPLICATION MATERIALS
MIT Online App

PORTFOLIO REQUIREMENTS OR SUPPLEMENTARY MATERIALS
Slideroom up to 10 pieces

TRANSCRIPTS
Required

WRITING SAMPLE
MIT Short responses online

INTERVIEW
Highly Recommended

APPLICATIONS DEADLINES
Early Action : Nov 1
Regular Action: Jan 1

RECOMMENDATION LETTERS
1 Teacher (Math or science)
1 Teacher (Humanities, social science, or language teacher)
1 Counselor (Recommended)

FOR INTERNATIONAL STUDENTS
TOEFL: 600+ paper or 100+ iBT
Early Action: Nov 1
Regular Action: Jan 1

ALUMNI
Michael Rakowitz, Artist
Pia Lindman, Artist
Jill Magid, Artist and Writer
Jennifer Allora, Artist
Jae Rhim Lee, Artist
Hope Ginsburg, Artist
Alia Farid, Artist and Architect
Matthew Mazzotta, Architect
Kelly Dobson, Artist
Marisa Jahn, Artist and Producer

MOORE COLLEGE OF ART & DESIGN

Philadelphia, Pennsylvania

www.moore.edu

60

15

MOORE COLLEGE OF ART & DESIGN
ART & DESIGN

Moore College of Art & Design is dedicated to excellence in art and design. Founded in 1848, Moore is the first and only visual arts college for women in the United States. Through its undergraduate bachelor of fine arts degrees for women and its coeducational graduate programs, Moore cultivates creativity, promotes scholarship and prepares its students for professional careers in the arts by emphasizing critical thinking, problem solving, risk-taking, and strong communication skills. Moore is dedicated to producing graduates that distinguish themselves as leaders in their fields.[22]

FACT!
BFA Tuition & Fees 2015-2016
Tuition: $35,608
General College Fees: $1,220
Room & Board: $13,836
Total: $50,664

CAN STUDENTS TAKE
COURSES IN OTHER SCHOOLS
OR MAJORS?

While the College collaborates with Temple University, Philadelphia University and other local institutions of higher education on exhibitions and educational programs, students at Moore do not take courses at other schools. However, Moore is in partnership with Arcadia University, through which it provides its students with international studies opportunities that enhance their understanding of global creative industries early in their college experiences.

WHAT MAKES YOUR SCHOOL'S
ART & DESIGN PROGRAMS
DIFFERENT & UNIQUE FROM
OTHER ART & DESIGN SCHOOL
PROGRAMS? WHAT ARE THE
TOP 3 FEATURES?

Moore provides a number of unique opportunities for its students, specific to the College:

It is the only higher education institution devoted to art and design in the U. S. that provides $1,000 paid internships for all undergraduate students in every major. This opportunity

is an important key to Moore's career-focused education and offers a first-hand experience in a professional setting.

Only 11% of those working in the gaming industry are women. Moore saw a need to change this and launched its Animation & Game Arts major in 2013. It is the only college that provides this program exclusively for women and is designed to help them pursue careers as visual artists in the fields of animation, game art and mobile media design.

Graduate Studies offers an MA in Art in Education *with an Emphasis in Special Populations*, the only graduate degree of its kind in the country. This rigorous program educates art teachers to develop skills for adapting and implementing strategies that enrich the lives of all students, with a particular emphasis on students with disabilities. Courses focusing on teaching students with disabilities are also taught at the undergraduate level.

WHAT STEPS DO YOU TAKE TO EVALUATE A STUDENT'S CANDIDACY, APART FROM REVIEWING THEIR CREATIVE PORTFOLIO?

When evaluating the student's candidacy, the Admissions office reviews their transcripts, GPA and test scores, as well as their portfolio, to ensure that the student has the academic and artistic ability to be successful in Moore's rigorous liberal arts and foundation programs.

WHAT DOES YOUR PROGRAM LOOK FOR MOST IN THE CREATIVE PORTFOLIO DURING ADMISSIONS? WHAT DO

Sabrina Salgado '15, Art Education, artwork connected to her senior thesis. Photo credit: Moore College of Art & Design

YOU THINK MAKES AN A+ PORTFOLIO?

The Admissions office looks at the following areas during the portfolio review process: drawing, composition, craftsmanship, value, color, concept and originality. The top portfolios show a high level of proficiency in each of these areas. The portfolio should demonstrate the student's strengths and allow submissions from any media or style. Work does not need to reflect a theme or concentration.

HOW ARE NEW TECHNOLOGIES AFFECTING STUDENT'S CURRICULUMS AND/OR WAYS OF LEARNING/COLLABORATING AT YOUR SCHOOL?

Moore recently added a new Animation & Game Arts major, placing the college as a major partner in the growing Philadelphia technology sector. The major is designed for women who want to pursue careers in the fields of animation, game art and mobile media design. Students are also learning how to integrate digital technologies into their art practice through Moore's fabrication lab, or "Fab Lab," comprised of digital fabrication tools and equipment, including a 3-D printer, laser cutter and engraver and digital embroidery machine.

FACT!
2014 Fall Enrollment
412 – BFA Students
36 – Grad Students
6 – Post Bacc

HOW DOES YOUR PROGRAM HELP GRADUATING STUDENTS WITH INTERNSHIPS OR JOBS? CAN STUDENTS EXPECT JOB

New Campus Commons. The College recently underwent a complete renovation of its dining facilities, the first comprehensive renovation of this area in over 50 years. Photo by: Roy A. Wilbur

PLACEMENT MORE AT YOUR PROGRAM THAN IN OTHERS? IF SO, HOW OR WHY? WHAT KINDS OF JOB OPPORTUNITIES HAVE YOU SEEN STUDENTS TAKE ONCE THEY COMPLETED THEIR DEGREES?

Moore is the only art and design school to provide $1,000 paid internships for each student in every major. Students are required to complete a 240-hour internship during the summer before their senior year. About 40 percent of Moore students have been hired immediately from their internship. Moore's Locks Career Center has built up a large network of employers and motivated alumni in art and design fields. The Center provides free resume advice, career coaching and an electronic job bank, while also sponsoring an annual Senior Show VIP Reception, a launching pad for students, ensuring that several hundred employers, collectors and internship hosts are in attendance to view and purchase student work and meet and interview students. 94 percent of 2014 Moore undergraduates are employed or in graduate school, 87 percent in their fields of study. Students are employed at such high-profile companies as Destination Maternity, Anthropologie, Lenox and Campbell's Soup.

ARE THERE ANY EXCITING DEVELOPMENTS FOR YOUR PROGRAMS THAT STUDENTS SHOULD KNOW ABOUT?

Moore is expanding its partnerships with businesses to provide students with academic enhancements tied to product development and merchandising with such companies as Campbell's Soup and Century 21 Department Store. These initiatives expose students to real world experiences tied directly to the classroom resulting in creative and curatorial projects that generate greater exposure for their work.

The College has integrated technology more heavily into the learning process. The number of online courses has increased to 16, including hybrid courses in the Graduate Studies program. The FabLab Studio, which includes a MakerBot 3D printer, digital embroidery machine and laser cutter has provided the tools for advanced instruction.

In addition, after extensive renovations, Moore recently opened its new Campus Commons, which includes a contemporary Dining Hall, lounge with a fireplace, café, and a wall on which students can express their creativity.

WHAT IS THE MOST DISTINGUISHED FEATURE AT YOUR SCHOOL?

Founded in 1848, Moore is the first and only visual arts college for undergraduate women in the United States with one of the oldest, ongoing Young Artists Workshop programs, founded in 1921.

WHAT IS THE BEST ADVICE YOU HAVE FOR STUDENTS ENTERING THE ART, DESIGN & ARCHITECTURE FIELD?

If these are fields you feel passionate about, do not let anyone dissuade you from your path toward mastery and career success. Ignore naysayers who give into the stereotypes that are meant to stop you from following your destiny. This is not to say you should take to the path without a good road map and a disciplined practice to sustain you. Ask for help but don't act helpless. Don't be afraid--plow ahead. Yes, you will get tired, disappointed and discouraged. Buck up. Don't whine. Develop grit. You will work harder than you thought possible, but you will achieve a meaningful life and have the chance to offer your best self to the world.

by Michele Cohen, Associate Director of Communications

DID YOU KNOW?
Founded in 1848 as the Philadelphia School of Design for Women; became Moore College of Art & Design in 1989. **Educating women for careers in art and design for over 160 years.**

APPLICATION MATERIALS
Online Application

SUPPLEMENTARY PORTFOLIO REQUIREMENTS
12–20 pieces

TRANSCRIPTS
Required

REFERENCE LETTERS
One letter is suggested

APPLICATIONS DEADLINES
Rolling basis all year

FOR INTERNATIONAL STUDENTS
TOEFL: 79 (iBT)
IELTS: 6.5
PTE: N/A

TIPS
First-year students who submit an application and are admitted by December 1st, are eligible for Early Action. The benefits of Early Action include a $500 scholarship on your first year at Moore as well as priority financial aid and housing consideration.

DEGREES
BFA:
1. Animation & Game Arts
2. Art Education
3. Art History
4. Curatorial Studies
5. Fashion Design
6. Fine Arts
7. Graphic Design
8. Illustration
9. Interior Design
10. Photography & Digital Arts

RANKING

ART AND DESIGN
#3 in the USA, The Economist magazine
#1 in Pennsylvania, The Economist magazine

ADMISSIONS OFFICE
Admissions Office, Moore College of Art & Design
20th Street and The Parkway
Philadelphia, PA 19103
+1 (215)-965-4015 or (800)-523-2025

ALUMNI
Alice Neel, Portrait artist
Myra Levick, Artist
Adrienne Vittadini, Fashion designer
Anne Occi, Designer
Dom Streater, winner of "Project Runway," season 12
Polly Smith, Emmy Prize winner
Sharon Wohlmuth, Pulitzer Prize winner

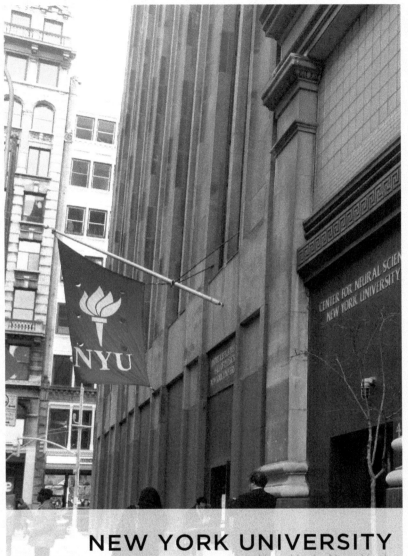

NEW YORK UNIVERSITY
New York, New York
www.nyu.edu

63

NEW YORK UNIVERSITY
STEINHARDT

Established in 1890, NYU Steinhardt's one-of-a-kind integration of education, communication, health, and the arts puts us at the heart of a movement: education for social change. Our mission is to advance knowledge, creativity, and innovation at the crossroads of culture, education, and human development. We exemplify NYU's commitment to be of public service.[23]

FACT!
Acceptance Rate
400 Students apply, roughly 60 students accepted

WHAT MAKES YOUR SCHOOL'S ART & DESIGN PROGRAMS DIFFERENT & UNIQUE FROM OTHER ART & DESIGN SCHOOL PROGRAMS? WHAT ARE THE TOP 4 FEATURES?

1. The NYU Steinhardt BFA Program is nestled in a world-class research university encouraging collaborative work and crossover with people of unprecedented know-how in other fields, while the relative small size of studio classes (12-15 students) fosters close relationships with both faculty and peers. Our students have access to Tier 1 Research level courses and a supportive home base. This is unique for an art school.
2. There other art schools in NYC but I cannot overstate how important it is to our curriculum that we use our city as a school. We have a two pronged internship program.
3. Our Senior Honors Program is one-of-a-kind. All Seniors can apply and if accepted, they work closely with curators from the famed NYU Institute of Fine Arts, recognized as one of the best Graduate Art History programs in the world. Seniors graduate having already been in exhibitions curated by these experts. Additionally, they have scholarly essays written by these top tier curators examining their work.
4. We are a Global Networked

University. Though many schools offer Study Abroad programs, we offer a Global network that is run by NYU and functions in sync with our curriculum, financial aid, etc.

CAN STUDENTS TAKE COURSES IN OTHER SCHOOLS OR MAJORS?

Yes absolutely. Most of our students minor in other fields such as business, entertainment, art history, psychology, or pretty much anything they want. Many students double minor and a few double major.

WHAT STEPS DO YOU TAKE TO EVALUATE A STUDENT'S CANDIDACY, APART FROM REVIEWING THEIR CREATIVE PORTFOLIO?

Their statement is very important. Writing, reading and thinking are highly stressed in our department. A student's statement is SUPER important. Additionally all students must be accepted into NYU which means they must pass high academic standards.

WHAT DOES YOUR PROGRAM LOOK FOR MOST IN THE CREATIVE PORTFOLIO DURING ADMISSIONS? WHAT DO YOU THINK MAKES AN A+ PORTFOLIO?

Passionate work. Depth of exploration.

HOW ARE NEW TECHNOLOGIES AFFECTING STUDENTS' CURRICULUMS AND/OR WAYS OF LEARNING/COLLABORATING AT YOUR SCHOOL?

A lot of students are expressing interest in our Digital Art area. The curriculum of this area is under constant formation as technology is always mutating. In our department students can learn software including the Adobe suite, animation programs and 3D modeling. 3D printing is taught. We have a CNC router (Computer controlled cutting machine) in our sculpture workshop and encourage the students to use it in their work. We also introduce the student to programming and interactive possibilities. As we are an interdisciplinary program, the students often integrate technology into their work no matter what medium they prefer. Students are also encouraged to reach out to larger technology departments located in the NYU network and many complete their math requirement in the Computer Science department.

Supporting our departmental work we also have the LaGuardia Studio providing advanced digital media services to the NYU community. Services include museum-grade digital fine art printmaking, 3D printing, 3D scanning, and design consultation.

HOW DOES YOUR PROGRAM HELP GRADUATING STUDENTS WITH INTERNSHIPS OR JOBS? CAN STUDENTS EXPECT JOB PLACEMENT MORE AT YOUR PROGRAM THAN IN OTHERS? IF SO, HOW OR WHY? WHAT KINDS OF JOB OPPORTUNITIES HAVE YOU SEEN STUDENTS TAKE ONCE THEY COMPLETED THEIR DEGREES?

Our internship programs start as early as spring of the sophomore year. As we are in NYC internship possibilities are vast and varied. We use the city as our school. We have double-pronged internship possibilities.
A. Within the department there is an internship counselor who works with students both informing them of existing internship possibilities and aiding them in finding their dream internship. Once placed, the counselor monitors the intern's progress and provides ongoing support.
B. Outside the department we have the renowned NYU Wasserman Career Center, a resource for full-time and part-time jobs, and internship positions. By using either or both resources our students are more than prepared for the real world. Many students leave senior year with full-time jobs in place.

The range of jobs our students have is quite broad due to the interdisciplinary nature of our department. We have had students leave and become art-stars selling in world-class galleries. We have had students open their own successful galleries. We have had students work with prominent artists in their studios; in galleries; and, in non-profit art organizations. Others have gone into animation or photography, fashion or film. A few students have wound up in entertainment business, medicine and law.

FACT!
The minor in Digital Art and Design is a 16-point program that will provide students from across the University with technical training, visual communication and digital fabrication skills, along with enhanced creative thinking and critical problem solving abilities.

ARE THERE ANY EXCITING DEVELOPMENTS FOR YOUR PROGRAMS THAT STUDENTS SHOULD KNOW ABOUT?

The collaboration with the NYU IFA mentioned in your first question is quite extraordinary.

WHAT IS THE MOST DISTINGUISHED FEATURE AT YOUR SCHOOL?

Our Department has the most exhibition opportunities available for students in New York City.

WHAT IS THE BEST ADVICE YOU HAVE FOR STUDENTS ENTERING THE ART, DESIGN & ARCHITECTURE FIELD?

Be Bold.
Be Brave.
Love what you do.

by Marlene McCarty
Clinical Associate Professor of Visual Arts at NYU Steinhardt

APPLICATION MATERIALS
Common Application

PORTFOLIO REQUIREMENTS
Slideroom 15-20 pieces done with in past 2 years

TRANSCRIPTS
Required

WRITING SAMPLE
NYU Artist Statement

INTERVIEW
Not Required

APPLICATION DEADLINES
Early Decision I : Nov 1
Early Decision II: Jan 1
Regular Decision: Jan 1

RECOMMENDATION LETTERS
1 Teacher

FOR INTERNATIONAL STUDENTS
Early Decision I: Nov 1
Early Decision II: Jan 1
Regular Decision: Jan 1

Preferred TOEFL: average above 100
Preferred IELTS: average 7.0
PTE Academic: average 70

DID YOU KNOW?
*The Steinhardt Studio Art Program **partners with NYU-Berlin** to provide an unparalleled studio experience for art majors. Berlin is home to the most innovative contemporary art scene in Europe, with an ever-expanding expatriate art community. Art students here work in newly renovated studio spaces dedicated to digital art, painting, drawing and exhibition.*

USA

NEW YORK UNIVERSITY

PARSONS SCHOOL OF DESIGN
AT THE NEW SCHOOL
New York City, New York
www.newschool.edu/parsons

64

PARSONS SCHOOL OF DESIGN AT THE NEW SCHOOL
ART & DESIGN

Parsons has been a pioneer in art and design education since its inception, spearheading new movements and teaching methods that have propelled artists and designers creatively and politically. The renowned American Impressionist William Merritt Chase founded the school in 1896. It was a rebellious gesture: Chase led a small group of Progressives who seceded from the Art Students League of New York in search of more individualistic expression.

In 1970, Parsons joined The New School (then called The New School for Social Research), a renowned institution of progressive thinking. The merger with The New School provided Parsons with new resources to expand its education offerings. The move also strengthened the connection between academic knowledge and social activism.

Today, The New School and Parsons are committed to employ design thinking to help solve complex global problems. Joel Towers, executive dean of Parsons, describes the school's forward-looking pedagogy.[24]

FACT!
The BBA in Strategic Design and Management educates students in the entrepreneurial and strategic aspects of design and in design aspects of business. Project-based studio and seminar courses integrate business, design, and liberal arts education, promoting interdisciplinary learning through wide-ranging research and collaborative work.

WHAT MAKES YOUR SCHOOL'S ART & DESIGN PROGRAMS DIFFERENT & UNIQUE FROM OTHER ART & DESIGN SCHOOL PROGRAMS? WHAT ARE THE TOP 3 FEATURES?

1. Parsons School of Design is the only major design school embedded within a major comprehensive university. In addition to Parsons, The New School houses a liberal arts college, a performing arts college, a social research institute, and additional graduate programs in international affairs, management, and urban policy; media; creative

writing; and more. The New School encourages collaboration across all majors and disciplines to address social issues with innovative, viable solutions.

2. Parsons is leading enlightened design thinking through a commitment to sustainability and cutting-edge problem solving that improves all facts of society.

3. Located in New York City, with a branch in Paris.

CAN STUDENTS TAKE COURSES IN OTHER SCHOOLS OR MAJORS?

Yes. A student may choose to take a course or two in another area, or they may take a minor in another discipline of The New School. University-wide minors listed here at www.newschool. edu/academics/minors/

Students may also choose to pursue a five-year dual BA/BFA degree in a liberal arts concentration at Eugene Lang College of Liberal Arts and a visual arts focus at Parsons School of Design.

WHAT STEPS DO YOU TAKE TO EVALUATE A STUDENT'S CANDIDACY, APART FROM REVIEWING THEIR CREATIVE PORTFOLIO?

In addition to the portfolio, it is essential that a student performs well in the classroom. Writing and communication is a part of the curriculum here at Parsons, so we want to see students connect their words to their visual work. A shared passion for creative inquiry and the desire to make real world impact is crucial.

The Prototyping, Education and Technology Lab (PETLab) is dedicated to the design and use of games as a form of public interest and engagement. PETLab projects include curricula in game design for the Boys and Girls Club and via the website activategames. org, a set of disaster preparedness games with the Red Cross/Red Crescent Climate Centre, and big games such as Re:Activism and the "fiscal" sport Budgetball.

66

The Healthy Materials Lab formed to build healthier lives for all people through the dramatic reduction of toxins in the building industry. This initiative aims to transform the way that building products are manufactured, eliminate avoidable toxics and support the creation of new materials. The first project of the Lab is The Healthy Affordable Materials Project. This project will improve the lives of residents living in affordable housing by dramatically reducing the use of toxins in the building product supply chain.

WHAT DOES YOUR PROGRAM LOOK FOR MOST IN THE CREATIVE PORTFOLIO DURING ADMISSIONS? WHAT DO YOU THINK MAKES AN A+ PORTFOLIO?

Ideally we want the portfolio to present a range of technical and conceptual strengths. It's truly exciting to get a sense of an applicant's personality and interests.

HOW ARE NEW TECHNOLOGIES AFFECTING STUDENTS' CURRICULUMS AND/OR WAYS OF LEARNING/COLLABORATING AT YOUR SCHOOL?

Parsons' approach to technology is to foster a culture of self-learning, so that students are capable of teaching themselves new skills; choosing appropriate tools for a given work, both known and unlearned; and responding and adapting to evolving and future technologies. A high priority in achieving this is maintaining currency and responding nimbly to changes and advancements in the field.

Cross-disciplinary, project -based learning is at the center of our educational experience, encouraging students to consider issues from multiple perspectives in order to reframe the possibilities of design for the larger community.

Starting in their first year, Parsons students are introduced to a variety of both analog and digital technologies in 2D, 3D, and 4D production, and image making. In subsequent years, students further refine their technological skills, while also acquiring those specific to their disciplines. The

use of technology and equipment is embedded in the larger context of studio learning, so that students are acquiring these capabilities while learning how to best apply them and the outcomes of their use.

FACT!

Parsons DESIS (Design for Social Innovation and Sustainability) Lab is an action research laboratory created in 2009 at The New School in New York City. DESIS Lab works at the intersection of strategic and service design, management, and social theory, applying interdisciplinary expertise in problem setting and problem solving to sustainable practices and social innovation.

ARE THERE ANY EXCITING DEVELOPMENTS FOR YOUR PROGRAMS THAT STUDENTS SHOULD KNOW ABOUT?

Continued investment in cutting-edge facilities and technology is a priority for the school. Parsons is currently constructing a state-of-the-art, 30,000 square foot Making Center to support making across all disciplines and programs. Designed to support the most advanced, sustainable practices in digital technology and physical craft, the Making Center will provide spaces for 3D printing, prototyping, modeling, printmaking, fabricating, constructing, physical computing, milling, engineering, and a host of other tools and skills.

WHAT IS THE MOST DISTINGUISHED FEATURE AT YOUR SCHOOL?

Parsons is organized into five schools: Fashion; Art, Media and Technology; Constructed Environments; Art and Design History and Theory; and Design Strategies. This structure facilitates specialization in a given field while enabling interdisciplinary and cross-school scholarship that affords designers the broad design perspective they need in today's professional world. Additionally, Parsons students benefit greatly from our integration within The New School, a research and liberal arts university. research and liberal arts university, The New School. Our students can complement their design education with first-rate courses in anthropology, political science, public policy, music and drama, and many other disciplines, acquiring the capacity to work collaboratively across a wide range of projects and contexts.

'Design is not a neutral act. Design enables human action. It is purposeful and magnifies capacity. It reveals and conceals who we are. Design is a generative and a regenerative endeavor with immediate impact and long-term implications. And the challenges of our time require more than ever that artists and designers focus their talents not simply on how things appear but on how things

fundamentally are and, more to the point, how they could be. It is an ideal time to study art and design. The future is always being designed. '

by Joel Towers, Executive Dean, Parsons School of Design

DID YOU KNOW?
Driven by its mission to confront real-world problems through bold and creative solutions, The New School is **tackling the global crisis of climate change head on**. *This year, the university will pursue a comprehensive plan to address climate change, including full divestment of fossil fuels. At its heart is the Tishman Environment and Design Center (TEDC), a facility that will foster the integration of design strategies and creative social and ecological approaches to environmental issues.*

APPLICATION MATERIALS
Common Application

PORTFOLIO REQUIREMENTS
BFA: Slideroom 8-12 pieces
Parsons Challenge 3 pieces
BBA: Parsons Challenge 3 pieces

WRITING SAMPLE
Artist Statement (for BFA)
Personal Statement (for BBA)

TRANSCRIPTS
Required

REFERENCE LETTERS
1 Teacher

INTERVIEW
Not Required

APPLICATION DEADLINES
Early Action: Nov 1
Regular Decision: Jan 15
*SAT or ACT not required now

FOR INTERNATIONAL STUDENTS
Bachelor-degree BBA, BFA:
TOEFL: 92
IELTS: 7.0
PTE: 63

Dual-degree BA, BFA:
TOEFL: 100
IELTS: 7.0
PTE: 68

ALUMNI
Sheila Bridges, Interior designer
Mario Buatta, Interior decorator
Sue de Beer, Fashion artist
Tom Ford, Fashion designer
Albert Hadley, Interior designer
Marc Jacobs, Fashion designer
Jasper Johns, Painter
Donna Karan, Fashion designer
Barbara Kruger, Artist
Alex Lee, Product designer
Jenna Lyons, Creative director
Ryan McGinley, Photographer
Steven Meisel, Fashion photographer
Paul Rand, Graphic designer
Narciso Rodriguez, Fashion designer
Evan Roth, Artist
Joel Schumacher, Film director, Screenwriter, and Producer
Ai WeiWei, Artist

DEGREES

BFA:
1. Communication Design
2. Design & Technology
3. Fashion Design
4. Fine Arts
5. Illustration
6. Integrated Design
7. Interior Design
8. Photgraphy
9. Product Design

BS:
1. Architectural Design
2. Urban Design

BBA (Bachelor of Business Administration):
Strategic Design & Management

BA/BFA: Dual Degree

RANKING

#2 Design School in the World QS rankings 2015
#1 School for Undergraduate Art & Design in the US
 QS Rankings 2015
#4 Business of Fashion in the World 2015
#1 Business of Fashion in the USA 2015
#Top 5 Design Schools Business Insider magazine 2012

ADMISSIONS OFFICE
University Admission
66 West 12th Street
New York, NY 10011
+1 (212)-229-5150

UNIVERSITY OF PENNSYLVANIA
Philadelphia, Pennsylvania

www.upenn.edu

67

UNIVERSITY OF PENNSYLVANIA
UNDERGRADUATE FINE ARTS DEPT.

Penn dates its founding to 1740. Penn's culture of innovation, entrepreneurship, and interdisciplinary collaboration generates discoveries and applies them to pressing social needs.

The Undergraduate Fine Arts Program combines studio practices, seminar courses, and interactions with visiting artists and professionals in order to provide an open intellectual framework to foster critical awareness and independent methods of artistic research and learning. The Fine Arts program works in conjunction with three interdisciplinary degree programs in Cinema Studies, Digital Media Design and Visual Studies. Fine Arts courses are available to all students at the university to take as electives in order to enhance multidisciplinary learning.[25]

FACT!
Student Body
Full-time: 21,441
Part-time: 3,365
Total: 24,806

WHAT MAKES YOUR VISUAL ART PROGRAMS DIFFERENT & UNIQUE FROM OTHER SCHOOL'S PROGRAMS?

The program's strengths are many. Firstly, fine arts study is integrated into a humanities-oriented undergraduate program within Pennsylvania's College of Arts and Sciences. Graduates in Fine Arts depart as well-rounded students, technically strong in terms of their chosen Fine Arts area but also critically strong in terms of their self-understanding in the world.

WHAT ARE THE TOP 3 PROGRAM FEATURES THAT MAKE YOUR PROGRAM STAND OUT?

1. The Howard and Patricia Silverstein photography and imaging studios and labs are second to none.
2. An amazing roster of guest speakers and visitors come through the program to meet with students throughout the year.
3. All instructors are active and

Tory Burch, Noam Chomsky, John Legend, and the current president of Harvard are all Penn alumni.

highly recognized in their field artists and designers.

CAN STUDENTS TAKE COURSES IN OTHER SCHOOLS?

Yes. This is definitely something encouraged by Penn.

WHAT DOES YOUR PROGRAM LOOK FOR MOST IN THE CREATIVE PORTFOLIO DURING ADMISSIONS? WHAT DO YOU THINK MAKES AN A+ PORTFOLIO?

At Penn Fine Arts, students have access to the most advance computers and digital media training. Course instruction involves to some degree on line distribution of reading assignments, etc. Teaching at Penn is aligned to developments in all forms of technology.

WHAT STEPS DO YOU TAKE TO EVALUATE A STUDENTS' CANDIDACY, APART FROM REVIEWING THEIR CREATIVE PORTFOLIO?

They should show interest in exploring the world as a highly interconnected place. They should be able to articulate some sense of what they want to say, why they are interested in Fine Arts and in what ways are what they want to say particular.

ARE THERE ANY EXCITING DEVELOPMENTS FOR YOUR PROGRAMS THAT STUDENTS SHOULD KNOW ABOUT?

We are constantly updating our facilities. We are now in the process of converting two large studio rooms to open in 2016 as large-scale image shooting and production spaces.

WHAT IS THE BEST ADVICE YOU HAVE FOR STUDENTS ENTERING THE ART & DESIGN FIELD?

Develop a strong work habit. Read as much as possible the history and theory of art and design. Connect the dots of what you have read to the at large social world.

HOW DOES YOUR PROGRAM HELP GRADUATING STUDENTS WITH INTERNSHIPS OR JOBS? CAN STUDENTS EXPECT JOB PLACEMENT MORE AT YOUR PROGRAM THAN IN OTHERS? IF SO, HOW OR WHY? WHAT KINDS OF JOB OPPORTUNITIES HAVE YOU SEEN STUDENTS TAKE ONCE THEY COMPLETED THEIR DEGREES?

While a student, there are many opportunities to work within a program called Penn Undergraduate Research Mentoring (PURM) in which students work as assistants to art and design Professors and paid to do so. There is a Penn Network upon graduation that is extensive and exists to facilitate job attainment.

by Kenneth Lum
Professor and Director
of the Fine Arts
Undergraduate Program

DID YOU KNOW?
93% of the students admitted

for Fall 2014 came from the top 10 percent of their high school graduating class.

APPLICATION MATERIALS
Common application

SUPPLEMENTARY PORTFOLIO
Min 10 pieces

TRANSCRIPTS
Required

WRITING SAMPLE
Common App supplement
Artist Statement

INTERVIEW
Recommended

RECOMMENDATION LETTERS
1 Counselor
2 Teacher

APPLICATION DEADLINES
Early Decision:
Nov 1 (letter)
Nov 10
Regular Application:
Jan 5 (letter)
Jan 15

FOR INTERNATIONAL STUDENTS
Regular Decision Jan 1
TOEFL: Average 112

TIPS
Digital Media: Portfolios should include at least one drawing or painting as well as any other work that highlights your talent. All forms of media are welcomed. Limit your selection to 5-12 pieces.

DEGREES

DESIGN
BFA:
1. Fine Arts
2. Architecture

BA: City and Regional Planning

RANKING

ARCHITECTURE
#8 Design Intelligence 2015

ADMISSIONS OFFICE

University of Pennsylvania Office of Admissions
1 College Hall, Room 1
Philadelphia, PA 19104-6376
+1 (215)-898-7507

69

Photography art project by students in the School of Art program.

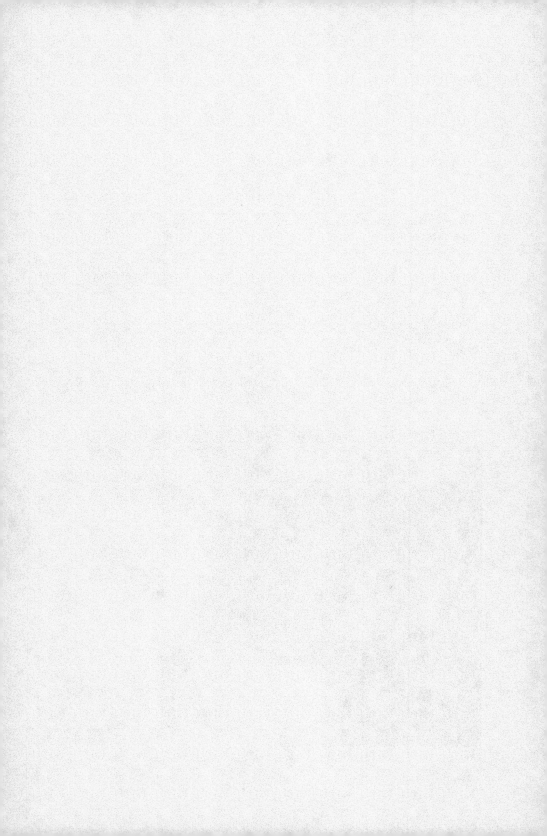

RHODE ISLAND
SCHOOL OF DESIGN
Providence, Rhode Island
www.risd.edu

70

RHODE ISLAND SCHOOL OF DESIGN
ART & DESIGN

Founded in 1877, Rhode Island School of Design is one of the oldest and best-known colleges of art and design in the U.S. Each year approximately 2,300 students from around the world pursue a creative, studio-based education at RISD, which offers rigorous bachelor's and master's degree programs in 19 architecture, design, fine arts and art education majors. The college is located in Providence, Rhode Island, which offers its own vibrant art scene and is conveniently located between two other major cultural centers: Boston and New York.[26]

FACT!

The Summer Pre-College Program offers 16- to 18-year-old high school students a comprehensive introduction to the experience of studying in an art school environment.

WHAT MAKES YOUR SCHOOL'S ART & DESIGN PROGRAMS DIFFERENT & UNIQUE FROM OTHER ART & DESIGN SCHOOL PROGRAMS?

A RISD education is grounded in deep, disciplinary learning that cultivates critical thinking + making, creativity and innovation. At RISD you can design and make art, teach and learn, work with your hands and with complex software. Students develop a way of thinking that will prepare them for whatever they choose to do, whether it's working as a professional artist or designer on their own or within an organization. Through a curriculum that combines a liberal arts and studio education, students learn to research and solve problems in a larger social and cultural context.

WHAT IS THE ADVANTAGE OF THE DUAL DEGREE PROGRAM WITH BROWN?

The Brown/RISD Dual Degree Program offers a unique opportunity for interdisciplinary education in which students earn both a Bachelor of Arts degree from Brown and a Bachelor of Fine Arts degree

from RISD by pursuing majors at each campus. The purpose of this rigorous course of study is to offer highly capable, talented and self-motivated students enhanced opportunities for integrating diverse spheres of academic work. In the process they gain access to a broader range of faculty and resources than would be available if they pursued a degree at either one or the other campus.

WHAT STEPS DO YOU TAKE TO EVALUATE A STUDENT'S CANDIDACY, APART FROM REVIEWING THEIR CREATIVE PORTFOLIO?

A key part of the criteria is for applicants to submit a visual art or design portfolio, two drawings, and writing samples. This is in addition to providing transcripts and test scores such as SAT or ACT, Test of English as a Foreign Language [TOEFL] or International English Language Testing System [IELTS].

WHAT DO YOU THINK MAKES AN A+ PORTFOLIO?

Rhode Island School of Design encourages applicants to take risks and consider the full range of possible expression in submissions, as we do not value any particular style/method of drawing or art making more than another.

HOW ARE NEW TECHNOLOGIES AFFECTING STUDENTS CURRICULUMS AND/OR WAYS OF LEARNING/COLLABORATING AT YOUR SCHOOL?

RISD's immersive model of art and design education is

RISD was founded and nurtured by women – more than 40 years before women in America even gained the right to vote. Photo Credit: RISD/Jo Sittenfeld

discipline-based and grounded in studio practice. Students embrace a culture of research and discovery that is encouraged through the use of traditional and emerging technologies. In addition to the deep immersion of studio majors, RISD offers interdisciplinary courses that integrate various approaches allowing students to construct individualized paths of learning and studies.

FACT!
Average Class Size
Undergraduate: 16
Graduate: 11
Student/Faculty Ratio
9.5:1

HOW DOES YOUR PROGRAM HELP GRADUATING STUDENT WITH INTERNSHIPS OR JOBS? CAB STUDENTS EXPECT JOB PLACEMENT MORE AT YOUR PROGRAMS THAN IN OTHERS? IS SO, HOW OR WHY?
WHAT KINDS OF JOB OPPORTUNITIES HAVE YOU SEEN STUDENTS TAKE ONCE THEY COMPLETE THEIR DEGREES?

The RISD Career Center offers a multitude of tools and resources, both off- and online, to help students maximize their potential for innovation and explore possibilities for exposure. Programming such as RISD Entrepreneurship Mindshare and Art + Business Boot Camps help students and alumni translate their education and creativity into fulfilling professional experiences. Design Portfolio Review and Fine Arts Portfolio review help students connect with more than 175 companies, galleries and organizations.
In addition to traditional art and design fields, many

72

STEM to STEAM is a RISD-led initiative to add Art and Design to the national agenda of STEM (Science, Technology, Engineering, Math) education and research in America. STEM + Art = STEAM. The goal is to foster the true innovation that comes with combining the mind of a scientist or technologist with that of an artist or designer. Photo Credit: RISD/Jo Sittenfeld

alumni are applying their knowledge and skills to areas including education, healthcare, government, technology and nonprofits.

ARE THERE ANY EXCITING DEVELOPMENTS FOR YOUR PROGRAMS THAT STUDENTS SHOULD KNOW ABOUT?

In addition to the deep immersion offered through major disciplines, RISD offers interdisciplinary courses that integrate various approaches. Funding from the National Science Foundation to a consortium of colleges, including RISD, has brought increasingly more focus on the exciting intersection of art, science, design technology and math. A uniquely design-oriented science curriculum enables students to explore topics ranging from insect morphology to cognitive neuroscience.

WHAT IS THE MOST DISTINGUISHED FEATURE AT YOUR SCHOOL?

From its incorporation in 1877, Rhode Island School of Design has stood out as a leader in art and design education, attracting extraordinary people who thrive in its creative culture. Founded simultaneously with the RISD Museum of Art, Rhode Island School of Design is one

of the first colleges of its kind in the country.

by Jaime Marland
Director of Public Relations
Photos by: Jo Sittenfeld

DID YOU KNOW?
*European Honors Program (EHP) allows 30 juniors/ seniors to pursue a full-credit, **independent study year in Rome**. Also, RISD's International Exchange Program allows students to participate in **one-semester overseas study experiences**. Currently RISD has agreements with approximately 43 institutions in 21 countries.*

APPLICATION MATERIALS
Common Application or RISD Online Application

MANDATORY
PORTFOLIO REQUIREMENTS
12-20 pieces, + RISD Hometest (2 Drawings)

WRITING SAMPLE
Up to 650 words
(see writing prompts)

TRANSCRIPTS
Required

REFERENCE LETTERS
One letter is suggested

203

APPLICATIONS DEADLINES
Early Decision: Nov 1
Regular Decision: Feb 1

FOR INTERNATIONAL STUDENTS
Early Decision: Nov 1
Regular Decision: Feb 1

TOEFL: 93
IELTS: 6.5
PTE: N/A

*Students applying for admission to the Dual Degree Program must complete the application process at both institutions by our respective deadlines: January 1 for Brown and February 1 for RISD.

TIPS

The Nature Lab offers unmediated access to authentic natural history specimens, while also fostering creative inquiry into biomimetics, biophilic design, ecology and climate change. It furthers RISD's hands-on approach to learning by enabling students to investigate ethical, sustainable modes of making informed by natural systems and designed to benefit the environment.

ALUMNI
Seth MacFarlane, Television producer and Film director
Nicole Miller, Fashion Designer
Michael Maltzan, Architect
Shahzia Sikander, Artist
Gus Van Sant, Film Director
David Macaulay, Illustrator and Writer
Shepard Fairey, Street Artist
Dale Chihuly, Glass Sculptor
Joe Gebbia, Co-founder of Airbnb
Brian Chesky, CEO of Airbnb

DEGREES
BFA:
1. Apparel Design
2. Ceramics
3. Film / Animation / Video
4. Furniture Design
5. Glass
6. Graphic Design
7. Illustration
8. Industrial Design
9. Interior Architecture
10. Jewelry + Metalsmithing
11. Painting
12. Photography
13. Printmaking
14. Sculpture
15. Textiles

BARCH: Architecture

CONCENTRATION:
1. History of Art + Visual Culture
2. History, Philosophy + the Social Sciences
3. Literary Arts + Studies

RANKING

ART AND DESIGN
#2 U.S.News 2015
#3 QS University Rankings by Subject 2015

#1 Graphic Design U.S.News 2015
#1 Industrial Design U.S.News 2015
#1 Printmaking U.S.News 2015
#2 Painting / Drawingg U.S.News 2015
#3 Ceramics U.S.News 2015
#3 Photography U.S.News 2015

ADMISSIONS OFFICE
Admissions Office, Rhode Island School of Design
Two College Street
Providence, RI 02903-2784
+1 (401)-451-6300 or (800)-364-7473

SAN FRANCISCO
ART INSTITUTE
San Francisco, California
www.sfai.edu

73

SAN FRANCISCO ART INSTITUTE
ART & DESIGN

Founded in 1871, San Francisco Art Institute is one of the nation's oldest and most prestigious schools of higher education in contemporary art. SFAI boast an illustrious list of faculty and alumni in all areas of focus. Most importantly, the institute have consistently held fast to a core philosophy of fostering creativity and critical thinking in an open, experimental, and interdisciplinary environment. At SFAI, they educate artists who will become the creative leaders of their generation.

FACT!
Average Credits Attempted Per Term and Average Time to Graduation
Students take an average of 11 credits per quarter for degree programs and 9 credits per quarter for diploma programs.

WHAT MAKES SAN FRANCISCO ART INSTITUTE'S VISUAL ARTS PROGRAMS DIFFERENT?

SFAI is different because we do not have any commercial programs. Students focus on contemporary art making, question asking, and investigating new ideas.

WHAT ARE THE TOP 3 PROGRAM FEATURES THAT MAKE YOUR PROGRAM STAND OUT FOR BFA ART/DESIGN STUDENTS?

1. Class size of 12-15 per studio class.
2. 11 to 1 faculty student ratio.
3. Interdisciplinary programs.

CAN STUDENTS TAKE COURSES IN OTHER DEPARTMENTS?

Yes, outside of their major, students may take up to 11 elective studio courses.

WHAT KIND OF JOB OPPORTUNITIES ARE AVAILABLE FOR SFAI GRADUATES?

Where to begin. Students are fully prepared to be successful working, practicing artists. This means so many things

SFAI was founded in 1871, and is one of the oldest art schools in the United States and the oldest west of the Mississippi River.

from making a gallery through selling work in galleries and attending residency programs. Many alum are entrepreneurial and start their own creative businesses. Many are teachers, filmmakers, and designers. Essentially SFAI students gain the transferable skills to invent and reinvent themselves.

HOW DOES YOUR PROGRAM HELP GRADUATING STUDENTS WITH INTERNSHIPS OR JOBS? CAN STUDENTS EXPECT JOB PLACEMENT MORE AT YOUR PROGRAM THAN AT OTHERS? IF SO HOW OR WHY?

We do not place students in jobs because we want them to find their own paths and do not have specific companies that we filter our students into. Each graduate is very individual

and unique.
We have a Career Center and Counselor that students meet with and faculty that mentor throughout the program.

WHAT DOES YOUR PROGRAM LOOK FOR MOST IN STUDENTS' BFA PORTFOLIOS/APPLICATIONS DURING ADMISSIONS?

Portfolio, interests, potential, and ideas.

FACT!
2014-15
Acceptance Statistics
Acceptance: 83%

WHAT DO YOU THINK MAKES AN A+ PORTFOLIO?

Investigation and not being afraid to go outside of class assignments.

WHAT IS THE BEST ADVICE YOU HAVE FOR GRADUATING HIGH SCHOOL SENIORS?

1. Debunk art school clichés.
2. Do the research.
3. Develop your portfolio.
4. Focus on ideas.
5. Try to research on contemporary artists.

by Colleen Mulvey
Sr. Associate Director for
Undergraduate Admissions

DID YOU KNOW?
In 1945, **Ansel Adams founded the first fine art photography department**. In 1968 **Annie Leibovitz begins photographing for Rolling Stone magazine** while still a student. She becomes the magazine's official photographer in 1973.

APPLICATION MATERIALS
Online Application

SUPPLEMENTARY PORTFOLIO REQUIREMENTS
10-15 digital images or 3-4 video clips

TRANSCRIPTS
1 Teacher or Counselor
(2 Recommended)

RECOMMENDATION LETTERS
Required

WRITING SAMPLES
BFA: Optional Artist Statement
BA: Required Critical Essay

APPLICATION DEADLINES
Priority Deadline
Spring Term: Nov 15
Fall Term: Feb 15

CA Residents: Mar 1

FOR INTERNATIONAL STUDENTS
Priority Deadline: Feb 15
TOEFL: 79
IELTS: 6.5
PTE: 58

ALUMNI

Annie Leibovitz, Photographer
Kathryn Bigelow, Director, Producer and Writer
Barry McGee, Painter and Graffiti artist
Roxanne Quimby, Businesswoman of Burts Bees

DEGREES
BA: History & Theory Of Contemporary Art
BFA:
1. Art & Technology
2. Film
3. New Genres
4. Painting
5. Photography
6. Printmaking
7. Sculpture

RANKING

ART
#19 Painting/Drawing U.S.News 2015

ADMISSIONS OFFICE

San Francisco Art Institute, 800 Chestnut Street
San Francisco, CA 94133
+1 (415)-749-4500 or (800)-345-SFAI

75

The SFAI has been at the forefront of several artistic trends, including Abstract Expressionism, the Beat Movement and the Bay Area Figurative Movement.

SCHOOL OF VISUAL ARTS
New York City, New York
www.sva.edu

76

SCHOOL OF VISUAL ARTS
ART & DESIGN

School of Visual Arts is a for-profit art and design college located in Manhattan, New York, founded in 1947. The college is a member of the Association of Independent Colleges of Art and Design, a consortium of 36 leading art schools in the United States.

It has been a leader in the education of artists, designers and creative professionals for more than six decades. With a faculty of distinguished working professionals, dynamic curriculum and an emphasis on critical thinking, SVA is a catalyst for innovation and social responsibility. Comprised of more than 6,000 students at its Manhattan campus and 35,000 alumni in 100 countries, SVA also represents one of the most influential artistic communities in the world.[28]

FACT!
Student/Faculty Ratio
18 to 1
Programs of Study
379
Toal Enrollment
44,251

WHAT MAKES YOUR SCHOOL'S ART PROGRAMS DIFFERENT & UNIQUE FROM OTHER ART & DESIGN SCHOOL PROGRAMS?

From its inception, the College has chosen its faculty from New York Citybased professionals working in the arts and art-related fields. SVA students thereby experience excellence while being introduced to and challenged by the professional standards they will be expected to uphold in their working lives. Because faculty members are working in the students' major field, they are an important link to internship and job opportunities. It is not uncommon for courses to meet off site at the offices and studios where our faculty members work.

For many of our programs like Animation, Computer Art, Film, Photography and Video and Interior Design, students begin taking courses in their major starting freshman year and do not have a traditional foundation year.

With an undergraduate population of 3,500 across 11 BFA departments, we are able to offer a wide selection of courses giving students in larger departments a lot of choices when creating their course plans. Programs, such as Design, Film, Illustration, Photography and Video, allow students to select a major concentration or track within the growing fields. A broad course selection also allows students to learn from a diverse range of faculty members, develop their own unique style and embrace different approaches to art making.

WHAT ARE THE TOP 3 PROGRAM FEATURES THAT MAKE YOUR PROGRAM STAND OUT?

1. Located in the heart of New York City, SVA features an urban-style campus with 15 buildings across the Gramercy-Flatiron and Chelsea neighborhoods. NYC has a creative workforce of 300,000 and is home to more than 14,000 creative business and nonprofits. It is from this community that we are able to choose faculty that are at the top of their profession and where students find opportunities for internships and jobs.
2. The resources and tools available to our students are state-of-the art and updated on a regular basis. Students learn on industry-standard equipment and software to ensure that they have all the skills and training that employers are looking for.
3. Our curriculum is updated regularly to make certain that we are teaching what is relevant in the field today and that our programs are meeting the needs of our students. We ensure this by requiring all faculty to be working professionals or practicing, gallery represented artists, who know first hand what it takes to be successful. We are adaptable and innovative, not afraid to experiment and try new things.

CAN STUDENTS TAKE COURSES IN OTHER SCHOOLS?

The curriculum for each program allows for students to take elective credits in other programs at the College. It is not uncommon for a Photography and Video major to take a Painting course or a Design student to take a digital photography course.

WHAT DOES YOUR PROGRAM LOOK FOR MOST IN THE CREATIVE PORTFOLIO DURING ADMISSIONS? WHAT DO YOU THINK MAKES AN A+ PORTFOLIO?

The best portfolios show strong technical ability along with originality and conceptual thought. We encourage applicants to incorporate their own personality and perspective

into their work and to not be afraid to push boundaries and take risks. Applicants should take great care when documenting their pieces and present to us a curated body of work that best reflects their interests and skills.

WHAT STEPS DO YOU TAKE TO EVALUATE A STUDENT'S CANDIDACY, APART FROM REVIEWING THEIR CREATIVE PORTFOLIO?

We require the following of our applicants:
1. Application and $50 fee
2. Statement of Intent
3. Transcripts from all high schools/colleges attended
4. SAT or ACT test scores
5. Portfolio
6. English Proficiency score (for international applicants)

All components of the application are considered when reviewing an applicant for admission. However, the student's academic record and the portfolio are the two parts of the application that carry the most weight.

The Bio Art Lab was founded in 2011 as part of the SVA's BFA Fine Arts new facility consisting of 54,000 square feet in the heart of Chelsea, NYC. The Lab offers courses like "Food: Projects in Bio Art," "Ecoventions: Your Art can change the world!" "Anatomy I & II" Artwork by Christian Eldridge

HOW ARE NEW TECHNOLOGIES AFFECTING STUDENTS' CURRICULUMS AND/OR WAYS OF LEARNING/COLLABORATING AT YOUR SCHOOL?

Today's learners benefit from having access to course work at any time, from any location, from many devices — and they deserve online access to their classmates for sharing ideas, and collaborating on challenging problems. SVA employs a campus-wide online learning system that includes tools specific to art education. We know that engaging students in discussion and project-based learning drives critical reflection, deeper understanding of key concepts, as well as the ability to apply the learning to various situations. To further support these learning goals we have developed multimodal courses that embrace various methods of communication between students, and create opportunities for project-based learning and collaboration beyond the traditional classroom. Such interactions can help students develop the confidence to share and defend their ideas, and collaborate effectively.

We are continually re-evaluating our curriculum to ensure that it is relevant and reflective of the industry today. We invest a lot of resources to ensure that our facilities, technology and equipment are as up to date as possible so that our students are learning on the industry standard. SVA also has a department — the Office of Learning Technologies (OLT) — dedicated to supporting our new online technologies both in the classroom and anywhere students and faculty might be.

HOW DOES YOUR PROGRAM HELP GRADUATING STUDENTS WITH INTERNSHIPS OR JOBS? CAN STUDENTS EXPECT JOB PLACEMENT MORE AT YOUR PROGRAM THAN IN OTHERS? IF SO, HOW OR WHY? WHAT KINDS OF JOB OPPORTUNITIES HAVE YOU SEEN STUDENTS TAKE ONCE THEY COMPLETED THEIR DEGREES?

Career Development supports students and alumni in building their professional networks while providing them with the information and resources they need to prosper as creative professionals. In addition to offering educational workshops and career counseling, the office hosts career fairs and industry events that directly connect students with industry. Recruiters from top creative companies visit campus to meet with students, review portfolios and promote their employment opportunities through the College's online job board. Our Internship for Credit Program provides opportunities for students to work with creative professionals at top New York City-based agencies, as well

as in their home cities over the summer. Rather than placing students, Career Development educates and helps students navigate their job search and make the transition from college to the world of work. Upon graduation, our alumni go on to become art directors, film makers, animators, photographers, writers, studio artists, illustrators, comic book artists/authors, and graphic designers.

ARE THERE ANY EXCITING DEVELOPMENTS FOR YOUR PROGRAMS THAT STUDENTS SHOULD KNOW ABOUT?

This year, we changed our BFA Photography program's name to BFA Photography and Video, recognizing that video has become an important aspect of the curriculum as technology has allowed for DSLR cameras to capture video and sound. Students in this program mostly focus on experimental or short-form video, as opposed to narrative filmmaking.

We will open a new residence hall in August 2016 at 407 First Avenue. The 146,827-square-foot building will house 500 students and administrative offices, while also featuring indoor and outdoor exhibition and screening spaces. For more information: blog.sva.edu/2015/04/sva-breaks ground-fornew-residence-hall

WHAT IS THE MOST DISTINGUISHED FEATURE AT YOUR SCHOOL?

1. SVA was the first accredited college to offer the MFA in Computer Art.
[Approved 1985, opened in Fall 1986.]
2. Built in 2011, the Nature and Technology Lab (also known as the Bio Art Lab) is the first lab of its kind built in an art school in the United States.
(bioart.sva.edu)
3. SVA is also home to the Milton Glaser Design Study Center and Archives.

WHAT IS THE BEST ADVICE YOU HAVE FOR STUDENTS ENTERING THE ART, DESIGN AND ARCHITECTURE FIELDS? WHAT ROLE DOES THE ARTIST PLAY TODAY?

In 2016 the artist's role in culture and commerce is, increasingly, any role the artist can imagine. An art school education teaches students to be critical thinkers, collaborators and creative problem solvers. These attributes are in high demand across the creative economy today and are a solid grounding for positions that have not even been created yet.
Success in today's art world is often dependent on your network and connections. The friends you meet in school, the faculty members and mentors you learn from and the other

78

Silas H. Rhodes and illustrator (Tarzan) Burne Hogarth co-found the Cartoonists and Illustrators School, with New York City-based professionals working in the arts as faculty, a practice that continues to this day.

people that make up your community are important relationships that will help you throughout your career. Taking the time to cultivate meaningful and substantive relationships is important and starts the first day of school.

by Yoi Tanaka Gayler, Director of Admissions at SVA

APPLICATION MATERIALS
SVA online app

PORTFOLIO REQUIREMENTS
Slideroom 15-20 pieces

WRITING SAMPLE
Statement of Intent

RECOMMENDATION LETTERS
1-2 Recommended

INTERVIEW
Not required

APPLICATION DEADLINES
Early Action: Dec 1
Regular Application: Feb 1

FOR INTERNATIONAL STUDENTS
Regular Decision: May 1
*It is recommended applicants submit all materials 4 months prior to start

TOEFL: 550 (paper) or 80 (iBT)
IELTS: 6.5
PTE: 53

DID YOU KNOW?
*To support the growing ranks of students and alumni from South Korea and China, **the College opened offices in 2014, in Seoul and Shanghai**, where members of the SVA community can meet to network, celebrate each other's work and attend lectures and workshops.*

Visual & Critical Studies is designed for students who want a broad exposure to the studio arts while they simultaneously investigate the historical, cultural and theoretical movements that give those arts shape, dimension and power.

ALUMNI
Michael Bierut, Designer
Jim Dine, Artist
Mike Gasaway, Animator
Michael Graves, Architect
Sean Gresens, Art director
Stan Herman, Designer
Cathy Davenport Lee, Creative director
Joseph Marioni, Painter
David Opdyke, Artist
Michael Reynolds, Architect
Kevin Roche, Interior designer
Joe Stitzlein, Creative director
Shane Wolf, Artist
Luke Woods, Product designer

DEGREES
BFA:
1. Advertising
2. Animation
3. Cartooning
4. Computer Art, Computer Animation and Visual Effects
5. Design
6. Film
7. Fine Arts
8. Illustration
9. Interior Design
10. Photography and Video
11. Visual & Critical Studies

RANKING
#2 Best Schools for Designer, LinkedIn, 2014-5
#2 Top Design Schools Today, Graphic Design USA, 2015
#10 Graphic Design Schools and Colleges on the East Coast, Animation Career Review, 2015
School of the Year Art Directors Club, 2011-5

OFFICE OF UNDERGRADUATE ADMISSIONS
School of Visual Arts
209 East 23 Street
New York, NY 10010-3994
+1 (212)-592-2000

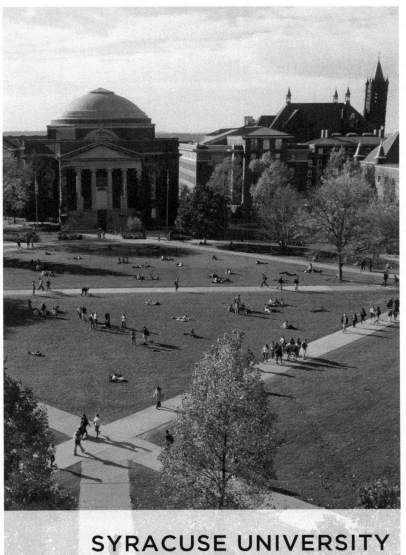

SYRACUSE UNIVERSITY
Syracuse, New York
www.syr.edu

79

SYRACUSE UNIVERSITY

COLLEGE OF VISUAL AND PERFORMING ARTS

From its founding in 1870, Syracuse University has a proud tradition of providing an environment in which students from diverse backgrounds come together to create, grow, and break boundaries.

The College of Visual and Performing Arts at Syracuse University is committed to the education of cultural leaders who will engage and inspire audiences through performance, visual art, design, scholarship, and commentary. We provide the tools for self-discovery and risk-taking in an environment that thrives on critical thought and action.[29]

FACT!
Student Demographics
The total student population at Syracuse University represents all 50 U.S. states and 123 countries.

WHAT MAKES YOUR SCHOOL'S ART & DESIGN PROGRAMS DIFFERENT & UNIQUE FROM OTHER ART & DESIGN SCHOOL PROGRAMS?

WHAT ARE THE TOP 3 FEATURES?

Syracuse University's College of Visual and Performing Arts (SU:VPA) is unique because it is structured like a stand-alone art, design, or media arts school within a major research institution. This allows our students to explore both academically and artistically within a diverse learning environment.

Specifically design and large studio spaces; ability to engage with the Syracuse community and put scholarship into action; cross-disciplinary possibilities both within visual art as well as across Syracuse University.

CAN STUDENTS TAKE COURSES IN OTHER SCHOOLS OR MAJORS?

Yes, students can take courses at any of the other undergraduate schools and college here at Syracuse

University. Students also have enough credits to minor in one of more than 100 minors or possibly double major depending on the desired combination.

WHAT STEPS DO YOU TAKE TO EVALUATE A STUDENT'S CANDIDACY, APART FROM REVIEWING THEIR CREATIVE PORTFOLIO?

We require the common application, a Syracuse University supplement, and a portfolio. The strongest candidates are both artistically and academically excellent.

FACT!
Degrees Conferred
Bachelors: 3,330
Masters: 2,077
Doctors: 385

WHAT DOES YOUR PROGRAM LOOK FOR MOST IN THE CREATIVE PORTFOLIO DURING ADMISSIONS? WHAT DO YOU THINK MAKES AN A+ PORTFOLIO?

The strongest portfolios have both technical and conceptual depth. Students who are capable of visually articulating their ideas in a sophisticated way would be considered "A+" portfolios.

HOW ARE NEW TECHNOLOGIES AFFECTING STUDENTS' CURRICULUMS AND/OR WAYS OF LEARNING/COLLABORATING AT YOUR SCHOOL?

New technologies are consistently incorporated into studios and coursework at SU:VPA. The technology itself isn't what creates new ways of learning and collaborating;

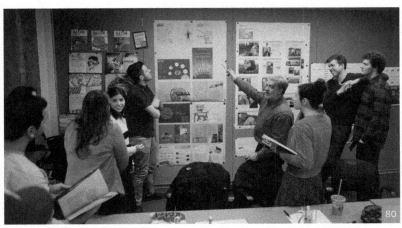

In 1874, Syracuse offers the nation's first bachelor of fine arts (B.F.A.) degree.

rather, it acts as a tool for the exploration of ideas.

HOW DOES YOUR PROGRAM HELP GRADUATING STUDENTS WITH INTERNSHIPS OR JOBS? CAN STUDENTS EXPECT JOB PLACEMENT MORE AT YOUR PROGRAM THAN IN OTHERS? IF SO, HOW OR WHY? WHAT KINDS OF JOB OPPORTUNITIES HAVE YOU SEEN STUDENTS TAKE ONCE THEY COMPLETED THEIR DEGREES?

Here at Syracuse University we have many tools to help students with internships and jobs. We have an Office of Career Services that helps with placement for both careers and internship opportunities. We find that students who take full advantage of the university environment are uniquely positioned for career placement.

The range of opportunities is wider because of the diversity in their education.

WHAT IS THE MOST DISTINGUISHED FEATURE AT YOUR SCHOOL?
The development of newly imagined first-year experiences in visual arts that are specific to the School of Art, School of Design, and Department of Transmedia and allow students to begin work within field of study immediately.

ARE THERE ANY EXCITING DEVELOPMENTS FOR YOUR PROGRAMS THAT STUDENTS SHOULD KNOW ABOUT?

Here at Syracuse University we have many tools to help students with internships and jobs. We have an Office of

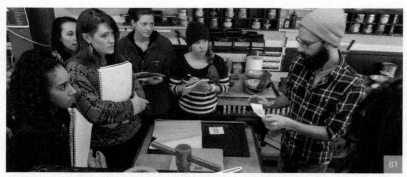

Students majoring in industrial design, communications design, and interior design are invited to apply to participate in the SU London design program. This program offers participants the opportunity to take courses in collaborative design and contemporary design history, complemented by studio and academic electives, in a world capital renowned for its cutting-edge design.

Career Services that helps with placement for both careers and internship opportunities. We find that students who take full advantage of the university environment are uniquely positioned for career placement. The range of opportunities is wider because of the diversity in their education.

WHAT IS THE BEST ADVICE YOU HAVE FOR STUDENTS ENTERING THE ART, DESIGN & ARCHITECTURE FIELD?

Explore! Students who spend their time building their visual vocabulary to express their own ideas are well positioned for a variety of different career paths. Additionally, students who take courses in professional practices, marketing, and entrepreneurship seem to have a leg up when it comes to independent, studio-focused careers.

by Shawn Rommevaux
Senior Recruiting Specialist,
Social Media Strategist

DID YOU KNOW?
*A total of **$67.1 million** was awarded for research, teaching, and other sponsored programs in fiscal year 2014.* *The federal government is the major sponsor ($45.9).* *Awards from non-federal sponsors totaled $21.2 million, the majority of which are from corporate entities ($7.6 million). New York State is the third largest sponsor ($4.8 million).*

APPLICATION MATERIALS
Common Application

PORTFOLIO REQUIREMENTS
Slideroom 12-20 pieces

TRANSCRIPTS
Required

WRITING SAMPLE
Personal or Artist Statement
(300 words max)

INTERVIEW
Portfolio Review recommended

APPLICATIONS DEADLINES
Early Decision: Nov 15
Early Decision 2: Jan 1
Regular Decision: Jan 1

FOR INTERNATIONAL STUDENTS
Regular: Jan 1
Early : Nov 15

TOEFL: 80
IELTS: 6.5

TIPS
It is strongly suggested that a minimum of six drawings from observation be included if you are applying to illustration, painting, or printmaking. Observational drawings can include still lifes, figure drawings, landscapes, etc.

ALUMNI
Sol Lewitt, Artist
Alan Dye, UI Designer
Gianfranco Zaccai, President and Chief design officer
Warren Kimble, Artist
Chris Renaud, Illustrator and Filmmaker
Thom Filicia, Interior designer
Bryan Buckley, Film director and Screenwriter
LaToya Ruby Frazier, Artist
Bill Viola, Video artist
Jeremy Bailey, Media artist
James Bishop, Painter
Gordon Chandler, Sculptor
Birgitta Farmer, Painter
Sharon Gold, Artist
Clement Greenberg, Art Critic
Henry Grethel, Fashion Designer
Betsey Johnson, Fashion Designer

DEGREES

SCHOOL OF ART

BFA:
1. Art Education
2. Ceramics
3. History of Art
4. Illustration
5. Jewelry & Metalsmithing
6. Painting
7. Printmaking
8. Sculpture

SCHOOL OF DESIGN

BFA:
1. Communications Design
2. Environmental & Interior Design
3. Fashion Design
BID: Industrial & Interaction Design

DEPARTMENT OF TRANSMEDIA

BFA:
1. Art Photography
2. Art Video
3. Computer Art & Animation
4. Film

RANKING

DESIGN
#3 Industrial Design Intelligence 2014
#8 Interior Design Intelligence 2014

FINE ART
#14 Multimedia / Visual Communications U.S.News 2015
#16 Ceramics U.S.News 2015

ADMISSIONS OFFICE
Office of Admissions
900 South Crouse Avenue, 100 Crouse-Hinds Hall
Syracuse, NY 13244-2130
+1 (315)-443-3611

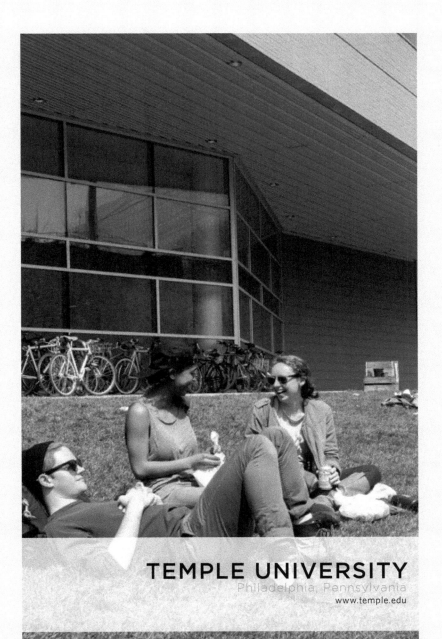

TEMPLE UNIVERSITY
Philadelphia, Pennsylvania
www.temple.edu

82

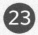

TEMPLE UNIVERSITY
TYLER SCHOOL OF ART

Since 1935, Tyler School of Art, Temple University has offered students the combination of a world renowned faculty of dedicated teachers, accomplished studio artists, and highly respected scholars with the resources of a major university.
From advanced technology to the most traditional methods, Tyler is dedicated to providing education in the arts to aspiring and talented students who share our belief that the arts are fundamental to life in the 21st century. [30]

FACT!
The Temple Option is an admissions path for talented students whose potential for academic success is not accurately captured by standardized test scores.
Students who choose the Temple Option will submit self-reflective, short-answers to a few specially designed, open-ended questions instead of their SAT or ACT scores.

WHAT MAKES YOUR SCHOOL'S ART PROGRAMS DIFFERENT &

UNIQUE FROM OTHER ART & DESIGN SCHOOL PROGRAMS?

Located in one of the most culturally vibrant, and historic cities in the country, the Tyler School of Art at Temple University in Philadelphia provides students with an education in the arts that both challenges and encourages creative exploration and prepares them to be active participants and leaders in the arts.

With the support of our world renown faculty, Tyler School of Art students are exposed to both traditional techniques and advanced technologies keeping them competitive with their disciplines.

The Tyler School of Art offers a wide range of majors from aBA in Visual Studies, BSEd/MEd in Art Education, Certificate in Community Arts Practices, BA/MA/PHd in Art History, BS/MArch in Architecture, BS in Architecture Preservation, BS in Facilities Management, BFA/MFA

in Ceramics, BFA/MFA in Fibers Materials Studies, BFA/MFA in Glass, BFA/MFA in Graphic and Interactive Design, BFA/MFA in Painting and Drawing, BFA/MFA in Sculpture, BFA/MFA in Metals/Jewelry/CADCAM, and a BFA / MFA in Photography.

Our students are able to creatively explore multi disciplinary studios within Tyler as well as academic disciplines within Temple University thus providing them with incredibly versatile opportunities and connections on a global scale.

WHAT ARE THE TOP 3 PROGRAM FEATURES THAT MAKE YOUR PROGRAM STAND OUT?

With state of the art technology in a newly constructed 300,000 sq ft facility (in 2009), our students have the capacity to maximize the scale of their work –from our 2-ton gantry cranes in our sculpture studio to large format printers to our industrial size gas and electric kilns- just to name a few.

Our digital fabrication studios allow our students easy access to 3d printers, 3d scanners, laser cutting, embroidery, and vinyl cutting technology.

The Tyler School of Art educates students to have an impact of art on a local and global scale through community engagement as well as international exploration and research.

CAN STUDENTS TAKE COURSES IN OTHER SCHOOLS?

Temple University offers a total of 421 academic programs (as of July 2014) and is regarded to be a national leader in education, research and healthcare. With that said, our students have the opportunity to take courses in other majors offered at Temple and can pursue double majors, minors or certificates. All Tyler and Temple students' curricula include a general education component that helps students make connections from academic knowledge to experience. The coursework develops strong communication skills, critical thinking skills, the ability to apply abstract theories and ideas to concrete experiences and practices, and problem-solving skills.

Tyler students can also choose to study abroad at either one of our Temple Rome or Temple Japan campuses where both studio and liberal arts courses are offered or may choose from one of the many other approved education abroad partnership programs.

WHAT STEPS DO YOU TAKE TO EVALUATE A STUDENT'S CANDIDACY, APART

FROM REVIEWING THEIR CREATIVE PORTFOLIO?

Applicants to the Tyler School of Art are evaluated both academically and artistically to determine whether they are admissible.

Applicants must meet the academic standards of Temple University while also passing the Tyler School of Art's portfolio review in order to be admitted. Applicants can arrange portfolio reviews in person, on-line or off site portfolio events.

WHAT DOES YOUR PROGRAM LOOK FOR MOST IN THE CREATIVE PORTFOLIO DURING ADMISSIONS? WHAT DO YOU THINK MAKES AN A+ PORTFOLIO?

This really depends on which program our applicant has applied for.

Architecture and Art History applicants are not required to submit a portfolio (although they certainly can as supplemental material). However, these applicants are first and foremost assessed academically.

BSEd Art Education and BA Visual Studies applicants are required to submit a portfolio of 5-10 works of art that are creatively diverse, but should also include at least 2 observational drawings. These applicants are also required to complete a drawing exercise and

writing exercise in addition to their portfolio.

Our BFA applicants have a more comprehensive portfolio which requires them to submit anywhere from 15-20 pieces portfolio and must include at least 5 direct observational drawings. The remaining pieces in the portfolio can be in one's preferred medium. A self-portrait from observation is also required, as well as a statement of intent. These are the three items our admissions staff evaluated per applicant.

HOW ARE NEW TECHNOLOGIES AFFECTING STUDENTS' CURRICULUMS AND/OR WAYS OF LEARNING/COLLABORATING AT YOUR SCHOOL?

This is an incredibly exciting time for art students. They are being encouraged to break boundaries and explore the arts using new technologies. Some are finding ways to merge traditional techniques with breakthrough technology thus acknowledging the dichotomy rather than ignoring it. The Tyler School of Art believes it is equally important to hone traditional techniques while also position oneself to remain competitive with advanced ever-changing technology.

In fact, while in the stages of designing our new facility, it was imperative that Tyler's new space housed state of the art

83

The Art and Technology Group is launching a year-long program of events that investigate the role of technology in visual art production and research, including questions of aesthetics and innovation, communication and distribution, and participation and agency. The objective of this program is to assess the current role of technology within Tyler and in the arts at large. Photos by Sam Fritch, Tyler School of Art

technologies and tools without taking away any historic methods- both are central to our curricula.

HOW DOES YOUR PROGRAM HELP GRADUATING STUDENTS WITH INTERNSHIPS OR JOBS? CAN STUDENTS EXPECT JOB PLACEMENT MORE AT YOUR PROGRAM THAN IN OTHERS? IF SO, HOW OR WHY? WHAT KINDS OF JOB OPPORTUNITIES HAVE YOU SEEN STUDENTS TAKE ONCE THEY COMPLETED THEIR DEGREES?

As soon as you become a Tyler student you become an important member to a much larger community — a community of creators, makers, thinkers, doers, leaders, educators, and inventors. In addition to their capstone courses in the majors, our students are provided with workshops, lectures, networking events, weekly newsletter updates as well as resources from the Temple Career Center to prepare them for careers and professional practice.

Our students have been featured in Forbes magazines 30 under 30's Art and Style category for their successful businesses.

Whether it is pursuing a higher degree for an MFA, MArch or PhD, becoming an entrepreneur

and starting your own business; teaching, writing, or research;or joining an established team as a creative director or designer, our Tyler students enter the work force confident in their skills and ability to succeed.

ARE THERE ANY EXCITING DEVELOPMENTS FOR YOUR PROGRAMS THAT STUDENTS SHOULD KNOW ABOUT?

The Tyler School of Art is committed to working with our students and developing new programs that can provide different and new pathways into the arts. We are excited to announce the launch of our new low residency MFA in Illustration degree. We also offer a undergraduate and graduate certificate in Community Art Practices. Lastly, we have created an intensive design MArch track that helps professionals with degree in all different areas obtain a masters in architecture. All of these programs were developed as a response to student desire.

WHAT IS THE MOST DISTINGUISHED FEATURE AT YOUR SCHOOL?

Temple Contemporary, previous known as Temple Gallery, provides our students and community with progressive programming and whose mission states to creatively re-imagine the social function of art through

questions of local relevance and international significance. Temple Contemporary utilizes our urban campus by engaging the surrounding community through exhibitions, and public programs. Most recent is the reForm exhibit, which commissioned artist and faculty Pepon Osorio. This installation, which has garnered attention by the New York Times,and Art in America addresses the issue of school closures in Philadelphia through video interviews and items from Fairhill Elementary School were gathered and installed in one of Tyler's classrooms.

We are very fortunate to have a space, which encourages active participation in the arts and community on both a local and global scale.

WHAT IS THE BEST ADVICE YOU HAVE FOR STUDENTS ENTERING THE ART, DESIGN & ARCHITECTURE FIELD? WHAT ROLE DOES THE ARTIST PLAY TODAY?

The most paramount advice for anyone considering or entering the arts is the following — Every thing you interact with in life has gone through a creative process. The creative arts, design and architecture are monumental for so many industries and with an increasingly more digital, and graphic visual culture, creative

minds and artist will be in high demand. Continue to explore, build your artistic vernacular and never stop creating.

by Grace Ahn Klensin
Senior Admissions Counselor

APPLICATION MATERIALS
Temple online App OR Common App

PORTFOLIO REQUIREMENTS
Portfolio Review or Slideroom 15-20 pieces

*Self Portrait: All freshman and transfer applicants must execute one drawing specifically for Tyler as an essential part of the application. The Self-Portrait should be drawn in pencil, charcoal or conte crayon on 8 1/2" x 11" paper from a mirror reflection. The Self-Portrait should be an original drawing and should not be matted, framed, drawn from a photograph or created digitally. This drawing is not considered part of your portfolio, but it is required as part of your application for Tyler. This drawing will not be returned.

TRANSCRIPTS
Required

WRITING SAMPLE
Statement of Intent

INTERVIEW
Portfolio Review highly recommended

APPLICATION DEADLINES
Early Action: Nov 1
Regular Decision(Rolling): Mar 1

RECOMMENDATION LETTERS
1 Teacher or Counselor Recommended

FOR INTERNATIONAL STUDENTS
Regular Decision Jan 1
TOEFL: Average 112

TIPS
You must include at least 5 strong examples of drawing from direct observation regardless of the major you wish to pursue. These drawings must be larger than 9" x 14", and show a wide range of values and strong composition. These drawings are separate from sketchbook drawings.

ALUMNUS
Jessica Hische, Illustrator
Paula Scher, Designer
Trenton Doyle Hancock, Artist
E.B. Lewis, Illustrator
Richard Sylbert, Academy Award winning Production designer

237

84

Temple University, Japan Campus (TUJ) is the oldest and largest foreign university in Japan. Founded in 1982, TUJ is the first institution to be officially recognized as a Foreign University, Japan Campus by Japan's Ministry of Education. It remains the only university in Japan to offer comprehensive programs in English for degree and non-degree students, and where students can earn American bachelor's, master's and doctoral degrees without leaving Japan. Photos by Sam Fritch, Tyler School of Art

DEGREES

BA:
1. Art (active in Japan, Minor in both campuses)
2. Art History
3. Visual Studies
4. Advertising (Art Direction)

BFA:
1. Art Education Concentration
2. Ceramics
3. Fibers & Materials Studies
4. Glass
5. Graphic & Interactive Design
6. Metals/ Jewelry/ Cad-Cam
7. Painting & Drawing
8. Photography
9. Printmaking
10. Sculpture

B.S:
1. Architecture
2. Architectural Preservation
3. Facilities Management
4. Landscape Architecture
5. Horitculture

RANKING
#13 Overall U.S.News & World Report's 2015
#9 in Sculpture U.S.News & World Report's 2015
#10 in Painting/Drawing U.S.News & World Report's 2015
#10 in Printmaking U.S.News & World Report's 2015
#13 in Ceramics U.S.News & World Report's 2015

ADMISSIONS OFFICE
1801 North Broad St, Conwell Hall 103
Philadelphia, PA 19122-6096
(215) 204-7000

VIRGINIA COMMONWEALTH
UNIVERSITY
Richmond, Virginia
www.vcu.edu

VIRGINIA COMMONWEALTH UNIVERSITY
SCHOOL OF ARTS

Virginia Commonwealth University, located in Richmond, Virginia, has evolved since its founding more than 175 years ago. VCU's School of the Arts comprises 16 programs and more than 3,000 students. With the inclusion of the campus in Qatar, come an additional five programs and another 214 students. As part of a large, urban public research university, VCUarts students have the opportunity to pursue cross-disciplinary collaborations and to study alongside scholars in different fields. VCUarts has the lowest annual tuition among the top 10 schools of arts and design in the country. [31]

FACT!
Faculty
2,229 full-time faculty members
1,082 part-time faculty members
17:1 student-faculty ratio

WHAT MAKES YOUR SCHOOL'S ART & DESIGN PROGRAMS DIFFERENT & UNIQUE FROM OTHER ART & DESIGN SCHOOL PROGRAMS? WHAT ARE THE TOP 3 FEATURES?

1. VCU School of the Arts is a top ranked art school within a major research university.
2. We embrace diversity - not only within our student body, but diversity of thought in our classroom and the diversity of programs we offer (16 undergraduate departments and programs, plus our graduate programs)
3. We are an urban campus located in Richmond, VA, a thriving, supportive arts community

CAN STUDENTS TAKE COURSES IN OTHER SCHOOLS OR MAJORS?

Yes, many students double major or minor in combinations of arts programs, or arts and non-arts programs. Some of the most popular double majors or minors outside of the arts include business, psychology, and foreign languages. Some arts students have also pursued engineering or pre-med tracks, as well.

WHAT STEPS DO YOU TAKE TO EVALUATE A STUDENT'S CANDIDACY APART FROM REVIEWING THEIR CREATIVE PORTFOLIO?

The entire aspect of a student's application is considered — including GPA, strength of academic curriculum, test scores, personal statement, essay, letters of recommendation, extracurricular activities, and portfolio or audition (as applicable to program of interest).

WHAT DOES YOUR PROGRAM LOOK FOR MOST IN THE CREATIVE PORTFOLIO DURING ADMISSIONS? WHAT DO YOU THINK MAKES AN A+ PORTFOLIO?

We are looking for a portfolio that broadly communicates an individual's intellectual curiosity, experimentation, and skill.

We require 12 to 16 works of art created within the past two years that show the individual's talent and potential in visual art and design. Applying students are asked to present their strongest work; we prefer to see a diverse range of 2D and 3D media. Drawing from observation is recommended, as are exercises or sketches that demonstrate the individual's creative process.

We look for a portfolio that embodies the individual and clearly expresses his/her point of view, ideas, and experiences.

We suggest that students who wish to apply to VCUarts come for a portfolio review before applying. (One can do this by attending a National Portfolio Day, or contacting the VCUarts admissions office to schedule a review.)

In Spring 2016, VCUarts launches a certificate program in Advanced Media Production Technology (AMPT).[24]The program is designed to connect graduates with employment opportunities in the expansive field of digital media production

HOW ARE NEW TECHNOLOGIES AFFECTING STUDENTS' CURRICULUMS AND/OR WAYS OF LEARNING/COLLABORATING AT YOUR SCHOOL?

We have a curriculum structure that's flexible enough to embrace innovation and allow a dialogue to occur between fundamental arts and design principles, and new technology as a tool to challenge and expand creativity. In many cases, technology is finding its way into the classroom - redefining the way art can be explored, pushing boundaries and creating a natural space for interdisciplinary collaborations. All VCUarts students have access to a sound stage featuring cyclorama and motion capture, and 3D printers, which allow for rapid prototyping. Students develop global connections as synchronous classes are taught with our campus in Doha, Qatar, and with other universities around the world.

FACT!
Tuition: 2014-2015
Virginia resident: $12,398
Non-resident: $30,459
Average financial aid awarded to full-time undergraduates: $10,527

HOW DOES YOUR PROGRAM HELP GRADUATING STUDENTS WITH INTERNSHIPS OR JOBS? CAN STUDENTS EXPECT JOB PLACEMENT MORE AT YOUR PROGRAM THAN IN OTHERS?

IF SO, HOW OR WHY? WHAT KINDS OF JOB OPPORTUNITIES HAVE YOU SEEN STUDENTS TAKE ONCE THEY COMPLETED THEIR DEGREES?

All VCUarts students have access to the VCU Career Center, which offers resources for finding internships and jobs, resume building and interviewing, preparing for grad school, as well as connecting students with an on-staff Arts and Design Career and Industry Adviser.

Students may participate in "Catapult," VCUarts' event series designed to engage students beyond the classroom and help them to prepare for the professional world. Speakers and workshops connect students with industry professionals and provide opportunities for feedback, as well as finesse their 'elevator pitch,' cover letter and resume. To date, the series has held two International Opportunities fairs; a 'Proposal Pitch' workshop which helped students translate a great ideas into a great funding proposal; and a Reverse Career Fair where students displayed their work while employers navigated the room asking and answering questions, giving feedback and sharing information for job and internship opportunities.

VCUarts Center for the Creative Economy offers four courses that provide the groundwork for the practice of entrepreneurship,

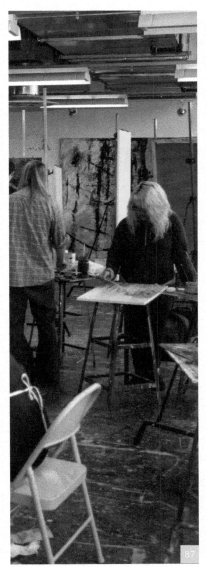

emphasizing creative and design methodologies. Undergraduate majors may enroll in any of these courses independently, or apply for admission into the undergraduate certificate program in Venture Creation for a deeper grounding in entrepreneurship and business development.

The VCUarts CoLaboratory (CoLab) is a for-credit, internship program that provides students with opportunities in hands-on, innovative problem solving. Students develop career skills and create value in existing organizations and professions through the completion of research-intensive, industry-focused projects. Emphasis is on the collaborative development and commercial application of products that focus on emerging technologies.

Middle of Broad (mOb) is an interdisciplinary design studio that combines students from fashion, graphic and interior design departments to work on community-based projects in downtown Richmond.

Part of the Center for the Creative Economy at VCUarts, CoLaboratory (CoLab) is a post-disciplinary, variable-credit, internship program that provides students with opportunities in hands-on, innovative problem solving.
A 2015 CoLab project was Navigate VCU[23] — a web-based app developed for the campus so that students, faculty, and staff could navigate the UCI Road World Championships.

ARE THERE ANY EXCITING DEVELOPMENTS FOR YOUR PROGRAMS THAT STUDENTS SHOULD KNOW ABOUT?

Currently under construction, the 41,000-square-foot VCU Institute for Contemporary Art (ICA) will be an incubator for

interdisciplinary experimentation for the entire university while simultaneously providing opportunities for collaboration both locally and internationally. This non-collecting museum will showcase a fresh slate of changing innovative exhibitions, performances, films and special programs. The building, which was designed by one of the world's most important living architects, Steven Holl, will become an iconic gateway for the city of Richmond.

WHAT IS THE MOST DISTINGUISHED FEATURE AT YOUR SCHOOL?

1. VCUarts offers students a world-class accredited arts education that provides graduates with credibility as an artist and a professional, and with a degree that's respected in the world of galleries, design and advertising firms, graduate schools, artistic directors and employers — with the lowest undergraduate tuition among our peers in the top-10 ranked schools of art and design.
2. The School of the Arts is just one of the schools and colleges that comprise Virginia Commonwealth University, a top-tier research institution. What this means for our students is a rich landscape of opportunities — and funding — to bridge gaps between disciplines with creative ideas. VCUarts students frequently collaborate with those studying medicine, engineering, business, liberal arts, mass communications, and beyond — breaking down barriers and pushing the periphery of what is possible.

WHAT IS THE BEST ADVICE YOU HAVE FOR STUDENTS ENTERING THE ART, DESIGN & ARCHITECTURE FIELD?

Pursue what you love and the

In 2014, sophomore in the Graphic Design department won a city-wide competition for his design of bike racks that were installed in the city for the UCI Road World Championships that took place in Richmond in 2015.

money will follow. Choose a major based on where your passion lies and what your skills lend themselves best to. Don't choose a major just because you think that's where the jobs are. If you are not truly passionate about that field, you won't do well, and consequently, it will be harder for you to land a job in that field. A degree in the arts is applicable to such a wide range of careers — you may likely end up in a job that you don't even know exists yet! And, as technology and the world of art and design evolve, there will be new careers available when you graduate that didn't even exist when you started school.

by Erin Neff, Associate Director of Admissions, Suzanne A Silitch, Director of Communications and Teresa Ilnicki, Associate Director of Communications

DID YOU KNOW?
VCU became **the first university from the U.S. to operate a campus in Qatar,** which now boasts programs from five other American universities, including Georgetown and Northwestern.

APPLICATION MATERIALS
Common Application

PORTFOLIO REQUIREMENTS
12–16 pieces

TRANSCRIPTS
Required

REFERENCE LETTERS
One reference

APPLICATION DEADLINES
Regular Decision: Jan 15
Portfolio Submission: Feb 2

FOR INTERNATIONAL STUDENTS
Regular: Jan 15 –rolling admissions
*Jan 5 for scholarship consideration

TOEFL: 550 (paper) 80 (iBT)
IELTS: 6.0
PTE: N/A

TIPS
VCUarts applicants are required to have one reference submitted by their recommender of choice. Choose the person best qualified to assess your ability to be successful at VCUarts. applicants will be prompted to enter your recommender's email address on the Common Application.

If applicants feel it is necessary, they may submit up to two additional letters of recommendation. Additional recommenders should mail their letters to:
VCU Office of Admissions
PO Box 842526
Richmond, VA 23284-2526

89

Due to open in 2017, the new Virginia Commonwealth University Institute for Contemporary Art (ICA, VCUarts) has been designed by architect, Steven Holl. It will be positioned as the new gateway to the city of Richmond. The ICA will be a non-collecting institution.

DEGREES

BA:
1. Art History
2. Cinema
3. Fashion Design and Merchandising

BFA:
1. Art Education
2. Communication Arts
3. Craft/Material Studies
4. Fashion Design and Merchandising
5. Graphic Design
6. Interior Design
7. Kinetic Imaging
8. Painting & Printmaking
9. Photography & Film
10. Sculpture & Extended Media

RANKING
#1 Public University arts & design U.S.News and World Report 2012
#1 Scuplture U.S.News and World Report
#4 Fine Arts U.S.News and World Report
#5 Graphic Design U.S.News and World Report
#5 Glass U.S.News and World Report
#7 Painting U.S.News and World Report
#9 Ceramics U.S.News and World Report

ADMISSIONS OFFICE
Admissions Office, Virginia Commonwealth University
821 West Franklin Street
Richmond, Virginia 23284-2526
+1 (804) 828-1222 or (800) 841-3638

ALUMNI
Teresita Fernández, Sculpture and Extended media artist
Tara Donovan, Sculpture and Extended media artist
Donwan Harrell, Founder and Creative director

YALE UNIVERSITY
New Haven, Connecticut
www.yale.edu

90

YALE UNIVERSITY
UNDERGRADUATE ART MAJOR

Yale University, located in New Haven, Connecticut, was founded in 1640 to preserve the tradition of European liberal education in the New World. When the School of Fine Arts opened to students in 1869, it was the first of its kind affiliated with a tertiary institution in America.

The program in art offers courses that, through work in a variety of media, provide an experience in the visual arts as part of a liberal education as well as preparation for graduate study and professional work.

FACT!
Fall 2014 Enrollment
50% Male,
50% Female,
25% International

CAN STUDENTS TAKE COURSES IN OTHER SCHOOLS WITHIN YALE?

Of course! They only take a limited number of credits for the art major, and must take many other classes within Yale College for their distributional requirements.

HOW DOES YOUR PROGRAM HELP GRADUATING STUDENTS WITH INTERNSHIPS OR JOBS LOCALLY AND INTERNATIONALLY? CAN STUDENTS EXPECT JOB PLACEMENT MORE AT YOUR ART PROGRAM THAN IN OTHERS? IF SO, HOW OR WHY?

We do one-on-one advising, upon request, and I run an annual Alumni in the Arts Life After Yale panel for the graduating Senior art majors, at which a variety of graduates of the program recount their different paths after graduating. There is also a Career Services office in Yale College that students may consult.

WHAT ARE THE TOP 3 FEATURES OF YOUR SCHOOL AND PROGRAMS THAT STAND OUT FOR UNDER GRADUATE

Yale students working on an art and lighting project.

STUDENTS IN THE SCHOOL OF ART?

Small classes with working artist faculty, state of the art labs and shared studios and access to daily extracurricular events, lectures, workshops, etc, both in the university and within the School of Art's graduate programs.

HOW ARE NEW TECHNOLOGIES AFFECTING STUDENTS' CURRICULUMS AND/OR WAYS OF LEARNING/COLLABORATING AT YOUR SCHOOL?

We annually add innovative new courses, including the mediums of animation, moving image, performance art and installation. We have a co-major with Computer Science for students interested in Computing and the Arts.

WHAT IS THE BEST ADVICE YOU HAVE FOR STUDENTS ENTERING THE ART & DESIGN FIELD?

Work hard, learn the rules so you can later break them, and take risks in your practice!

by Lisa Kereszi
Director of Undergraduate Studies in Art

2014-15
Acceptance Statistics
Number of Applicants: 30,932
Acceptance: 6.3%
2014-15 Test Scores
SAT VERBAL: 710-800

253

SAT MATH: 700-800
SAT WRITING: 710-790
ACT: 31-35

DID YOU KNOW?
Yale is **the first college art museum, and the first School of Fine Arts in the USA** to be associated with a large educational institution, which admitted women almost a full century before Yale College did.

APPLICATION MATERIALS
Common application

SUPPLEMENTARY
PORTFOLIO REQUIREMENTS
5-8 pieces (including at least 1 drawing)

WRITING SAMPLE
Common app Yale essay

TRANSCRIPTS
Required

REFERENCE LETTERS
1 counselor
2 teachers

INTERVIEW
Recommended

APPLICATION DEADLINES
Early Action: Nov 1
Regular Application: Jan 1

FOR INTERNATIONAL STUDENTS
Early Decision: Nov 1
Regular Decision: Jan 1
TOEFL: (paper) min 600
(iBT) min 100
IELTS: 7
PTE: 70

TIPS
To apply for more than one area of concentration, separate applications, fees, and supporting documentation must be submitted. The work submitted should be representative of the applicant's experience in that particular field.

Portfolio of work. Applicants who fail to upload a portfolio as outlined in this bulletin by the stated deadline will not be considered. The portfolio should represent images of your best work, indicate your current direction, and demonstrate your ability.

One image from the portfolio should be designated as a "representative work." This selection will be printed for the application file as the piece you feel most strongly represents ideas central to your current body of work.

USA • YALE UNIVERSITY

254

92

Yale's 353 Crown St. gallery is an eclectic mix of talent and burgeoning artists. Recently, there's been speculation that Yale's School of Art hones the potential for experienced consumers and collectors to meet with young artists. Friends and professionals in the industry that have connections with Yale faculty may also come to scout inspiring students, giving students a unique opportunity once they graduate.

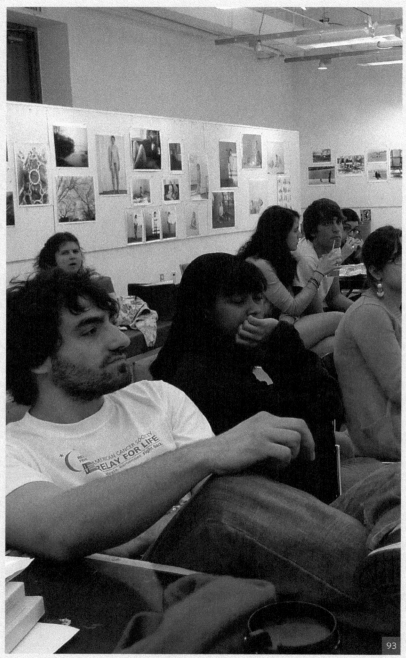

93

Marta Kuzma, vice chancellor and rector of the Royal Institute of Art in Stockholm, Sweden, will be the next dean of the Yale School of Art. Kuzma will be the first woman to lead the School of Art, which opened in 1869 as the nation's first art school connected with an institution of higher learning.

DEGREES
BA: Art

RANKING

SCHOOL OF ART
#1 U.S.News & World Report's 2012-2013

SCHOOL OF ARCHITECTURE
#3 U.S.News 2013

ADMISSIONS OFFICE

Yale University Office of Undergraduate Admissions
38 Hillhouse Avenue
New Haven, CT 06511
+1 (203)-432-9300

ALUMNI
Mark Rothko, Artist
Eva Hess, Artist
Chuck Close, Artist
Brice Marden, Artist
Richard Serra, Artist
Robert Mangold, Artist
Jonathan Borofsky, Artist
Lisa Yuskavage, Artist
Wangechi Mutu, Artist
Matthew Barney, Artist
Norman Foster, Architect
Eero Saarinen, Architect
Richard Rogers, Architect
Maya Lin, Architect
David Childs, Architect
Paul Rand, Graphic designer
Eddie Opara, Graphic designer

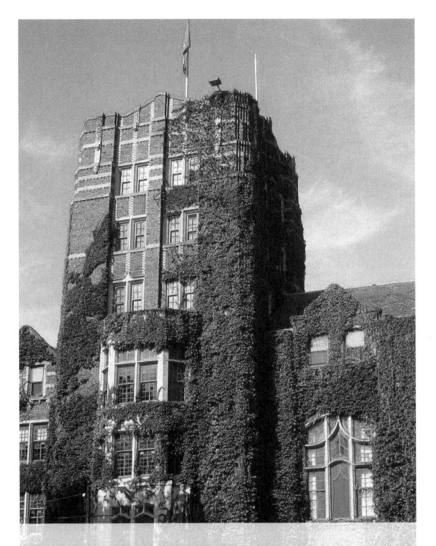

UNIVERSITY OF MICHIGAN
Ann Arbor, Michigan
www.umich.edu

94

UNIVERSITY OF MICHIGAN
INTEGRATED PRODUCT DEVELOPMENT

WHAT MAKES THIS PROGRAM STAND OUT, AND WHAT ARE THE 3 TOP FEATURES?

This is the only design course in the country (to our knowledge) that combines the design and manufacture of a fully functional customer-ready prototype, with an economic competition.

Students are formed into teams and each team has at least one designer, one business student and one engineer. The teams are given a common design challenge, and then each team must go through the entire exercise of market research, design, build, and sell. Since all teams are responding to the same challenge, they are in competition with each other.

The teams have to build what they design, using all authentic materials (these are not appearance models, they are fully functional products). The teams need to design and cost out (materials + processing costs) a production process for their product, so each product

has a known fixed and variable cost structure. The teams then compete with their products in two channels. The first is a web-based trade show where each team designs and posts a web site describing their product and retail price. People from around the world (typically about 1,000 people participate) look at the sites and choose how to spend a fixed amount (typically $200 or so) of virtual money. We keep track of the revenues and costs for each team. Then the teams compete in a physical trade show (they construct trade show booths) to which we invite the local community (typically about 300 attend). Attendees look at all of the products and, again, get to spend a fixed amount of virtual dollars. We combine the web and trade show results to rank the teams by profits generated, and grade them accordingly.

ARE THERE ANY WELL-KNOWN ALUMNI OR PRODUCTS TO HAVE COME OUT FROM THIS PROGRAM?

'Alcove' hanging shelf using existing dorm furniture as structural elements to support snap fil sleeve.

I should, but do not, keep track of students after they graduate. I know they go on to be problem-solvers in all manner of roles in industry, because I get emails frequently from graduates saying they are "reliving IPD". I'm sure we have success stories that I am unaware of, although I do stay in touch with one of our grads who was very senior in laptop design and production for Dell. Our grads do not necessarily go into design departments, but they do bring their creative, cross-disciplinary, grounded talents to any department they join. Describing our course and their experience in it is one favorite tactic they use with recruiters.

No products that are well known, but some that were very gratifying at a more local level (like employing ex-homeless people in a sustainable business in Detroit).

FACT!
Top 5 U.S. Public University — U.S. News & World Report

HOW ARE NEW TECHNOLOGIES AFFECTING THIS CURRICULUM AND/OR WAYS OF LEARNING/COLLABORATING IN THE PROGRAM?

With the emergence of MakerSpaces and accessible CNC machines and 3D printers, and easy DIY templates for products and web site production, the potential for entrepreneurs to serve local markets without prohibitive startup costs has never been greater. We try to be attentive to trends, for example recently the design challenge was to serve student needs with dorm furniture fabricated using nothing more than locally available commodity inputs (from big box retail home improvement stores, for example) and the

production capabilities of a local MakerSpace.

ARE THERE ANY EXCITING DEVELOPMENTS FOR YOUR PROGRAMS THAT STUDENTS SHOULD KNOW ABOUT? DO YOU HAVE PLANS TO EXPAND THE PROGRAM TO MAJOR OR MINOR?

The IPD course has always evolved, subject to its core commitment to making what one designs, and being judged by an external market rather than an internal panel of experts. Subject to this, we are always trying new things. This year, for example, we may try company sponsorship of a design challenge to give students better access to more detailed market knowledge.

HOW DOES YOUR PROGRAM HELP GRADUATING STUDENTS WITH INTERNSHIPS OR JOBS? WHAT KINDS OF JOB OPPORTUNITIES HAVE YOU SEEN STUDENTS TAKE ONCE THEY COMPLETED THEIR DEGREES HAVING TAKEN THE COURSE?

Again, I do not keep track of alums the way I should. However, the VP of new product development at Steelcase once told me IPD saved him 6 months of training. Our grads already knew best practices and the constraints of the business context.

WHAT HAS BEEN THE ROLE OF ART & DESIGN IN YOUR PROGRAM?

Absolutely critical! I cannot emphasize this too much. Engineers and MBAs are very much alike in the way they think through problems. Art & Design students bring a very different perspective and tool set to the table, and enrich and are enriched by the other disciplines. Also, we noticed a quantum leap in the design quality of the web sites and trade show presentations when we included A&D students. Finally, A&D students are used to actually making things, something MBAs and (surprisingly) Engineers may not be. This, in fact, is a challenge because recently the bulk of the fabrication effort (which is very time consuming) has fallen to A&D students.

WHAT IS THE BEST ADVICE YOU HAVE FOR STUDENTS ENTERING THE DESIGN FIELD?

Don't design for a museum, design for society. Understand when you are creating social value with your designs, and how that value relates to its economic viability. Business is not about profits as much as it is about creating social value. Once you create that value, who gets to keep it is a personal decision. You can keep it (maximize your profits) or give it away (be a non-profit). The value is the

same. You can separate value creation from decisions about value distribution, always doing the former and letting your heart guide you on what you do with the latter.

by Professor Bill Lovejoy, Faculty Co-Director, Master of Entrepreneurship Program, Raymond T J Perring Family Professor of Business Administration, Professor of Technology and Operations, Professor of Art, School of Art and Design

APPLICATION MATERIALS
Email mlreeves@umich.edu with intent to take this class

*There are 25 spots open for business students and 25 spots for engineering students

DID YOU KNOW?
84% *of undergraduate classes at U-M have less than 50 students in them. There are* **more than 1,000 undergraduate research opportunities** *on campus (and beyond). Every five weeks a new company is launched based on U-M technologies.*

96

'Seed' eco-friendly cell phone: cover, use it, put it in the ground. The case is biodegradable with embedded seeds and will grow.

DEGREES

STAMPS SCHOOL OF ART&DESIGN
BA: Art and Design
BFA: Art and Design

DUAL DEGREE

TAUBER INSTITUTE
MBA or MSCM: Business and Design program
MSCM: Business and Design
EGP: Business and Design
EGL: Business and Design

RANKING

BUSINESS PROGRAMS
#4 U.S.News & World Report's 2015

FINE ARTS
#27 U.S.News & World Report's 2015

ADMISSIONS OFFICE

Tauber Institute for Global Operations
1220 SAB 515 E JEFFERSON
Ann Arbor, MI 48109-1316
(734) 647-1333

ALUMNUS
Mike Kelly, American politician
Chris Van Allsburg, Illustrator
and Writer
Michelle Oka Donner, Artist
Warren Robbins, Art collector
Jim Shaw, Artist
James A. Chaffers, DARCH Charles
Correa, HSCD
Michele Oka Donner, MFA
Charles W. Moore, HDRAC
Warren Robbins, MA
Madonna, Pop Star
Kenneth Jay Lane, Designer

NEW YORK UNIVERSITY
New York, New York
www.nyu.edu

97

NEW YORK UNIVERSITY
ITP-TISCH SCHOOL OF THE ARTS, GRADUATE PROGRAM

ITP is a two-year graduate program located in the Tisch School of the Arts whose mission is to explore the imaginative use of communications technologies — how they might augment, improve, and bring delight and art into people's lives. Perhaps the best way to describe us is as a Center for the Recently Possible.[33]

FACT!
One ITP class, called "Redial," teaches students how to hack the phone system and requires them to sign a legal waiver before enrolling.

WHAT MAKES NYU'S ITP PROGRAMS DIFFERENT FROM OTHER GRADUATE PROGRAMS

ITP is a 2-year, full-time department where the students are exploring new forms of creativity and experimentation using interactive media technologies. We like to see ourselves as the Center for the Recently Possible. ITP students are very diverse. We don't require that our students have any prior technical or design knowledge before coming. The more diverse the backgrounds, the better. Rather, we want students who can think creatively about the uses of interactive technology.

CAN STUDENTS TAKE COURSES IN OTHER GRADUATE DEPARTMENTS?

Students can take up to 8 credits (usually 2 or 3 graduate classes) in other departments at NYU, given departmental permission. The courses need to be relevant to the subject matter they are exploring at ITP department.

WHAT KIND OF JOB OPPORTUNITIES HAVE YOU SEEN NYU'S ITP GRADUATES TAKE?

There is a wide range of possibilities where students go after graduating from ITP.

98

Michael Mills, former full-time faculty member of ITP, went on to Apple Computer. He contributed to the group that developed the original prototypes that later became QuickTime.

Because our students are so very different before they come, they have vastly different skill sets. They also focus on different things at ITP as there are no pre-defined tracks or majors that students need to declare. So when they leave, they are qualified and interested in different types of jobs and industries. That said, we have people going to big companies like Microsoft, Apple, Google, Facebook, Twitter, museums and galleries, advertising/ marketing agencies, experience and design agencies, schools and universities, non-profits and freelance, to name a few. Others pursue their own art, and still others have the entrepreneurial spirit to start up their own companies.

WHAT ARE THE TOP 3 PROGRAM FEATURES THAT MAKE YOUR PROGRAM STAND OUT FOR GRADUATE STUDENTS?

1. Collaboration
2. Diversity
3. Freedom to experiment and learn from failure

WHAT STEPS DO YOU TAKE TO EVALUATE A STUDENTS' CANDIDACY, APART FROM REVIEWING THEIR CREATIVE PORTFOLIO?

Personal statements, resumes, portfolios and recs are all considered. We also have group interviews for applicants who can make it to New York.

WHAT DOES YOUR PROGRAM LOOK FOR MOST IN THE CREATIVE PORTFOLIO DURING ADMISSIONS?

The creative portfolio is optional. It's optional because we have such a range of candidates with very different backgrounds that not everyone will have a portfolio to share. For example we have people coming from business, philosophy, biology, engineering backgrounds. They may not have a portfolio and that's ok. We also have candidates from architecture, web, fine arts and design — they will have a portfolio and they really should share it. That said, if an applicant has explored anything creative that they would like to share, whether it's through formal study or personal explorations, we would love to see it. It helps us get to know the candidate further.

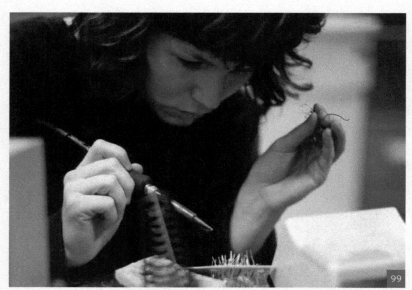

99

Students at ITP are diverse and almost never straight from college. The program admits one in every three applicants, and tries to gather a diverse group of students such as lawyers, painters, doctors, poets, etc. There is no requirement of a background in computer science or the arts necessary, and students are taught the basics of coding and programming in their first year.

HOW ARE NEW TECHNOLOGIES AFFECTING STUDENTS' CURRICULUMS AND/OR WAYS OF LEARNING/COLLABORATING AT YOUR SCHOOL?

We offer 10-15 new classes each semester. We are constantly adapting our curriculum to cover the latest technologies, trends and thinking.

HOW MUCH IS DESIGN & VISUAL ARTS A PART OF THE CLASSES ASIDE FROM LEARNING COMPUTER SCIENCE/ TECHNOLOGY?

Design and visual arts is very much a part of our curriculum.

FACT!
In the crowds at ITP's two annual expos, there are bound to be a mix of advertising recruiters, tech entrepreneurs, reporters and even the occasional Defense Department recruiter.

ARE THERE ANY EXCITING DEVELOPMENTS FOR YOUR ITP PROGRAMS THAT STUDENTS SHOULD KNOW ABOUT?

We are always adapting and changing with the times.

WHAT IS THE BEST ADVICE YOU HAVE FOR STUDENTS ENTERING THE DESIGN TECHNOLOGY FIELD?

Follow your heart and do what you love. Invest in yourself with the 2 years of freedom to create your own projects and explorations.

HOW DOES YOUR PROGRAM HELP GRADUATING STUDENTS WITH INTERNSHIPS OR JOBS? CAN STUDENTS EXPECT JOB PLACEMENT MORE AT YOUR PROGRAM THAN IN OTHERS? IF SO, HOW OR WHY?

We receive daily job, freelance and internship postings that we share with our student and alumni communities. We regularly organize recruitment events with companies who come in and present to our students. We don't do formal job placement, but we give students a lot of opportunities with job listings and making real networking contacts through these recruitment events and also as we bring in guest speakers to critique during classes. Everyone is a potential networking contact and we encourage our students to put themselves out there.

by Midori Yasuda
Admissions/Special Events/ Alumni Administrator

APPLICATION MATERIALS
Common Application
Personal Statement
Current Resume
2 letters of Recommendations

SUPPLEMENTARY
PORTFOLIO REQUIREMENTS
Different parts of creative
portfolio vary from major

TRANSCRIPTS
Required

INTERVIEW
Highly Recommended
or Group Interviews

APPLICATIONS DEADLINES
Regular Decision: Dec 1

FOR INTERNATIONAL STUDENTS
Regular Decision: Dec 1
TOEFL: (iBT) min 100
IELTS: 7

ALUMNI
Felix Gonzales Torres, Artist
Joel Schapiro, Artist
Ross Bleckner, Artist
Carol Bove, Artist
Nate Lowman, Artist
Borna Sammak, Painter
Jasmin Tsou, Art dealer
Nikki S. Lee, Photographer
Nicole Cherubini, Artist and Sculptor
Elaine Cameron Weir, Artist
Charles Harlan, Artist
Rachel Rampleman, Artist
Zaq Landsberg, Artist
Charlotte Ronson,
Womenswear Designer
Dennis Crowley, CEO
Daniel Rozin, Artist
Leo Villareal, Designer
Sigi Moeslinger, Designer
Margaret Gould Stewart, User
Experience Master
Tom Igoe, Co-founder

100

Phil Groman, a former student from ITP developed "Stringwire" which is a service that works through Twitter-asking users to click a link on their accounts and point what they are seeing which can be broadcast straight to live video. The web service was bought by NBC Universal for coverage of all-consuming protests and rallies.

ITP:
MPS : Master of Professional Studies

FILM
#1 Los Angeles Times 2013
MULTIMEDIA / VISUAL COMMUNICATIONS
#11 U.S.News 2015

New York University Admissions Office
665 Broadway, 11th Floor
New York, NY 10012-2339
+1 (212)-998-4500

CHAPTER 3

SCHOOLS IN EUROPE & ASIA

EUROPE

•

275

HOCHSCHULE PFORZHEIM
UNIVERSITY
Pforzheim, Germany
www.hs-pforzheim.de

101

HOCHSCHULE PFORZHEIM UNIVERSITY
THE SCHOOL OF DESIGN

The School of Design is the oldest faculty of the University and was founded in 1877 as the Pforzheim School of Applied Arts. In 1887, this institution became the Grand Ducal School and in 1919 the Baden School of Applied Arts. Further development resulted in the formation of the "State Master School for the German Precious Metal and Jewelry Industry" which then became the "Goldsmith and Art College" in 1952. The University of Design was founded in 1971 and became part of Pforzheim University in 1992.

The School of Design is the smallest of the three faculties, comprising about 560 students and 30 professors. The School places great importance on its unique tradition, which combines traditional fine arts training with innovative and leading-edge design instruction and broad-based theoretical studies. Small class sizes encourage personal contact between students and professors and enable the teaching staff to closely supervise an individual student's work throughout the entire course of studies.

FACT!
Being the center for the German jewelry, watch and silver goods industry, Pforzheim is also known as the "Goldstadt" (Gold City).

CAN STUDENTS TAKE COURSES IN OTHER SCHOOLS? FOR EXAMPLE, TAKE SOME CLASSES IN THE BUSINESS OR ENGINEERING SCHOOL?

Yes, if they want. But it is not necessary. Our students have relevant business or engineering classes for design, for instance "Design and Management", "Design and Business" or "Ergonomics" (for Industrial Design and Transportation Design). So most students from Design School usually take no classes in the other schools.

WHAT ARE THE TOP 3 FEATURES OF YOUR SCHOOL AND PROGRAMS THAT STAND OUT FOR BOTH UNDERGRAD AND GRADUATE STUDENTS?

You want to study design and learn about our university? Then take part in our DESIGN PF Camp! For three days, you can experience the everyday life at our faculty: Our students attend workshops, work in workshops and meet our professors.

I think that answer is different for every program. There is no specific answer. For all bachelor courses I can tell you that the students have minimum one semester for internship in design companies, and there are many cooperations between design school and design companies in semester projects. That is a special benefit of all "Universities of Applied Sciences" in Germany, different to "simple" University.

WHAT STEPS DO YOU TAKE TO EVALUATE A STUDENTS' CANDIDACY, APART FROM REVIEWING THEIR CREATIVE PORTFOLIO?

AND WHAT DOES YOUR PROGRAM LOOK FOR MOST IN THE CREATIVE PORTFOLIO DURING ADMISSIONS?

There is a mandatory artistic aptitude test (sketching) in our school, it takes two days. The canditates (who will be invited if the portfolio was accepted from the Profs commission) have to show their skills in sketching and creativity. Basics of all design courses are the art classes like drawing, sketching, photography, sculpture etc. So every applicant needs sketching and drawing talents on a higher level.

by Antje Dreißig, Faculty of Design

FACT!

The regular duration of a Bachelor program is 3.5 years (seven semesters); Master's Degree Programs normally last 1.5 years (three semesters)

SUPPLEMENTARY PORTFOLIO REQUIREMENTS

10-15 original works
(e.g. drawings, paintings, sketches..) and additional 5-7 works that are referring to the desired field of study.

*Maximum size of the portfolio is DIN A 1 — works should not be rolled up and the university down not accept portfolios made out of metal, wood or heavy plastic. Three-dimensional works can only be accepted as photographs printed/glued on paper. The university does not accept CDs, DVDs, Memory Sticks etc.!

TRANSCRIPTS
Required

INTERVIEW
Not required

APPLICATIONS DEADLINES
Summer Semester: Oct 30
Winter Semester: Apr 30

TIPS

Please be aware that you have to do a 6-month internship (12 months for Jewellery) before you start your first semester. Requirements for the internships (depending on the chosen field of study)

In any case, you should check back with our registrar's office (roland.mueller@hs-pforzheim.de) whether your internship will be accepted before you start it

ALUMNI

Marc Lichte, Transportation designer and Chief designer from AUDI
Daniel Simon, Designer
Melitta Baumeister, Fashion designer

DEGREES
BA:
1. Industrial Design
2. Fashion
3. Accessory Design
4. Jewelry
5. Visual Communication (with integrated pathways in Advertising, Spatial Design, Print and Digital Media Design)
6. Transportation Design

RANKING
#60 Best academic institutions in the field of design worldwide - alongside Harvard, Stanford and the MIT
BusinessWeek Magazine

ADMISSIONS OFFICE
Zulassungsamt, Hochschule Pforzheim
Holzgartenstrasse 36
75175 Pforzheim, Germany
+44 (0)20-7919-7171

STRATE SCHOOL OF DESIGN
Sèvres, France
www.strate.education

103

STRATE SCHOOL OF DESIGN

GRADUATE PROGRAM IN
TRANSPORTATION DESIGN AND
INTERACTION DESIGN

Since 1993, Strate has always had a vision: design will become the strategic point in sustainable development, success will be collective, and our way of working will be collegial. From this vision, Strate has become the top private institution in France and one of the world's 60 best design schools as ranked by Business Week. It has also grown from 18 students to over 500 and has put into place 3 programs. In 2010, Strate also settled into a brand new 3000 m2 campus in Sèvres. A great campus for great ambitions!
What are these ambitions? Put simply: To contribute to the education of professionals who are passionate about their fellow man and attentive to the everyday needs, desires and dreams of those around them and of future generations.

FACT!
There is not a single car company without Strate alumni.

WHAT MAKES YOUR SCHOOL'S ART & DESIGN PROGRAMS DIFFERENT & UNIQUE FROM OTHER ART & DESIGN SCHOOL PROGRAMS?

Design taught at Strate is a post-industrial design, which claims a multidisciplinary approach to address and solve big or small, individual or collective, public or private problems that make the complexity of "living together" in an open and globalized world. The leitmotif at Strate - "Making the World simpler, fairer, more beautiful" — perfectly matches this ambition.
So the arts dialogue with the human and social sciences, technology, marketing, history of art and science to form "honest men" of the XXI century.

WHAT ARE THE TOP 3 PROGRAM FEATURES THAT MAKE YOUR PROGRAM STAND OUT?

1. All lecturers are local professionals, coming from the industry.

2. Industrial partnerships, which ensure a confrontation with reality — The 4th year is built around industrial partnerships in direct relation with companies and their design, marketing or R&D departments. These companies give students the opportunity to make complete prospective design studies in fields related to their Major subjects at Strate: Product(s), Pack / Retail, Mobility, Interaction. This gives them the opportunity to confront with the realities of a company and its offer. Our partners have understood the meaning of this process and commits with us into a true relationship, offering professional internships in their integrated design service and employment to our graduates.

3. The inter-schools projects, which ensure the practice of interdisciplinarity.
Example of inter-school project: CPI
Since 2007, ESSEC and Strate are partners, along with the Ecole Centrale de Paris, in the CPI program ("Creating Innovative Products"). This program, a pioneer of the inter-school educational project, is built around the methodology

From August to January, all the students are required to go abroad. They have three different possibilities for this stay: international academic exchange, professional internship or study trip. The latter can be organized around a theme in relation to creation and design in the part of the world they choose.

The "Design" curriculum is a five year course in order to deliver practical transversal and specific skills.

of Design Thinking, as it has been developed and tested by Tim BROWN within IDEO.

Every year, 10 different industrial partners bring real life brief to ten-student teams from the 3 schools. Each project is attached to an interdisciplinary team of students from 3 schools: ESSEC (Business), Ecole Centrale de Paris (Engineering) and Strate (Design).

For more than 6 months, these teams will gather each week to address the brief in all its dimensions: design, engineering, business model, marketing, communication. Supervised by teachers from the three schools and professional tutors in each subject, the students will experience what their future professional life will be, learning how to work for clients, in a respectful collaboration with other innovation actors.

CAN STUDENTS TAKE COURSES IN OTHER SCHOOLS?

In design, at the end of the second year, students decide towards which department they want to focus. Once they are accepted in that department, they study in there until their diploma. They will have the possibility, in 4th year, to go abroad and study in another school/university to discover new ways of learning/teaching.

In addition, in their third year, Design students can apply for the double-diploma with Grenoble Business School. By spending 1.5 year in Grenoble Business School, they will get both diplomas.

WHAT STEPS DO YOU TAKE TO EVALUATE A STUDENT'S CANDIDACY, APART

FROM REVIEWING THEIR
CREATIVE PORTFOLIO?

We look for open-minded students. So we take the time to discuss with them to understand their vision of design, their goals in life, as human beings and as future designers. We're interested in students who want to make other people's life better.

WHAT DOES YOUR PROGRAM
LOOK FOR MOST IN THE
CREATIVE PORTFOLIO DURING
ADMISSIONS? WHAT DO YOU
THINK MAKES AN A+ PORTFOLIO?

Originality, professionalism.

HOW ARE NEW TECHNOLOGIES
AFFECTING STUDENTS'
CURRICULUMS AND/OR WAYS OF
LEARNING/COLLABORATING AT
YOUR SCHOOL?

As most of the students around the world, our students are using massively social networks and application, as well as cloud facilities. Nevertheless, design is a practice, and more than that a situated and collaborative practice. They learn by doing, sharing, challenging, and to do this a pencil is as much important as a computer!

FACT!
Strate Collège has recently

launched an interdisciplinary degree in innovation management in partnership with engineering school Ecole des Mines. Graduates of this one-year degree often go on to become translators between design and engineering at the managerial level in major French companies.

HOW DOES YOUR PROGRAM
HELP GRADUATING STUDENTS
WITH INTERNSHIPS OR JOBS?
CAN STUDENTS EXPECT JOB
PLACEMENT MORE AT YOUR
PROGRAM THAN IN OTHERS?
IF SO, HOW OR WHY? WHAT
KINDS OF JOB OPPORTUNITIES
HAVE YOU SEEN STUDENTS
TAKE ONCE THEY COMPLETED
THEIR DEGREES?

Strate has a strong relationship with the industry and we highly support our students in finding internships and job opportunities. We train students to be professionals and ready work as such when they graduate.
Students have different periods of internships during the curriculum: 1 month in 2nd year, 4-6 months in 3rd year, 4-6 months in 4th year and abroad, and 6 months in 5th year.
Strate has made its relationship with the industry the keystone of its pedagogy.

ARE THERE ANY EXCITING
DEVELOPMENTS FOR YOUR
PROGRAMS THAT STUDENTS
SHOULD KNOW ABOUT?

Our programs and pedagogy are always evolving. We open new programs, start new courses, hire new professionals in order to answer the industry needs. This year (Sept. 2015), we opened 2 new programs taught in English (Interaction and Transportation), as well as a new program dedicated to 3D Experience. We are also working of the creation of programs to be developed in Singapore.

WHAT IS THE MOST DISTINGUISHED FEATURE AT YOUR SCHOOL?

We are training Bruce Waynes type of designers. Nobody knows that they are Batman. The real heroism is anonymous. Our designers work for the greater good, not for themselves or for any celebrity.

by Cecilia Talopp, Head of International Affairs

APPLICATION MATERIALS
Studialis Application PDF

SUPPLEMENTARY MATERIALS
Portfolio Not Required

TRANSCRIPTS
Required

INTERVIEW
Required via Skype

RECOMMENDATION LETTERS
1 Letter of Recommendation

APPLICATION DEADLINES
Early Decision:
Nov 1 (letter)
Nov 10
Regular Application:
Jan 5 (letter)
Jan 15

TIPS
The Interview is key for enrollment as staff learns more about the student and their ideas on design

DID YOU KNOW?
*Strate Research was created as the result of the realisation that Design and Research are both identified by economical and political instances as major levers of differentiation, sustainable development and of creation of value. Hence the absolute necessity that designers start doing research. Within Strate Research, our researchers and our students work together on three main issues: — **technological objects** — **sustainable economy** — **innovation management by design.***

ALUMNI
Julien Montousse, Design director
Olivier Denamur, Design director
Felix Kilbertus, Exterior designer
Dorothée Meilichzon, M&O PARIS
designer of the year

DEGREES
MA(in English):
1. Transportation Design
2. Interaction Design

RANKING
#60 Best academic institutions in the field of design worldwide BusinessWeek Magazine

ADMISSIONS OFFICE
Studialis
13 Rue Saint Ambroise
75011 Paris
+33 (1)-55-28-8885

AALTO UNIVERSITY

Helsinki and Espoo, Finland

www.aalto.fi/en

106

AALTO UNIVERSITY
SCHOOL OF ARTS, DESIGN AND ARCHITECTURE

Aalto University has six schools with nearly 20,000 students and 4,700 employees, 390 of whom are professors. There is a wide variety of bachelor's and master's degrees awarded at Aalto University, and we also offer doctoral programmes in all the fields of study. The School of Arts, Design and Architecture is part of Aalto University, which is a multidisciplinary university operating in the fields of technology, business and commerce, and the arts. Aalto builds on Finnish strengths and its objective is to become one of the leading universities in the world as a unique entity.[36]

FACT!
Aalto University's strategy for 2016–2020 has been updated. With its vision of 'An innovative society', the university's mission can be summed up as 'Shaping the future: Science and art together with technology and business.'

WHAT ARE THE TOP 3 PROGRAM FEATURES THAT MAKE YOUR PROGRAM STAND OUT?

On top of the features mentioned above, in all our programs, we focus on five areas:
1. Design in All Scales of Human Environment and Everyday Life.
2. Culture of Sharing; New Ways of Planning, Producing and Distributing.
3. Meanings and Expressions, and Storytelling.
4. Artistic Research Practices.
5. Digital Society.

When doing this, we always also pay extra attention to human/user point of view; bridge art, design and architecture; combine traditional and groundbreaking cultural knowledge; and appreciate experiences based on senses and hands-on skills.

CAN STUDENTS TAKE COURSES IN OTHER SCHOOLS?

Yes, both in other schools of university as well as in other Helsinki based universities.

WHAT MAKES YOUR DESIGN PROGRAMS DIFFERENT & UNIQUE FROM OTHER SCHOOLS' PROGRAMS?

We offer both BA, MA and Doctoral (PhD level) education. We are a part of Aalto University, a combination of science, art, technology and business. We have a strong research tradition and theoretical emphasis in all our studies. We have highly selective admission processes (only some 10% of the applicants are accepted) In 2015, we are in top 5 in the QS World University Ranking in Art & Design in Europe. We have very low or no tuition fees at all.

HOW ARE NEW TECHNOLOGIES AFFECTING STUDENTS' CURRICULA AND/OR WAYS OF COLLABORATING/LEARNING AT YOUR SCHOOL?

We are always actively embedding the latest technologies in all our studies.

WHAT STEPS DO YOU TAKE TO EVALUATE A STUDENTS' CANDIDACY, APART FROM REVIEWING THEIR CREATIVE PORTFOLIO?

Depends on the program but evaluation may include a three step intake exam and interview.

ARE THERE ANY EXCITING DEVELOPMENTS FOR YOUR PROGRAMS THAT STUDENTS SHOULD KNOW ABOUT?

Aalto University School of Arts, Design and Architecture was formed of two separate schools: the faculty of architecture (previously part of the Helsinki University of Technology) and the University of Art and Design Helsinki (known in Finnish as TaiK). TaiK, founded in 1871, was the largest art university in the Nordic countries.

We have just renewed and updated all our programs and we are planning to renew also the departmental structure to make the school even stronger in the face of present and future challenges. Moreover, we will move to a new campus in a couple of years and will have brand new premises for us.

HOW DOES YOUR PROGRAM HELP GRADUATING STUDENTS WITH INTERNSHIPS OR JOBS? CAN STUDENTS EXPECT JOB PLACEMENT MORE AT YOUR PROGRAM THAN IN OTHERS?

IF SO, HOW OR WHY? WHAT KINDS OF JOB OPPORTUNITIES HAVE YOU SEEN STUDENTS TAKE ONCE THEY COMPLETED THEIR DEGREES?

We have close relations, through our alumni, with the field. Alumni actively take part in teaching (as visitors and adjunct professors). It is typical for our students to work during their studies, and they can also get credits for that (working can form a part of their studies). Careers are highly varied: entrepreneurs in the field of design, game and film industry,

The school in its earlier incarnation as Taik educated many of the household names of Finnish art, design and cinema.

teachers, artists, researchers... In general, Aalto University has a strong entrepreneurial spirit and community where students have a very important role. See, for example, our Aalto Entrepreneurial Society at http://aaltoes.com/

by Ossi Naukkarinen
Dean of Aalto University School
of Arts

FACT!
The university is known for its research projects and industrial collaborations

WHAT DOES YOUR PROGRAMME LOOK FOR MOST IN THE CREATIVE PORTFOLIO DURING ADMISSIONS? WHAT DO YOU THINK MAKES AN A+ PORTFOLIO?

A portfolio should show future potential, creativity, ability and will to learn and think big as well as skills needed in the program one is interested in.

WHAT IS THE BEST ADVICE YOU HAVE FOR STUDENTS ENTERING THE ART, DESIGN & ARCHITECTURE FIELD? AND WHAT DO YOU THINK IS THE ROLE OF THE ARTIST TODAY?

APPLICATION MATERIALS
Bachelor's programmes are not offered in English in the field of Art and Design. Applicants for Bachelor's degree programmes must have a solid knowledge of Finnish in order to apply and to be able to participate in lectures and exams. Applicants will need to be able to prove their proficiency in Finnish by taking a National Certificate of Language Proficiency in Finnish.

DEADLINES
Masters of Art: Dec 1 to Jan 15

Think big, work hard, share your ideas, experiment and try boldly. Artists are needed to make the world more human, surprising, and emotionally rewarding — as well as to criticize and show alternatives. At Aalto University, artists are directly co-operating with engineers, scientists and business experts which puts them/us in an excellent position to show what our role is.

DEGREES
BS and BA: Architecture; Art; Design; Film, Television and Scenography; Media

RANKING

ART AND DESIGN
#1 QS University Rankings in Finnland 2015
#14 Architecture QS World University Rankings 2015

ADMISSIONS OFFICE

Aalto University Admission Services, Otaniemi Campus (Technology and Engineering & Art and Design)
Aalto University Admission Services,
P.O. Box 11110, 00076 Aalto, Finland
+358 (50)-361-6430 or +358 (50)-573-1344

Studio at department of Art And Design.

At Otaniemi, Espoo in the Helsinki metropolitan area we are building our main campus. Otaniemi will be the site of all university undergraduate studies. The international architectural design competition for the core campus was won by an entry of a Finnish bureau Verstas Architects.

DID YOU KNOW?

*Aalto Design Factory is home for students, researchers, industry partners, start-ups and companies. It is **a new open environment** for the research and education on product development. Check out more at www.aaltodesignfactory.fi*

ALUMNI

Alvar Aalto, Designer
Tapio Wirkkala, Designer
Kaj Franck, Designer
Harri Koskinen, Designer
Paola Suhonen, Designer
Eero Aarnio, Designer
Pirjo Honkasalo, Designer
Elina Brotherus, Designer
Kim Simonsson, Designer
Lasse Seppanen, Designer

DOMUS ACADEMY
Milan, Italy
www.domusacademy.com/en

111

DOMUS ACADEMY
DESIGN

In the early eighties, Milan emerged as the epicenter of Italian design. Yet no one in the city was teaching design in a formalized way. Top art critics and designers recognized an extraordinary opportunity to fill this void and mentor the next generation of designers. In 1982, they founded Domus Academy, Italy's first postgraduate design school.

The founders envisioned a school where students and faculty members from all over the world would meet and exchange ideas. A school that would bring company representatives in to lead real-world projects focusing on the most important aspects of contemporary design. [37]

FACT!
You'll spend two years in Italy and two years in the United States. In both locations, you'll take courses taught by industry experts to build your theoretical foundation.

WHAT MAKES YOUR SCHOOL'S ART & DESIGN PROGRAMS DIFFERENT & UNIQUE FROM

OTHER ART & DESIGN SCHOOL PROGRAMS?

Domus Academy is a living laboratory. An incubator of talents and a springboard for interdisciplinary adventures. A place where stellar careers are launched.

At Domus Academy, we help students become protagonists in the highly competitive world of fashion and design. Offering one-year master's courses in a wide variety of design specializations, the school centers around a "learning by designing" methodology, in which students solve real-life design problems with the help of world-class faculty members who are opinion leaders in their fields. Students also have the opportunity to intern with some of the most exciting brands in fashion, product design, car design, interaction design, luxury goods, and more. Working directly with companies, you'll learn how to address the most contemporary design challenges in fresh and original ways.

Domus Academy is a school where students make the connections that accelerate their careers, gain inspiration from collaborative projects, and develop their skills and talents in a self-directed way. Whether students wish to work at a traditional job or found their own design studio, Domus Academy prepares them to become leaders within all facets of the fashion and design industries.

Learning by designing

We believe that working on real-world projects is the best way to learn. That's why 90 percent of our curriculum is "learning by designing." Students work on practical design assignments that replicate today's professional design practices in an environment supportive of learning and experimentation.

Faculty excellence

At Domus Academy, students work side-by-side with pre-eminent international designers and thought leaders who bring the pulse of the design world into the classroom and impart their knowledge of the latest design trends and practices.

Multidisciplinary approach

Many of the most innovative design solutions are created through the collaboration of various design tools, competencies, and perspectives. Students across disciplines share points of view on design and learn to combine these ideas in their own fresh expressions.

Multiculturalism

Currently, more than 50 nationalities are represented on the Domus Academy campus. We believe that a multicultural point of view spurs a dynamic exchange of ideas and informs design excellence: An open mind sees a diversity of options and chooses concepts with universal resonance.

When you graduate from Domus Academy, you'll receive a degree that is recognized in Europe and around the world - the Academic Master's Degree, accredited by the Italian Ministry of Education, Universities and Research (MIUR). You'll also earn a second valuable qualification: the Domus Academy Master's Diploma.

WHAT ARE THE TOP 3 PROGRAM FEATURES THAT MAKE YOUR PROGRAM STAND OUT?

Fashion Design
Dream. Express. Make.
The Master in Fashion Design program brings students into direct contact with the fashion design industry in Italy and abroad. They have the rare and exciting opportunity to develop their own original, compelling fashion collection under the guidance of industry professionals.

Through both theoretical studies and project experiences, they develop an individual mode of expression, explore the cultural factors that influence fashion trends, learn the ins and outs of production, and create innovative solutions.

Besides honing the "problem solving" skills that every fashion designer needs, students also develop a "problem defining" approach: the ability to determine the true parameters of each challenge. As they learn to follow your intuition and promote their aesthetic vision within those parameters, you will cultivate more awareness of the reasons behind your own fashion design choices, and those of others.

Interior & Living Design
Shape. Experience. Live.
The Master in Interior & Living Design encourages students to consider a wide range of design practices as they learn to shape the space of interiors. In this course they are inspired to overcome disciplinary boundaries, make choices that are both more sophisticated and more daring, and cultivate an attitude of continuous inquiry into the material and immaterial aspects of space. They learn the theory, best practices, and methodologies, getting used not only to solve problems creatively — but to define problems as well. As they collaborate with international peers on company projects that re-invent the interior domain, they come to define their own work in the context of the field. Milan is an ideal place to study interior design, with its long tradition of experimenting with and solving the design challenges of everyday life. It offers a variety of exemplary historical and contemporary interiors for students to visit and take as inspiration.

Product Design
Think. Sketch. Make.
A good product began as a need that a designer identified and brought to life in the form of an object or mechanism. It is a reflection of society. It is about potentiality, adaptation, discovery.

The Master in Product Design program combines the study of theory with the process of direct experience.

During workshop collaborations with eminent professionals from local studios and businesses,

students have the range to experiment with design methodologies as you develop a deeper understanding of product design and its role in our world.

In Domus Academy students have also the chance to get in touch with "made in Italy" and the principles of the Italian Design culture:

1. Rooted on historical and cultural heritage. The human beings and their evolution at the center. The humanistic approach to design comes from cultural insights about the evolution of artifacts, environments, spaces, social and technical systems.

2. An integrated perspective. From "spoon to city". The Italian design culture covers all dimensions of the project promoting a design direction vocation, namely the capacity to integrate the design choices in a broader vision. Designers deal with in any dimension of complex projects in an integrated view during their professional life.

3. Problem setting vs problem solving. Before identifying solutions, designers have to support their potential clients (i.e. Companies, Institutions..) in defining the problem to be solved. DA's programs are structured as an exploration of research and design experiences, which not only provides the tools for "how to do" but helps each and every individual to find the reasons "why doing".

FACT!
In their 2012, 2013, and 2014 Masterclass guides, Frame Publishers named Domus Academy among the world's top 30 graduate schools for design, architecture, and fashion.

CAN STUDENTS TAKE COURSES IN OTHER SCHOOLS?

The Domus Academy School of Design at NewSchool is a unique partnership between NewSchool of Architecture & Design in San Diego and Domus Academy in Milan.

It's a collaboration that brings together Old World and New World design methodologies into exciting, innovative Bachelor of Interior Architecture & Design and Bachelor of Arts in Product Design. These are two degrees like no others: an immersive, hands-on experience in European and American design. Students will learn the Italian design approach in Milan, the world capital of design, and in San Diego they'll examine the influence of contemporary design on technology, lifestyle, and sustainability. Students will spend two years in Italy and two years in the United States. In both locations, they'll have the possibility to take courses taught by industry experts to build your theoretical foundation.

WHAT STEPS DO YOU TAKE TO EVALUATE A STUDENT'S CANDIDACY, APART FROM REVIEWING THEIR CREATIVE PORTFOLIO?

Domus Academy is a selective school that limits the number of entering students in order to provide living and study conditions that best enable all students to complete their degrees. When considering candidates for admission, our Faculty and Admission Commitee look at the entire profile of the applicant, including academic records, work experience if any, extracurricular activities, test scores and recommendations.

WHAT DOES YOUR PROGRAM LOOK FOR MOST IN THE CREATIVE PORTFOLIO DURING ADMISSIONS? WHAT DO YOU THINK MAKES AN A+ PORTFOLIO?

What catches the most our attention is the candidate's ability to demonstrate the necessary skills for the area of interest through the use of the proper graphic/painting/multimedia instruments, communicating values and emotions through their work.

HOW ARE NEW TECHNOLOGIES AFFECTING STUDENTS' CURRICULUMS AND/OR WAYS OF LEARNING/COLLABORATING AT YOUR SCHOOL?

Students have the possibility to work in our state-of-the-art facilities.
Our design laboratories provide the tools they need to create great work: equipment for computer graphics, video editing, 2D and 3D modeling, sound design, printmaking, painting, light design, tailoring, and model-making.

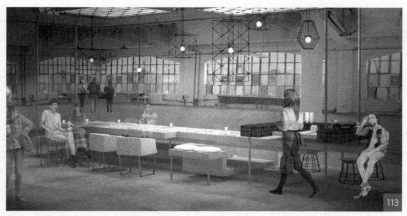

Our students have worked on projects with Maserati, Motorola, Swarovski, Versace, Bayer, P&G, Adidas, Fiat, Tommy Hilfiger, BMW Design, De Beers, Trussardi, and more.

HOW DOES YOUR PROGRAM HELP GRADUATING STUDENTS WITH INTERNSHIPS OR JOBS? CAN STUDENTS EXPECT JOB PLACEMENT MORE AT YOUR PROGRAM THAN IN OTHERS? IF SO, HOW OR WHY? WHAT KINDS OF JOB OPPORTUNITIES HAVE YOU SEEN STUDENTS TAKE ONCE THEY COMPLETED THEIR DEGREES?

Internship
There is no better way for you to gain experience in your field than actually working in it. The internship is a chance for you to work onsite for a company or design studio in your field of interest—while applying all the strategies you learned in the classroom and in workshops. Alternatively, you can complete an intensive project in collaboration with a company on the Domus Academy campus. Either way, you'll get an inside perspective on how your industry really works, and you can make important connections that will further your career.
The internship lasts two months and comes at the end of your year of studies. 100% of our students participate in the internship, including non-EU students, who may extend their visas for up to one year to complete this portion of their studies.
Internship & Placement
One of the most exciting and valuable aspects of your Domus Academy master's education is the opportunity to intern at a prestigious design company.

Working directly with industry leaders on actual company projects is the best way to gain meaningful, relevant experience in your field.
An internship can help you to:
— apply your classroom learning to real workplace challenges,
— learn to solve contemporary design problems in original ways,
— expand your knowledge, develop practical skills, and increase your confidence as a professional,
— make connections that can launch or accelerate your career as a designer or entrepreneur
— make your CV more attractive to prospective employers
Domus Academy has established long-standing internship agreements with some of the most important Italian and international brands in design, fashion, business and architecture.
With an internship placement rate of 100%, students from the programs are placed as intern in leading companies such as:
Alberta Ferretti, Bastard, BMW Design Group, Borbonese, Conde' Nast, Continuum, Costume National, Crea International, Design Innovation, De Beers, Diego Dolcini, Dsquared, Elica, Emilio Pucci, Fiat, Flos, Frog Design, Futurebrand, Karl Lagerfeld Amsterdam, La Triennale di Milano, Matteo Thun & Partners, Moncler, Neil Barrett, Pambianco, Proenza Schouler NY, RCS Media Group, Studio Urquiola, Studio Lissoni, Tommy Hilfiger Amsterdam, Triumph

Switzerland, Trussardi, Valentino, Versace, Vivienne Westwood, Whirlpool, Zara.

Our Career Services Office helps to place students in internship, matching each student's skills and aspiration with company requirements.

Non-EU students are eligible to participate in an internship and can extend their permit of stay to work in Italy for up to one year after degree completion.

Career Services
When taking into consideration various work opportunities and establishing respective goals, an understanding of the personal background of each student is the foundation and departure point towards every new beginning.

Domus Academy supports their students in the realization of their CV and Portfolio by helping them in terms of efficiency and clarity in the writing itself, as well as in content. By placing an emphasis on the project portfolio and evaluating the potential and talent within each student, Domus Academy helps students approach and face job interviews. Students are also assisted in their development and formulation of key ideas and clear messages, which can be interpreted as indications of value, quality and assertiveness.

The Domus Academy Career Services are closely available to the students to help them in their transition to the world of work. Through orientation and assistance, they guide them at every stage, and strengthen them with supportive and intensive tutoring.

FACT!
A key feature of all Domus Academy master's programs is your internship at a design studio or company, where you can get an insider's view of the industry and make valuable connections. Non-EU students are also eligible to participate in the internships; they may extend their visa to work in Italy for up to one year after completing their degree.

WHAT IS THE BEST ADVICE YOU HAVE FOR STUDENTS ENTERING THE ART, DESIGN & ARCHITECTURE FIELD? WHAT ROLE DOES THE ARTIST PLAY TODAY?

This is an issue often discussed within the Domus Academy's Metaphysical Club, composed of 14 of the most important innovators on the international design, art, and architectural scene, that students have the chance to meet periodically. Like a high-level salon, the Metaphysical Club guides the practical activities and future direction of the school.

To answer this question we would like to take inspiration from a lecture by Patricia Urquiola, world famous designer and Metaphysical Club member: our floor is changing, future artists and designers have first of all to understand the territory in which they're moving. Then

they should move outside their comfort zone every day. Creative people must keep an open mind, they need to put your individuality in connection with others. Nowadays, there is not a right way to be an artist.

ARE THERE ANY EXCITING DEVELOPMENTS FOR YOUR PROGRAMS THAT STUDENTS SHOULD KNOW ABOUT?

Domus Academy has recently opened its doors to undergraduate students: with the new bachelor degree, developed in collaboration with San Diego New School, we're able to offer so much more than a typical bachelor's degree. This is a truly global that will provide unique opportunities in terms of possibility to express creativity and career. It will help students expanding their contacts within the international marketplace, so they can prepare for a global career in design.

WHAT IS THE MOST DISTINGUISHED FEATURE AT YOUR SCHOOL?

Our biggest peculiarity is the opportunity to participate in real-world projects with international and domestic companies. Every master's program features four hands-on workshops, plus an internship/work experience. "Learning by designing" is a revolutionary approach that

114

Domus Academy has cultivated over decades of partnering with large and small companies, studios, consultancies, cultural institutions, magazines, and advertising agencies. To date, Domus Academy students have worked with more than 250 Italian and international companies.

Workshops and internships are a chance for students to apply the techniques they learn in class to a relevant company project — and make industry connections that could help launch your career. This is the main reason why 85% of our graduates are working one year after graduation, according to a survey conducted by the third-party research firm Demoskopea.

The involvement of international companies within educational activities is the main peculiarity of Domus Academy. It provides real life assignments to students to increase effectiveness of their overall learning experience.

by Angela Ambrogio, Marketing & Communication Specialist

DID YOU KNOW?
97% International students
50 Nationalities
represented 250 companies
involved in internships
agreement processes

APPLICATION MATERIALS
Online Application

PORTFOLIO REQUIREMENTS
Required

WRITING SAMPLE
Personal Essay

TRANSCRIPTS
Required

REFERENCE LETTERS
2 letters

ENGLISH PROFICIENCY
IELTS: 5.0
TOEFL: Computer 173 – 180
TOEFL: Internet 59 – 64
PTE: 36 – 42

TIPS

Applicants for the Global Design Degree program must meet NewSchool of Architecture & Design admission requirements, which include a High School diploma or comparable academic achievement, minimum GPA levels, statement of purpose and English language proficiency.

The intake for the Global Design Degree program occurs annually in October and adheres to NewSchool's quarter-based academic term.

The student services team will provide enrolled students with the necessary support to apply for student visas.

DEGREES
BA:
Global Design Degree
1. Interior Architecture & Design
2. Product Design

RANKING
#Top8 Interior Design Schools Azure Magazine 2016
#Top30 Best Graduate Schools Frame Publishers 2012-5
#Top 100 Schools of Architecture & Design
Domus Magazine 2012-5

ADMISSIONS OFFICE
Via Mario Pichi, 18,
20143 Milano, Italy
+39 (02)-4241-4001

ALUMNI
Francisco Gomez Paz,
Industrial designer
Anna dello Russo, Editor-at-large
and Creative consultant
Patrick Kampff, Product designer
Philippe Bestenheider, Architect
Christophe Pillet, Architect

ISTITUTO EUROPEO DI DESIGN
Milano, Italy
www.ied.edu

115

ISTITUTO EUROPEO DI DESIGN
ART & DESIGN

IED was first founded in 1966 in Milan by Francesco Morelli.

For almost fifty years, the Istituto Europeo di Design has been operating in the fields of education and research in the disciplines of design, fashion, visual communication and management. Today, the IED is a constantly expanding international network that issues first-level academic diplomas and organises three-year courses, Masters courses, continuous professional development and advanced training courses.

The most significant milestones in the Group's history include the foundation of the IED campuses in Milan (1966), Rome (1973), Turin (1989), Madrid (1994), Barcelona (2002), São Paulo (2005), Venice (2007), Florence (2008) and Cagliari (2009). In 2012, the Aldo Galli Academy in Como also joined the IED Group and as of 2013 courses have commenced in Rio de Janeiro, the second IED school in Brazil.

Since 1966, the IED has developed innovative and diversified teaching methodologies, focused on synergies between technology and experimentation, creativity, strategies and integrated communication, market issues and a new form of professionalism. Thus does the Istituto Europeo di Design offer young professionals working in the fields of Fashion, Design and Communication the knowledge and the effective tools they need to cater for the constantly developing requirements of the working world.

FACT!
IED is proud to mention that ninety percent of its graduates find work within six months of graduation.

WHAT MAKES YOUR VISUAL ART PROGRAMS DIFFERENT & UNIQUE FROM OTHER SCHOOL'S PROGRAMS?

IED — Istituto Europeo di Design — is a 100% Made in Italy international network of excellence, operating in the fields of training and research, in the disciplines of Design, Fashion, Visual Arts and Communication. IED Educational Offer includes Undergraduate courses (Diploma and Bachelor of

Arts), Graduate courses (Diploma and Academic Master's Degree), Academic Year and Semester courses, Summer/Winter courses, Specialization courses.

Its mission is widespread and clear: to offer young creatives a thorough training — both theoretical and practical — and hand them the 'Design Knowledge and Mindset' that will accompany them throughout their lives. IED is present in Italy, Spain and Brazil in the most vibrant capitals of design, fashion and innovation, each IED location houses four completely independent schools: IED Design, IED Fashion, IED Visual Arts and IED Communication united by the common denominator of design culture and shared inspiring principles. IED teaching methods require that all the schools, forge strong bonds with the local industry in their regions; interface with their benchmark sectors; evolve depending on the growth standards of their underlying employment possibilities

Generally speaking IED courses are student-based programs, applying "learning by doing" philosophy and differentiating from others due to the practical expertise that students acquire making them ready for an active career as soon as they graduate. Talking about visual art area, the lecturer pool that IED has created for its students allows them to face techniques, approaches, concepts and to be updated about tendencies that are used, realized and recognized in each relevant field. IED academic board relies on a number of nationally and internationally recognized professionals: this is our main access to all the contemporary trends, the most important source of

As a school with an international vocation, the Istituto Europeo di Design welcomes students with different nationalities and cultures to all its campuses. Some 2,000 foreign students – primarily from the Far East, Central and South America and Europe – enroll in its courses every year.

innovation and knowledge. With the development of the digital technology, visual arts and communication platforms have lately become deliciously intricate and exciting. Every day new communication tools make new media more interactive and engaging.

The peculiarity of IED programs is they are the result of a training offer that is developed in a continuous relation among different fields, integrating the latest tools/technologies, the project culture and methodology with a sensibility towards Visual Communication and its representations.

WHAT ARE THE TOP 3 PROGRAM FEATURES THAT MAKE YOUR PROGRAMS STAND OUT?

1. IED programs aim to fill the gap between available study paths and the ever-more demanding professional world, particularly in terms of acquired/practical experiences and skills. The peculiarity of studying design, fashion, visual arts and communication in IED is the involvement of experts during the whole study path. Lecturers are professionals and therefore able to update programs in real time. IED academic offer is the perfect balance among design, fashion, arts, and cultural studies that are enriched by spots on visual language, semiotics and business and the strong emphasis on an applicable theoretical content that require dedication to techniques and processes.

2. One of the main remarkable features lands in the cross disciplinarily — especially related to design methods — and special projects that

As a result of the IED's constant, active relationship with the business world, more than 200 firms contribute in various ways every year to its student training programmes.

challenge students — from different departments — to work together on a team to develop a real assignment.

Special attention will be given to New Media aspects and to the latest frontiers of digital in communication, in order to create professional figures capable of acting within an evolving scenario.

3. Lessons and classes are very practical and structured as working briefs and workshops. Students work on the basis of real briefs, which are inserted in a context that recreates the dynamics of working companies in multiple contexts, such as communication studios or visual departments within institutions. Further to the methodology, a multidisciplinary involving all the faculties supports the layout. Surely one of the main standouts lands in the cross disciplinary subjects — especially those involved with design methods — and special projects that challenge students from different departments to work together on a team to develop a real assignment.

CAN STUDENTS TAKE COURSES IN OTHER SCHOOLS?

IED courses are usually full-time paths, especially those addressed to the international market, therefore is not possible to attend classes in other schools. However students can always participate IED complete offer of extra labs, lectures and workshops with special guest and professionals, as well as build their own study path (BA courses only) by choosing extra subjects from any other major.

WHAT STEPS DO YOU TAKE TO EVALUATE STUDENT'S CANDIDACY, APART FROM REVIEWING THEIR CREATIVE PORTFOLIO?

The selection is mainly based on the assessment of the curriculum vitae, motivation letter and portfolio.

Moreover, students could have to take a selection interview carried out in the language of the chosen course, aimed at assessing the skills developed during the learning pathway or the possible professional experiences, the individual talent and the student drive.

A Language Test could be scheduled for those candidates who don't have a proper certificate. The application process in IED is always accompanied by a personal or virtual meeting between the future student and the course coordinator besides the evaluation of the whole documentation including a portfolio and a motivational letter.

WHAT DOES YOUR PROGRAM LOOK FOR MOST IN THE CREATIVE PORTFOLIO DURING ADMISSIONS? WHAT DO YOU THINK MAKES AN A+ PORTFOLIO?

Generally speaking, what we're looking for is a structured portfolio showing a full project development — which is not merely a technical exercise. For Bachelor courses we do not expect our students to have an A+ portfolio when they are applying at IED but just after they are graduated. Strong motivation, deep interest in a specific field, awareness and consciousness about the profession are relevant indicators in the application process for a BA program. A creative presentation of themselves can be a good alternative to a portfolio.

For Masters we expect a whole documentation of all skills relative to design techniques, great accuracy, and a creative potential to be further developed. In general a good portfolio needs to show, not only, proper technical skills in the use of the software and in the graphic composition, but also the ability to use different languages of communication. Furthermore it needs to show a full range of projects developed with a professional approach, where creativity is linked with the technique and represented through the use of media design tools.

FACT!
IED, considered one of the best design schools in Italy, is starting one-year program in luxury brand management at IED Rome and is expected to take prospective students from all over world.

HOW ARE NEW TECHNOLOGIES AFFECTING STUDENTS' CURRICULUMS AND/OR WAYS OF LEARNING/COLLABORATING AT YOUR SCHOOL?

Our technologies equipment grows along with our courses as IED offers students the chance to work on the latest software and hardware releases.

IED students are required to use new techniques during their studies, and using new instruments for the visual documentation of a concept they are elaborating, applying new techniques for business presentations etc.

All programs introduce the major applications needed, also to photography and video-making techniques.

In particular we try to train thorough designers, despite the chosen Major, as the visual communication design figure, today, needs to be particularly dynamic; being not only an expert in Visual Languages, but also a director of Communication Strategies based on the sign that is expressed on physical support in both real locations or virtual

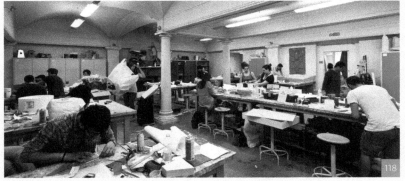

IED Moda Lab: An education and research project keyed to cover transversally every segment of the Italian Fashion Textile Industry that guarantees complete training across 3 specific didactic/professional Areas: Creativity & Design, Image & Communication, Marketing & Product.

environments. For this reason, it is necessary to deal with new technologies and be constantly updated on latest digital tools to offer innovative solutions to clients. Scrollable images, video and audio is becoming a common place to share interactive documents. The professional figure is capable of interacting with multiple clients in different fields thanks to a developed versatility, for this reason, it is necessary to deal with new technologies and always be up-dated on latest digital tools, to anticipate the times and offering innovative solutions to the Market. Our visual courses incorporate creative design and art direction, communication dynamics and creativity developing techniques. Emphasis is given to strategic communication, to facilitate project integrity within the guidelines given by the commissioner.

HOW DOES YOUR PROGRAM HELP GRADUATING STUDENTS WITH INTERNSHIPS OR JOBS? CAN STUDENTS EXPECT JOB PLACEMENT MORE AT YOUR PROGRAM THAN IN OTHERS? IF SO, HOW OR WHY? WHAT KINDS OF JOB OPPORTUNITIES HAVE YOU SEEN STUDENTS TAKE ONCE THEY COMPLETED THEIR DEGREES?

IED has a dedicated placement office that is well connected to a large number of small and big companies supporting graduates and former students during their professional path. Our Career Service submits successful portfolios to interested companies, arranges the selection interviews aimed at activating

internships (or training periods), collaborations, field projects, and ensures constant support activities.

During the study pathway, IED trains students and provides them with the techniques and tools required to write their CVs, to tackle a selection interview and to realize their personal projects portfolio.

The internship is conceived as an on-site learning and training period at one of the companies collaborating with IED. This period allows students to apply the acquired tools and knowledge to a real professional project. In general students are involved in extra-curricular projects that might be transversal with other faculties in which they have the possibilities to meet companies and challenge themselves in order to obtain for instance an internship.

ARE THERE ANY EXCITING DEVELOPMENTS FOR YOUR PROGRAMS THAT STUDENTS SHOULD KNOW ABOUT?

Being an international network IED offers the possibility to create a tailor-made and international path as well for students. Our Bachelor students can also proceed their educational career within IED applying to our Masters that are the best completion of their educational path by a strong emphasis on the

IED is starting a new training program: One Year Course in ART and DESIGN in Milan.

creative development, on the business perspective, and the management of the whole creative process.

Every academic year IED offer its students the possibility to challenge themselves on company projects that are an important real-life scenario experience and further supports the creation of their own network. On the other hand, we update our academic offer every year and we also schedule regular activities — such as workshops, lectures, seminars, visit/participate to exhibitions — around significant and specific topics straightly related to current events, trends and interests.

In each academic programs there are included weeks of cross-disciplinary courses (Special Week) in which students from different classes, structured in mixed groups, work together on a real project starting from a brief provided by the Company. The students, under the supervision of Professors chosen according to the commission, work on the brief during for an entire week and at the end of it realize the final presentation directly to the Company. This is definitely a great opportunity for students to face with real companies and professionals. Last but not least: in 2011 IED got the validation of its undergraduate courses as BA by the Ministries of Education and of Research, both in Italy and Spain. In 2015 has started the validation of IED Master catalogue.

WHAT IS THE BEST ADVICE YOU HAVE FOR STUDENTS ENTERING THE ART & DESIGN FIELD?

Being able to develop a strong creativity demands a reliable background of studies in terms of culture, techniques, and concepts.
We warmly recommend our students to make the most out of the opportunities and group cross disciplinary projects. Learning to collaborate, working on several different grounds, during school years give our students the chance to grow stronger professionals. Find your attitude, enjoy being creative and above all being smart!

by Andrea Tosi, Dean of International Partnership and Innovation

319

DID YOU KNOW?
In collaboration with **Muhammad Yunus, winner of the Nobel Peace Prize in 2006**, *the IED launched a social project focused on sustainable design business. Seven of the IED's best students are allowed to travel for a month with Professor Yunus in Haiti, Albania and Colombia with the goal of improving the lives of the poor, by using local materials and labor to create products and services at fair prices.*

order to guarantee the effective interaction among teaching staff and students, IED has a restricted number of available places to its Undergraduate courses. To be assured of having a place in the class applicants will have to complete the enrollment process. Non-European students are advised to contact as soon as possible the Italian Diplomatic Authorities in their countries for further information on the Pre-enrolment, VISA and language issues, as requirements are often subject to change.

APPLICATION MATERIALS
Online Application

PORTFOLIO REQUIREMENTS
Varies by Program, check online

TRANSCRIPTS
Required

WRITING SAMPLE
Motivation Letter

INTERVIEW
selected by late February

APPLICATION DEADLINES
Rolling until Oct 15

ALUMNI
Olimpia Zagnoli, Illustrator
Nocurves, Artisit
Alessandro Gottardo , Illustrator and Animator
Mauro Fiorese, Photographer
Salvatore Giunta, Graphic designer
Rino Stefano Tagliafierro, Video designer
Manuel Alberto Claro, Photographer
Jennifer El Hage Art director
Max Pirsky, Graphic designer
Anastasia Yakovleva , designer
Rawad Saghir, Designer
Alice Paviotti, Graphic designer
João Pucci, Designer

TIPS
Suggested timing: Applications are open until the beginning of the course (October) however to comply with the Ministerial entry requirements and its strict level of quality, and in

*undergraduate program is a three-year, full-time diploma.

BA:
Visual Arts:
1. Graphic Design
2. Digital and Virtual Design
3. Illustration and Multimedia Animation
4. Photography
5. Sound Design
6. Video Design

Communications:
7. Advertising
8. Marketing and Business Communications
9. Event Design and Management

Design:
10. Industrial Design
11. Interior Design
12. Set Design
13. Furniture Design (hold in English)
14. Garden and Landscape Design (hold in English)

Moda Lab:
15. Fashion Design
16. Jewellery Design
17. Fashion Accessories and Shoe Design

RANKING

DESIGN
#Top 100 European School of Architecture and Design
Domus Magazine

ADMISSIONS OFFICE
Via Pompeo Leoni, 3,
20100 Milano, Italy
+39 (02)-583361

EUROPE • ISTITUTO EUROPEO DI DESIGN

NUOVA ACCADEMIA
DI BELLE ARTI

Milan, Lombardy, Italy

www.naba.it/?lang=en

120

NUOVA ACCADEMIA DI BELLE ARTI
ART & DESIGN

Founded in 1980, NABA is an internationally renowned innovative arts and design academy based in the heart of Milan's design scene. NABA is the largest private educational academy in Italy offering six BA and seven MA courses, all recognised by the Italian Ministry of Education, University and Research (MIUR).

The continued success of NABA over 30 years stems from the multidisciplinary approach of all of our programs and relies upon a well-balanced combination of theory, taught by distinguished teaching professionals and practical work with leading companies and studios. NABA prides itself on its networks with the most prestigious companies and top-level professionals, offering students the unique opportunity to develop their professional artistic competencies whilst preparing them for the world of work. Within one year of graduation 82% of students find jobs.

FACT!
With 2.000 students coming from 60 different countries NABA has a real international feel that adds value and enriches the student experience. NABA proudly promotes intensive educational exchanges with Art and Design universities in Europe, USA, Latin America and Asia.

WHAT MAKES YOUR SCHOOL'S ART & DESIGN PROGRAMS DIFFERENT & UNIQUE FROM OTHER ART & DESIGN SCHOOL PROGRAMS?

NABA was founded in Milan in 1980 upon the private initiative of Ausonio Zappa, Guido Ballo and Gianni Colombo; its objective always was to challenge the rigid academic tradition and introduce visions and languages that are closer to contemporary artistic practices and to the system of arts and creative professions.
Over the past 30 years, NABA has refined a proven instructional method that thoroughly integrates classroom study with

experiential workshop practice. Our multidisciplinary approach combines traditional visual disciplines with new digital technologies and synthesizes individual study with group project work.

We establish numerous collaborations and projects with Italian and international companies and institutions to give students hands-on workplace opportunities to develop their critical thinking, conceptual problem-solving, and practical artistic and design skills.

1. Over 30 years of excellence.
2. Accredited by the Italian Ministry of Education, Universities and Research (MIUR) since 1980.
3. Reputation
4. Exposure to Creative Professional World
5. Unique Curriculum
6. World class facilities

7. Academic Excellence
8. A student-centered mind
9. Diversity
10. Based in Milan, the world fashion and design capital.
11. A dedicated service for job placement after your studies.
12. An International Network.

WHAT ARE THE TOP 3 PROGRAM FEATURES THAT MAKE YOUR PROGRAM STAND OUT?

1. Three-year Bachelor of Arts in GRAPHIC DESIGN AND ART DIRECTION.

Upon completing the three-year BA in Graphic Design and Art Direction, students are sufficiently autonomous and possess the necessary skills to embark on careers in various areas of communication: corporate, advertising and social media strategy. Analytical skills and methods, technical expertise

121

NABA is a member of MANET (Media Art Net), in the development and research of technologies related to media

and creative qualities help them become sensitive to and ready to perceive trends and to respond to new market demands.

2. Three-year Bachelor of Arts in DESIGN.
Inspired by a "learning by doing" philosophy, the three-year BA in Design alternates and integrates theoretical studies with experiential workshops.
During the program, students are challenged by progressively more demanding tests and exercises as they hone their conceptual and technical skills. This accelerates their education and experience and exposes them to the many roles for designers today.
After exploring basic concepts and techniques, students learn to observe the multitude of contemporary forms of design and apply them in their work. The program aims to stimulate sensitivity and passion for the world of objects, understood as cultural artifacts that reflect and shape human life. It explores space as an environment, examining its interactions with objects and its function as a stage for individual and collective rituals.

3. Three-year Bachelor of Arts in FASHION DESIGN.
The goal of the BA in Fashion Design is to prepare students to find a job within the Italian and international fashion system. The program is structured to help the student achieve learning objectives in a coherent and progressive way. Each year, students can take a fun, experimental course focused on coaching and free creativity, from which they gain motivation and passion and discover their personal skills through teamwork. Along with the program, students participate in collaborative projects with companies that give them a realistic experience of professional life. This structure allows students to specialize within different areas of expertise, thus focusing the field of their future job.

CAN STUDENTS TAKE COURSES IN OTHER SCHOOLS?

NABA's International Office assists students wishing to study abroad, including through exchange programmes. The office promotes educational experiences at numerous prestigious international partner universities worldwide that are members and non-members of the Laureate International Universities.
Thanks to this vast international network, students at NABA are able to spend periods of study abroad, enriching their educational curriculum and laying the groundwork for increasingly international future careers.
International study opportunities are mainly provided as part of

the Erasmus+ project promoted by the European Commission, the International Exchange Program for destinations outside of Europe, the Semester Abroad Program at the Laureate group Art & Design Universities and Short Summer Courses.

NABA's partner universities and institutions for the several international programs include: Central Saint Martins College of Art and Design and London College of Fashion in the UK; BTK in Germany; UE Madrid and ELISAVA Escola Superior de Disseny in Spain; Bilgi University in Turkey; Aalto University School of Art and Design and Helsinki Metropolia University of Applied Sciences in Finland; Santa Fe University of Art and Design, NewSchool of Architecture and Design, Pratt Institute, Cornell University, San Francisco State University, West Virginia University in the United States; Pearl Academy of Fashion in India; Kyoto University of Art & Design and Nagoya University of Arts in Japan; UVM in Mexico; Universidad UNIACC and Diego Portales University in Chile; Los Andes Universidad in Colombia; Hongik University in South Korea; Bezalel Academy of Arts & Design in Israel; East China Normal University, Tsinghua University, China Academy of Art, Donghua University, Beijing Normal University, Shanghai University of Engineering Science and Soochow University in China; RMIT in Australia; Media Design School in New Zealand.

FACT!

As member of Laureate Education Institutions, students at NABA can profit of several study abroad opportunities from Erasmus to semester, summer or exchange programs in different location across the world.

WHAT STEPS DO YOU TAKE TO EVALUATE A STUDENT'S CANDIDACY, APART FROM REVIEWING THEIR CREATIVE PORTFOLIO?

International students applying for our bachelor's programs must go through an entry selection process. This helps NABA assess each applicant's motivation and potential for success in his or her chosen field of study. International applicants may choose one of the following options:
1. take an entry exam at the NABA campus in Milan;
2. choose the portfolio assessment option, in which NABA faculty evaluates the applicant's portfolio and motivation letter. This option is available at all times.

The onsite entry exam and portfolio assessment are completed by an onsite or online interview with the faculty of the chosen program.

Non-EU students shall comply

with the pre-enrollment procedures outlined by the Italian embassies in their home countries.

WHAT DOES YOUR PROGRAM LOOK FOR MOST IN THE CREATIVE PORTFOLIO DURING ADMISSIONS? WHAT DO YOU THINK MAKES AN A+ PORTFOLIO?

Creativity is not an abstract exercise, on the contrary, it requires the ability to contextualize elaborate information and look for new solutions with an open spirit capable of listening and interacting.
NABA will evaluate students' capability to take decisions in terms of selection of your works and way to present them together with technical skills already known.
In order to attract talented international students and maintain a diverse international academic environment, NABA provides a number of scholarships reserved to foreign students. Every year, special calls for scholarships are published for bachelor's degrees, master's degrees, and academic master programs.

HOW ARE NEW TECHNOLOGIES AFFECTING STUDENTS' CURRICULUMS AND/OR WAYS OF LEARNING/COLLABORATING AT YOUR SCHOOL?

NABA's campus hosts more than 3000 students from all over Italy and more than 70 foreign countries. Its 13 buildings are located downtown in the Navigli district — one of Milan's most exciting and stimulating areas — in a newly renovated industrial complex with significant architectural value. NABA's superb IT infrastructure, high-tech equipment, and fully equipped labs provide students with every resource for unlimited experimentation and self-expression. Numerous and spacious common areas help to build a strong feeling of community among students and faculty members by fostering invaluable interaction and collaboration.
The NABA campus, which covers approximately 17,000 sqm, includes an atelier and labs for several activities: design, knitwear, fabrics printing and dyeing, 3D printing, computer graphics, sound design. In addition to these, there are also a student lounge area, print and paint shops, and a cafeteria. The library contains books and other media relevant to NABA courses, all students theses from 1980 to the present, DVDs of Italian and foreign films, and magazines about specialized fields of design. Students can search for articles on EBSCO, the premiere online academic database. Lecture notes and supporting materials are available, as well as a complete record of design contests that

Among the Institutions that cooperate with NABA it is worth mentioning Central Saint Martins College of Art and Design (London), Parsons Paris School of Art and Design (Paris), National Institute of Fashion Technology (New Delhi and Mumbai); Chulalong-korn University (Bangkok), Stroganov Academy and Marhi University (Moscow).

students can participate in. NABA's Design Lab is a great resource for the production of models and projects. It is equipped with high-tech machines, tools, and a wide range of materials for the realization of ideas. Fashion students use NABA's Fashion Lab to produce models and prototypes. Fully equipped with sewing machines, mannequins, and irons, as well as leathers and fabrics, the Fashion Lab is where students' designs take shape.

HOW DOES YOUR PROGRAM HELP GRADUATING STUDENTS WITH INTERNSHIPS OR JOBS? CAN STUDENTS EXPECT JOB PLACEMENT MORE AT YOUR PROGRAM THAN IN OTHERS? IF SO, HOW OR WHY? WHAT KINDS OF JOB OPPORTUNITIES HAVE YOU SEEN STUDENTS TAKE ONCE THEY COMPLETED THEIR DEGREES?

The Career Services & Industry Relations Office at NABA offers real and reliable support to help students and alumni find the right career path.

The office represents a bridge connecting academia with the working world, providing students and alumni with opportunities to gain experience and take up challenges by means of internships with leading companies operating in the fields of art, design, fashion, graphics, communication and entertainment.

Through its targeted Career Coaching service, NABA assists students in creating self-promotion tools, offering special services and organizing meetings with external sectoral-specific professionals.

A further tool directed at developing and favoring exchanges between Students-Alumni-School-Companies is Darwinsquare, the on-line platform representing

a showcase for student and alumni curricula vitae and portfolios and where companies can advertise internships and placements and select the profiles that best fit their requirements.

Every year, the Career Services & Industry Relations Office conducts certified and comprehensive market research relating to employment figures in all relevant areas in collaboration with the Demoskopea* Institute of Research.

Our students collaborate with several prestigious companies, including: Armando Testa • Atelier Mendini • BMW • Condé Nast • Diesel - 55DSL• Dolce & Gabbana • Costume National • Emergency • Giorgio Armani • Giugiaro Architettura • Gruppo Cimbali • Gruppo Miroglio • Gruppo Percassi • Gucci • IKEA • Guzzini Illuminazione • J. Walter Thompson • JilSander • Kenzo • La Triennale di Milano • Leo Burnett • Luceplan • Luxottica • Magnolia TV • Magnum Photos • McCann Erickson • Moschino • Ogilvy • Piccolo Teatro di Milano • Pininfarina • Pirelli • Saatchi & Saatchi • Salvatore Ferragamo • Siemens • Sotheby's • The Swatch Group • Teatro alla Scala • Tod's • Trussardi • Veneta Cucine • Versace • Whirlpool • Zanotta

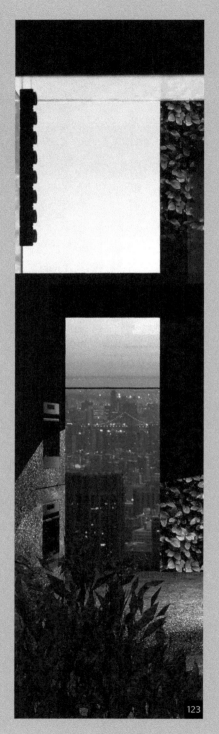

123

FACT!
Laureate Design Universities China Pathway Program. Partnership between LDU and School of Design, East China Normal University (ECNU), one of the most prestigious universities in China.

ARE THERE ANY EXCITING DEVELOPMENTS FOR YOUR PROGRAMS THAT STUDENTS SHOULD KNOW ABOUT?

THE SEMESTER ABROAD PROJECT AT LAUREATE DESIGN UNIVERSITIES

Through the Semester Abroad project with Laureate Design Universities, NABA students have the exciting opportunity to study in the United States or New Zealand—for no extra tuition cost. In Santa Fe, USA, a high-altitude city renowned for its obsession with art and culture, students can focus on film production, fine arts, theatre design, and more. In San Diego, a metropolis bordering the beaches of Southern California, they can study interior architecture and design. And in Auckland, New Zealand, a centre of media arts, they can learn the newest techniques of animation, game art, and interactive design. See the graphic on the next page to match these study abroad options with corresponding degree paths at NABA. Studying abroad is not just a great life experience. It's also a way to make new connections, learn to think in more expansive ways, and cultivate the skills professional designers need.

According to the newspaper Il Sole 24 ORE (23 September 2014), "92% of employers look, in future employees, for the transferable skills that study abroad programs can strengthen."

WHAT IS THE MOST DISTINGUISHED FEATURE AT YOUR SCHOOL?

NABA is unique among all Italian art and design academies. It was the first and private academy accredited by the Italian Ministry of Education, University and Research (MIUR). First and second level academic degrees are legally recognized in Europe and the world over.

The NABA approach has received high accolades from third-party authorities. Magazines such as Frieze, Flash Art, and Kaleidoscope have ranked NABA as a top design school. Domus magazine named it as one of Europe's top schools of architecture and design. NABA was included in Frame Publishers, Masterclass among the 30 World's Leading Graduate Schools in Product Design (2012), Fashion Design (2013) and Interior Design (2014). NABA students have won awards in several international contests, including Who is on Next? Accessories 2012, Orange France vous confié

les clés, Lipton Ice Tea Limited Edition 2012, 55DSL's FiftyFive Fights for the Future, EPDA (European Packing Design Association) contest 2014, Camera Nazionale della Moda Italiana prize 2015, Who is on next? Man Cathegory 2015. They have also taken part into design contests sponsored by the Unesco Seoul Agenda, Premio Nazionale delle Arti, Fondazione Roberto Capucci, and the Milan Chamber of Commerce. NABA students were selected by the Art Directors Club Italiano for the Best of European Design and Advertising 2012 and by Vogue Talents 2012, 2013, 2014 and 2015.

WHAT IS THE BEST ADVICE YOU HAVE FOR STUDENTS ENTERING THE ART, DESIGN & ARCHITECTURE FIELD?
WHAT ROLE DOES THE ARTIST PLAY TODAY?

Contemporary transformations are blurring the traditional borders of art disciplines in favor of a project-driven perspective that attempts to connect art to a broader social context. The artist is becoming more and more a professional capable of playing various roles, carrying out functions connected to the worlds of production and communication. This is the reason why NABA encourages students to develop also skills in self-promotion and organization, in order to gain

easier access to the professional world. They are guided through experimentation with a variety of environments, techniques and methods and supported in finding individual ways of expressing themselves.

by Federica Arrighi, Marketing Communication

DID YOU KNOW?
NABA is proud of a large network of selected academic relationships, among the others with **East China Normal University** *and* **Tsinghua University** *in China and* **Hongik University** *in Korea.*

APPLICATION MATERIALS
Online or through NABA sheet

ENTRY ASSESSMENT TEST
Required

PORTFOLIO REQUIREMENTS
Around 5 pieces, but depends on diffenrt major

DIPLOMA
Valid Secondary School, or min. 12 years of previous global

INTERVIEW
Selected by late February

LANGUAGE REQUIREMENTS
B1 level of Italian

APPLICATIONS DEADLINES
Earliest Date: Oct
Regular Application: Sep

EUROPE • NUOVA ACCADEMIA DI BELLE ARTI

DEGREES
BA:
1. Design
2. Graphic Design and Art Direction
3. Fashion Design
4. Media Design and Multimedia Arts
5. Painting and Visual Arts
6. Theatre Design

RANKING

ART AND DESIGN
#Top 30 World Leading Schools Frame Publishers 2013
#Top 50 Design School Domus Magazine 2014

ADMISSIONS OFFICE
Via Carlo Darwin,
20-20143 Milano, Italy
+39 (02)973721

TIPS
*NABA offers two different kinds of Entry Assessment Tests:
A: Distance evaluation (Artistic Statement+ProjectAssignment)
B: On campus test + Personal Interview (September 15th and 16th, 2016)*

ALUMNI
*Vicky Gitto, Chairman&Chief Creative officer
Miao Ran, Stylist*

UMEÅ UNIVERSITY
Umeå, Sweden
www.uid.umu.se/en

EZGI SABIR
2014 - 2016 / IXD

N. VANIS

124

UMEÅ UNIVERSITY
INDUSTRIAL DESIGN

Umeå University was founded in 1965 and is Sweden's fifth oldest university. The University is a dynamic meeting place where interdisciplinary knowledge is generated and disseminated. Creative environments attract students, resarchers, teachers and collaborating partners nationally and globally. Since Umeå Institute of Design opened in 1989, the school has gained a reputation as a dynamic environment with exceptional possibilities for creative studies.[40]

FACT!
The master programmes are run in English and are open to international students. Scholarships are available for non-EU students.

WHAT ARE THE TOP 3 FEATURES OF YOUR SCHOOL AND PROGRAMS THAT STAND OUT? IS THERE ONE PROGRAM THAT SEEMS TO BE MORE FAVORED THAN ANOTHER PROGRAM?

1. Close collaboration with industry & external partners. Through all of our programmes and courses, we run studio- and team based education in project form with external partners — international, national and local — on issues and problems that our students work with to create design concepts for the future. Project partners during the last years include: Kiska, Skype, Audi, LKAB, Atlas Copco, Philips, Komatsu, and many more.

2. Focus on making. Our students are trained in all kinds of different visualisation and prototyping techniques, and we have excellent facilities and support for everything from manual to digital techniques in sketching and model making: Full woodworking, metal and paint workshops, clay studios, rapid prototyping and full scale milling and an interaction lab with focus on electronics and experiences.

3. People first. In our educations, we base our pedagogy and design process in a strong Scandinavian design tradition focusing on users and users' needs, including social and environmental sustainability as well as

design-for-all-approaches in themes as well as in physical and cognitive ergonomics. We also put people first in the way that we have very open and close collaborations at Umeå Institute of Design, between students as well as between staff and students, since we believe that the best solutions (and the best questions) emerge when people work together in teams rather than on their own.

All of our programmes are very sought after, from Bachelor to Master and PhD level, and also our 1-year intensive course has a high level of applicants. We have in the recent years seen a steady increase in the number of applications to our MFA in Interaction Design.

WHAT STEPS DO YOU TAKE TO EVALUATE A STUDENT'S CANDIDACY, APART FROM REVIEWING THEIR CREATIVE PORTFOLIO? AND WHAT DOES YOUR PROGRAM LOOK FOR MOST IN THE CREATIVE PORTFOLIO DURING ADMISSIONS?

A detailed description of how the different programmes at UID run their admission process can be found at the school's website. A jury of at least 3 persons are involved in the portfolio reviews. After an initial portfolio based selection, the admission processes vary a bit between our different programmes. However, there are always personal interviews made with each short listed applicant, either over Skype or on location. Several programmes also include shorter additional assignments or work samples to be made on-site or IRL over Skype.

What we look for in a portfolio is a solid understanding of the basics of industrial design. We look for different kinds of contents in each portfolio, overall it is the applicant's ability to creatively, factually and systematically express and display their thoughts, work process and final design result in a persuasive and convincing manner. The portfolio should therefore contain samples of the creative thinking process and artistic ability expressed both by freehand sketches and in other media, such as pictures of mock-ups, sculptures, physical and digital models.. Understanding of three-dimensional form is an important skill and therefore should also be documented in the portfolio for students aiming for the programmes focusing on products or transportation, while an understanding of time-based form and the aesthetics of interaction is important to address in applying for the interaction desgin program
In particular we look at how sketching is used as a tool for visualisation, ideation and communication, including the present level of digital skills in

different 2D and 3D software.

We also look at the applicant's previous experience of identifying and addressing identified problems and how they have used form and aesthetics to express and communicate the intended design language of the generated solution. We believe that experience of building either mock-ups, prototyping simple functional models or final presentation models is valuable. Other aspects that are taken into consideration are the applicant's understanding of industrial and post-industrial production and technologies, the ability for creative and maybe even innovative thinking and past experience with both individual and group work. Last but not least, we try to look for what we call "factor X", that is what makes the applicant stand out compare to others and the unique quality that we believe he or she can contribute with to the group.

HOW ARE NEW TECHNOLOGIES AFFECTING STUDENTS' CURRICULUMS AND/OR WAYS OF LEARNING/COLLABORATING AT YOUR SCHOOL?

We work systematically with incorporating the emerging technologies of relevance to the design profession both in our curriculum and in our design research practices.

Making is an integral part of all of our educations, whether prototyping interactions in our Interaction lab or making different kinds of digital or physical models in diverse stages of the design process. Our teaching methods integrate theory and practice in a very hands-on way, not least by basing much of the education on team work and collaborative processes.

HOW DOES THE LOCATION OF YOUR SCHOOL HELP OR AFFECT THE STUDENTS EXPERIENCE AT YOUR SCHOOL?

The location of Umeå Institute of Design in the northern Swedish city of Umeå is, we think, one of the foundations for the success of our school and for the development of both a strong social network, and of the individual talent that we see in our students. Umeå is quite a small city (in Sweden it is considered medium-sized) with 120.000 inhabitants, with a young population and a very dynamic and vibrant cultural scene. The city was the Cultural Capital of Europe in 2014, and hosts several interesting museums, of which at least two have a strong international reputation: the Bildmuseet museum for contemporary art and the Guitars Museum. Musically, the city also has interesting venues for everything from pop, indie

and hardcore scenes to opera and world music — both concert halls, festivals and other venues. However, even thought there is a bit of everything, the cultural offerings are limited in time and space, and allow for our students to concentrate quite intensely on their design studies. The students also spend a lot of their free time at the school, engaging in social activities — including a local student sauna, waffle sessions, pot lucks and parties. Northern lights displays are quite common and students often share the experience of hunting and appreciating them.

HOW DOES YOUR PROGRAM HELP GRADUATING STUDENTS WITH INTERNSHIPS OR JOBS LOCALLY AND INTERNATIONALLY? CAN STUDENTS EXPECT JOB PLACEMENT MORE FROM YOUR DESIGN SCHOOL THAN IN OTHERS? IF SO, HOW OR WHY?

On our Bachelor programme, internships is part of the curriculum, but students need to find placements themselves. On the Master level, the majority of our students will take a year-long study break between year 1 and 2, and go for internships in different companies and consultancies all over the world. Thanks to our extensive network of collaborating partners and alumni, most students have ample opportunities to find interesting internship opportunities all over the

125

Photograph by Elin Berge.

Studio tutoring at UMEÅ Institute of Design. Photograph by Elin Berge.

world. During the last year, our students have been interning at Audi, Apple, BMW, Frog, Google, IDEO, Lego, Microsoft, Tengve, Veryday and many other places.

Our students often have job placements upon graduation, or very shortly thereafter. Recruiters visit our school during the study year, and we also arrange our UID Design Talks each early June, which is a networking hub for the design field world wide. Then, all of our graduating students on all levels present their degree projects to their future colleagues both orally in 3-4-minute presentations and through a degree exhibition, and we arrange portfolio sessions where the graduates present their work to companies and consultancies. Many of our students are offered employment directly in these sessions. So yes, our students have a very high — perhaps higher than in some other schools

— likelihood of job placement, and many students from UID also state that the high employment potential is one of the factors for choosing to study at our school.

FACT!
In all programmes and courses, Umeå Institute of Design cooperates regularly with a number of companies and organizations such as Volvo Cars, Skype, Atlas Copco, Kiska, Umeå Municipality, and many more, several of which are also strongly involved with our research programmes.

ARE THERE ANY EXCITING DEVELOPMENTS FOR YOUR INDUSTRIAL DESIGN PROGRAMS OR SCHOOLS THAT STUDENTS SHOULD KNOW ABOUT?

UID has a strong reputation for being one of the leading educations within the field of industrial design, due to that

340

during our first 25 years we have been very proactive in developing our educations to anticipate needs and practices emerging in society and within the design profession. We are now, in our 27th year, initiating an even more intensified work with identifying what we see as the most important themes and practices within design, and further develop our educations in a way that hopefully leads and pushes development in the field of design practice, design education and in practice-based design research. In this process, our students are highly engaged and active in pushing the agenda and in influencing the future of design education and the design profession.

WHAT IS THE BEST ADVICE YOU HAVE FOR STUDENTS ENTERING THE INDUSTRIAL DESIGN FIELD?

Stay curious! Both in regard to tools, work methods, technology and production techniques, but also to the overall and different directions of industrial design and which of these you want to pursue and master over time.

Prepare for change! The design profession is changing rapidly, and the complexities that a designer will have to address in a future professional design practice are increasing simultaneously with our joint global challenges. With issues of climate change, democratic

processes, demography, migration and changing production methods and consumption patterns, the skills and practices of designers need to not only adapt, but also lead and influence these fields. So as a designer, you will need to be prepared to address the not only big, but huge questions of how you can contribute to shaping a sustainable future for people, for our societies, and for our whole ecosystem, with and through the way you practice design.

by Maria Goransdotter
Vice Rector at Umeå Insitute of Design

APPLICATION MATERIALS
Register at
universityadmissions.se

SUPPLEMENTARY
Letters of Motivation

PORTFOLIO REQUIREMENTS
Porfolio/Home Assignment

TRANSCRIPTS
Required

APPLICATIONS DEADLINES
Earliest Date: Oct 16
Regular Application: Jan 15

EUROPE • UMEÅ UNIVERSITY

Study environment at UMEÅ. Photograph by Elin Berge.

127

DEGREES
BFA: Kandidatprogrammet i Industridesign(In Swedish)

IDI: Industrial Design Intensive
(One year course. Requires a minimum of one year of
previous full-time university studies or 60 ECTS credits.)

MFA:
1. Advanced Product Design
2. Interaction Design
3. Transportation Design

RANKING
ART AND DESIGN
#2 Red Dot Institute 2015

ADMISSIONS OFFICE
Umeå Institute of Design, Umeå University
SE-901 87 UMEÅ, Sweden
+46 (0)90-786-6996

ALUMNI
Alberto Villareal, Lead designer
Bilgi Karan, Designer
Camille Moussette, Interaction
design engineer
Diana Africano Clark, Vice
President design
Tommy Forsgren, Designer
Mike Kruzeniski, Design lead
Özgur Tasar, Senior designer

DESIGN ACADEMY EINDHOVEN
Eindhoven, Netherlands
www.designacademy.nl

128

DESIGN ACADEMY EINDHOVEN
DESIGN

The Design Academy Eindhoven was established in 1947 and was originally named the Akademie Industriële Vormgeving Eindhoven. In 1997, the Academy moved into "De Witte Dame" (The White Lady) building and subsequently changed its name to Design Academy Eindhoven (DAE). In 1999, Li Edelkoort, was elected chairwoman of the Academy. In 2009 she left the Design Academy to pursue personal projects and was replaced by Anne Mieke Eggenkamp as chair. Since 2013 Thomas Widdershoven is chairman. Thomas Widdershoven is founder and designer at Thonik design Amsterdam.

Design Academy Eindhoven is an interdisciplinary educational institute for art, architecture and design inEindhoven, Netherlands. The work of its faculty and alumni have brought it international recognition.

FACT!
Design Academy Eindhoven is the only University of Applied Science (HBO) in the Netherlands that is fully specialised in design.

WHAT MAKES YOUR SCHOOL'S ART & DESIGN PROGRAMS DIFFERENT & UNIQUE FROM OTHER ART & DESIGN SCHOOL PROGRAMS?

The courses at Design Academy Eindhoven are set up to guide students; give them insight into design processes and broaden the way they view this ever-changing world. We want our students to have and develop their own personality, talents, skills and fascinations. We do not box the designer in a field — the exploration of different fields is more important than mastering one craft. With the guidance of design or art experts as well as multidisciplinary collaborations, our students learn to offer alternatives rather than solutions whilst engaging with their surroundings.

WHAT ARE THE TOP 3 FEATURES THAT MAKE YOUR PROGRAM STAND OUT?

The Academy isn't set up in the

129

The Academy has set up its educational model based on social phenomena with man as the focal point. Design is in the service of man and society and social developments are the most important mainsprings for innovative design.

traditional way, where a student becomes a graphic designer, or an interior or fashion designer. Instead, we educate and guide conceptual, hybrid design students — broad in interests, methods, disciplines and talents. This allows a student to experiment, and develop personal views and research into what is current or relevant. Together with a vast network of experts within the field, this is the way our students create endless possibilities — fitting personal style, signature and preference.

CAN STUDENTS TAKE COURSES IN OTHER SCHOOLS?

In the four-year Bachelor course, our students can take part in an exchange program. The Master courses take place in two years' time, which is already quite tight for the content we offer. However, every DAE student — Bachelor or Master — gets the chance to work with other academies, institutions or businesses.

WHAT STEPS DO YOU TAKE TO ELEVATE A STUDENTS' CANDIDACY, APART FROM REVIEWING THEIR CREATIVE PORTFOLIO?

This differs per course; our aspiring Bachelors are interviewed during the admission assessment, where the home assignments and the portfolio are the main topics. In the Master selection, applicants are asked to send

in a personal introduction film to complement their portfolio. Both application procedures are set up to show the personality, process and creativeness of the future student.

WHAT DOES YOUR PROGRAM LOOK FOR MOST IN THE CREATIVE PORTFOLIO DURING ADMISSIONS? WHAT DO YOU THINK MAKES AN A+ PORTFOLIO?

Within potential Bachelor students, we look for original and interesting projects — preferably 3D work as well. But most of all, we look for Bachelors that show unique alternatives and social engagement. For the Masters, DAE seeks for diversity and an analytical view. Stand-out, slick projects are wonderful… However, not being afraid to show failures, or the less pretty steps in the design process — and being able to explain that, tends to impress us more.

HOW ARE NEW TECHNOLOGIES AFFECTING STUDENTS' CURRICULUMS AND/OR WAYS OF LEARNING COLLABORATING AT YOUR SCHOOL?

We stimulate the drive to explore and experiment in our students. They are open to new techniques and experiences as it is often incorporated in their projects through research or development. They lead the quest to combine tech with crafts, virtual with tactile, fast or harsh electronics with the warmth of well-being. That is why we hand our students the tools to discover what is new and

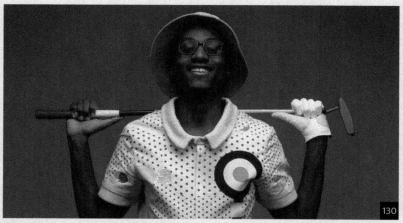

130

Designers who graduate from the Academy are particularly gifted conceptualists. Wherever they end up, whatever they do, their main weapon is conceptual thinking.

relevant in their design process. If we don't have the knowledge at hand, students can reach out to our circle of friends; organizations with expertise.

HOW DOES YOUR PROGRAM HELP GRADUATING STUDENTS WITH INTERNSHIPS OR JOBS? CAN STUDENTS EXPECT JOB PLACEMENT MORE AT OUR PROGRAM THAN IN OTHERS? IF SO, HOW OR WHY? WHAT KIND OF JOB OPPORTUNITIES HAVE YOU SEEN STUDENTS TAKE ONCE THEY COMPLETED THEIR DEGREES?

We have a very hands-on approach to design. Doing an internship is part of the curriculum, so our alumni know what to expect. Working through assignments, and dealing with boundaries such as money or a specific question, is imbedded in the education to prepare our students. After graduation, we keep investing in our alumni v we are a small school and a tight community. So we share – our successes, their successes, interesting job offers and invites for each other's events.

ARE THERE ANY EXCITING DEVELOPMENTS FOR YOUR PROGRAMS THAT STUDENTS SHOULD KNOW ABOUT?

In response to the dynamic field of design, our programs are in a continued process of development — reacting to the changes around us. Currently, the line between concrete and conceptual is something we focus on, revaluing the existing product and the process toward that product. Other keystones in our education are the collaborations with design institutes and government, such as The Ministry of Infrastructure and the Environment and the Veenhuizen Design Deal, but also numerous commercial businesses — for instance energy provider E.On and funeral insurer DELA.

WHAT IS THE MOST DISTINGUISHED FEATURE AT YOUR SCHOOL?

Our annual Graduation Show has grown up to be a world-wide heavyweight, attracting 40.000 visitors during the Dutch Design Week. The Graduation Show exhibits all graduation projects by both Bachelors and Masters, giving an indication of what the future of design entails — but mostly, showing off our talented graduates.
What distinguishes us from other schools is that we are a small academy that teaches solely in design. We think big — but really, we are a close-

knit creative community. Because of the size of the school, teachers and students have a very personal understanding of each other — much less distant than one sees in conventional colleges and universities.

WHAT IS THE BEST ADVICE YOU HAVE FOR STUDENTS ENTERING THE ART, DESIGN & ARCHITECTURE FIELD? WHAT ROLE DOES THE ARTIST PLAY TODAY?

Use your curiosity to question everything around you. If you dare to ask why things work the way they work or do the way they do,
creativity becomes a self-fulfilling prophecy. You could use creativity as a tool to make a change. Start within yourself — be passionate and driven, yet critical of yourself and the world around you. That is a great base to work off — especially when collaborating with fellow designers to expand creativity and capacity.

by Ella Van Kessel, Intern Communication, Publicity and Projects

APPLICATION MATERIALS
Online App

PORTFOLIO REQUIREMENTS
- 5 or more other (3D) works/projects
- your portfolio
- a simplified printed copy of your portfolio

*Hometests

TRANSCRIPTS
Required

WRITING SAMPLE
General Questions on App.

INTERVIEW
Required 15 mins
Feb 29, Mar 1-4

RECOMMENDATION LETTERS
Not necessary

ENGLISH PROFICIENCY
IELTS: 6.0

APPLICATION DEADLINES
Rolling: Nov 1

EUROPE • DESIGN ACADEMY EINDHOVEN

DEGREES

UNDERGRADUATE:
Bachelor of Design

GRADUATE:
1. M.Des Contextual Design
2. M.Des Social Design
3. M.Des Information Design.

ADMISSIONS OFFICE
Emmasingel 14,
5611 Eindhoven, Netherlands
+31 (40)-239-3939

DID YOU KNOW?
The **home assignment** consists of two parts:
1. Mandatory small assignment
2. Choose one of the five big home assignments
A. Mandatory small assignment for all candidates
ONE EURO: Well-designed / Poorly-designed
Buy a 'well designed' product for 1 Euro and buy a 'poorly designed' product for 1 Euro. You have one minute in total to explain why the products you have chosen are 'well designed' or 'poorly designed'.

ALUMNI
Piet Hein Eek, Artist,
Maarten Baas, Designer,
Hella Jongerius, Designer,
Joris Laarman, Designer,
Jerry van Eyck, Architect

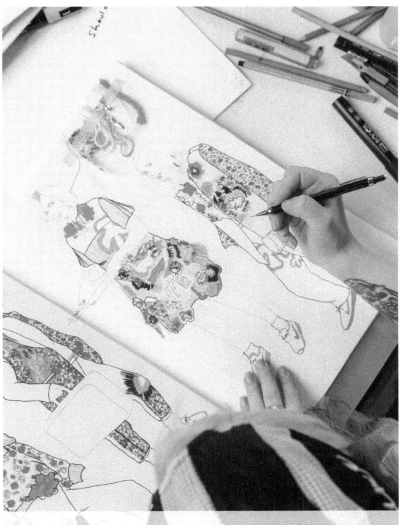

UNIVERSITY OF
THE ARTS LONDON (UAL)
London, United Kingdom
www.arts.ac.uk

131

UNIVERSITY OF THE ARTS LONDON (UAL)

UAL is made up of six renowned Colleges: Camberwell College of Arts; Central Saint Martins; Chelsea College of Arts; London College of Communication; London College of Fashion and Wimbledon College of Arts.

Each College offers a wide range of pre-degree, undergraduate and postgraduate courses in art, design, fashion, media, communication and performing arts. Located in the heart of London, UAL is Europe's largest specialist art and design university with a diverse community of over 19,000 students from more than 140 countries worldwide.

FACT!

UAL is Europe's largest specialist art and design university.

WHAT MAKES YOUR SCHOOL'S ART AND DESIGN PROGRAMS DIFFERENT AND UNIQUE?

Six unique Colleges make up UAL, each with a history dating back to the 19th or early 20th centuries and a reputation for work of outstanding quality. Each College boasts specialist facilities, including public galleries, spectacular performance venues and workshops equipped with industry-standard technology. UAL students have access to a range of learning resources — including archives and special collections, with items dating from the 15th century to the 21st — and can borrow materials from all of the College libraries.

UAL's Colleges offer over 200 courses at pre-degree, undergraduate and postgraduate level. Courses span 14 subject areas: 3D design and product design; Accessories, footwear and jewellery; Animation, interactive, film and sound; Architecture and spatial design; Business & management, and science; Communication and graphic design; Curation and culture; Fashion design; Fine art; Illustration; Journalism, PR, media and publishing; Photography; Textiles and materials; Theatre, screen and performance design.

UAL is home to more than 19,000 students from over 140

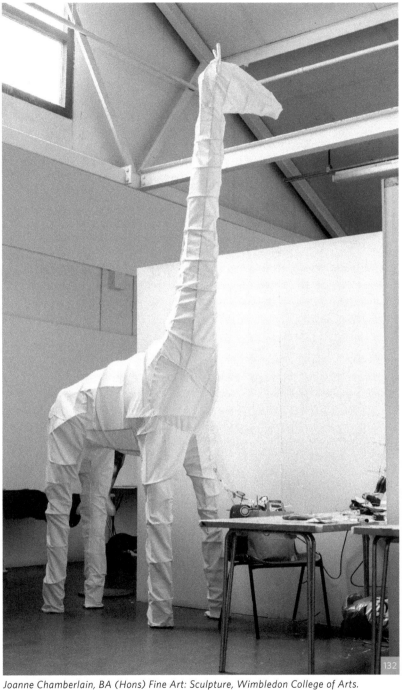

Joanne Chamberlain, BA (Hons) Fine Art: Sculpture, Wimbledon College of Arts.
Photo credit: Courtesy of UAL

countries. It's a place to meet new people, try new things, discover unexpected talents and live in one of the world's most exciting and creative cities.

HOW ARE NEW TECHNOLOGIES AFFECTING STUDENTS' CURRICULUMS AND WAYS OF LEARNING AND COLLABORATING AT YOUR SCHOOL?

Each of our Colleges provides its own culture, philosophy and focus, and our academic staff bring their interests and expertise to their courses. Styles of teaching range from well-established traditional methods to those which embrace the very latest technologies. Technology is embedded throughout UAL — from the award-winning Kings Cross home of Central Saint Martins which opened in 2011 and Wimbledon College of Arts' new sustainable studio building which opened in 2014, to the specialist industry-standard equipment and facilities available across the university.

WHAT STEPS DO YOU TAKE TO EVALUATE A STUDENTS' CANDIDACY, APART FROM REVIEWING THEIR CREATIVE PORTFOLIO?

Entry requirements differ depending on the course. The course pages on the UAL website (arts.ac.uk) are the best place to find up-to-date information.

Most courses require a certain level of academic achievement and a personal statement detailing relevant ambitions, skills and experience.

Not all courses require a portfolio, but when applying for a course in a practice-based subject like fine art, graphic design and other hands-on disciplines, a portfolio is the most important part of the application.

WHAT MAKES A STRONG APPLICATION PORTFOLIO?

A portfolio should start and end with a student's strongest pieces of work and should show how their skills and ideas have developed over time. It should demonstrate creativity, personality, ability and commitment. It is important to demonstrate variety and development of work, as well as final pieces. A student's recent work is always the most interesting and relevant.

HOW DOES UAL HELP GRADUATING STUDENTS WITH INTERNSHIPS OR JOBS? WHAT KIND OF JOB OPPORTUNITIES HAVE YOU SEEN STUDENTS TAKE ONCE THEY HAVE COMPLETED THEIR COURSE?

UAL has a track record for launching and furthering careers. Armed with a UAL qualification, graduates could follow the path of many alumni to become a

Solveig Rocher-Purchase, BA (Hons) Illustration, Camberwell College of Arts.
Photo credit: Courtesy of UAL

world-leader in their field. 89% of recent graduates are undertaking further study or are working.

UAL jobs websites and databases include CSM Talent Scout and LCF Careers Live, which give top names in business and the art and design world access to emerging graduate talent, and allow students to forge impressive networks. The Careers and Employability team equips students with the skills to develop their own practice, business or employment prospects. Artsmart Graduate Career Fair and Creative Enterprise Week are initiatives which support the prospects of UAL students and graduates.

Recent graduate jobs include practising artists, user experience designers, journalists and fashion designers.

WHO WOULD YOU SAY ARE THE MOST FAMOUS UAL ALUMNI?

UAL graduates can be found in every part of the creative and cultural sectors, from leading global businesses to working as self-employed practitioners. They are celebrated with awards ranging from the Turner Prize to the Oscars.

Some of UAL's more famous alumni include: fashion designer Christopher Kane (Central Saint Martins), actor Tom Hardy (Central Saint Martins — Drama Centre London), sculptor Anish

134

Hyeri Lee, BA (Hons) Cordwainers Fashion Bags and Accessories — Product Design and Innovation, London College of Fashion. Photo Credit: Courtesy of UAL

Kapoor CBE (Chelsea College of Arts), playwright Kwame Kwei-Armah (London College of Communication), and footwear designer Sophia Webster (London College of Fashion).

WHAT IS THE BEST ADVICE YOU HAVE FOR STUDENTS ENTERING THE ART AND DESIGN FIELD?

Make the most of your time at UAL — attend everything, try everything, join in everything, volunteer for anything, explore UAL, enjoy London.

DID YOU KNOW?
• All four 2015 Turner Prize nominees were UAL alumni or staff, and half of all Turner Prize winners are UAL alumni.
• The 2015 Catlin Guide named ten UAL students in their list of most promising graduate artists. Since the Catlin Guide started in 2010, 55 UAL graduates have been included.
• Over half of the designers named British Designer of the Year are UAL graduates.
• Eight Oscar winners, 14 BAFTA winners and two Palme d'Or winners are UAL alumni.

GOLDSMITHS
UNIVERSITY OF LONDON
London, The United Kingdom

www.gold.ac.uk

135

GOLDSMITHS UNIVERSITY
BA FINE ART & HISTORY OF ART

Goldsmiths, University of London was founded in 1891, and The University of London acquired the new Institute and re-established it as Goldsmiths College in 1904.

Goldsmiths, University of London was founded in 1891 as Goldsmiths' Technical and Recreative Institute by the Worshipful Company of Goldsmiths in New Cross, London. It was acquired by the University of London in 1904 and was renamed Goldsmiths' College. The word College was dropped from its branding in 2006, but "Goldsmiths' College", with the apostrophe, remains the institution's formal legal name.

FACT!
Rank #1 in London for high quality and helpful staff 2014 - Times Higher Education Student Experience Survey

WHAT MAKES YOUR SCHOOL'S ART & DESIGN PROGRAMMES UNIQUE,

AND DIFFERENT FROM OTHER SCHOOLS' PROGRAMMES?

On the BA Fine Art Degree: Studios contain students from all three years of the programme. Studios are not segregated according to discipline — people engaged in painting, sculpture, installation, performance, video and film making, and a wide variety of other practices work alongside each other. No projects are set; all students have a studio space and develop their own, self-initiated work with regular tutorial contact, group tutorials and presentations. Time in workshops and laboratories is arranged and organised on a one-to-one basis. In addition to individual and group tutorials all students attend larger, day-long Convenors. At these they not only present and discuss their own work, but also contribute to critical discussion of others' work.

Critical Studies lecture and seminar courses, with their associated essays and dissertation, are an integral

element of the BA Fine Art programme. Critical studies accounts for 25% of the overall degree. On the Joint Honours Degree Fine Art comprises 50% of the degree and Art History 50%. Art History is taught in another department in the college — the Department of Visual Cultures. Fine Art studio practice is organised along the same lines as in Single Honours (students have their own studio space and so on from year one), but the time with Fine Art staff is slightly shorter as the students are talking 2 Art History courses per year in the Department of Visual Cultures at Goldsmiths.

HOW ARE NEW TECHNOLOGIES AFFECTING STUDENTS' CURRICULA AND/OR WAYS OF COLLABORATING/LEARNING AT YOUR SCHOOL?

New technologies are having a considerable impact on the ways in which students research, discuss, develop and realise their work. As one indication of this, an electronics lab has recently been added to the range of facilities available to students. Social media inevitably play a useful part in sustaining contact and debate.

WHAT ARE THE TOP 3 PROGRAMME FEATURES THAT MAKE YOUR PROGRAMME STAND OUT?

BA Fine Art: Mixed year and mixed discipline studios with your own space from day one; strongly student-centred programme, with no projects set; convenors.

Joint Hons: the equal weighting of fine art practice with rigorous study of modern and contemporary Art History

136

The Goldsmiths shops on New Cross Road will be redeveloped, and we'll create space for new business and enterprise.

and Theory. Students are expected to be serious artists as well as researchers, developing an interdisciplinary / expanded practice in fine art and writing.

CAN STUDENTS TAKE COURSES IN OTHER SCHOOLS?

BA Fine Art is a full time, fully integrated programme. It is not necessary to acquire credits by taking other courses. Nonetheless, where a student has a particular interest it is possible to attend lectures in other departments.

Joint Hons students can take 1 course in another department in Goldsmiths in their second year (English, History, Anthropology eg). In reality however, they rarely do, as the course is very full time and there are many course options already in the Department of Visual Cultures.

WHAT STEPS DO YOU TAKE TO EVALUATE A STUDENT'S CANDIDACY, APART FROM REVIEWING THEIR PORTFOLIO?

The work in the portfolio is the most important element of a candidate's application. Their personal statement can also be taken into account, as may their academic reference. School grades are much less significant. Applicants are asked to upload an online portfolio. All portfolios

137

The Anomalistic Pscyhology Research Unit was established by Professor Chris French in 2000 to provide a focus for research activity in the area of Anomalistic Psychology.
In general terms, Anomalistic Psychology attempts to explain paranormal and related beliefs, and ostensibly paranormal experiences in terms of known or knowable psychological and physical factors.

are reviewed, and a portion of candidates invited to interview — either in person or via Skype. The portfolio (including any work made since the original application was made) will also provide the focus of the interview conversation. Interviews are conducted by two tutors and a current student. All applicants to the undergraduate programmes must complete a one-year Foundation course (or have equivalent experience). We do not prescribe where the Foundation should be done, but for overseas students the college does have its own one year course, called BA Fine Art (Extension). Successful completion of the Extension course allows for automatic progression onto whichever undergraduate programme (BA Fine Art, or BA Fine Art & History of Art) the student wishes. Students who choose to do their Foundation elsewhere would apply to the programme while on that course. Applications direct from school are not considered for entry onto undergraduate programmes. Such applications made by overseas students are referred to the Extension course.

WHAT DOES YOUR PROGRAMME LOOK FOR MOST IN THE CREATIVE PORTFOLIO DURING ADMISSIONS? WHAT DO YOU THINK MAKES AN A+ PORTFOLIO?

We are looking for a portfolio that conveys a sense of the passions, curiosities and interests of the candidate. It is more important they include a selection of work that demonstrates their own enthusiasms than for them simply to show that they are competent across a range of technical skills. Much work in a portfolio is likely to have been made in response to the setting of a project. We are keen to see evidence of those occasions where a candidate has gone beyond the requirements of the brief and taken it further for their own satisfaction.

FACT!

The university has a distinguished history of contributing to arts and social sciences. Its Department of Art is widely recognised as one of Britain's most prestigious, producing the YBA's art collective and over 20 Turner Prize nominees

HOW DOES YOUR PROGRAMME HELP GRADUATING STUDENTS WITH INTERNSHIPS OR JOBS? CAN STUDENTS EXPECT JOB PLACEMENT MORE AT YOUR PROGRAMME THAN AT OTHERS? IF SO, HOW OR WHY? WHAT KINDS OF JOB OPPORTUNITIES HAVE YOU SEEN STUDENTS TAKE ONCE THEY HAVE COMPLETED THEIR DEGREES?

Sessions on life beyond graduation are organised for all

students. The programme does not organise job placements for students. As well as going on to establish a professional practice as an artist, or to postgraduate study, recent graduates are now working in galleries and museums, in film making and production, in social media and software development, in theatre and dance, as musicians and in the music industry, in fashion, 2D, 3D and digital design, in journalism, marketing, research, and many other areas.

For Joint Honours students the Visual Cultures Department has a 2nd year course option called 'Visual Cultures as Public Practice' where students can arrange bespoke research placements in organisations over the summer. The focus is on archival research, and students are then required to write about their experience as well as feed that on the groundwork into a term-long follow up academic course in their 3rd year.

All Fine Art students regularly organise exhibitions of their own work with fellow students and others in spaces around London and elsewhere, usually in their second and third years. These are self-initiated, though strongly encouraged by programme staff. The experience gained through these activities is often key to setting up self-organised studio groups, events and exhibitions immediately after graduation.

WHAT IS THE BEST ADVICE YOU HAVE FOR STUDENTS ENTERING THE ART AND DESIGN FIELD? AND WHAT DO YOU THINK IS THE ROLE OF THE ARTIST TODAY?

It is for the students to show us what the role of the artist is today, rather than for us to make them conform to what we think it is.

ARE THERE ANY EXCITING DEVELOPMENTS FOR YOUR PROGRAMMES THAT STUDENTS SHOULD KNOW ABOUT?

The Department of Art is currently developing a gallery. Designed by the Turner Prize-shortlisted practice Assemble, this will expand learning opportunities for all students, as well as increasing the scope of what are already strong connections to the wider international art world.

*by Michael Archer
Programme Director of
Fine Arts*

DID YOU KNOW?
At Goldsmiths we aim to recognise and nurture talent. **7 of our students have been Turner Prize winners and a further 24 have been shortlisted.** *Among these is Steve McQueen, the first black director to win Best Picture Oscar for his 2014 film 12 Years A Slave.*

138

Goldsmiths is pleased to be the University Sponsor for Mulberry University Technical College (UTC). The UTC is a new 14-19 co-eduational school with a unique employer led curriculum in Creative, health and digital technologies.

APPLICATION MATERIALS
Online through UCAS
(Universities and Colleges
Admissions Service)

SUPPLEMENTARY
PORTFOLIO REQUIREMENTS
12 pieces

TRANSCRIPTS
Required

INTERVIEW
selected by late February

APPLICATIONS DEADLINES
Earliest Date: Sep 1
Regular Application: Jan 15
Intrenational Application: Jan 30

TIPS
Portfolio should consist of original artwork and/or documentation in the form of, for example, photographs and films. Students at Goldsmiths are expected to work very independently. Applicants portfolio should therefore indicate not only what you have studied, but also what motivates you.

Applicants should include a range of works that show areas of independent enquiry that are emerging in your art practice. Goldsmiths is interested in seeing students ability to go beyond the requirements of a given brief: for example, your working process and your visual curiosity. Please only include work that is central to your practice and concerns.

139

The Centre for Creative And Social Technology (CAST) aims to foster interdisciplinary research and collaboration around technology and its relation to society and creative practice. In particular it draws together social science and cultural research with computing research and arts practices.

DEGREES

ART DEPARTMENT
BA:
1. Fine Art
2. Fine Art & History of Art
3. Fine Art (Extension Degree)

DESIGN DEPARTMENT
BA: Design

RANKING
#6 CUG Rank's 2016
#12 CUG Rank's 2015
#Top 5 UK Universities for Art & Design QS World Rank

ADMISSIONS OFFICE
Lewisham Way, New Cross,
London SE14 6NW, United Kingdom
+44 (0)20-7919-7171

ALUMNI
Steve McQueen, Actor
Damien Hirst, Artist
Liam Gillick, Conceptual artist
Sarah Lucas, Artist
Yinka Shonibare, Artist
Bridget Riley, Painter
Lucian Freud, Painter

ROYAL COLLEGE OF ART
London, The United Kingdom
www.rca.ac.uk

140

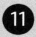

ROYAL COLLEGE OF ART
DEPARTMENT OF ARCHITECTURE

The Royal Academy Schools form the oldest art school in Britain. They offer a three-year postgraduate art course to students.

The Royal Academy Schools was the first institution to provide professional training for artists in Britain. The Schools' programme of formal training was modeled on that of the French Académie de peinture et de sculpture, founded by Louis XIV in 1648.

FACT!

The Royal Academy does not receive financial support from the state or the Crown. Its income is from exhibitions, trust and endowment funds, receipts from its trading activities, and from the subscriptions of its Friends and corporate members.

WHAT MAKES YOUR ART PROGRAMS DIFFERENT FROM OTHER SCHOOLS PROGRAMS?

1. The school of architecture is located in the world's number 1 university of Art & Design, according to the 2015 QS World University Rankings by subject

2. The programme draws on a broad intake on students that is characterized by its maturity, independence and experience in other art and design fields

3. There is a powerful tradition of making and live projects in the Architecture school and across the college.

4. The school has a rich studio culture in which individual students have the opportunity to explore alternative forms of architectural practice.

CAN STUDENTS TAKE COURSES IN OTHER SCHOOLS?

1. Every design studio runs workshops that draw on the diverse material and intellectual resources available across the college. Students have the opportunity to take classes in everything from digital fabrication to ceramics and printmaking to photography and animation.

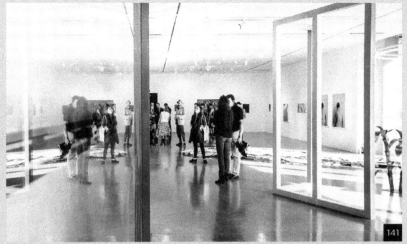

141

InnovationRCA provides business coaching and incubation services to students and graduates to help them protect and commercialise pioneering design-led ideas through company formation or licensing.

2. Every year we host Across RCA, which is an opportunity to work collaboratively with students from every disciplinary area in the college.

WHAT KIND OF JOB OPPORTUNITIES HAVE YOU SEEN STUDENTS TAKE ONCE THEY COMPLETED THEIR DEGREES?

Students primarily go on to work in architectural practice. The RCA is unique in encouraging an expanded view of architectural practice with students going on to work in interaction design, service design, art practice, set design and product design.

HOW ARE NEW TECHNOLOGIES AFFECTING STUDENTS'

CURRICULUMS AND/OR WAYS OF LEARNING/COLLABORATING AT YOUR SCHOOL?

1. The school is unique because its pedagogy does not separate out 'technical' 'social' or 'cultural' forms of research or design interest. This is an artificial split that architectural education has inherited from its past but is no longer relevant.
2. We are interested in the way that important challenges that spring from outside the institution re-organize the way that we teach, learn and practice as architects.

WHAT ARE THE TOP 3 PROGRAM FEATURES THAT MAKE YOUR PROGRAM STAND OUT?

1. A rich, experimental

373

studio culture
2. The opportunity to work across multiple areas in art and design
3. The long-term relationships established while at the RCA with future leaders in art and design.

CANDIDACY, APART FROM REVIEWING THEIR CREATIVE PORTFOLIO?

We look for maturity, independence and initiative in the way that the student has pursued their career.

WHAT DOES YOUR PROGRAM LOOK FOR MOST IN THE CREATIVE PORTFOLIO DURING ADMISSIONS?

Evidence of creativity, design ability and critical intelligence in the portfolio is by far the most important characteristic in making any assessment of a candidate.

WHAT STEPS DO YOU TAKE TO EVALUATE A STUDENTS'

HOW DOES YOUR PROGRAM HELP GRADUATING STUDENTS WITH INTERNSHIPS OR JOBS? CAN STUDENTS EXPECT JOB PLACEMENT MORE AT YOUR PROGRAM THAN IN OTHERS? IF SO, HOW OR WHY?

One of the enduring qualities of the RCA is the strength of the network of students both past and present across many different art and design fields that students will form life long working relationships with.

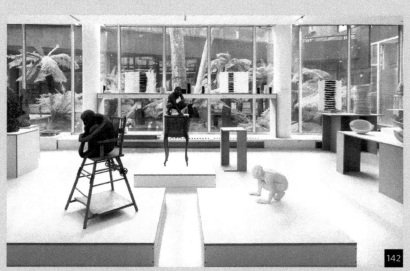

142

From 2010-13, five of the world's top ten exhibitions with the highest daily attendance were held at the RA, including David Hockney RA: A Bigger Picture, The Real Van Gogh and Anish Kapoor RA. In 2015, nearly 400,000 visitors came to see Ai Weiwei..

ARE THERE ANY EXCITING DEVELOPMENTS FOR YOUR PROGRAMS THAT STUDENTS SHOULD KNOW ABOUT?

1. The programme is developing a more intense set of ADS offerings in which every studio orchestrates a rich environment of internal and external relationships, professional partnerships and collaborations with industry.
2. A new and comprehensive workshop calendar that formalizes opportunities for engagement outside of the school of architecture with other disciplines in the RCA.
3. An expansion of the live project and making projects.
4. A new student led council that fosters student led initiatives in the school.
5. A new seminar programme that brings together world leading researchers and practitioners to discuss major global challenges.

HOW DOES THE LOCATION OF YOUR SCHOOL AFFECT STUDENTS' CREATIVE EXPERIENCE?

1. The RCA School of architecture is fortunate to be located in London, the city with the most design expertise in the world.
2. Its location in South Kensington is within walking distance to the V&A gallery and the Serpentine Museum.

WHAT IS THE BEST ADVICE YOU HAVE FOR STUDENTS ENTERING THE ART & DESIGN FIELD?

1. Find the best teachers and most inspiring mentors you can.
2. Build a culture with your collaborators.

Royal College of Art —
Department of Architecture
Dr. Adrian Lahoud, Head
of Architecture

FACT!
Membership of the Royal Academy is composed of up to 80 practising artists, each elected by ballot of the General Assembly of the Royal Academy, and known individually as Royal Academicians (RA, or more traditionally as R.A.). The Royal Academy is governed by these Royal Academicians. The 1768 Instrument of Foundation allowed total membership of the Royal Academy to be 40 artists.

DID YOU KNOW?
The digital and the material within architecture are viewed inclusively, as extensions of each other, and impact-in-the-world. Staff research pursues this integration in collaboration with internal and external research

375

*partners in two main subject areas: **fabrication**, which includes digital fabrication, advanced timber components and sustainable construction, and **public space**, which includes digital urbanism, ecological urbanism, and flood adaptation and mitigation.*

APPLICATION MATERIALS
Online App

PORTFOLIO REQUIREMENTS
Depends on each program

TRANSCRIPTS
Required

WRITING SAMPLE
Personal Statement

INTERVIEWS
By Invitation only

RECOMMENDATION LETTERS
1 Teacher or Counselor

APPLICATIONS DEADLINES
Priority Deadline: Jan 13
Portfolio Deadline: Jan 22

TIPS
The assessment will consider: creativity, imagination and innovation evident in the work; ability to articulate the intentions of the work; intellectual engagement in relevant areas; appropriate technical skills; overall interview performance, including oral use of English.

ALUMNI
DrMM(Alex de Rijke), Architect
Gollifer Langston, Architect
David Webster, Partner of IDEO
Adam and Alan, Nexus productions
David Hockney, Artist

RANKING
#1 Art & Design QS World Ranking 2015
#1 Art School artnet news 2015
#1 Fashion Design Business of Fashion 2015

ADMISSIONS OFFICE
Kensington Gore,
London SW7 2EU, United Kingdom
+44 (0)20-7590-4444

MA:
SCHOOL OF ARCHITECTURE
1. Architecture
2. Interior Design
3. Mres Rca: Architecture Pathway
4. Architecture Research

SCHOOL OF COMMUNICATION
1. Animation
2. Information Experience Design
3. Visual Communication
4. Communication Research
5. Mres Rca: Communication Design Pathway

SCHOOL OF DESIGN
1. Design Interactions
2. Design Products
3. Global Innovation Design
4. Innovation Design Engineering
5. Service Design
6. Vehicle Design
7. Mres Rca: Design Pathway
8. Mres Healthcare & Design
9. Design Research

SCHOOL OF HUMANITIES
1. Critical & Historical Studies
2. Critical Writing In Art & Design
3. Curating Contemporary Art
4. V&A/Rca History Of Design
5. Mres Rca: Humanities Pathway
6. Humanities Research
7. The Peter Dormer Lecture

SCHOOL OF FINE ART
1. Contemporary Art Practice
2. Painting
3. Photography
4. Print
5. Sculpture
6. Mres Rca: Fine Art Pathway
7. Fine Art Research
8. Visual Cultures Lecture Series
9. Dyson Gallery: Rise Up & Envision Exhibition Series

SCHOOL OF MATERIAL
Ceramics & Glass
Jewellery & Metal
Fashion Menswear
Fashion Womenswear
Textiles
Material Research
Footwear, Accessories & Millinery Specialisms

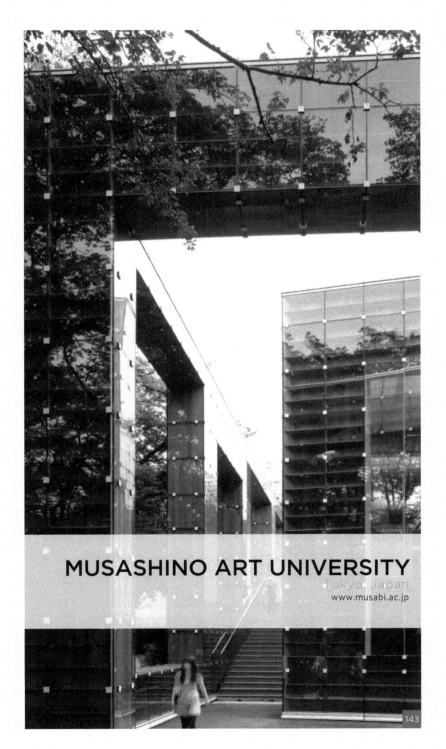

MUSASHINO ART UNIVERSITY
Tokyo, Japan
www.musabi.ac.jp

143

MUSASHINO ART UNIVERSITY
COLLEGE OF ART AND DESIGN

Musashino Art University (MAU) located in Tokyo, marked the 80th anniversary of its foundation on 2009. MAU was founded as a private art school and was officially designated as a university in 1962. Currently MAU is one of the leading art institutes in Japan, with over 4,500 students and 3,000 correspondence students.[44]

FACT!
Tuition ranges from $17,500 to $20,000 yearly for both local and international students

WHAT MAKES YOUR DESIGN PROGRAMS DIFFERENT & UNIQUE FROM OTHER SCHOOLS PROGRAMS?

Striving to train graduates with both general skills and skills in specialized fields, we offer a well-rounded curriculum whereby students take courses in general education and special fields other than their own, as well as courses in their own program.

WHAT ARE THE TOP 3 PROGRAM FEATURES THAT MAKE YOUR PROGRAM STAND OUT?

Choosing a list of top three features would be difficult. Each of the 11 programs offers distinctive strengths.

WHAT STEPS DO YOU TAKE TO EVALUATE A STUDENT'S CANDIDACY, APART FROM REVIEWING THEIR CREATIVE PORTFOLIO?

International students must take the Examination for Japanese University Admission for International Students (EJU) on the Japanese language and sit for an interview.

CAN STUDENTS TAKE COURSES IN OTHER SCHOOLS?

Subject to certain restrictions, students may choose to take courses within other departments or at other institutions.

ARE THERE ANY EXCITING DEVELOPMENTS FOR YOUR PROGRAMS THAT STUDENTS SHOULD KNOW ABOUT?

In 2012, we became the only art university in Japan to be selected for the Ministry of Education, Culture, Sports, Science and Technology's Project for Promotion of Global Human Resource Development.

WHAT DOES YOUR PROGRAMME LOOK FOR MOST IN THE CREATIVE PORTFOLIO DURING ADMISSIONS? WHAT DO YOU THINK MAKES AN A+ PORTFOLIO?

This varies from program to program. Most design-related undergraduate programs assess actual works.

HOW DOES YOUR PROGRAM HELP GRADUATING STUDENTS WITH INTERNSHIPS OR JOBS? CAN STUDENTS EXPECT JOB PLACEMENT MORE AT YOUR PROGRAM THAN IN OTHERS? IF SO, HOW OR WHY? WHAT KINDS OF JOB OPPORTUNITIES HAVE YOU SEEN STUDENTS TAKE ONCE THEY COMPLETED THEIR DEGREES?

The Career Team provides a full range of support in areas such as portfolios, seminars to facilitate job searching, and face-to-face counseling. The support has, alongside a curriculum that helps students gain broad-ranging general skills, enabled us to retain one of the highest graduate employment rates of art universities in Japan. While most graduates choose careers in creative positions — for example, becoming designers — others choose careers in education or management.

HOW ARE NEW TECHNOLOGIES AFFECTING STUDENTS' CURRICULA AND/OR WAYS OF COLLABORATING/LEARNING AT YOUR SCHOOL?

The Design Lounge in Roppongi frequently hosts design seminars, exhibitions, and events organized in partnership with businesses.

WHAT IS THE BEST ADVICE YOU HAVE FOR STUDENTS ENTERING THE ART & DESIGN FIELD?

All things and spaces that are not natural objects were built, designed, or otherwise created. The fields of endeavor open to art university graduates are limitless. The creativity needed to create new things not yet seen will become even more important in the years to come.

by Tanikawa Minori, Admissions and Public Relations

ASIA • MUSASHINO ART UNIVERSITY

APPLICATION MATERIALS
Take entrance examination, and register online through www.musabi.ac.jp/wp-content/uploads/2015/08/2016_foreign_guideline_0904.pdf. (Available only in Japanese)

ENTRANCE QUALIFICATIONS
Japanese as a Foreign Language score from the Examination for Japanese University Admission for International Students (EJU)

ENTRANCE QUALIFICATIONS
High school or completed 12 years of education

APPLICATION DEADLINES
Regular Application: Dec 20

TIPS
For evaluation, each department conducts examinations in technical skill. Technical skill varies from drawing, painting, writing essays, etc. depending on the department. Acceptance is based on the applicant's overall score consisting of the technical skill score, interview score, and the Japanese language score of EJU. The EJU score is valid only if within two years of application deadline.

MAU consists of the College of Art and Design (undergraduate) which encompasses eleven departments, the Graduate School (MA, PhD), and the Correspondence Course (undergraduate).

DID YOU KNOW?
Musashino Art University develops collaborations in various forms with **business entities, local governments, and other groups**. *ie: joint project with MIZUNO, YAMAHA, Dentsu, etc.*

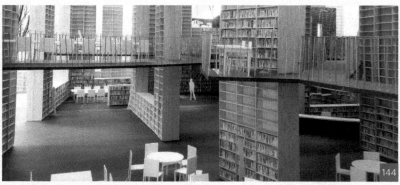

The Musashino Art University Library is in fact a library made of bookshelves. Sou Fujimoto's vision of combining searchability and strollability into one system is translated into a spiral shape, in the center of the building, covered with wooden shelves.

COLLEGE OF ART AND DESIGN
BA:
1. Japanese Painting
2. Painting
3. Sculpture
4. Visual Communication Design
5. Industrial, Interior and Craft Design
6. Scenography, Display and Fashion Design
7. Architecture
8. Science of Design
9. Imaging Arts and Sciences
10. Arts Policy and Management
11. Design Informatics
12. Correspondence Course

ADMISSIONS OFFICE
Musashino Art University Center for Admission
1-736 Ogawa-Cho, Kodaira-shi, Tokyo 187-8505, Japan
+81 (42)-342-6021

ALUMNI
Shinro Otake, Designer
Kenya Hara, Automotive designer
Satoshi Wada, Art director
Shinya Nakajima, Art director
Chie Morimoto, Anime and Cartoon director
Satoshi Kon, Motion-picture Production designer
Yohei Taneda, Architect
Yoshifumi Nakamura, Product designer
Fumie Shibata, Designer
Toru Narita, Sculptor
Noe Aoki, Film Director
Shinsuke Sato, Storyteller
Taihei Hayashiya, Illustrator
Miura, Illustrator
Lily Franky, Model
Kiki, Columnist and Artist
Nameko Shinsan, Artist

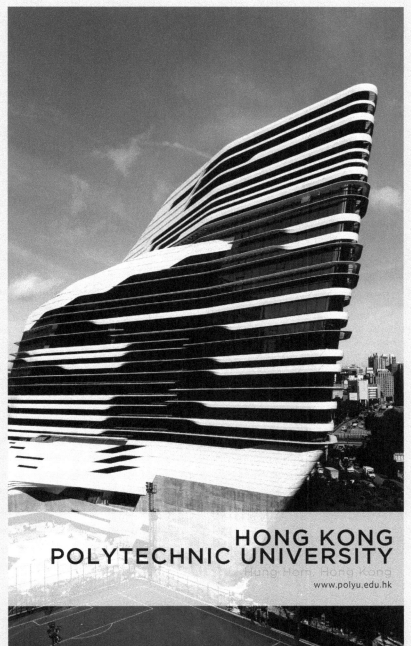

HONG KONG
POLYTECHNIC UNIVERSITY
Hung Hom, Hong Kong

www.polyu.edu.hk

145

POLYTECHNIC UNIVERSITY
DESIGN

The story of The Hong Kong Polytechnic University can be traced back to the founding of the Government Trade School in 1937. The BA(Hons) Scheme in Design welcomes students from all over the world to apply. The scheme offers students a design education that is attuned to new trends and is sensitive to change. The School encourages its students to think critically, learn independently and in teams, experimenting with dynamic, multilayered design processes to weave culture and industry strands into appropriate social narratives.

FACT!

The School's research and academic programmes are governed by our core values: 1. Developing an Open Mind Frame; 2. Steering Positive Change; 3. Establishing Visionary Entrepreneurship; 4. Practicing Authentic Expression; and 5. Designing Responsibly.

WHAT MAKES YOUR DESIGN PROGRAMS DIFFERENT

& UNIQUE FROM OTHER SCHOOLS' PROGRAMS?

The PolyU Design has an excellent setting in the East-meets-West culture in Hong Kong. With its close proximity to Mainland China and the rest of Asia, Hong Kong is one of the most dynamic, prosperous and safe metropolitan cities of China and the world. At PolyU, you will be exposed to both English and Chinese, the most widely spoken languages of the world and the former is the official teaching medium. You will gain knowledge and understanding of the culture, society and people of China, and meet people from all around the world. With China's emergence as the world's focal point of economic development, such exposure will create a competitive edge for our students' future development. The School's vicinity to the world's manufacturing centre allows students to be exposed to manufacturing in a way no one else can.

Our faculty is one of the most internationally mixed in the world. The team has strong industry experience, conduct research in a specialised area and bring these skills into the classroom. The highly internationalized mix of faculty and students from different cultural backgrounds has set up a strong network with many top schools around the world and provides exchange opportunities for students to explore.

The School provides a high level, well equipped environment that includes significant research infrastructure with eight laboratories and a variety of first class technical workshops in the Jockey Club Innovation Tower — a landmark building designed by Zaha Hadid.

PolyU is the only government-subsidised university offering a full spectrum of programmes in design at undergraduate, master's and doctoral levels in Hong Kong.

WHAT ARE THE TOP 3 PROGRAM FEATURES THAT MAKE YOUR PROGRAM STAND OUT?

1. Design thinking for social development.
2. Creative outlook articulated through a critical appreciation of technology.
3. The rich diversity of its international design culture.

CAN STUDENTS TAKE COURSES IN OTHER SCHOOLS?

In addition to the major study, the students are required to complete 30 credits of General University Requirements which may be offered by other departments in various topics.

Students can also take extra 18 credits from another department for Minor Study, and/or other free electives which do not bear any credits.

Our students are encouraged to join the Exchange Programme and explore the world, while students from the following collaborators are welcome to join us as inbound exchange students:
1. Aalto University, Finland
2. Weissensee School of Art, Berlin, Germany
3. Buckinghamshire New 4. University, United Kingdom
4. Cornell University, USA
5. Delft University of Technology, The Netherlands
6. TH Köln Technology, Arts and Sciences, Germany
7. Konstfack, University of College of Art, Craft and Design, Sweden
8. Lahti University of Applied Sciences, Finland
9. Politecnico di Milano, Italy
10. Northumbria University, United Kingdom
11. Osnabrück University of Applied Science, Germany
12. Ryerson University, Canada
13. Swinburne University,

Australia
14. The Ohio State University, USA
15. The University of Edinburgh, United Kingdom
16. Tongji University, China
17. University of Art and Design Helsinki, Finland
18. University of Arts London, LCC, United Kingdom

FACT!
The School has over 1400 students and is the only government-funded university offering design education from undergraduate to doctoral levels in Hong Kong.

WHAT STEPS DO YOU TAKE TO EVALUATE A STUDENT'S CANDIDACY, APART FROM REVIEWING THEIR CREATIVE PORTFOLIO?

Those who meet our entrance requirements will be invited to submit a portfolio, and the shortlisted applicants will be invited to a telephone or Skype interview.

HOW DOES YOUR PROGRAM HELP GRADUATING STUDENTS? HOW ARE NEW TECHNOLOGIES AFFECTING STUDENT'S CURRICULA AND/OR WAYS OF

146

TEND TO ZERO by **Eva Chan & Long Kwok - BA(Hons) in Design (Industrial & Product)** *A collection of stationary that takes care of your everyday essentials. Magnetic points help to keep all the pieces together. Made of special water-resistant paper and hidden ferrite magnets.*

COLLABORATING/LEARNING AT YOUR SCHOOL?

3D scanning technology has contributed to our product design students for their study of ergonomics. It helps them to create design works in creative 3D printing application.

WHAT DOES YOUR PROGRAMME LOOK FOR MOST IN THE CREATIVE PORTFOLIO DURING ADMISSIONS? WHAT DO YOU THINK MAKES AN A+ PORTFOLIO?

1. Personal projects on top of school assignments (sketches, illustrations, posters, photo essays, short films, science experiments, tinkering, handicrafts, models, or any constructed structures, etc.)
2. Documentation of project processes
3. Creativity and authenticity of creative intentions
4. Curiosity and personal approaches/views on social and cultural aspects of everyday life

WHAT IS THE BEST ADVICE YOU HAVE FOR STUDENTS ENTERING THE ART & DESIGN FIELD?

Potential applicants need to realise the best asset of a designer is his/her ability to discern value in the everyday, so as to enhance people's material lives. A willingness to engage with social and cultural realities beyond consumer dynamics is paramount to today's design practice.

FACT!
Number of partner/collaboration institutions
Overseas: 310+

WITH INTERNSHIPS OR JOBS? CAN STUDENTS EXPECT JOB PLACEMENT MORE AT YOUR PROGRAM THAN IN OTHERS? IF SO, HOW OR WHY? WHAT KINDS OF JOB OPPORTUNITIES HAVE YOU SEEN STUDENTS TAKE ONCE THEY COMPLETED THEIR DEGREES?

To prepare students for a smooth transition from the PolyU Design to the design profession, we invite collaborators to participate in two kinds of Work-Integrated Education: Co-operative Workshop and Summer Internship.

Internship is a credit-bearing subject to be taken during summer months. It is compulsory for BA(Hons) Scheme in Design Year 2's or Year 3's.

Co-operative workshops provide third year students with opportunities to join collaborative projects sponsored by clients in both the commercial and non-profit sectors. Held over nine weeks between September and

November, the Workshops feature students from different disciplines addressing a mutually agreed design brief.

Our graduates are 100% employed. They work in corporations, government, educational institutions, design agencies, firms, or set up their own startup companies.

WHAT DO YOU THINK IS THE ROLE OF THE DESIGNER TODAY?

Designers shape culture (literally), and facilitate the application of technology to benefit human development. Designers hence have the responsibility to argue for every design they produce in a way that is convincing and contributes to socially fair and progressive cultural transformation.

by Anita Law
Professor de Bont

APPLICATION MATERIALS
Online or email Academic Secretariat at
asnlocal@polyu.edu.hk

INTERNATIONAL STUDENTS
GCE A-level / International A-level or International Baccalaureate (IB)

ENGLISH REQUIREMENTS
TOEFL or equivalent English standard scores

PORTFOLIO REQUIREMENTS
10 pieces with portfolio information sheet

TRANSCRIPTS
Required

INTERVIEW
Oct- May

APPLICATIONS DEADLINES
Earliest Consideration: Nov 26
Regular Consideration: Jan 15
Extended Consideration: Mar 15

TIPS
Use the enclosed information sheet to clearly mark your portfolio on the outside before you submit it.
All the work inside the portfolio should also be marked with your name and application number just in case they get separated from your portfolio

DID YOU KNOW?
*The University logo is developed from the **well-established symbol**. "P" for Polytechnic and "U" for University. The image of "T" for technical excellence.*

DEGREES

SCHEME IN DESIGN
BA:
1. Advertising Design(Hons)
2. Communication Design(Hons)
3. Environment and Interior Design(Hons)
4. Product Design(Hons)
5. Fashion and Textiles (Hons) Scheme
6. Art and Design in Education
7. Digital Media
8. Interactive Media

RANKING

#8 QS World's Top Universities 2014-2015
#9 U.S.News 2015

SCHOOL OF DESIGN
#3 BusinessWeek Top 3 Design Schools in China 2009
#8 QS World's Top Universities 2014-2015

ADMISSIONS OFFICE

Hong Kong Polytechnic University the
Academic Secretariat Service Centre
Room M101, Li Ka Shing Tower
Hung Hom, Kowloon, Hong Kong
+852 2334-6671

ALUMNI
Raman Hui, Animation designer
Freeman Lau, Artist
Vivienne Tam, Fashion designer
Eric Chan, Product designer
Anthony Lo, Automotive designer
Yip Kam-Tim, Film
Dennis Chan, Jewelry designer

NATIONAL TAIWAN
NORMAL UNIVERSITY

Taipei City, Taiwan

www.en.ntnu.edu.tw

147

NATIONAL TAIWAN NORMAL UNIVERSITY
COLLEGE OF ARTS

The College of Arts at National Taiwan Normal University (NTNU) was established in August, 1982 on the merger of the Department of Fine Arts and the Department of Music (both previously under the College of Liberal Arts), and the Department of Industrial Arts Education (currently Department of Technology Application and Human Resource Development). Incepted in 1947, the Department of Fine Arts enjoys the longest history among art higher education institutions in the country and boasts top-notch faculty members. The College strives to strengthen interdisciplinary cooperation among its departments and centers through support and complementary measures. As part of the plan, the College will work to combine art creation and theory studies with our prestigious tradition, multi-faceted contemporary view and international visions.[46]

FACT!
The Department of Arts is the first art institute in Taiwan.

WHAT MAKES YOUR SCHOOL'S ART & DESIGN PROGRAMS DIFFERENT & UNIQUE FROM OTHER ART & DESIGN SCHOOL PROGRAMS? WHAT ARE THE TOP 3 FEATURES?

1. Our program features thorough grounding in drawing skills and courses that focus on the application of art and technology.
2. We provide interdisciplinary courses and projects that integrate different design disciplines.
3. The arts education and historic research courses we provide are considered the best in Taiwan.

CAN STUDENTS TAKE COURSES IN OTHER SCHOOLS OR MAJORS?

Yes, all students can take courses in other schools or majors.

WHAT STEPS DO YOU TAKE TO EVALUATE A STUDENTS'

The building of Department of Fine Arts houses the well-appointed Teh-Chun Art Gallery, purpose-designed classrooms, a library with an extensive collection, and other teaching facilities including large plaster models imported from Europe.

CANDIDACY, APART FROM REVIEWING THEIR CREATIVE PORTFOLIO?

We evaluate a student's candidacy through interviews to see their personality. We believe that students with good learning ability, positive attitude, and curiosity are the best fit for our program.

FACT!

The College has preserved works created by previous graduates with substantial quantity and quality and can serve as a significant reference in the research of development history of Taiwanese arts since Taiwan's restoration from Japan in 1945. In view of the importance in preserving the collections, the College set up the Research Center for Conservation of Cultural Relics and a restoration lab at the Department of Fine Arts to engage in important domestic and overseas arts and crafts restoration projects

WHAT DOES YOUR PROGRAM LOOK FOR MOST IN THE CREATIVE PORTFOLIO DURING ADMISSIONS? WHAT DO YOU THINK MAKES AN A+ PORTFOLIO?

An A+ portfolio should has unique style, shows clear working process, and includes experimental works.

HOW ARE NEW TECHNOLOGIES AFFECTING STUDENTS' CURRICULUMS AND/OR WAYS OF LEARNING/COLLABORATING AT YOUR SCHOOL?

We arrange workshops and projects that integrate different new technologies.

ARE THERE ANY EXCITING DEVELOPMENTS FOR YOUR PROGRAMS THAT STUDENTS SHOULD KNOW ABOUT?

We focus on international exchange opportunities for students in recent years , for example, providing exchange programs for students.

HOW DOES YOUR PROGRAM HELP GRADUATING STUDENTS WITH INTERNSHIPS OR JOBS? CAN STUDENTS EXPECT JOB PLACEMENT MORE AT YOUR PROGRAM THAN IN OTHERS? IF SO, HOW OR WHY? WHAT KINDS OF JOB OPPORTUNITIES HAVE YOU SEEN STUDENTS TAKE ONCE THEY COMPLETED THEIR DEGREES?

The office of career development in our school help graduated students to get internship or job opportunities.
The employment situation is different between the department of arts and the department of design. Due to the employment market in Taiwan , the employment rate of department of design is relatively higher. Most graduates from department of arts turn out to be full-time artists, teachers or be running art studio.

WHAT IS THE MOST DISTINGUISHED FEATURE AT YOUR SCHOOL?

Our College is the oldest higher institute of Arts in Taiwan and is seen as the headstream of Taiwan's art history. We have work collections of famous artists which they made when they were still students and the Research Center for Conservation of Cultural Relics in our school is an important institute in Taiwan for preserving artworks and cultural relics.

WHAT IS THE BEST ADVICE YOU HAVE FOR STUDENTS ENTERING THE ART, DESIGN & ARCHITECTURE FIELD?

Be curious, passionate, and bold enough to try experimental works.

by Chun-liang Lin
Dean of College of Arts

PORTFOLIO REQUIREMENTS
At least 10 works
*printed in A4 size

TRANSCRIPTS
Required

REFERENCE LETTERS
Not required

INTERVIEW
Not required

APPLICATIONS DEADLINES
Fall Term: Mar 15
Chinese as a Second Language
Deadline: Mar 16

Spring Term: Oct 31

CHINESE PROFICIENCY
Level 2 on Test of chinese as a
Foreign Language(TOCFL)

TIPS
Admitted students should take TOCFL to level 3 and level 4. Those who not reach should take Chinese language courses as required. *Contact Mr. Luo for more information: design@ deps.ntnu.edu.tw or call at +886-2-7734-5584*

The college established an international print-making center in 2014 to promote the international exchange of printmaking arts and actively sets up a dedicated fine arts museum with modern equipment to provide top quality exhibition space and exchange platform for international arts exhibitions and performances.

150

NTNU Arts Festival, an annual festival held in Mar-Jun, is a key event in a series of art activities hosted by the College of Arts.

DEGREES
BFA:
1. Fine Arts
2. Design

RANKING
#1 Taiwanese Universities International Outlook 2015
#22 Asian Universities QS World University Rankings 2015

ADMISSIONS OFFICE
National Taiwan Normal University
162, Section 1, Heping E. Rd.,
Taipei City 106, Taiwan
+886 (2)-7734-1111

ALUMNI
Teh-Chun Chu, Artist
Kuo-Sung Liu, Artist
De-Jinn Shiy, Artist
Shiou-Ping Liao, Artist
Hui-Kun Chen, Artist
Pai-Sui Ma, Artist
Hsin-Yu Pu, Artist
Jun-Bi Huang, Artist
Shih-Chiao Lee, Artist
Qin-Bo Jin, Artist
Yu-Shan Lin, Artist
Chia-chin Sun, Artist
Shan-Hsi Cheng, Artist
Ching-Jung Chen, Artist
Yinhui Chen, Artist
Kun-Pei Li, Artist
A-Sun Wu, Artist
Ming-Shian Jiang, Artist
Keung Szeto, Artist
Chin-Lung Huang, Artist
Hsien-Fa Su, Artist
Pang-Soong Apex Lin,
Graphic designer

Chun-Liang Leo Lin,
Graphic designer
Ken-tsai Lee, Graphic designer
Ming-lung Yu, Graphic designer

Lee Rou Xuan

NANYANG ACADEMY OF
FINE ARTS

Singapore, Singapore

www.ntu.edu.sg

151

15

NANYANG ACADEMY OF FINE ARTS
SCHOOL OF ART AND DESIGN

Established in 1938, the Nanyang Academy of Fine Arts (NAFA) is Singapore's pioneer arts education institution, well-known for grooming diverse artistic talent. Through research-based practice and experiential learning, NAFA nurtures creative talent who lead at the forefront of both traditional and contemporary art practices. The academy offers full-time diploma and degree programmes across three schools: the School of Art and Design (which offers studies in fine art, design and media, fashion studies and 3D design), the School of Music (which offers classical Western and Chinese music studies) and the School of Arts Management, Dance and Theatre.

The NAFA School of Art and Design (SOAD) is one of the schools under the Academy. It offers multidisciplinary learning through its four programmes: 3D Design, Design & Media, Fashion Studies and Fine Art. SOAD takes the lead in contributing to the contemporary arts and design education with focuses on creative expression, technical competencies, integrative practices and critical thinking.[47]

FACT!

More students are opting for arts qualifications, going by figures at the Nanyang Academy of Fine Arts (Nafa), one of two publicly funded tertiary arts schools here. The school had 816 students enrolled in its diploma programmes last year, up from 714 in 2014 and 641 in 2013. The number of applications it received also grew from 1,238 in 2013 to 1,348 last year.

WHAT MAKES YOUR SCHOOL'S ART PROGRAMS DIFFERENT & UNIQUE FROM OTHER ART & DESIGN SCHOOL PROGRAMS?

NAFA provides a holistic and creative environment to allow collaboration and inter-disciplinary learning to take place.

The curriculum is designed to cultivate a strong foundation in fundamental art and design skills before students progress to their respective choice of discipline. In the first year, students will develop knowledge and skills across different

media, apply critical thinking and research methodologies with historical, cultural, social and technological perspectives. They will be exposed to different disciplines and discover new areas of interest.

Offering a practice-led and industry-focused curriculum — the latter years of study focus on developing discipline-specific technical skills and competencies that aim to help students meet new and evolving career demands. Our part-time lecturers bring currency and industry relevance to students' learning, and we incorporate 'live' projects in the curriculum.

WHAT ARE THE TOP 3 PROGRAM FEATURES THAT MAKE YOUR PROGRAM STAND OUT?

1. Several modules are designed common across all progammes, which makes the transfer of courses easier, should a student change his or her mind at the end of the first year.

2. Our curriculum offers a range of electives that students can decide what they wish to learn. These electives can either be within the same programme (depth of learning) or across programme (breath of learning).

3. Besides training students to be creative, a large of the learning is on the making process; students thus often are expected to produce prototypes, or work within simulated parameters to develop their design proposal.

CAN STUDENTS TAKE COURSES IN OTHER SCHOOLS?

Yes. Students can opt to take modules across other schools under the Student-Specific Requirement (which takes up 15% of the curriculum).

As a school which started humbly in 1938 with 14 Fine Art students, NAFA has been at the forefront of arts education development in Singapore for more than 70 years and continues to chart new frontiers.

FACT!

NAFA Arts Kindergarten (NAK) is the first and only Arts Kindergarten in Singapore. Just like its senior affiliate, Nanyang Academy of Fine Arts, NAK provides arts education in music, art and dance. NAK aims to achieve teaching excellence in grooming children into refined young talents dedicated in every pursuit of their lives.

WHAT STEPS DO YOU TAKE TO EVALUATE A STUDENT'S CANDIDACY, APART FROM REVIEWING THEIR CREATIVE PORTFOLIO?

We evaluate a students' academic performance as well as his or her artistic abilities. For the latter, he or she will either submit a portfolio or sit for an admission test. All applicants are expected to provide a written statement that will give insights on their aspirations and potential to undertake an arts course. A student will also be awarded bonus points if he or she has demonstrated active participation or dedication in the arts or arts-related activities.

WHAT DOES YOUR PROGRAM LOOK FOR MOST IN THE CREATIVE PORTFOLIO DURING ADMISSIONS? WHAT DO YOU THINK MAKES AN A+ PORTFOLIO?

We look for portfolios that display creative visualization of ideas, the ability to think out-of-the-box, and their interpretation of questions posed. We seek individuals who demonstrate aptitude in the articulation of design, their thought process, personal aesthetic and flair for the discipline that they are applying for.

153

NAFA celebrated its Diamond Jubilee in 2013. It was a major milestone in our history and heritage.

HOW ARE NEW TECHNOLOGIES AFFECTING STUDENTS' CURRICULUMS AND/OR WAYS OF LEARNING/COLLABORATING AT YOUR SCHOOL?

Technology has helped to make learning more engaging. Students, for instance, may be asked to read lessons posted online before coming to class for discussions; or they may be expected to go online to post blogs on a topic they have been asked to research on. More importantly, technology is paving ways for students to take more ownership on their learning and training them to be more independent.

HOW DOES YOUR PROGRAM HELP GRADUATING STUDENTS WITH INTERNSHIPS OR JOBS? CAN STUDENTS EXPECT JOB PLACEMENT MORE AT YOUR PROGRAM THAN IN OTHERS? IF SO, HOW OR WHY? WHAT KINDS OF JOB OPPORTUNITIES HAVE YOU SEEN STUDENTS TAKE ONCE THEY COMPLETED THEIR DEGREES?

NAFA has an Office of Student Care & Internship which offers both career advice and also administers internships opportunities for our students. The Academy has an internship portal that serves both the industry and NAFA students in match-making work placements. Students often get employment from their internship employer after graduation as companies are also more favorable to graduates with some working experience. Linking students to the industry for internships and engaging companies on real-life projects help students to build confidence, experience and networking skills. As it is a very challenging industry, every opportunity counts.

ARE THERE ANY EXCITING DEVELOPMENTS FOR YOUR PROGRAMS THAT STUDENTS SHOULD KNOW ABOUT?

The school regularly invites practitioners and industry partners to conduct talks and workshops, so that students are exposed to the latest developments and trends in the creative profession. We would also be initiating more overseas programs, with the aim to let students acquire a more globalized perspective in their learning.

WHAT IS THE MOST DISTINGUISHED FEATURE AT YOUR SCHOOL?

The Institute of Southeast Asian Arts (ISEAA), established in April 2010, promotes a distinct practice-led research in both visual and performing arts. The ISEAA works with the three Schools in NAFA, and through practice-led research

and activity, aims to benefit students and faculty primarily through organized workshops and talks.

In addition, the Institute also forms a network of different partners in Singapore and the Southeast Asian region, representing the spectrum of visual, performing and management arts to formulate broad-based collaborative projects with individuals, groups of artists and students.

WHAT IS THE BEST ADVICE YOU HAVE FOR STUDENTS ENTERING THE ART, DESIGN & ARCHITECTURE FIELD? WHAT ROLE DOES THE ARTIST PLAY TODAY?

Students will need to think out of the box and set new trends with the mind-set to improve peoples' lives, while being socially responsible at the same time.

They will need to be patient, be persistent, and never stop learning.
Beyond just enriching lives, art, design and architecture have a greater role to invigorate lives and to change the way we see things, the way we live (hopefully for the better).

Do not stop learning and do not be afraid of mistakes and setbacks. Be a Risk taker, be a Leader in their field and be worldly

by Ms Sabrina Long Chin Ling Dean, School of Art & Design Emma Goh, Manager of Corporate Communications, Outreach & Media Relations

APPLICATION MATERIALS
Online, post or hand delivery

PORTFOLIO REQUIREMENTS
15-20 examples

PERSONAL STATEMENT AND WRITING SAMPLES
4 questions. Around 500 words

SUPPLEMENTARY CREATIVE PROJECTS
Address the concept of "risk"

SUPPLEMENTARY VISUALS
3 pieces

TRANSCRIPTS
Required

APPLICATION DEADLINES
Regular Application: Mar-Apr
International Application:
Oct 15

DEGREES
SCHOOL OF ART, DESIGN AND MEDIA
BFA:
1. Digital Animation
2. Digital Filmmaking
3. Interactive Media
4. Photography and Digital Imaging
5. Product Design
6. Visual Communication

RANKING

World University
#13 QS Ranking, 2015

Universities in Asia
#2 QS Ranking, 2015
#6 U.S.News, 2015

ADMISSIONS OFFICE AND FINANCIAL AID
Nanyang Academy of Fine Arts
80 Bencoolen St,
Singapore 189655
+65 (6512)-4000

ALUMNI
Melvin Ong, 3D designer
George Budiman, 3D designer
Kenneth Zhang, 3D designer
Thomas Yang, Head of
Art&Design, DDB
Wang Fei, OgilvyOne Beijing,
Head of Art
Max Tan, Founder of MAX.TAN
Tan Yoong, Fashion designer
Ming Wong, Artist
Susie Lingham, Artist
Chua Mia Tee, Artist
*Mohammed Zulkarnaen Bin
Othman*, Artist

CHAPTER 4
TALKS WITH CREATIVES

ANGIOLA CHURCHILL

Artist & First Female Full-Time Professor, Chair of New York University's Dept. of Art

New York, NY, USA

Angiola Churchill is a professor emeritus of New York University and former Head and Chair of the Department of Art and Arts Professions - 1975-2005. She's the Founder and director of the NYU studio art program in Venice, 1974-2006, and co-director of the International Center for Advanced Studies in Art, as well as Professor at Teacher's College in Columbia University. She is author of the classic text, Art for Preadolescents, and an artist exhibiting both in the US and abroad.

AS THE FIRST TIME FULL-TIME FEMALE PROFESSOR AT NYU DURING THE 1960S, HOW DID YOU MANAGE AND RUN THE NYU ART DEPARTMENT FOR 15 YEARS?

I started to teach in 1958 at NYU, and then I became the Chair of the Department of Art & Art Education around 1976 until 1991. For a number of years, I was the first female full time professor in the art department. There were definitely problems I ran into being the only female. I don't think they — The men understood how to act around nor me around them or to take me seriously. I started the first NYU study abroad program in Venice, which I ran for 30 years. Also, in Venice I work with Jorge Glusberg the former Director of the Museum of art in Buenos Aires, we develop in New York ICASA (International Center for Advanced Studies in Art), which lasted 20 years.

HOW DID YOU COME UP WITH MAKING A MASTER'S DEGREE PROGRAM 40 YEARS AGO IN VENICE? AT THAT TIME NO ONE THOUGHT ABOUT VENICE BECAUSE IT WASN'T A PARTICULARLY

154

POPULAR DESTINATION, SO HOW DID YOU CHOOSE VENICE OVER OTHER CITIES?

First of all, I'm of Italian parentage, also spent the first 12 years of my life in Italy. Later, I used to go to Italy every summer to Lake Como on vacation with my family. One summer, I was told by my boss, at School of Education, N.Y.U. Dean Griffiths, to research and start a program in Italy, this in the middle of my sabbatical. I was not thrilled and left the job to do until my last 2 weeks in Italy. Starting from Milan, I explored all the major cities of sea region of Lombardy and Veneto cities. Until I reached Venice, it was there that I met with Dr. Russo in the prestigious Palazzo Grassi on the grand canal. I had no idea that I would eventually set up the program in Venice, but I was offered the palace for the program and the Dean of NYU said take it. The Masters program in Studio Art consisted of 3 summers of 6-week sessions. The first two summers in Venice, and the third and final summer in New York City.

The other program I started was ICASA, a graduate program built on a 2-3 day conference; masters and doctoral students applied for it. Jorge Glusberg and I would invite 10-15 people from all over the world to participate, and I would have public events for local artists and our students.

At that time, SoHo was the place where all artist lived, Mr. Glusberg and I wanted them to have the opportunity to meet their international fellows and artists, so the conferences were open to them for 3-days at N.Y.U. free of charge. We had to put guards at the door, after 500 people no one else could come in because it was a hazard.

The panelists who came to talk would

stay for a couple weeks. We would have 6 week sections for Masters and Doctoral students to meet with them a year in New York City.

YOU DID MANY MUSEUM SOLO SHOWS, BUT WHICH ONE LEFT A LASTING IMPRESSION OR WAS AN IMPORTANT SHOW FOR YOU?

The ones that got the most national attention was in Museo di Palazzo Fortuni Venice, and then the exhibits in Palazzo di Diamonti, Ferrara and Palazzo Reale, Naples. I owe much to those who assisted me in my various shows: Lola Bonora, Fiorella la Lumia, Anna Maria Orsini, Wook Choi, and Robert Morgan.

TO BE A GOOD ART EDUCATOR, WHAT WOULD YOU RECOMMEND TO STUDENTS? OR ANY ADVICE?

If you love art and enjoy making it you want others to have that pleasure too. As an educator, you create that atmosphere to make that happen.

HOW CAN YOU BALANCE LIFE AS AN EDUCATOR AND ARTIST?

As an educator you want to give major attention to a student's development. In my case, it is difficult to have enough time and energy for my own work, but I was fortunate enough to have people that were interested in my art, like Lola Bonora, who took my art very seriously. She dealt it; all the exhibits, took care of the marketing, and everything else involved.

TO BE A GOOD ARTIST, WHAT KIND OF ADVICE WOULD YOU GIVE TO STUDENTS?

Keep working on your artwork all the time, therefore studying other artists. When I did the gardens, it was part of my childhood experience. Your art is a personal experiences unique to you.

YOU ARE 93 YEARS OLD, AND YOU'RE STILL CREATING ARTWORK AND READING MANY BOOKS, AND WRITING AN AUTOBIOGRAPHY. HOW DO YOU BALANCE ALL THESE THINGS? AND WHAT BOOK ARE YOU READING RIGHT NOW?

I'm doing the best I can, I think it's very hard to sustain my artwork with all those things that my age has to take care of. But it's because I love doing the artwork. In the end, art is the only thing that remains as yours. What you do with your students, you give out to them and you get rewards. And that's nice, but the bigger reward is how you get to experience the world and share that. My sight is poor, but I read a book every two days.

WHAT IS CONTEMPORARY ART LIKE NOW, AND HOW DO YOU COMPARE CONTEMPORARY ART IN ITALY, AND NEW YORK?

I'm nearly 100 years old now, and I don't have experience with what students must be going through now. I have no idea how the technology with all its changes is affecting them. Before, when we older generations made art, all we had was paper, crayons, paint — We did it with primitive materials.

DO YOU HAVE ANY ADVICE FOR STUDENTS ENTERING THE CREATIVE FIELDS TODAY?

Your art is your personal treasure. It evidences the way you think and respond to life — The adventure of figuring out who you are.

156

ALEX JEONG

UX, PUI and GUI Designer & Product Designer
Seoul, Korea

Alex Jeong is a product designer that started his design education in France. He was scouted by companies like Daewoo and Samsung and has extensive knowledge in GUI design.

WHEN AND WHICH SCHOOL DID YOU GO TO? AND WHAT WAS YOUR MAJOR?

I studied interior design at ERSEP (École Régional supérieure d'expression plastique) in Tourcoing, France. After I graduated from ERSEP in 1989, I studied industrial design at ENSCI (École nationale supérieure de création industrielle, les ateliers) in Paris, France in 1994.

WHY DID YOU CHOOSE THIS SCHOOL OUT OF MANY ART SCHOOLS IN EUROPE AFTER YOU GRADUATED FROM HIGH SCHOOL, INSTEAD OF GOING TO ART SCHOOL IN KOREA?

I was introduced to the French education system and the culture through an acquaintance who lives in France. We talked about the French arts, contemporary architecture and design, and I realized the French perspective and way of ordering things attracted me.

WHAT DID YOU DO AFTER YOU GRADUATED SCHOOL IN FRANCE? AND WHAT DID YOU DESIGN MOSTLY AT YOUR JOB?

I got my first internship while I was attending ERSEP. I was an intern for a designer who was affiliated with Alessi in Arnhem, Netherlands. At that time, I designed the office desk lamp. And before I transferred to ENSCI, a professor recommended me to the Frank architecture firm and I mostly drew up building blueprints and plans for them. In those days, CAD drawing was uncommon to use in many places. So, we had to draw floor plans manually in order to create a blueprint.

WHAT DO YOU THINK EUROPEAN DESIGN IS AFTER YOU HAVE LIVED IN FRANCE FOR 10 YEARS?

Professors who taught me were also from all over the world. I do not believe that the design was specialized by region, but I do believe there are obvious differences in the way people think and understand design, depending on their life styles because design is already a big part of their daily lives.

HOW DID YOU GET SCOUTED TO DAEWOO ELECTRONICS?

At that time, Daewoo implemented the localized global marketing strategy (Glocalization) into all regions by promoting their advertising slogan as "World Management", and France did a role for bridgehead in Europe. And design was not an exception. Daewoo was recruiting a qualified person for Glocalization and they found me.

HOW DID YOU GET SCOUTED TO SAMSUNG AFTERWARDS?

I got an offer from my friend who was already working at Samsung. However, large companies sometimes have a retirement policy where employees cannot change their job to another company within 6 months after they retire. So, I went though difficulties because I did not even know about this policy.

WHAT IS THE DESIGN YOU ARE MOST PROUD OF WHILE WORKING AT SAMSUNG? AND WHY?

I was a designer at the Department of Information and Communications when I was working at Samsung. In 1997, Samsung had a turbulent period with regards to their design. Samsung was the first company to receive an Idea Award in Asia, and collaborated with a lot of famous design agencies all over the world, which led them to grow and extend overseas.

157

I am so honored to have spent and shared this special period at Samsung.

YOU ARE KNOWN AS AN EXPERT OF GRAPHICAL USER INTERFACE (G.U.I.), WHAT IS G.U.I.?

Graphical User Interface (G.U.I.) is a neologism coined after computing the environment of Character User Interface (C.U.I) changed into the graphic environment in the late twentieth century. But, G.U.I. takes on a different meaning in product design. A lot of products that require a display are gradually increasing their size to deliver more information to the users at once. And so all the substitute operation buttons, except the main operation buttons, are integrated into the display. All the elements of hardware have been replaced with operation buttons of the software. However, there is no change in the essence of the User Interface.

YOU WERE MAJORING IN INDUSTRIAL DESIGN, BUT HOW DID YOU ESTABLISH THE G.U.I. LABORATORY AND WHAT DOES G.U.I. DO?

Making an accurate prediction in the market trends in IT design is essential, because the market is rapidly changing. In order to do so, one should not neglect to design and visualize the near future for each product line-up. In this analysis, we realized that G.U.I would take on great importance in IT products in the future. G.U.I.'s research in the IT field was insufficient at that time. After G.U.I. had been established, G.U.I. mainly replaced the hardware control buttons on the phone with graphic buttons, and developed the Algorithm of User Interface that can be offered to mobile phone users.

WHAT DO YOU THINK THE DIFFERENCE IS BETWEEN KOREAN AND EUROPEAN DESIGN?

I think the gap has been diminished these days, but how much the design has been permeated within our individual lifestyles are still different.

HOW AND WHERE DID YOU GET YOUR INSPIRATION FROM?

A lot of designers agonize about the inspiration process, but I do not really believe in inspiration. I think design is a process of making optimal ideas, and is the best result from one's experience, not just from the sparking of an idea. I think we can create outcomes that are more approachable to consumer's needs as we do more research about the design and environmental analysis.

MAIN DOMESTIC ELECTRONIC CORPORATIONS HAVE BEEN REQUESTING YOU FOR PRODUCT DESIGN PROJECTS SUCH AS SAMSUNG'S WEB PHONE (ALSO KNOWN AS INTERNET PHONE), LG ELECTRONICS' PCS PHONE, SK TELECOM'S PHONE, PENTA MEDIA'S SATELLITE BROADCASTING RECEIVER, SEOUL TELECOM'S HOME SECURITY SYSTEM AND MANY MORE EVEN INCLUDING IT FIELDS. HOW MANY PROJECTS HAVE YOU DONE SO FAR AND WHAT SORT OF DESIGN HAVE YOU DONE MAINLY?

I have never counted but I assume it may be over a hundred IT related projects mostly landline, cell phones, and smar phones.

WHAT IS THE HARDEST THING TO DESIGN?

Design is unlike the arts but is very scientific so the process of actualizing the idea into the real world is the hardest part. Design might be easy but the process of delivering those ideas to the end users has a very long way to go and is oftentimes difficult.

WHAT IS THE MOST IMPORTANT THING TO CONSIDER IN DESIGNING A PRODUCT?

I think it is the communication between the user and the product.

DO YOU HAVE ANY PROJECTS YOU ARE WORKING ON NOW OR YOU WANT TO DESIGN IN THE FUTURE?

Yes. Besides product design, I would like to design products in between metaphysics and concrete science. Something you cannot really touch physically, but something that does exist in reality.

WHAT ADVICE WOULD YOU GIVE TO STUDENTS OR PROSPECTIVE PRODUCT DESIGNERS?

It is extremely important to know the essence of the products. For example, the basic condition for a vacuum is to clean well, not the powerful and strong vacuum itself. If you do not get confused with these two things, you can pursue the essence of the products and you will be a good product designer.

WOULD YOU GIVE SOME ADVICE TO PROSPECTIVE DESIGNERS WHO WANT TO STARTUP A NEW COMPANY?

Even if you are an expert in a specialized area for a long time, always be flexible and ready for change. You are already designing products of the future.

VOIP Phone Design
a

158

159

ALFREDO MUCCINO

Founder, CEO of Solid Design Agency
San Jose, CA & New York, NY, USA

Alfredo Muccino is the founder of Solid Agency. Previously, he was the CCO of Liquid Agency, and has worked on major brand launches and brand initiatives for companies like Adidas, Adobe, Google, Facebook, HP, LexisNexis, LSI, Microsoft, Nike, Skype, Sony, Visa and Walmart.

HOW DID YOU SEE THE VISION FOR YOUR COMPANY?

I've started a new company called Solid this year. Solid is for me, a return to a simpler organizational structure. The company is less about managing people and more about doing the work. I'm more interested in returning to the practice of design, as opposed to the management and organizing for a structure. I'm also building a new company model, compared to Liquid my old company I was with for 24 years — it will be way more virtual. I like to create partnerships and collaborations with all sorts of different people. And from a business model perspective, it allows me to be very agile, and my overhead is a lot lower, and I don't have a lot of pressure to go out there and sign a lot of work. And at the same time I can put lots of people together, teams of people, that are perfect for the client in a way that creates value for them at a lower cost, with a lot more flexibility.

Today, I'm working for example on a fairly large project for Lenovo, and I'm collaborating with an industrial designer. Because of the fact that it's going to be more of a virtual operation, it's easier for me to manage it. Everything is going to be based on an outsourcing model, instead of hiring people to manage the departments, I will hire people based on when we need them.

YOU LOVE READING BOOKS — WHAT BOOKS WOULD YOU RECOMMEND FOR STUDENTS WHO WANT TO MAJOR IN ART AND DESIGN?

For one, I recommend people identify some of the top designers of the field, and get familiar with their work. Paul Rand, Saul Bass, a lot of the classic designers. But then for younger people, those that are current today.

I also feel like besides books, it's super helpful to subscribe to magazines, and that gave me a sense of what was good and what's not. It allowed me to look at what things win awards, and from there you can understand why certain things are good and helps you make better decisions.

YOUR SPEECH TO MY STUDENTS AT YOUR COMPANY IN SILICON VALLEY WAS VERY MOVING — WHAT ADVICE WOULD YOU GIVE

TO THEM AGAIN? HOW CAN THEY PREPARE FOR THEIR ART AND DESIGN CAREER LIFE?

Preparing for art and design career in life, one of the things I've told my own daughter, is that it doesn't matter how talented you are, preparing to be successful means spending a lot of time doing the work. When I started out, I would stay up two nights in a row and work because I couldn't stop. It's important to continue to practice, and besides being able to do something, you'll have to be able to articulate why it is the way it is.

Design is less about how to make something look good, but rather about how to solve a problem. So I understand how design solves a problem, as opposed to just why that looks good, is super important to advancing your career.

HOW WOULD YOU DESCRIBE BRAND MARKETING TO HIGH SCHOOL STUDENTS?

Branding is the sum of all the parts of how people feel about the company, product, or service. Marty Neumeier the Director of Transformation of Liquid Agency, a good friend of mine talks about this. It's a person's gut feeling, but that gut feeling is informed by what something stands for, or how something looks like and how it behaves.

For example, you recognize

reddot design award
winner 2011

160

The Nike Swoosh — but you also attach "Just Do it." And the athletes that wear those clothes, and the idea is that if you buy into that brand, you might be able to feel or perform like those athletes. So branding is how to manage all of that. Brand Marketing is how to develop campaigns that help create awareness, preference, and loyalty for the brand.

WHAT'S THE MOST IMPORTANT THING YOU'RE WORKING ON RIGHT NOW, AND HOW ARE YOU MAKING IT HAPPEN?

The most important thing I'm working on right now, is building the new business, "Solid." and making sure that I

can build a business that I can be proud of, or build a business that continues to be focused on design work that helps a client be successful and that is positioned to work with interesting people doing interesting projects, and building a culture internally that is stimulating, and interesting and supportive, and where we spend a lot less time talking about money and more time talking about ideas and making a difference.

WHAT ARE SOME OF THE CHALLENGES IN THE INDUSTRY?

Lots of things... For one the fact that technology is constantly changing the way we do things. It means that people have

to stay on top of it, and be educated all the time. When I think about it, when we started the business, we didn't have computers. And, you know, computers were first tools to do projects. And then this thing called the internet was created, and connected all these people together. And the internet needed websites created, which no one knew how to do well at the time, and then this thing called the iPhone came out, which requires different design and coding, and Facebook, and social media platform. All these things are constantly changing, and the challenge is always putting yourself in a position keeping up and staying on top of it. There's lots of focus on that.

HOW IS ART & DESIGN SIGNIFICANT IN YOUR PERSONAL AND BUSINESS LIFE TODAY?

I'm an artist and a designer. I see the potential for artistic expression in design, and everything around me. Whether it's the shape of a coffee cup, or an image you see walking down a street or even the way someone moves. I think art informs design for me. I think design informs art for me sometimes. In essence it's what differentiates us from animals. I mean Humans need to connect to their sense of self, their emotions, their connection to the world.
So, I encourage designers for example to spend a lot of time in museums, galleries, and take a look at what work is being done in those fields, and how that work can be used for us to influence design.

WHO ARE SOME OF YOUR CLIENTS THAT YOU'RE EXCITED TO HAVE DONE WORK FOR?

I did a project for Google, that I'm very proud of, that was a packaging project. It was the first ever computer packaging done with potato pulp, so not only is it recyclable it's 100% compostable it has zero footprint and I'm very proud of that.

WHAT DO YOU CONSIDER FIRST WHEN YOU SEE YOUR PROSPECTIVE EMPLOYEE'S PORTFOLIO & RESUME, AND WHAT IS THE MOST IMPORTANT THING YOU EXPECT FROM THEM?

Well, obviously creativity and talent, but I also want to know that they're good thinkers, not just good doers. If design is problem solving, it requires thinking more than anything. Talent, might be making something look good, but not having a good idea behind it doesn't really help. And also I look for other qualities like curiosity. I think that people who are curious will be good problem solvers, and then, I want people who are articulate and who can express themselves,

423

and their ideas verbally, and deal at writing, people who are not afraid to do different things. There are designers that I know for example, where I say let's change the headline, and they say oh I'm not a good writer. But you can do anything you set your mind to. And I like people that are not afraid to cross boundaries, who are willing to take a chance and say "you know what, I've never designed a package before, but wouldn't it be great do design that"

But there's great learning to try different things, but you have to not be afraid to do things you haven't tried before. I do look for humility, and it's important to have a willingness to learn, doesn't matter how old you are, how experienced you are. We all have an opportunity to continue learning from the people.

I feel like I am very lucky from other people, and I still feel like I learn from a lot of people around me. And the openness is amazing.

HOW DID YOU BECOME A VERY SUCCESSFUL DESIGNER WITHOUT FINISHING A COLLEGE DEGREE?

Well, I didn't really go to art college. My father wanted me to be an engineer, and I tried, but I wasn't interested in it. So I tried doing economics, and I tried it for a year and I realized I didn't like doing that. But my father got very mad at me,

because I wasn't pursuing the career he wanted me to, and he cut me off financially. I was 17 years old, and I got a job at the print shop. And inside the print shop, I learned the process of printing, and I saw a lot of stuff that was being designed that came in, and I also started working in the newspaper office of the school, and the yearbook office and the literary magazine, and I started doing all the posters for the theatre production and the clubs, and I mean I was working a lot, but I loved it. And that's what inspired me to pursue my career. So my education is not from school, I did a lot of reading. Every magazine and book that I had to do a design for, I would study it, and I did a lot of practice, and eventually I got better. and I got lucky, I met a lot of great mentors along the way.

I took one painting class once. But otherwise I am self-taught. I watched my father paint, he was a painter, and I also just tried things. It's something I care about very much, and there's a lot of things I cannot do very well.

YOU HAVE LIVED MANY DIFFERENT COUNTRIES WHEN YOU WERE YOUNG AND CAN SPEAK 3 PERFECT LANGUAGES. WHAT KINDS OF EXPERIENCES WOULD YOU RECOMMEND HIGH SCHOOL STUDENTS TO BECOME A DESIGNER OR AN ARTIST?

161

Travel can do that for you. For me, being in different countries, you realize that their typography is different; in Arabic, Italian, or sometimes even in China, the language, there are things organized that are different—there are traditions around street signs, advertising, packaging, etc. So I was very interested in how all these different cultures managed communications, both written orally, and visually, the set of iconography, and stuff that they used, and that has helped me I think greatly refine the way I communicate. Because life as a graphic designer is obstructing an idea, and having all these different ways of saying the same thing can help you get there.

I also encourage a lot of travel. Because whenever I travel to a new place, it's like you're a little kid again. You see the world with a different set of eyes, because you're exposing yourself to new things and you notice things that you haven't noticed before. but keeping your eyes open and trying to understand why things are the way they are, again it connects back to this idea of curiosity.

It's super helpful because I remember when I started out — I spent a lot of time understanding how to do things, and at one point, I realized, ok well I know how to do these things, and then I thought, well why am I doing these things?

The conversation needs to be a lot bigger, but why am I designing a chair? What am I trying to accomplish? I'm designing a chair, I know how to design a chair, so that people can sit in it. But why am I trying to design it differently from other chairs and what emotion am I trying to connect people to, or what behavior am I trying to change?

So I think that helps guide design and attention to things, looking at things deeper trying to understand it.

WHAT DO YOU LOVE MOST ABOUT WHAT YOU DO?

I like solving problems, I like helping clients be successful. I enjoy feeling like I'm part of a productive process. I want to contribute to society, as a human being, as a professional, and that gives you purpose. You know, if I was making a lot of money in the stock market on Wall Street I wouldn't feel very good about myself, because I wouldn't feel like I was contributing personally that much.

But by doing what I do, I can help a company that doesn't have an image, a plan, a way to connect with its clients, develop that. And their success, and I help their role in that and if I do that, I feel like I help society in a larger way, and doing it in a responsible way. You know, like the Google project.

The other things I like doing is also surrounding myself with creative people, people that you can have interesting, stimulating conversations with, people you can learn from and share values with, and those are the things that make me excited about my work and what I do.

WHAT ADVICE WOULD YOU GIVE TO STUDENTS OR GRADUATES ENTERING THE FIELD TODAY?

I think it's important to learn skills, like Photoshop, and all the various programming. Again, I think the biggest piece of advice I have is to learn how to think like a designer, so that you can be prepared to solve all sorts of problems. Because everything you learn today about how to solve a problem with some sort of technological tool will be outdated 5 years from now. What doesn't change is that you still have people to think through these problems. And learning how to do that will prepare you for the rest of your life, because you will constantly evolve as the world evolves. I think a broader education allows you to do that. It's less about training and more about learning. And less producing than it is about thinking. Keep yourself flexible.

When I started this business, like I told you, we didn't have computers. But, as a designer, I found myself as someone who worked in images, colors, and typography.

Today, in our company we do movies. I never thought we'd do movies. But keeping yourself flexible to be able to adapt the way you think about problem solving in 2 different mediums is going to be key, because honestly it's really hard to predict what you're going to be doing tomorrow.

But I do know that a designer has more potential today than someone who designs and executes a logo. Designing companies, organizational throws, for service design. Designing system, cities, Design is the purpose for changing something for the better. So, if you keep yourself flexible you can adapt it to a lot of different things. I think it's a very exciting time to be a designer, but you also have to be more open to change than ever before.

4

RON JOHNSON

CEO of WAGIC
San Jose, CA, USA

Created by Bob Johnson and his sons, *Ron and Ken Johnson*, WAGIC has not only helped companies bring their products to life through renderings and prototypes, they have the personal knowledge of how to position and launch a product successfully, that only comes from having a line of their own products go from a problem to solve, a customer to serve, and finally a product in a store on the shelves to purchase.

HOW DID YOU COME UP THE COMPANY NAME, WAGIC? THIS IS A VERY CREATIVE AND MEMORABLE NAME.

We thought about several names, "Why didn't I think of that" and "What a great idea" but WAGI for short did not work. After looking at WAGI for a while I came up with What a great idea company or WAGIC, like Magic, where great ideas come out of the magic hat.

I WAS VERY IMPRESSED WITH THE PRODUCTS THAT YOUR COMPANY DESIGNED AND INVENTED. HOW DID YOU SEE THE VISION FOR YOUR COMPANY?

In the consulting business we see a lot of product ideas and technologies that, on their own, are really good products. The challenge is that many of these ideas don't merit building an entire company around them as they may not support an entire company. This is where we came up with

the model for WAGIC. Sort of an orphanage for great ideas. A company that could bring to market many great products by providing the necessary infrastructure required to be successful in the market.

WHAT'S THE MOST IMPORTANT THING YOU'RE WORKING ON RIGHT NOW, AND HOW ARE YOU MAKING IT HAPPEN?

We have been developing a unique watering mat that allows plants to be watered automatically through their root systems. You can check out the product line at www.waterpulse.com. We just finished launching the product line into Walmart where 4,000 of their stores use the system in their nursery sections. We are getting ready to launch the product into Home Depot as we speak. This is a client of ours, and we are an investor in the company. We oversee all of the product design and development, intellectual property development, as well as the manufacturing of the product. The Walmart program was a $25 million project and the Home Depot program will be about $30 million.

HOW IS ART & DESIGN SIGNIFICANT IN YOUR PERSONAL AND BUSINESS LIFE TODAY?

There is not a moment in my life that I am not looking at things from a design perspective. Every product that I use, or see, I am always thinking of how that particular product could be better through design.

WHAT ARE SOME OF THE CHALLENGES IN YOUR INDUSTRY?

The biggest challenges that we face in our industry is the fact that everyone is trying to copy our designs. When you are a successful trend setter through design everyone wants to follow your work. It is the part of our business that drives me crazy, actually really bothers me, and because of this I spend a lot of my time and money with lawyers trying to protect our work.

WHAT ARE SOME GREAT RESOURCES YOU RECOMMEND FOR YOUNG ARTISTS & DESIGNERS?

There is a great book, "The Art of Innovation" by Tom Kelley, which I highly recommend. I find myself spending a lot of time on Pinterest and on the social funding sites, Indiegogo and Kickstarter, to keep up with new ideas.

WHO ARE SOME OF YOUR CLIENTS THAT YOU'RE EXCITED TO HAVE DONE WORK FOR?

Working on major Hollywood films with Jerry Bruckheimer has

been a lot of fun. We have done work on films like Transformers, GI Joe, Ironman, etc. which is very exciting, especially when you get to see your work on the big screen. We developed products for some very big clients including the likes of HP, Olympus, Sun, Adobe, GM to name a few.

WHEN YOU SHOWED ME YOUR EMPLOYEE'S PORTFOLIO, IT WAS DEEPLY GRATEFUL THAT YOU COULD SHARE IT WITH ME. WHAT DO YOU CONSIDER FIRST WHEN YOU SEE YOUR PROSPECTIVE EMPLOYEE'S PORTFOLIO, & RESUME, AND WHAT IS THE MOST IMPORTANT THING YOU EXPECT FROM THEM?

Most importantly I look for passion around the work that perspective employees have around their ideas and projects. Secondly I try to understand the process that they have experienced when developing their ideas, and in particular, did they experience any failures while developing their work. This is extremely important for me to know because I believe that failure is an important part of the innovation process.

WHAT DID YOU STUDY IN COLLEGE?

I studied mechanical engineering. As a young boy I was always building things

and tearing down things to understand how things worked and why they were done a certain way. This fascination continues every day for me as I am always looking for ways to improve existing products.

I ALSO REMEMBER YOU AS A VERY GOOD FATHER SPENDING TIME WITH YOUR SON DOING SPORTS, HOW DO YOU BALANCE YOUR LIFE BECAUSE YOU MUST BE VERY BUSY WITH YOUR COMPANY.

I have 3 boys, all of whom I have spent time coaching them in numerous sports. I am a baseball coach and have been for the past 30 years. I find that the time I spend with these players is just as important as the time I spend with my employees and customers. Coaching is a true passion of mine and allows for me to take a break from all of the stress of my day-to-day work, and focus on helping others out as I experienced from great coaches as I grew up.

WHAT DO YOU LOVE MOST ABOUT WHAT YOU DO?

Spending time meeting new people and being able to share all that I have learned with them.

WHAT ADVICE WOULD YOU GIVE TO STUDENTS OR GRADUATES ENTERING THE FIELD TODAY?

The advice I would give students today is the same advice I give to everyone that I interface with on a daily basis. A couple of very simple thoughts:

1. Never assume that you have all of the answers
2. Treat others like you would want to be treated
3. If you are not making mistakes you are not working hard enough
4. Do or Do Not, there is no try
5. Don't make the same mistake twice
6. Never be afraid to "Go outside the box"
7. Be humble
8. Appreciate the small things in life
9. One step at a time
10. Keep a sense of humor
11. Success is never ending, failure is never final

5

BENJAMIN CHIA

CEO & Industrial Designer of Elemental8
San Jose, CA, USA

Benjamin Chia is an experienced and multi-faceted industrial designer capable in all phases of the design process. As CEO and Chief Designer, he directs the creative staff and develops new business potentials.

HOW DID YOU SEE THE VISION FOR YOUR COMPANY?

The goal is to create a better user experience with multidisciplinary design approaches.

HOW DID YOU COME UP WITH THE PROBEAM PATIENT TREATMENT ROOM — WHAT KIND OF PREPARATION DOES A PROJECT LIKE THAT TAKE TO EXECUTE?

Varian, our client hired us to design for them. We had to a lot of research up front and take in all aspect of this product offering into consideration, including patient throughput, work efficiency, user experience, engineering constrains, marketing requirements, and of course aesthetics.

WHAT ARE SOME OF THE CHALLENGES IN YOUR INDUSTRY?

Competitions, domestically and internationally. There are so many great designers that

Elemental8's treatment of the Varian ProBeam proton therapy system is an integrated solution to numerous design, engineering, and usability challenges, while treating a room-sized medical system with an attention to detail normally use on much smaller products.

433

164

The Acuson P-10 handheld ultrasound scanner is the world's first pocket ultrasound imaging device, providing physicians and clinical personnel with earlier, faster and more accurate clinical assessment at the point of care.

came before us, and there are many talents that will compete with us. We need to continue training ourselves to be better at what we do and producing great designs. It is actually not so much a challenge but more of a perpetual responsibility.

HOW IS THE RAPID GROWTH OF TECHNOLOGY INFLUENCING THE WAY YOU APPROACH YOUR COMPANY?

We have to constantly learn, adapt, grow, and evolve so we can stay on top of the edge of technology.

YOUR PRODUCT DESIGNS ARE VERY ADVANCED, HOW DO YOU COME UP WITH IDEAS AND INSPIRATION?

Good ways to stay inspired are to observe, learn, and stay curious about anything and everything.

WHAT ARE SOME GREAT RESOURCES YOU RECOMMEND FOR YOUNG ARTISTS & DESIGNERS?

I am very inspired by books by Don Norman. I also visit various sites such as core77, Engadget, & Wired, to stay current. At the same time learning about business through sites like Forbes, Linkedin is very prudent. We also need to learn from all those great design heros that came before us as well as other design firms' site in the industry to stay encouraged.

WHO ARE SOME OF YOUR CLIENTS THAT YOU'RE EXCITED TO HAVE DONE WORK FOR?

The benefit of being in Silicon Valley is we get to be exposed to various types of clients. For sure, Variant Medical. It is great to know we have created products that are saving lives. We were also very fortunate to work with companies like Clearwire that allowed us to put together very comprehensive yet cohesive design results for everyday consumers.

WHAT DO YOU CONSIDER FIRST WHEN YOU SEE YOUR PROSPECTIVE EMPLOYEE'S PORTFOLIO & RESUME, AND WHAT IS THE MOST IMPORTANT THING YOU EXPECT FROM THEM?

We look for different things at different levels. For entry-level designers we look for skills, motivation, and diligence. Obviously talent is a must but personality and willingness to work and grow in a dynamic and collaborative environment are just as important.

WHAT ADVICE WOULD YOU GIVE TO STUDENTS OR GRADUATES ENTERING THE FIELD TODAY?

Willingness to learn, to grow, and to challenge oneself for what she is passionate about. Be happy and responsible for what you create.

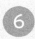

LIZA ENEBEIS

Partner and Creative Director of STUDIO DUMBAR

Rotterdam, Netherlands & Seoul, Korea

Liza Enebeis studied at the Parsons School of Design, Paris and the Royal College of Art in London, where she received her Masters.

HOW DID YOU SEE THE VISION FOR YOUR COMPANY?

We are an international design agency specialized in visual branding in all dimensions. With our personal approach we create pure, sustainable and powerful design.

HOW IS ART & DESIGN SIGNIFICANT IN YOUR PERSONAL AND BUSINESS LIFE TODAY?

Art and Design is very much intertwined with both business and personal life. One influences the other. Every decision you make every action you take in whatever aspect is in fact design. For example a successful negotiation has gone through the same principles as when you are designing, — a question — a search — a proposition — to an eventual well balanced result.

HOW IS THE RAPID GROWTH OF TECHNOLOGY INFLUENCING THE WAY YOU APPROACH YOUR COMPANY?

165

The growth of technology is not only influencing our company but the world around us. It is not a question of anticipating and changing but innovating with every step. We strive to innovate in our design.

WHAT'S THE MOST IMPORTANT THING YOU'RE WORKING ON RIGHT NOW, AND HOW ARE YOU MAKING IT HAPPEN?

At the moment we are working on an identity for a museum in the Netherlands. With a small multidisciplinary team and in collaboration with our client we investigate all aspects of the museum. Our research and sketching phase is the most crucial and exciting time. We spend our time experimenting testing and slowly distilling our ideas into the purest concept that captures the essence of the Museum.

WHAT ARE SOME OF THE CHALLENGES IN YOUR INDUSTRY?

The design industry is a competitive industry and very sensitive to the ups and downs of economic growth. if a company is going through economic turmoil the design budgets are the first to be reduced. Unfortunately for some design feels like a luxury and not a necessity.

WHAT ARE SOME GREAT RESOURCES YOU RECOMMEND FOR YOUNG ARTISTS & DESIGNERS?

Visiting museums and galleries have always been a great inspiration and resource. Walking and observing your surroundings, reading anything you can get your hands on — the most obscure read can lead you to a fantastic idea. But if you are looking for books in the design field I recommend the Unit Editions collection.

166

167

MAURITSHUIS — A New Identity For The Home Of Dutch Golden Age Painting
Inspired by artists' monograms, the new logo overlaps reproductions of key paintings
to communicate a clear link between the Mauritshuis and its collection. Supported by a
contemporary wordmark, the logo hints at the museum's heritage while placing it in the 21st
century. Golden Age paintings are known for their details: look closer and you'll see more. We
expressed this idea in the logo and a new photographic style: paintings are shown in context,
through doorways. The core colour evokes royalty, the Golden Age and the house's baroque
interiors, while a brighter secondary palette echoes its famous damask wall coverings.
We applied the identity to a range of collateral including entrance tickets, invitations, ground
plans, trams and flyers, as well as a new and comprehensive collection catalogue. We also
created a new identity for The Friends of the Mauritshuis – a foundation that supports the
museum with funding for new acquisitions and exhibitions. Photograph by Gerrit Schreurs

WHO ARE SOME OF YOUR CLIENTS THAT YOU'RE EXCITED TO HAVE DONE WORK FOR?

I would like to name all of them but to name the most recent one — Branding for Transavia the low budget airline — it was always a dream project to design an airline and it came true — we designed everything from the livery to sugar bags, from safety instructions to billboards and their online presence. Apart from the designs we made the collaboration with Transavia was also exceptional — their vision was an inspiration to the whole team and its thanks to a good collaboration that we were able to achieve the results we did.

WHAT DO YOU CONSIDER FIRST WHEN YOU SEE YOUR PROSPECTIVE EMPLOYEE'S PORTFOLIO, & RESUME, AND WHAT IS THE MOST IMPORTANT THING YOU EXPECT FROM THEM?

The portfolio and the person — the resume is not important.
I look for a portfolio that shows a variety of work, an openness to experimentation, good craftsmanship and concepts. Most importantly a unique way of looking at design, not a copy cat style. But besides a portfolio I look at character. Is this person a team player, are they curious, driven, open minded, out spoken, shy. You can have the best work but if you are an ass it won't take you very far. And as far as your resume is concerned — good colleges and recommendations can help but at the end of the day its what you do and who you are in practice that will get you the job.

WHAT ADVICE WOULD YOU GIVE TO STUDENTS OR GRADUATES ENTERING THE FIELD TODAY?

Experiment, practice, fail, persevere and say yes to everything you never know where you will end up.

WHAT DID YOU STUDY IN COLLEGE?

Communication Design

WHAT DO YOU LOVE MOST ABOUT WHAT YOU DO?

Translating an abstract thought into a strong identity that touches the heart and reflects the essence of an organization.

SVEIN HAAKON LIA

Co-Founder and Creative Director of **Bleed Design**
Oslo, Norway

Svein Haakon Lia is the creative director, senior designer and founding partner of Bleed, a multidisciplinary design consultancy based in Oslo and Vienna.

HOW DID YOU SEE THE VISION FOR YOUR COMPANY?

In 2000 the dot com wave was still going pretty strong in Norway. Design studios was inflated by capital without any especially good work output. The goal of a lot of studios was to gain size to gain value. It was a time of stock options and broken promises. Not great to be a creative. I quit my job, in a company that grew from 8 to 60 people over very few months, the day I was offered stock options. I went freelance for a while, it was a great marked and very easy making money.

I did a lot of work together with a friend and former colleague that had made the same choice as me. It was a lot of easy money but we did not feel we were building anything new. After a while we found that we needed to start something, so we found 3 more people and founded Bleed in June 2000 at a coffee shop in Oslo.

We found a name that suited

us, we wanted to work on the edges, in the bleed, actually working with concept and design equally, building real values. Being small and dynamic. And we wrote our very simple 10 point manifest that we have more or less followed since then.

WHAT'S THE MOST IMPORTANT THING YOU'RE WORKING ON RIGHT NOW, AND HOW ARE YOU MAKING IT HAPPEN?

In general the process has become much more important for us, also how we integrate identity in both experience and product. It is an exciting time to be a designer with so many diverse challenges.

HOW IS THE RAPID GROWTH OF TECHNOLOGY INFLUENCING THE WAY YOU APPROACH YOUR COMPANY?

Besides the usual making the world smaller, technology makes us spend more time in the concept phase. It frees up time for us to focus on our main tasks and makes it easier to execute. It has made us and our clients more professional.

WHAT ARE SOME OF THE CHALLENGES IN YOUR INDUSTRY?

Money, time & people.

HOW IS ART & DESIGN SIGNIFICANT IN YOUR PERSONAL AND BUSINESS LIFE TODAY?

I think that art & design is the main differentiator of quality of life and attitude.

WHO ARE SOME OF YOUR CLIENTS THAT YOU'RE EXCITED TO HAVE DONE WORK FOR?

I think all clients are exciting in some way. We try to be unbiased.

WHAT DO YOU CONSIDER FIRST WHEN YOU SEE YOUR PROSPECTIVE EMPLOYEE'S PORTFOLIO, & RESUME, AND WHAT IS THE MOST IMPORTANT THING YOU EXPECT FROM THEM?

The most important thing is that the portfolio reflects a burning desire to try new things, then the second is that it is well thought through and executed.

WHO ARE SOME CLIENTS THAT YOU'RE EXCITED TO HAVE DONE WORK FOR?

It was for Disney and Sony. The way they went about asking us to do the project is, "here, we are giving you this much award for you to do the design, so please do the best design you've ever done in your life." Typical clients request so many detailed design direction, but

since Disney and Sony knew the best outcomes from the client, they leave the creativity to the designer.
If so, the designer will be fired up to do one of the best designs he's ever done, and enjoy the project with a balanced pressure.

WHAT DID YOU STUDY IN COLLEGE?

Marketing, fine arts and design.

WHAT DO YOU LOVE MOST ABOUT WHAT YOU DO?

The diversity of every day and that I can wear what I want.

WHAT ADVICE WOULD YOU GIVE TO STUDENTS OR GRADUATES ENTERING THE FIELD TODAY?

Try stuff, do your own projects.

WHAT ARE SOME GREAT RESOURCES YOU RECOMMEND FOR YOUNG ARTISTS & DESIGNERS?

Search things that have little as possible to do with what you are looking for.

168

8

PETE WRIGHT

Founder of Urban Influence
Seattle, WA, USA

Pete Wright is the Owner, principal, and lead strategist of Urban Influence, bringing years of C-level marketing experience to clients' brands & businesses.

HOW DID YOU SEE THE VISION FOR YOUR COMPANY?

Before founding Urban Influence, I came from a business background, and I saw a lot of the firms that I worked with in business didn't understand the foundation of what business was: their brand. They had a set methodology, and tried to make their branding fit within whatever formula they were using.

When I launched Urban Influence, it was with the idea of starting with the business strategy and then designing the brand from there, rather than trying to make the brand fit in some pre-written methodology.

We were the first Northwest firm that didn't have a methodology to get to that solution. We customized the solution for every single client, and now that is the norm for every branding and design firm out there.

By customizing our process to each customer and project, we start with the stuff that matters

— the core business strategy — and we let that inform our branding, which makes for smarter, better design.

WHAT'S THE MOST IMPORTANT THING YOU'RE WORKING ON RIGHT NOW, AND HOW ARE YOU MAKING IT HAPPEN?

My most important work is building Urban Influence into a cohesive team that works well with each other in all aspects. The teams needs to mesh not only creatively, but in communication and in making sure that all of our customers are treated the best that we possibly can treat them. It's my job to make sure we hire the right people, grow the company at a pace that is manageable, and that we don't get too over our skis to keep doing great work.

HOW IS ART & DESIGN SIGNIFICANT IN YOUR PERSONAL AND BUSINESS LIFE TODAY?

Art and design are significant in every aspect of my life. In home, in every business that I own, in everything.

And it's significant in all of our lives every day. Everything we do, whether it be music or visuals or an ad or a building, art and design effects us every day. It can change our moods from amazing to horrible, all within design.

HOW IS THE RAPID GROWTH OF TECHNOLOGY INFLUENCING THE WAY YOU APPROACH YOUR COMPANY?

At Urban Influence, we don't give in to squirrel syndrome. Because tech is so fast right now, new tools are coming out daily, which can be very distracting. You really have to find something and stick to it, and ignore things that might are new and shiny but not actually useful for you. If you do decide to change, it's got to be for a good reason, not just because something's new.

WHAT ARE SOME OF THE CHALLENGES IN YOUR INDUSTRY?

Really, truly the biggest challenges that we have are people understanding the value of strategy. It's so imperative that a person (whether it's a client, an employee, anyone involved in the process) understand strategy before you start designing.

There are so many design firms out there and the competition has grown exponentially. The younger generation is so creative, but what they're lacking is the strategy. They can make beautiful things, but those beautiful things don't mean much if they don't speak to the values or goals of the business.

Showing clients the value of

445

strategy can be difficult when they're distracted by beautiful design, so as designers it is our job to make them understand why strategy must come first and inform the design — and not the other way around.

WHAT ARE SOME GREAT RESOURCES YOU RECOMMEND FOR YOUNG ARTISTS & DESIGNERS?

For web, it would be awwwards.com. And for design, it's your local architecture. It's going out and exploring and finding the unique and thought out and designed architecture in every city. Not only architecture, but design in general. Products as well. If you really look, you can find some really inspiring designs in building and products.

WHAT DO YOU CONSIDER FIRST WHEN YOU SEE YOUR PROSPECTIVE EMPLOYEE'S PORTFOLIO & RESUME, AND WHAT IS THE MOST IMPORTANT THING YOU EXPECT FROM THEM?

The very first thing I look for is a custom introduction that lets me know they have actually researched the company and the people who work there. The second thing I look for is their passion in the rest of the introduction, and then I look at their portfolio. What you cannot

teach is passion, so that's what I look for first.

WHAT DID YOU STUDY IN COLLEGE?

Business.

WHAT DO YOU LOVE MOST ABOUT WHAT YOU DO?

What I love most about what I do is tackling hard challenges that come though the door every day.

WHAT DID YOU STUDY IN COLLEGE?

First, you have to have a passion for this industry. Second, work your ass off.

9

CHRISTY KARACAS

Executive Producer and Animation Director of SUPERJAIL!
New York, NY, USA

Christy Karacas is a director and writer, known for Superjail! (2007), Royal Blood: Out of the Black (2015) and Space War (1997). He studied film and animation at the Rhode Island School of Design. He's a founding member and guitar player for the band Cheeseburger, and formerly animated title sequences and other animation for Vice Broadcasting System (VBS.tv)

HOW DO YOU COME UP WITH YOUR IDEAS AND STORIES?

I've always loved to draw and sketch since I was very young, so I start by drawing. A funny drawing or cool sketch is almost always the start of an idea or story for me.

WHAT'S THE MOST IMPORTANT THING YOU'RE WORKING ON RIGHT NOW, AND HOW ARE YOU MAKING IT HAPPEN?

I am working on a new pilot for Adult Swim right now. It's super fun and exciting, but also can be challenging and difficult. Right now at this very moment I am feeling very stuck with the story, but every day there are ups and downs. If I keep plugging away, I know I will work things out, you just have to be patient sometimes (I am very impatient!). You just have to keep working every day and get it out of your brain, and then edit and tweak it later as you go. Nothing is set in stone, it's always about perfecting the

TALKS WITH CREATIVES • ANIMATION DIRECTOR

idea, changing, growing and trying to do better. But also having fun.

HOW IS THE RAPID GROWTH OF TECHNOLOGY INFLUENCING THE WAY YOU APPROACH YOUR ANIMATION? WHAT ARE SOME CHANGES?

'It is changing it a lot! But mostly for the better! When I started in animation everything was on paper and film. It took much more time and work to draw and then shoot your drawing under hot lights and a camera, then send it to the lab to get it developed, wait for it. Ugh! Then things went digital in the 1990s and were much cheaper and faster, but even then you still had to scan and clean up all the art work, hundreds of drawings. The way I work now is completely digital. We don't even use paper! We draw directly onto a tablet monitor so the artwork is completely digital from start to finish. I do still like to sketch and draw on paper tho. Something about sketching in a cafe or bar is really fun and while I love working digitally, the tactile feeling of a pen or pencil on paper is something that I love and don't ever want to give up completely!

WHO ARE SOME OF YOUR CLIENTS THAT YOU'RE EXCITED TO HAVE DONE WORK FOR?

I have done work for Adult Swim, Cartoon Network, Nickelodeon, Playboy, Vice, and MTV.

IN YOUR OPINION, WHAT ARE THE DIFFERENCES BETWEEN WEST COAST AND EAST COAST ANIMATION?

There is definitely more work on the west coast and I would say in my experience more money/better salaries. The big studios like Disney, Nickelodeon, and Cartoon Network studios are out there and also there is more feature work and VFX work, while the east coast is more smaller boutique studios and commercial work/motion graphics. There are exceptions to both of these, for instance Titmouse Inc has both east and west coast studios, and big feature studio like Blue Sky is on the east coast, and motion graphics studios like Imaginary Forces are on the west coast. I would say in my experience the east coast has more freelance based work and the work is less steady than the west coast and also no union work (for character animation) like in the west coast. That said, it's really a matter of personal preference. I enjoy visiting Los Angeles, but I've remained on the east coast because I love the energy of New York, but if you like the sun and the beach you might prefer the west coast!

WHAT'S AN IMPORTANT LESSON YOU LEARNED IN COLLEGE?

Work, work, work! Make lots of friends, talk to everyone and try to soak up as much as you can. College is like a special 'fantasy time' where you need to work very hard and build the fundamentals that are very important and the basis for everything you do in the future, but also to expose yourself to new things and ideas. When you are in college it is hard work and you are tired all the time, but after college the 'real word' is not as fun and you will miss college and wish you had more time to practice and learn again.

WHAT IS THE BIGGEST CHALLENGE THAT COMES AS AN ANIMATOR?

It's hard to sit alone in a room for many long, lonely hours every day! You miss being outside and interacting with people!

WHAT ADVICE WOULD YOU GIVE TO STUDENTS OR GRADUATES ENTERING THE FIELD TODAY?

Work really hard and build strong drawing skills. Expose yourself to new things. If you want to do animation, it's great to know all about animation, but it's just as important to study other disciplines of art and let them excite you and influence you as well. And also anything that interests you: music, writing, shoemaking, whatever it is! It's good to do many things and meet many different kinds of people. It's very important to get out there and meet people. Making friends and making connections will always help you and you will be surprised what a small world it is. If you stay in this industry, people you meet in your early 20's you will still be working with in your 50's!

WHAT DO YOU LOVE MOST ABOUT WHAT YOU DO?

I love creating new imaginary worlds, and drawing. I also love all of the cool creative people I get to work with everyday. There are so many fun interesting great people and it really is a lot of fun.

WHAT ARE SOME GREAT RESOURCES YOU RECOMMEND FOR YOUNG ARTISTS & DESIGNERS?

Richard WIlliams 'The Animators Survival Kit' and Disney Animation 'The Illusion of Life' are great animation recourses. For animation, www.cartoonbrew.com has a lot of great animation news and information. Going to animation festivals like Ottawa International Animation Festival or Annecy Animation Festival

are great ways to network and meet people and see exciting new things that aren't available online or on television yet. And it's fun to travel if you can.

WHAT DO YOU LOOK FOR FIRST WHEN YOU SEE YOUR PROSPECTIVE EMPLOYEE'S PORTFOLIO, & RESUME, AND WHAT IS THE MOST IMPORTANT THING YOU EXPECT FROM THEM?

Strong drawing and draftsmanship/design skills and originality/creativity.

ROD JUDKINS

Author of *The Art of Creative Thinking and Change Your Mind: 57 Ways to Unlock Your Creative Self*
London, UK

Rod Judkins is an artist, writer, and lecturer. He speaks passionately on creativity, and the creative processes at the Central St. Martins College of Art. He's had numerous solo shows and written two books on the subjects of creativity.

YOU ARE TEACHING APPLIED MEDICAL SCIENCES AT THE UNIVERSITY COLLEGE OF LONDON; HOW DOES THAT TIE IN WITH THE CREATIVE FIELD & CREATIVE THINKING?

I think there is a realization in the medical profession that creative thinking can help them improve the way they work. A lot of surgeons have attended my creative thinking workshops recently. Surgeons are the kind of people who are looking for ways to improve how they work. Creative thinking can help them think of ways to improve their equipment, ways of working and all sorts of other aspects. At UCL they want their students in medical science to think of themselves as creative people who are pushing and advancing science. That's where I come in — I show them practical methods to generate new ideas.

"THE ART OF CREATIVE THINKING" IS A BESTSELLER THAT'S TRANSLATED IN MANY COUNTRIES, INCLUDING KOREA

TRANSLATED IN KOREAN AS I
FEEL IT'S A BOOK EVERYONE
THERE SHOULD READ SINCE
CREATIVITY IS NOT NURTURED
OR VALUED SO MUCH IN THE
SOCIETY. WHAT DREW YOU TO
WRITE THE BOOK, AND
WHAT WERE SOME PROBLEMS
YOU WANTED TO ADDRESS
ABOUT CREATIVES?

I'm glad it's in Korean too. There's also a Japanese version just out and a Chinese translation on the way. I teach a lot of Korean students at Central Saint Martins. I think Asian culture is starting to realize that creativity can help them be at the forefront of innovation. Recently I've been doing consultancy work for Samsung and Apple. Although they are technology companies, creative thinking is at the heart of what they do — creating new products and software.

WHAT DID YOU STUDY IN
COLLEGE, AND WHAT'S A
VALUABLE EXPERIENCE YOU
HAD THERE?

I studied illustration at the Royal College of Art. Another student started copying my work and style on one occasion. I complained to my tutor, the illustrator Quentin Blake. All he said was, 'You'll have to make sure your work is better than theirs.' It was good advice because if you do something

interesting then someone is bound to copy it. Quentin Blake has hundreds of imitators – but he is the best at what he does.

HOW IS THE RAPID GROWTH OF
TECHNOLOGY INFLUENCING THE
WAY CREATIVES THINK, THAT
YOU'VE WITNESSED? HAS IT
CHANGED YOUR APPROACH TO
YOUR CREATIVE PROCESS TOO?

I think the mental processes are pretty much the same — for instance, a lot of the techniques Leonardo da Vinci used are still applicable today. The computer has helped me with my writing because I am able to use it to pull lots of diverse strands of thought together quickly. It would take me a lot longer on a typewriter.

WHAT ARE SOME OF THE
CHALLENGES OF YOUR FIELD?

I think in England the education system has not kept in line with the changes in the workplace. New developments in technology change so quickly now but people are educated to think in a way that suited the society of the 1900's.

WHAT ARE SOME GREAT
RESOURCES YOU
RECOMMEND FOR YOUNG
ARTISTS & DESIGNERS?

I really like the website and

books that It's Nice That produce. They always have the latest developments and are full of new ideas.

I READ THAT DESIGN MAKES UP A HUGE COMPONENT OF THE ECONOMY IN BRITAIN, AND I WANTED TO ASK HOW IS DESIGN GOOD FOR A COUNTRY? HOW IS IT NECESSARY?

The film, fashion, music and computer game industry are huge in England and the economy relies on them. They need a constant stream of new ideas to keep at the forefront of their fields. New young creative going into those industries feed in new ideas and concepts.

WHAT DO YOU LOVE MOST ABOUT WHAT YOU DO? WHAT ADVICE WOULD YOU GIVE TO STUDENTS OR GRADUATES ENTERING THE ART FIELD TODAY? HOW CAN STUDENTS LEARN TO EMBRACE THEIR DIFFERENCES AND NOT BE CONVENTIONAL?

I think that the problem students have today are very much the same as they were when I was a student. Society thinks that the creative industries are risky and uncertain. Their parents and schools try to steer them to safer options. But this is nonsense. There are hundreds of thousands of people working in the creative industries in England. All the students I was at college with are either successful illustrators or working for Pixar or other film companies. They are successful, but more importantly they are doing a job they love and care about.

JUDY COLLISCHAN

Museum Director, Art Historian and Art Critic
New York, NY, USA

Judy Collischan served as a museum and public art director and associate director, curating over one hundred exhibitions in a span of about 20 years. She taught art history on the university level for thirteen years; has written four books and is working on a fifth; has written numerous catalog essays, magazine articles and reviews; and worked as a newspaper columnist for four years.

YOU WERE AN ENGLISH MAJOR, MFA, ART HISTORY PH.D, WHAT INSPIRED YOU TO BECOME AN ART HISTORIAN AND ART CRITIC?

In undergraduate school, for the B.A., I had an art major and English minor. After that I went on for the M.F.A., in painting. The school I attended was particularly strong in Art History and I enjoyed it. Upon graduation the only jobs for women at the time were in art history, art education or humanities. Women couldn't get studio positions. So I wound up teaching humanities and art history at Kansas State University. As I was a bit restless, I stayed there for two years and then left for Europe where I was thinking of staying for awhile. For three months, I traveled on a self-guided tour of art history beginning at Stonehenge, museums in London, Paris, Milan, Florence, Pizza, Arezzo, Sienna, Rome, and Naples. When I arrived back in the states, I decided to pursue the Ph.D. in art history. As for art criticism, I began writing a weekly column for newspapers — first for the Waterloo Courier

169

(while teaching at University of Iowa) and then for the Omaha World Herald (while at the University of Nebraska). Later in New York, I wrote catalogue essays, a couple books, magazine articles and reviews.

WHEN YOU WERE DIRECTOR AT THE NEUBERGER MUSEUM, WHAT WAS THE PROUDEST SHOW THAT YOU CURATED? HOW MANY YEARS DID IT TAKE TO PREPARE?

At the Neuberger, I was the Associate Director of Curatorial Affairs, essentially meaning that I curated all the shows in two cavernous spaces of about 500 square feet each, two smaller galleries, I put pieces from the collection in the women's "powder room," and invented a Biennial for Public Art to enliven the bleak SUNY-Purchase campus and to emphasize the theme of public art. The largest and most important show I did was called "Welded: Sculpture of the Twentieth Century." This exhibition took about four years to prepare and ranged in work by Julio Gonzalez (an early welder), David Smith and the fifties metal sculptors, on up to the then present. I wrote a book that was published in conjunction with the show.

As Director of Hillwood Museum at Long Island University-Brookville, I did about 12 shows per year. On a miniscule budget with one assistant, a secretary and a couple graduate students, we did group and single person shows, created a public art program of 70 outdoor works, published catalogues for all shows, including several now prominent artists. It was their first publication. To do this, I wrote grants, and we regularly received money from NEA, NYSCA, and IMS. This was a time when government monies were not only available but was awarded for original projects.

WHAT IS THE DIFFERENCE WHEN YOU WERE WORKING IN THE GALLERY VS. THE MUSEUM?

I only worked in a commercial gallery for about a month. I quit abruptly mainly because I thought the dealer might not be entirely "up front" in his business. Also, it was terribly boring just managing one small space that already had a stable of artists. There was not much opportunity for creativity in putting together group exhibits.

THERE ARE A LOT OF STUDENTS WHOSE DREAM IS TO WORK AT A MUSEUM, BUT WHAT KIND OF ADVICE WOULD YOU WANT TO GIVE TO THEM? WHAT MAJOR OR PATH OF STUDY WOULD YOU RECOMMEND TO UNDERGRADUATE STUDENTS?

Made in the U.S.A. Modern/Contemporary Art in America

They should major in art history period. I have been told by a curator at a major, blue chip gallery in the city that none of the curators know anything about art history. How can this be? But since it appears to be a reality, perhaps this is why shows have become so vapid and boring. Museums and galleries show work that has been done before and better. Also, they should learn to write about art, and that means truly expressing something of the essence of the work perhaps based on conversations with the artist or consummate research. Writing involving meaningless strings of words does nothing to advance art.

HOW DO YOU PREPARE A SHOW AT A MUSEUM?

I will answer in terms of contemporary exhibitions. First of all, you LOOK! I always spent one day every week — 8+ hours — first with a studio visit to view the work of an artist of interest and then seeing alternate space, gallery and museum shows. This was much more interesting in the eighties, when there were many alternative spaces in New York. It was so exciting to "discover" an artist at the beginning (or middle/end) of her/his career before a gallery picked them up. Now that galleries have mushroomed while alternatives have all but vanished, it is less interesting.

WRITING IS VERY IMPORTANT AS AN ARTIST AND DESIGNER, I'M VERY IMPRESSED THAT YOU'VE PUBLISHED FOUR BOOKS SO FAR, ESPECIALLY ESSAYS — COLLEGE ESSAYS, HOW WOULD YOU RECOMMEND A STUDENT WRITE THEIR ESSAY?

Students writing college essays should ignore any thought of pleasing the college with remarks about how wonderful that institution is and how it is a perfect fit for them. Instead, the student MUST look inside themselves and examine who they are, what made them who they are and how these background facts or fantasies have contributed to their art. They should consider an influential ordinary person or menial event, i.e., an eccentric uncle who made bird baths, a grandmother's rock garden, or a teacher who advised them to go to college.

WHAT ADVICE WOULD YOU GIVE TO HIGH SCHOOL STUDENTS OR GRADUATES ENTERING ANY CREATIVE FIELD TODAY?

Follow your heart/dreams. Don't be misled by the pressure to find a job; better to create one. Be true to yourself, and be inventive and open at all times and in all activities — not just when making art. Be flexible, take risks and be constantly vigilant about your immediate time and place. Think of new solutions to issues/problems and especially seek out that which gives you pleasure.

12

JONATHON JEFFREY

Founding Partner of BIBLIOTHEQUE
London, UK

Jonathon Jeffrey, is one of the three founding partners of Bibliotheque; the London-based design consultancy produces "captivating design solutions, underpinned by conceptual thinking, meticulous attention to detail and innovative production".

HOW DID YOU SEE THE VISION FOR YOUR COMPANY?

We wanted the company to be about the quality of the work created by a team, not an individual.

WHAT'S THE MOST IMPORTANT THING YOU'RE WORKING ON RIGHT NOW, AND HOW ARE YOU MAKING IT HAPPEN?

The most important project is always the project you are currently working on.
At the moment this includes issue 2 of The Hour Magazine, a new identity for Flamingo (a global insight and brand consultancy), a spirit guide for Clarks and and identity for a high end gym; Core Collective

HOW IS ART & DESIGN SIGNIFICANT IN YOUR PERSONAL AND BUSINESS LIFE TODAY?

When you work in the creative industries there is not much of a

boundary between the two, it is just part of your lifestyle.

HOW IS THE RAPID GROWTH OF TECHNOLOGY INFLUENCING THE WAY YOU APPROACH YOUR COMPANY?

We find it exciting, challenging, liberating and sometimes frustrating in equal measure!

WHAT ARE SOME OF THE CHALLENGES IN YOUR INDUSTRY?

The current rate of those studying graphic design and the commercial demand for our services, compounded by advances in technology that allows anyone to design a logo or website, are not sustainable. Luckily technology cannot replicate the creative process and talent is always spotted by those who value it.

WHAT DID YOU STUDY IN COLLEGE?
A Foundation course followed by a degree in Graphic Design.

WHAT DO YOU LOVE MOST ABOUT WHAT YOU DO?

Working with a great team of talented individuals and with clients who have a great ambition.

WHAT DO YOU CONSIDER FIRST WHEN YOU SEE YOUR PROSPECTIVE EMPLOYEE'S PORTFOLIO, & RESUME, AND WHAT IS THE MOST IMPORTANT THING YOU EXPECT FROM THEM?

Creative thinking, a positive attitude, and a good personality.

WHAT ARE SOME GREAT RESOURCES YOU RECOMMEND FOR YOUNG ARTISTS & DESIGNERS?

Inspiration is all around you. Get away from the screen and engage with all that is available to you: books, magazine, cinema, theatre, galleries, exhibitions.

WHAT ADVICE WOULD YOU GIVE TO STUDENTS OR GRADUATES ENTERING THE FIELD TODAY?

Work hard, be a team player and stay positive.

ELISA JAGERSON & JASON STONE

CEO of SPECK DESIGN
Palo Alto, CA, USA

As CEO at Speck Design, *Elisa Jagerson* is focused on facilitating relationships and an infrastructure supporting them, to ensure that both Speck's clients and team members find the desire to remain a long-term partner of Speck. *Jason Stone*, Associate Director of Industrial Design at Speck Design, provides guidance on projects for the medical, data communications, and consumer markets.

TALKS WITH CREATIVES • CEO

HOW DID YOU SEE THE VISION FOR YOUR COMPANY?

Elisa: We intend to create the innovation engine of the new economy. We believe that the new product creation ecosystem is in its infancy from a reliability and accurate future casting perspective, and we intend to bring the efficacy of human sciences, accountability, and business acumen to the process. The foundational pillars of brand, strategy, and innovation design must be interwoven in a heretofore unprecedented way, in order to create the value generation engine that the industry deserves.

HOW IS THE RAPID GROWTH OF TECHNOLOGY INFLUENCING THE WAY YOUR COMPANY APPROACHES ISSUES?

Elisa: Companies are facing a pace of change, variable volume, and a new technology abundance that is simply overwhelming. More than anything, companies need the ability to curate new

opportunities through the multi-faceted filters of brand reach, consumer expectations, human behavior, future technology availability, supply chain ecosystem transformation, new material availability, and a myriad of other nuanced drivers. Because technology is advancing in every discipline, it is often the down selection, not the opportunity identification that, done well, represents the greatest source of growth.

WHAT DO YOU CONSIDER FIRST WHEN YOU SEE YOUR PROSPECTIVE EMPLOYEE'S PORTFOLIO, AND RESUME, AND WHAT IS THE MOST IMPORTANT THING YOU EXPECT FROM THEM?

Jason: Use your portfolio and resume to tell the best and most concise story about yourself. Rather than inundating your resume with information, use your resume as a simple and clean platform for expressing how your experiences have influenced and shaped your desire to be a designer. Your resume and portfolio should reflect your passion, drive, and design aspirations. The sample work you choose to feature in your portfolio should show how you've thought through the entire process — from the initial sketch, to the rendering, to the model, to the final product. As a designer, I like to see that you've thought about the size, proportions, and reality of how

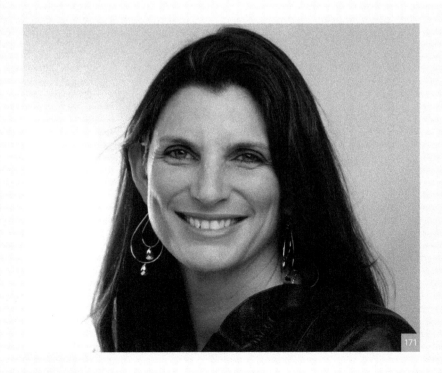

171

172

the product will ultimately be manufactured. A good designer is familiar with the basics of the engineering process.

WHAT ARE SOME GREAT RESOURCES YOU RECOMMEND FOR YOUNG ARTISTS & DESIGNERS?

Jason: Depending on the area of design you are interested in, there are several valuable online resources in each industry, but my three favorite general design-related websites are: Core77, designboom, and Dezeen. I highly recommend Donald Norman's Design of Everyday Things, the Universal Principles of Design by William

Lidwell, Kritina Holden and Jill Butler, and The Measure of Man and Woman: Human Factors in Design by Alvin R. Tilley and Henry Dreyfuss Associates.

WHAT ADVICE WOULD YOU GIVE TO STUDENTS OR GRADUATES ENTERING THE FIELD TODAY?

Jason: Relationships play a key part of your entry into the field of design. I strongly recommend seeking a mentor with vast experience in the field who can provide guidance, share experiences, and help build your library of knowledge. Be sure to listen to their constructive criticism and input on your growing portfolio. The

relationships you make during and after school will become a key influence on your career growth. I still keep in touch with some of the design professionals I met during the early stages of my career. It's also important that students get involved in various forms of networking, from attending events to applying to internships. During your internship, expect to go above and beyond your duties — don't just do the minimum. The best interns have a drive and initiative to look for the next project, are good at navigating ambiguity, and look at several different ways of approaching a single problem.

WHO ARE SOME OF YOUR CLIENTS THAT YOU'RE EXCITED TO HAVE DONE WORK FOR?

Speck Design is an interdisciplinary team of strategists, designers, and makers who have been helping companies identify and create new and better products for 20 years. We serve companies in diverse markets: medical, datacom, industrial systems, consumer, cleantech, robotics, and automotive. Google, Samsung, Audi, and Silicon Valley's leading start-ups come to Speck Design to create innovative products with a team that conducts generative research, applies world-class design, and engineers for manufacturing all under one roof. We are the best kept secret behind many of the products and services in your home, hospital, office, and automobile. From developing the best-selling Cisco router, to optimizing the PayPal experience for businesses, to streamlining the automotive repair process for AAA — Speck Design is behind it.

WHAT DO YOU LOVE MOST ABOUT WHAT YOU DO?

Elisa: The best part is participating in and advancing a vision for making the process of discerning the future ever more reliable. Our heritage is in hardware, and therefore clients often ask us how best to build it and what to build. Because the cost of tooling was so expensive, we very seriously considered the requirements for accuracy in our recommendations for new product development. The identification of opportunity methodologies for making that process ever more reliable, and advancing that conversation throughout the industry is by the far most rewarding thing I've done.

ALEKSANDR KHOMYAKOV

Assistant Designer at Apple
Cupertino, CA, USA

Alexander Khomyakov is a recent graduate of RISD, having studied graphic design and now works as a Design Assistant at Apple.

DID YOU WORK IN A SMALL OFFICE OR START AS AN INTERN?

I interned twice at a Swiss design studio called /Department, which has now joined forces with a much larger advertising agency called FCB (Zürich). When I was there, it was a small studio with about 15-20 people. Since there were only about eight designers working at /Department, even as an intern I had a good amount of freedom with the work I was doing.

WHAT ADVICE COULD YOU GIVE STUDENTS WHO WANT TO ENTER INTO THOSE BIGGER COMPANIES?

Don't be afraid to apply early, even if you don't feel "ready" yet. I worked on a few freelance branding/logo projects during my freshman year at RISD, and applied for my first internship that summer. I was highly doubtful and wasn't expecting to get accepted. Though, I was accepted and ended up interning in Switzerland during

Wintersession (mid-semester at RISD) of my Sophomore year. /Department wasn't a large company, but it provided me with amazing work and life experience. I think interning early took a lot of pressure off my back when it came to applying for more internships/ jobs later on, which allowed me to focus more on my work at RISD.

Another piece of advice would be to always photograph/ record your work as you go or right after you finish it. And photograph it well because that is how your work lives online aka how people see it. You also won't regret it when it comes to quickly having to put together a portfolio.

Also, as I mentioned, to gain real world experience during my first year at RISD, I worked on a few freelance projects. I did not get paid for this work, which I think is okay because I was very interested in it. A lot of my friends did not agree with this, but without doing freelance for free, I wouldn't have gotten the experience necessary to get my first internship.

WHAT ARE SOME OF THE MOST CHALLENGING ASPECTS ON A PROJECT AND HOW DID YOU GET INSPIRATION?

For me, I guess the most challenging aspect of any personal project is finishing it to the point where I feel like it's done. I'm always very interested in the beginning, but if the project drags on too long, I have a difficult time putting on the finishing touches. This especially happens when something new comes along. I still have about 5 or so projects that I want to finish / continue working on.

For inspiration, I follow blogs and buy a ton of books that I never actually read. I also use Pinterest (@khomyakov) to save work that inspires me, so I can easily refer back to it. And sharing my ideas/work with other designers and friends also helps a lot when I'm stuck.

HOW DID YOU PREPARE YOUR JOB PORTFOLIO?

I've always kept up with photographing my work and because of small freelance gigs, I've kept a PDF of my portfolio up to date. I did prepare a very simple website (khom.us) for when I had my interviews.

HOW WAS YOUR RISD LIFE? DID IT HELP YOU GET A JOB?

I love RISD. I think the main reason the school is so successful is because of the diverse and talented students that go there. They are the ones who overly critiqued my work

in class and who I spent many long nights in studio with. The students cause RISD to have a very competitive atmosphere that made me want to create the best work possible. This atmosphere forced me to get a job.

HOW DO NEW YORK, RISD, CALIFORNIA LIFE ALL COMPARE/ CONTRAST TO EACH OTHER?

California life is more distracting I would say, in a good way. There is so much to do around San Francisco, especially because the weather is so nice all of the time and there is so much nature close by — you can drive to the beach and surf in the Pacific or drive 3 hours west and ski in the Sierra Nevada. My ultimate goal in life is to ski and surf here, both in one day. At RISD, I was constantly thinking about my assignments, which gets stressful at times.

WHAT ADVICE WOULD YOU GIVE TO STUDENTS ENTERING CREATIVE FIELDS?

Meet and talk to as many people as you can, especially those with more experience than you. You can learn a ton and meet new people because of them.

WHEN YOU MADE YOUR PORTFOLIO IN HS — YOU WERE ALWAYS PUSHING THE

BOUNDARIES AND MAKING REALLY UNIQUE PIECES. WHAT ADVICE WOULD YOU GIVE TO STUDENTS THAT ARE MORE CONSERVATIVE, TO OPEN UP AND BE MORE CREATIVE IN THAT ASPECT?

I would definitely advise to step out of your comfort zone and try new things — and these new things don't have to be directly linked to art, design, or whatever creative field you are trying to pursue. Anything you do will feed your overall knowledge, experience and skill.

WHAT IS YOUR PLAN IN 5-10 YEARS?

I recently started surfing, so my plan is to be able to catch more waves by then. I haven't actually thought that far into the future much. I also want to learn how to speak Korean and enhance my Russian by then.

ASHFAQ ISHAQ

Founder of International Child Art Festival (ICAF)
Washington D.C., USA

Ashfaq Ishaq is the editor of Child Art magazine. He is also an entrepreneur, manager, researcher, and civil sector organizer.

HOW DID YOU FOUND THE INTERNATIONAL CHILD ART FOUNDATION?

This was in the 1990s during the digital revolution which carried a lot of promise for humanity. Everyone neighborhood could transform into a creative community and innovative solutions to all problems were at hand. But creativity does not grow with digitization, it grows with a child. Children's creative development was not a priority for the powerful elites or technology leaders. They never took arts education seriously. Hence they did not know that the arts are a powerful and yet least-cost approach to nurture a child's creativity. No national arts organization for American children existed. Nor an international one for the world's children. There was this big hole and somebody had to do something. So I founded the ICAF in 1997.

WHAT IS THE CHILD ART MAGAZINE THAT YOU PUBLISHED?

Published since 1998 as a quarterly, the ChildArt magazine fosters creativity and global understanding through the arts. It is the only full-color, professionally designed magazine for children which does not accept any commercial advertisement.

YOU'RE DOING AMAZING WORK, CONNECTING CHILDREN FROM ALL OVER THE WORLD, AND A TRAVELING SHOW, WHY YOU FIND THIS TO BE NECESSARY?

Problems like poverty, pollution, terrorism or war signify a lack of creativity and empathy. Since no solutions can be found or agreed upon, small problems linger on, and become intertwined and too huge to be solved without resorting to injustice or violence. However, if the next generation is creative and empathic, sustainable prosperity and lasting peace possible. The ICAF endeavors to increase this likelihood. Our Arts Olympiad commences in classrooms and leads to a community celebration where the art contest winners are selected and their creativity is celebrated. These winners are then invited to come to Washington for the World Children' Festival which is produced to honor them. The WCF provides a global community setting in which empathy can be fostered. Creative children come together and celebrate their differences.

They bond with each other and may develop lifelong friendships with strangers. The WCF sparks a creativity and empathy revolution. Following the WCF, the ICAF arranges the Arts Olympiad Exhibition which travels the world to increase public awareness and draw more families into the revolution.

IN JULY 2015 YOU PRODUCED THE WORLD CHILDREN'S FESTIVAL AT THE ELLIPSE NEXT TO THE WHITE HOUSE IN WASHINGTON D.C. HOW MANY YEARS DID IT TAKE TO PREPARE FOR THIS EVENT, AND HOW MANY PEOPLE FROM DIFFERENT COUNTRIES ATTENDED?

It was the 5th World Children's Festival. All previous four WCFs were held at The National Mall between the National Gallery of Art and the National Air and Space Museum. In the summer of 2015 this large area was being renovated and hence not available. So we moved the WCF to The Ellipse. At this space we could only have a smaller festival not a large one attended by 20,000 or even 50,000 people. Our limit was 2,500 and yet exceptional visual artists and extraordinary performers from 50 countries were able to participate and showcase their talents during the three-day event. The weather seemed uncooperative because it was raining before the festival opened, and then

the rain stopped right on time. The following day a rare double-rainbow came over The Ellipse, delighting the children. I think it was the coming together of the world's children that brought the rainbow.

WHAT IS THE MISSION FOR ICAF?

To employ the power of the arts to nurture children's creativity and imbue it with empathy.

EVEN THOUGH YOU WERE AN ASSOCIATE PROFESSOR OF ECONOMICS AT GEORGE WASHINGTON UNIVERSITY, WHAT MADE YOU CHANGE YOUR CAREER AND FOUND A NONPROFIT ORGANIZATION?

I was not really interested in the nonprofit sector and did not study it. My research focused on entrepreneurship. I had previously worked at the World Bank and co-authored a book *"Success in Small and Medium Scale Enterprises"* published by the Oxford University Press. Creativity is a key attribute of entrepreneurs and yet many adults are not really creative. Why do innately creative children lose their creativity when they grow up? Creativity researchers had discovered the "4th-grade slump" in creativity, when children begin to conform to the adult world and start suppressing their wild imaginations and creative

divergent thinking. I found a way to inoculate children against the "4th-grade slump" and had to start a nonprofit to conduct this essential and urgent work.

WHAT IS THE ARTS OLYMPIAD?

This is ICAF's flagship program for schoolchildren and even homeschooled children. The Arts Olympiad Lesson Plan introduces children to the "Artist-Athlete Ideal" of the creative mind and healthy body.

WHAT IS LEADERSHIP TO YOU?

Creativity and empathy are key attributes of today's successful learners and leaders. You need problem solving skills and the ability to leap over your own perspective to view the perspective of others. Only then can you manage people and lead them towards the fulfillment of an objective or fruition of a task.

WHAT ADVICE WOULD YOU GIVE TO STUDENTS ENTERING THE NON-PROFIT ART ORGANIZATION FIELD TODAY?

The charity sector is now the third sector between the private and public sectors. Nonprofits are generally essential and typically inefficient. They are mushrooming at a rate that far

exceeds the increase in grants and donations. This has resulted in the best minds chasing money instead of providing the service. So beware, plan well and have clear objectives.

WHY IS VOLUNTEERING IMPORTANT?

An underfunded charity like the ICAF cannot function without volunteers. Hence, our student interns and professional volunteers serve as the backbone of the organization. They contribute their own creative ideas to enhance our programs, deepen our impact, and broaden our outreach through social media channels. Volunteering is an important part of American life and organizations such as the ICAF exist only in the United States because of capable and devoted volunteers willing to help out.

16

ANGELA LEE
Fashion Designer at The Gap
New York, NY, USA

Angela Lee is a recent graduate of Parsons School of Design, having studied fashion she worked at Calvin Klein before becoming a Womens wear knit designer at The Gap.

WHAT WAS YOUR JOB AT CALVIN KLEIN? AND WHAT ARE YOU DOING AT THE GAP RIGHT NOW?

At Calvin Klein, my position was an Assistant Designer. Being straight out of school, I would assist the team in anything they needed my help in. This included making inspiration boards, matching colors, to sketching, etc. Being super organized and taking really detailed notes during meetings was also an important role. Currently, I am a Womens wear Knits Designer at the GAP, designing all the knit tops for the brand.

WHAT'S ONE OF THE MOST IMPORTANT THINGS YOU'RE WORKING ON RIGHT NOW, AND HOW ARE YOU MAKING IT HAPPEN?

One of the most important things I am currently working on is building the knits business during these financially difficult times. This can't be done alone. Having a really talented

174

and collaborative team is very important to make this successful. Having an amazing work relationship with my product managers, technical designers, merchandisers, and fellow designers gave us a huge advantage on working towards improving the business.

WHAT ARE SOME OF THE CHALLENGES IN YOUR INDUSTRY? HOW DO YOU GATHER INSPIRATION?

During the times of fast fashion making a huge presence in the industry with brands like Zara, H&M, and Forever21, we are faced with the challenge of competing with these brands. It has been really important for me to design classic, well-designed styles for the masses that will last in their closets for years.
I gather inspiration from all places- whether it's from what people are wearing on the streets, to art, or designer runway shows.

WHAT ARE SOME GREAT RESOURCES YOU RECOMMEND FOR YOUNG ARTISTS & DESIGNERS?

Being in New York City give us a huge advantage on having really great resources at our fingertips. Some of my favorites are Museum of Modern Art, Storm King Art Center, and Dia:Beacon. I like

to get inspired from other things outside of fashion for my designs — whether it's for color, or design aesthetics, or the other artist's way of thinking.

WHAT DOES KNITWEAR DESIGN COVER? HOW DO YOU COME UP WITH PATTERNS?

Knitwear consists of two different processes the garments are made. Knit is a type of fabric construction. In "cut-and-sew knit", the required pattern is cut from the knit fabric and sewn together to create the garment. While in "fully-fashioned knit" the pattern is engineered by knitting to the specific shape of the pattern and sewn together — with no extra fabrics. I design cut-and-sew knits.

I'VE KNOWN YOU FOR A LONG TIME, PROBABLY 10 YEARS, YOU ALWAYS HAD A DREAM TO BE A FASHION DESIGNER. WHAT DO YOU LOVE MOST ABOUT WHAT YOU DO?

What I love most about my work is being able to design garments for wide range of customers with all different demographics, world-wide. Designing well-designed product while also considering the customer's day-to-day life and providing them with the garments to feel good in, while also being comfortable

has been my priority when I'm coming up with designs.

PARSONS HAS A ONE YEAR COURSE IN PARIS FOR FASHION DESIGN, WOULD YOU RECOMMEND IT SINCE YOU WENT TO PARSONS? IF SO, WHY?

This has been one thing I regret not doing while I was in Parsons. I would recommend to all students to take this chance to study abroad because this chance will not come by very often. Being a student has this sense of freedom to create or design anything they want, being able to explore and discover who they are as a designer or artist. What better way to do this in a different country — to be inspired by everything surrounding them?

HOW IS THE GROWTH OF TECHNOLOGY CHANGING THE FASHION INDUSTRY?

Many companies these days require designers to be able to sketch not only by hand but also by Adobe Illustrator. It's important for designers to be able to use Adobe programs. It helps to create an even more accurate sketch on the computer and is very easy to update.

WHAT ADVICE WOULD YOU GIVE TO FUTURE FASHION STUDENTS,

AND WHAT DO YOU RECOMMEND FOR HIGH-SCHOOL STUDENTS?

The first advice would be to make sure you really want to go into this industry and you can't imagine doing anything else. It's very competitive and there is lots of great talent.
Another advice would be, even though it's a bit cliche, treat others the way you want to be treated. This industry is very small and it's not only about the talent. Everyone knows somebody and you want to make sure you have a good reputation in this business. People hire those they want to work with, but also someone they want to spend time with.

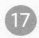

YOSHI SHIRAISHI

Architect and Interior Designer of YDNY & eCool Hawaii LLC
Honolulu, HI, USA & Tokyo, Japan

Yoshi Shiraishi is originally from Japan, graduating from Musashino Art College as an Architect major. He has lived in NYC as an interior designer for over 25 years. Upon achieving the International Design Competition Grand Prix Award he received his position in the New York leading design firm Walker Group/CNI. He is the owner of the interior design company YDNY an international architectural firm with a talent for combining Japanese and Western culture into a uniquely distinct aesthetic, and and eCool Hawaii LLC. which specializes in developing, consulting, and designing off grid clean energy technology.

HOW DO YOU COME UP WITH INSPIRATION BEFORE YOU BEGIN A PROJECT?

When I start the project, inspiration is coming out from my ideas like a drawer in my brain/heart. I've traveled to over 50 countries all over the world, and whenever I saw a building, market, train station, church, all images are archived in my memory drawer. When I need ideas or inspiration, it naturally comes out from this drawer.

WHAT'S AN IMPORTANT PROJECT THAT YOU'RE WORKING ON RIGHT NOW, AND HOW ARE YOU MAKING IT HAPPEN?

An important project now is The Kahala Resort and Hotel in Hawaii, and the Blue Note Jazz Club Hawaii.
The Kahala project was based from a competition, and since I am of Japanese origin and live in Hawaii with many experiences from doing international projects in NY, I was selected.
For the Blue Note Jazz club,

I had the chance to meet the owner of Blue Note Hawaii and express how much I loved Blue Note NY when I lived in NY, and how important this project for Hawaii is and for tourists coming to Hawaii. He needed someone like me who knows the spirit of Blue Note Jazz.

YOU LIVED IN NY FOR OVER 20 YEARS, AND HAWAII AROUND 6 YEARS, YOU ALSO DID 500 PROJECTS, WHAT IS THE DIFFERENCE BETWEEN NEW YORK, HAWAII, & TOKYO AS AN INTERIOR DESIGNER & ARCHITECT?

In New York it is very competitive and you really need to establish your own style to differentiate from others. New York does not copy any other designs from other cities in the world. They only learn from the history or use imagination about the future.
Hawaii is a very resort driven city and harmony of nature is very respected. So, design requited something soft and harmonized with the personality and spirit of Hawaii. Tokyo is similar to New York, but still very Japanese for everyone. It has totally different values, tastes, and combinations of traditional designs and modern pop culture is blended in.
New York is cutting edge modern, Hawaii embodies harmony of nature and modernism, Tokyo is Pop modern, and has Asian Energy and Sophistication.

WHAT DO YOU THINK NEW YORK DESIGNERS CAN LEARN FROM JAPANESE DESIGNERS, AND VICE VERSA?

Japanese designers start very detailed and refine the design. They care about the harmony of material, color, nature. They spend a lot of time creating a concept that differentiates from other similar designs. Originality and identity is a very high priority for designers. Japanese designers have a high demand for very high quality work. They run the extra mile to meet their satisfaction no matter how late they have to work.

Designers in New York are very good at looking at the overall design rather than the details. It is almost the opposite concept compared with the Japanese, but there is a similarity which is that they both have great passion for creating great design.

WHAT DREW YOU TO MOVE FROM NEW YORK TO HAWAII?

I have been in New York for 24 years flying all over the world do projects.
But, New York became a little

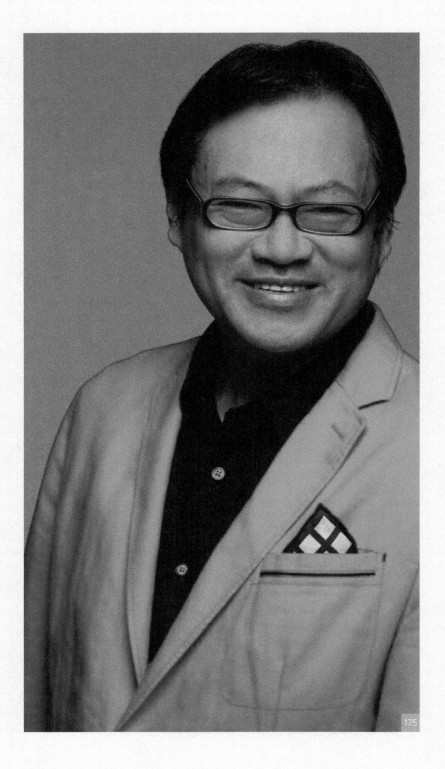

175

too competitive after the 2008 recession. Then I was assigned two very interesting projects to design, both from Honolulu, Hawaii. One being the Trump Tower Waikiki for a brand new hotel & condo, and the other was Halekulani hotel renovation. I could go back and forth from Hawaii, and I decided it was better for my family, especially for the kids to stay in paradise.

WHAT ARE SOME OF THE CHALLENGES IN YOUR INDUSTRY?

You need to express your own original design ideas, but at the same time you will have to balance that with your client's preference of design. This is the big difference compared to being for example, a fine artist. You can do whatever you want in order to create your own artwork and ideas, and you do not care what other people think.
You need to convince your client about your designs but also go over the client's input and make it so that he felt like his design is appreciated too.

Also producing great design and running the design firm as a business is a different story. As an artist, you want to do as many fun, inspiring projects as possible, but as a business owner, you need to spend time only on very profitable projects.

So the challenge is how to effectively do the marketing, and how to make it a profitable project with the clients satisfaction.

WHAT ARE SOME GREAT RESOURCES THAT YOU RECOMMEND FOR YOUNG ARTISTS & DESIGNERS?

The best design resource is traveling around the world as much as you can to visit different places. It can be low budget travel, but you need to see a lot of different types of architecture, including for example, markets, churches, event venues, etc.
I met a handful of famous internationally renown architects and designers, and they've always been world travelers since they were young.

I do not think viewing the space or environment on a website really works as effectively if you are creating a space which is three dimensional.

WHO ARE SOME CLIENTS THAT YOU'RE EXCITED TO HAVE DONE WORK FOR?

It was for Disney and Sony. The way they went about asking us to do the project is, "here, we are giving you this much award for you to do the design, so please do the best design you've ever done in your life." Typical clients request so many

detailed design direction, but since Disney and Sony knew the best outcomes from the client, they leave the creativity to the designer.
If so, the designer will be fired up to do one of the best designs he's ever done, and enjoy the project with a balanced pressure.

OUT OF THE SEVERAL HUNDRED PROJECTS THAT YOU'VE COMPLETED, WHAT ARE SOME PROJECTS THAT WERE SPECIAL TO YOU-THAT YOU REMEMBER SIGNIFICANTLY?

One is the Itoen kai restaurant and tea shop in New York. I created an intangible atmosphere. You are able to experience a Tea related culture though your five senses.
The other one is The Brick Square in Park Building in Tokyo. It took four years to design to create a timeless design that was somehow nostalgic but still fresh. The design remains modern like the architecture in the 60's by Frank Lloyd Wright, le Corbusier. It is an opposite design style which is very trendy after the opening, but becomes obsolete in six months.

WHAT DO YOU CONSIDER FIRST WHEN YOU SEE YOUR PROSPECTIVE EMPLOYEE'S PORTFOLIO, & RESUME, AND WHAT IS THE MOST IMPORTANT

THING YOU EXPECT FROM THEM?

I always check his or her free hand sketching skills. CAD and CG are main stream now, but I still see the importance of raw idea sketching. That, I believe, is the best way to come up with great ideas. You need to express your style and passion about your design, so free hand skill is the most important element for me when I look at a portfolio.

FROM YOUR EXPERIENCE, YOU DID INTERIOR DESIGN ALL OVER THE WORLD, INCLUDING EUROPE, WHEN YOU DESIGNED THE FAMOUS DEPT. STORE IN PARIS-FROM YOUR INFLUENCES, HOW DID YOU COMBINE THE CLASSICAL PARISIAN ARCHITECTURE WITH YOUR OWN STYLE?

I believe French people respect and admire both classical Art/ Architecture as well as the modern pop culture in Japan.
I tried to harmonize "The Old and New " in My DNA as Japanese origin.
I was not intentional in expressing that, but after many years living in and being with beautiful Japanese nature, art and culture, it was naturally expressed from my heart.
I tried to also combine French Classic with Japanese minimalism that was already succeeded in Fashion by a Japanese fashion designer.

WHAT ADVICE WOULD YOU GIVE TO STUDENTS OR GRADUATES ENTERING THE ARCHITECTURE OR INTERIOR DESIGN FIELD TODAY?

I would suggest traveling around the world, visiting as many countries as you can.
As I said, it can be low budget travel, but seeing the architecture, meeting different people, checking the markets, etc. gives you so many seeds of creativity for the future. You need to be globally aware of both cultures and creativity, and think about the harmonization with other cultures and nature all the time.

Believe your talent and this will allow you to do things to the best of your ability.
"Life is short, Design is Long!!"

MARCO LAFIANDRA

Product and Furniture Designer at DDC
New York, NY, USA

Mr. LaFiandra lives in NYC where he works for DDC (Domus Design Collection), one of the leading showrooms of contemporary furniture in North America. As a designer and project manager at DDC DESIGNPOST, he collaborates with many important companies, such as Zanotta, Vitra, Paola Lenti, Roda, Glass Italia, Arflex, Venini and many others.

WHAT ARE SOME OF THE CHALLENGES WHEN YOU START WORKING ON A PROJECT? HOW DO YOU GATHER INSPIRATION?

What challenges me more is building a connection with the clients I work for. It is fundamental to me to understand what their needs are and to be sure they understand and like my concept as well. Here is where I gather inspiration from: the deeper is the connection with the clients, the more my concept will satisfy them.

WHAT ARE SOME GREAT RESOURCES YOU RECOMMEND FOR YOUNG ARTISTS & DESIGNERS?

Above all, I think that no one could be a great designer without knowing Bruno Munari's work. He is considered the first Italian designer, the first who analyzed and described the creative process that takes you from the concept to the product. His books opened my

mind while at the university and still inspire all my work. Also, I have recently read "Creative Confidence" by David and Tom Kelley, founders of IDEO, which persuasively demonstrated how every aspects of real life could benefit from the design creative process.

WHAT DO YOU LOVE MOST ABOUT WHAT YOU DO?

My clients' feedback is what I love the most. When I am capable to translate their feelings into something tangible, their emotional reaction still touch me very much.

HOW IS LIFE IN NEW YORK AS A DESIGNER FROM ITALY? AND HOW LONG HAVE YOU BEEN IN NY?

Life in the city is great. I have moved here 6 years ago and people still make fun of my accent. As you can imagine, living in NY could be tough as well. However, I try to get the most that I can from its creativity and artistic environment and I have learnt how to turn its flaws into inspiring peculiarities.

WHAT IS THE BENEFIT LIVING IN NY AS AN ITALIAN DESIGNER?

Being an Italian designer in NY could be fun and tough at the same time: fortunately most

people give me credit because I'm Italian, but sometime they underestimate me for the same reason. Surely it helps with sales, for some reasons that are still hard for me to understand, Americans believe that we Italians have a better taste with furniture and interior designing.

HOW CAN STUDENTS LEARN TO EMBRACE THEIR IMAGINATION & QUIRKS RATHER THAN SETTLE FOR BEING 'NORMAL'?

I would never get tired with saying that when undertaking a career as designer, especially at the very beginning, each student should not build any boundary to limit his own imagination. What we learn in Italy about design is not to label, not to categorize, but to express freely, and let your very self come out.

WHAT ADVICE WOULD YOU GIVE TO STUDENTS OR GRADUATES ENTERING THE CREATIVE FIELD TODAY?

To be patient, at first. Students should be aware that the 90% of the job they are going to perform has very little to do with creativity. Being a designer needs as well much of social and administrative skills. Having said that, I would recommend to every student entering the creative field today to never abandon his personal vision

and mission, no matter how big and anonymous is the work environment they work in.

WHAT DID YOU STUDY IN COLLEGE?

Industrial design.

IN YOUR OPINION AND EXPERIENCE LIKE IN NY, 1) WHAT IS THE DIFFERENCES OF DESIGN IN USA AND IN ITALY? 2) WHAT IS THE DIFFERENCES OF DESIGN EDUCATION IN USA AND IN ITALY?

The main difference between design education in the US and in Italy is that in Italy designers constitute a very closed group, mainly working with the big names of domestic design, such as Cassina, Minotti...... — In the US, instead, designers are artists in first place, and by being that they aim to establishing their own names and their personal brand. To simplify, in Italy design is still more related to the industrial production, while in the US it is more about craftsmanship.

WHAT'S ONE OF THE MOST IMPORTANT THINGS YOU'RE WORKING ON RIGHT NOW, AND HOW ARE YOU MAKING IT HAPPEN?

Building my own language.

MARCO,
TI AMO

176

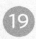

19

HYUN KYU HAN

Interactive Environment Designer at ESI Design
New York, NY, USA

Mr. Han lives in NYC where he works at ESI Design (Edwin Schlossberg Incorporated). ESI Design is one of the world's foremost experience design firms. As an interdisciplinary team, ESI works at the intersection of physical, digital and social design. From ESI's roots of transforming the Brooklyn Children's Museum to current work with a diverse set of leading institutions and brands, ESI has collaborated with many clients to design and create hundreds of cultural and brand experiences. Mr. Han is an Interactive Environment Designer (Physical Designer) who works closely with the design team and clients to create engaging social experiences.

WHERE DID YOU GO TO SCHOOL AND WHAT WAS YOUR MAJOR?

I went to Pratt Institute and majored in Interior Design and minored in Art History.

WHAT IS AN INTERACTIVE ENVIRONMENT DESIGNER?

At ESI Design, we call this long title a Physical Designer. I, along with many of my colleagues from the Physical Design Department concentrate on the physical aspect of the environment we are designing. While collaborating with other members of the design team, I focus on how our ideas exist in scale and how it works as a space to get the experience across. Sometimes this will mean a small detail of a digital media environment and other times this will mean a large portion of the design with digital media involved.

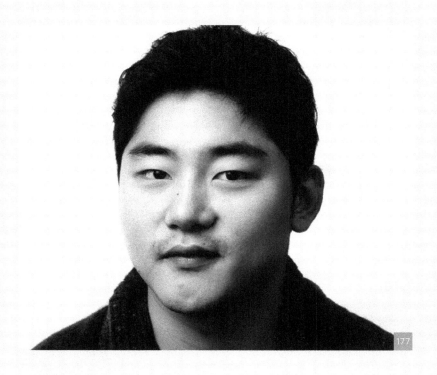

177

HOW DID YOU GET IN AN ESI DESIGN FIRM? WHAT KIND OF WORK DO YOU DO?

Throughout my college years I was very much interested in creating a meta-layer that enriched not only the aesthetic feature of the space but enriched the experience of where you are. To get here, I started off by entering into competitions using a programming kit called Arduino which helped me tap into the data of the surroundings of the design context like CO2 levels, temperature, wind-speed and such to act as a 3rd medium to my design projects after the building envelope and the interior space. However, I never thought I would be able to use technology similar to this professionally, until I found ESI Design through research.

ESI Design is an interdisciplinary team of designers who collaborate on the platform of experience design. ESI is currently involved in many design fields including interactive museum design, retail brand experience and media architecture. Designers come from various professional backgrounds such as storytelling, interaction design, technology, systems and A/V design, media design and physical environment design. I am currently a Physical Designer there.

WHAT ADVICE COULD YOU GIVE TO STUDENTS WHO WANT TO ENTER INTO THOSE BIGGER COMPANIES?

I did work at several architecture companies prior to joining ESI Design and the core difference between being at ESI and working at an architecture office is that there aren't as many opportunities to collaborate with other creatives and to me, that is something that I enjoy the most about my career.

WHAT ARE SOME OF THE MOST CHALLENGING ASPECTS ON A PROJECT AND HOW DID YOU GET INSPIRATION?

Projects can be challenging for various reasons, but in almost every case the inspiration comes from talking amongst colleagues who have completely different views from you.

HOW DID YOU PREPARE YOUR JOB PORTFOLIO?

I guess I began my portfolio in a very traditional sense for an Interior Design major. My portfolio consisted of various Interior Design projects (renderings, diagrams, and so on). I think for the most part my portfolio influenced my earlier career path since it got me hired at an architectural firm.

However, I had to completely changed up my portfolio when I interviewed for my current job. I think I only had 1 interior design project and everything else consisted of competition pieces from school.

HOW MANY JOBS DID YOU APPLY TO? AND HOW MANY CALLED YOU BACK?

To be honest, I did apply to about 120 architecture and interior design offices and about 20 of them asked me to come in for an interview; quite possibly because my portfolio consisted of projects that I was less invested in, since I spent most of my time in school working on competitions.

WHAT ADVICE WOULD YOU GIVE TO STUDENTS ENTERING CREATIVE FIELDS?

I would advise students to find a project or a competition in my case where you're able to collaborate with students from other majors. I felt like that is where I learned the most about the collaborative design process and using various mediums to achieve a holistic design prior to joining ESI.

WHAT IS YOUR PLAN IN 5 YEARS?

I hope to remain in the creative industry that I am in right now.

I think it is amazing to be in a professional field where no projects are alike and I am constantly learning new things every day.

WHEN YOU MADE YOUR PORTFOLIO IN HIGH SCHOOL, YOU WERE ALWAYS PUSHING THE BOUNDARIES AND MAKING REALLY UNIQUE PIECES. WHAT ADVICE WOULD YOU GIVE TO STUDENTS THAT ARE MORE CONSERVATIVE, TO OPEN UP AND BE MORE CREATIVE IN THAT ASPECT?

I think a conservative approach in art or design is sometimes a better solution depending on context. But, I can't imagine being an artist or a designer who recognizes the true context of conservative art without having had an extensive amount of experience trying other mediums.

PHOTO CREDITS

SOURCES

1 pg 9: taken from RISD website
2 pg 9: taken from MIT website
3 pg 10: taken from ArtCenter College of Design's website
4 pg 10: taken from NYU website
5 pg 34: taken from ArtCenter College of Design, SVA, NYU, RISD, Parsons
6 pg 39: NYU website
7 pg 39: University of Michigan Stamps website
8 pg 56: ArtCenter website
9 pg 62: Boston University website
10 pg 70: University of Cincinnati website
11 pg 78: CCA website
12 pg 86: Taken from CMU website
13 pg 102: CCS website
14 pg 112: Columbia website
15 pg 120: The Cooper Union website
16 pg 126: Cornell University website
17 pg 134: Dartmouth website
18 pg 142: Harvard University website
19 pg 150: University of Michigan website
20 pg 156: MICA website
21 pg 164: MIT website
22 pg 172: Moore College of Art & Design website
23 pg 180: NYU website
24 pg 186: Parsons School of Design at the New School website
25 pg 194: University of Pennsylvania website
26 pg 200: RISD website
27 pg 208: SFAI website
28 pg 214: SVA website
29 pg 224: Syracuse University website
30 pg 232: Temple University website
31 pg 242: VCU website
32 pg 252: Yale University website
33 pg 268: NYU ITP website

CHECK OUT SOME OF OUR OTHER BOOKS

ART COLLEGE ADMISSIONS
An insider's guide to portfolio preparation, selecting the right college and gaining admission with scholarships. In the first half of this book, you'll learn how vital a role art plays in the success of businesses today, what admissions committees at top art colleges really look for when deciding who to admit, and essential tips for developing award-winning art portfolio pieces.
In the second half, you'll learn about the distinct advantages and histories of the most highly-ranked and popular art colleges in the Northeast, specific and actionable tips for getting into each school, and any changes these schools have made to their admissions criteria in recent years.

YOU CAN CONTINUE TO DEVELOP YOUR ARTISTIC SKILLS IN DIFFERENT MEDIA!

SMART SKETCHBOOK 1:
Still Life in Pencil

SMART SKETCHBOOK 2:
Still Life in Charcoal

SMART SKETCHBOOK 3:
Still Life in Charcoal and Pastel

SMART SKETCHBOOK 4:
Still Life in Acrylic

SMART SKETCHBOOK 5:
Facial Features in Charcoal
and Pastel

SMART SKETCHBOOK 6:
Joints in Charcoal, Pastel
and Acrylic

SMART SKETCHBOOK 7:
Upper Torso Anatomy
in Pastel

SMART SKETCHBOOK 8:
Portraiture in Charcoal
and Acrylic

SMART SKETCHBOOK 9:
Hair Textures in Charcoal
and Pastel

CPSIA information can be obtained
at www.ICGtesting.com
Printed in the USA
LVHW071032280720
661635LV00008B/439